CREATIVE PHOTOGRAPHY

Aesthetic Trends 1839–1960

HELMUT GERNSHEIM

DOVER PUBLICATIONS, INC.

NEW YORK

Published in Canada by General Publishing Company,
Ltd., 30 Lesmill Road, Don Mills, Toronto, Ontario.
Published in the United Kingdom by Constable and Com-
pany, Ltd., 3 The Lanchesters, 162–164 Fulham Palace Road,
London W6 9ER.

This Dover edition, first published in 1991, is a slightly
revised and updated republication of the edition originally
published by Faber & Faber, London, and the Boston Book
& Art Shop, Boston, in 1962. A new foreword has been
written for this edition.

Manufactured in the United States of America
Dover Publications, Inc., 31 East 2nd Street, Mineola,
N.Y. 11501

Library of Congress Cataloging-in-Publication Data

Gernsheim, Helmut, 1913–
 Creative photography : aesthetic trends, 1839–1960 / Hel-
mut Gernsheim.
 p. cm.
 "A slightly revised and updated republication of the edi-
tion originally published by Faber & Faber, London,
and the Boston Book & Art Shop, Boston, in 1962"—
T.p. verso.
 Includes bibliographical references and index.
 ISBN 0-486-26750-4 (pbk.)
 1. Photography, Artistic. 2. Photography—History.
I. Title.
TR650.G385 1991
 779—dc20 91-12203
 CIP

CONTENTS

ILLUSTRATIONS

The author and publisher gratefully acknowledge the loan of forty-four blocks from the Shenval Press.

Originals of all the illustrations in this book are in the Gernsheim Collection, Harry Ransom Humanities Research Center, The University of Texas at Austin, unless otherwise stated. Those by living photographers are reproduced with their kind permission.

The following individuals and organizations have kindly allowed the reproduction of the following photographs:

Mrs Rosellina Bischof, 238, 239, 240; The Bodley Head, 86; Mr Paul Boissonnas, 125; The British Film Institute, 179, 181; British Railways, 3; Contemporary Films, 243; Mr Anthony Denny, 12; George Eastman House, Rochester, 100, 137, 158, 161; Edinburgh Public Library, 24; Mr Hans Hammarskiöld, 119; Mr Peter Hunter, 219; Mrs Anneliese Lerski, 182; The Library of Congress, Washington, 226, 227; London Press Exchange, 3, 4; Palace of the Legion of Honor, San Francisco, 103; The Royal Photographic Society of Great Britain, 62, 63; the Société Française de Photographie, 8, 19; Stenger Collection, 38; Mr Brett Weston, 190; Mr Berthold Wolpe, 36; Mrs. A. Erfurth, 130.

7

9

FOREWORD TO THE DOVER EDITION

It is gratifying that *Creative Photography* is having a new edition after nearly thirty years in print. It was originally published in June 1962 by Faber & Faber in London and the Boston Book & Art Shop in Boston, Massachusetts. In 1970 the English-American edition was surprisingly followed by a Rumanian edition, published with a different layout and in a slightly reduced format in Bucharest—then behind the Iron Curtain. Finally, Bonanza Books of New York brought out a 12,000-copy facsimile reprint of the Faber edition in 1974. (The date does not appear on this reprint and has given rise to all sorts of imaginative speculation.)

There was little that required change in this new edition, apart from small additions to the text here and there. I still agree with everything I wrote thirty years ago except for a paragraph on abstract photography, formerly on p. 207, having meanwhile completely reversed my opinion on that subject. For many years now I have been a great admirer and strong advocate of photographic abstractions, as Ferenc Berko, Pierre Cordier, Franco Fontana, Victor Gianella, Aaron Siskind, J. P. Sudre and Howard Bond—to mention only a few outstanding practitioners represented in my collection of contemporary photography—would testify.

All the chapters in this book are historical reviews except the last, "The Face of Our Time." For a moment I felt tempted to add pictures of more recent work; yet having said everything that in my opinion needed saying, any extension seemed to me superfluous. *Creative Photography* is not a history; I merely offer contemplative thoughts on the constantly changing ideals of aesthetic expression, often triggered by new technical inventions that extended the range of photography. Every field produced its masters, and every master devised his or her own form of aesthetics. Changing beliefs, changing conceptions have pervaded photography during the 160 years of its existence. Until recently no one wasted time or money on trivialities.

Many photographers whose work is illustrated in *Creative Photography* have died in the last thirty years. I am grateful for their friendship and their art, which enriched my life.

Castagnola HELMUT GERNSHEIM
15 November 1990

INTRODUCTION

The close of the eighteenth century, which gave birth to lithography, also saw the first steps towards the invention of photography.

Aloys Senefelder of Munich devised in 1798 a method of surface-printing from stone, a material which he had been using as a cheap substitute for copper plates in printing plays, music scores, prayer-books and similar work. Five years later the first publication of artists' lithographs appeared[1]—in England—and it was this that brought into prominence the possibilities of lithography as a new graphic art.

At the time of Senefelder's invention there was an increasing demand from the rising middle classes for inexpensive illustrations—reproductions of paintings, topographical views, and in particular portraits of themselves. It is impossible to say whether this demand led Thomas Wedgwood, son of the famous potter Josiah Wedgwood, to experiment with photography, or whether he was thinking first and foremost of simplifying the task of the art department at the Etruria Works in their production of portrait plaques, and of dinner and tea services decorated with landscapes and the country seats of the aristocracy. But it is known for certain that Wedgwood employed in his experiments the *camera obscura* used by the firm for sketching such views.

Since the middle of the sixteenth century this optical instrument had been in demand to an ever-increasing extent as an aid to drawing in perfect perspective and to achieve an exact copy of nature. The image thrown upon the ground-glass screen by the lens had to be traced by hand, and the desire to find

a chemical process 'by which natural objects may be made to delineate themselves without the aid of the artist's pencil'—as Fox Talbot put it—probably occurred to many artists and scientists using the apparatus. Thomas Wedgwood was the first person to attempt this. He failed owing to insufficient chemical knowledge, but his 'Account of a method of copying paintings upon glass and of making profiles by the agency of light upon nitrate of silver'[2] describes the first deliberate experiments towards photography.

Independently, a number of other investigators in France and England took up the problem. The first to succeed was Nicéphore Niépce, a French land-owner with scientific interests, who approached photography through Senefelder's invention, for originally he wanted to make lithographs, which had become a fashionable hobby in France. His artistic skill proving inadequate, Niépce tried to find a way of fixing the images of the *camera obscura* chemically—initially on lithographic stone. After ten years of experimentation with a great variety of materials Niépce managed in 1826 to obtain a faint 'heliograph' or 'sun drawing' on a pewter plate coated with bitumen of Judea, a substance which he discovered to be light-sensitive. The exposure of this, the world's first photograph (*No.* 1), was eight hours in full sunshine!

Heliographic plates were intended to be etched and inked in order to print a large number of copies on paper. However, pictures from nature taken in the *camera obscura* were too faint, and Niépce only succeeded in printing from those plates which he had made by placing line engravings directly on the sensitive surface; i.e. art reproductions.

[1] 'Specimens of Polyautography, consisting of impressions taken from original drawings made purposely for this work.' Published by Philipp André, London, 30 April 1803.

[2] *Journal of the Royal Institution*, London, June 1802.

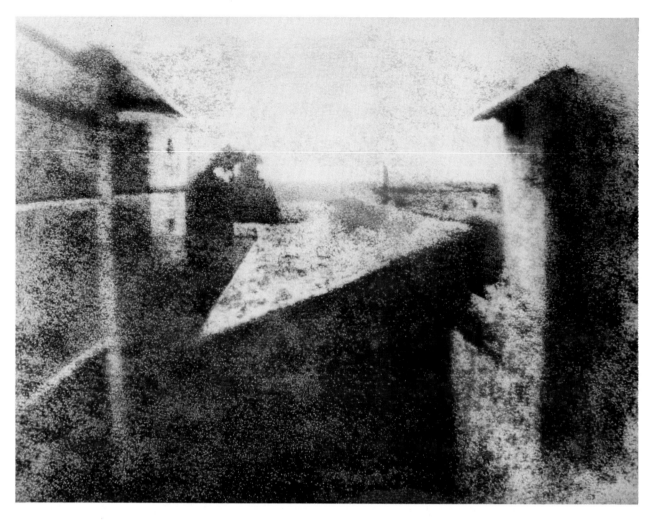

1. *Nicéphore Niépce. View from his workroom window at his estate Gras near Chalon-sur-Saône. The* point-illiste *appearance of the reproduction is due to surface impurities of the pewter plate which are unnoticeable in the original.*

Niépce, Daguerre, Talbot and other independent inventors of photography, the Rev J. B. Reade, Sir John Herschel, Hippolyte Bayard and Friedrich Gerber—all thought only of the practical usefulness of the invention in copying nature. The possibility of photography being a creative art was an idea as far removed from their minds as the artistic application of lithography had been from Senefelder's. As in the case of lithography, it was several years after the introduction of photography to the public that the first conscious effort in this direction emerged. Like the older technique, photography had to fight for recognition as a graphic art, though a host of distinguished artists in both media have given ample proof that they can be creative art forms, as well as inexpensive methods of illustration.

There is probably no sphere of activity in our modern civilization that could be thought of today without photography. Its thousandfold applications to science, medicine, industry, commerce, education, the cinema, television, etc., have made photography indispensable in daily life. Next to the printed word the photographic image is the widest form of communication, and for this reason it has been aptly called the most important invention since that of the printing press. Photography in the service of mankind disseminates information about man and nature, records the visible world, and extends our knowledge far beyond it.

In considering the artistic aspect of photography we are not concerned with photographs intended to serve scientific or technical purposes, although some

of them do have great aesthetic appeal, which is of course incidental (*No. 2*).

We can also ignore the billions of snapshots taken every year by the estimated hundred million camera users all over the world for no other purpose than to serve as mementoes of family events and holidays. For the snapshooter a photograph is merely 'a mirror with a memory', to borrow the expression from Oliver Wendell Holmes. It bears the same relationship to a composed creative picture, as noise does to music. Only a tiny core of amateurs and professionals—perhaps no more than 1 per cent of all camera owners—strive to use their apparatus creatively. In other words, only a minute proportion of the immense output of photographs has any pretensions to art—an important point which critics invariably overlook in discussing the subject. If few photographers succeed in their intentions, this only proves the elusiveness of the creative element in a technique almost anyone can learn to master, but is no reason for denying to photography the existence of such creative possibilities. Is not the position analogous to that in other art media in which thousands of mediocrities are produced for every masterpiece? Yet we admire these arts in spite of the abundance of failures.

Whether photography is or is not an art is a question that has been debated from the moment it came before the public in 1839. It is nonetheless a futile argument, for the question is not whether photography is an art *per se*—neither music, literature, painting nor sculpture can make that claim, although they are classed amongst the fine arts—but whether it is capable of artistic expression. In its comparatively short history convincing proof has been forthcoming that in the hands of a true artist photography can be an art, and we trust that the illustrations bear this out.

Since its official introduction in 1839 photography has passed through a number of stylistic phases which coincide more or less with similar periods in painting; only in photography they are trends rather than periods, confined to a few photographers. Some were due to the influence of contemporary thought and taste, some to technical developments, and a few owe their origin to schools of painting. Whilst the majority of creative photographers have been satisfied to explore the pictorial possibilities of their medium, remaining purely photographic in conception and execution, mistaken ambition to compete with painting drove a minority to artificial picture-making alien to the nature of photography. From the 1850s onward for nearly a hundred years 'pictorialism' dominated photographic exhibitions, and it still forms a substantial proportion of certain Salon exhibitions today, just as descriptive popular painting remains entrenched in art academies. Thus whilst a number of progressive painters and photographers have explored new fields, constituting the modern movement in art and photography, for the defenders of traditional art time has stood still.

It is understandable that it has always been those photographs closest to contemporary painting in style and feeling, i.e. those apparently most advanced, that make a special appeal to art critics. Unfortunately, however, they are usually the very pictures that are least true to photographic technique—a fact to which the art critic seems quite oblivious. He is naturally so absorbed in the image-making of the painter and the graphic artist that he is apt to apply the same criteria to photography, seeking in it qualities characteristic of other art media. To appreciate photography requires above all understanding of the qualities and limitations peculiar to it.

Prejudice, jealousy, and sheer ignorance of the functions of photography were bound to frustrate any rational argument so long as it was considered a cheap substitute for, or a short-cut to, painting. For nearly a century the apparent parallelism of drawing with light and painting in oils befogged artists and critics alike. The misconception was first brought forward by the painter Paul Delaroche, whose classic remark on first seeing a daguerreotype: 'From today, painting is dead!' was prophetic, though premature. For a time, painting became still more naturalistic in competition with photography. From the point of view of those European schools of painting which from the fifteenth century onward considered a mirror-like imitation of nature the aim of art, photography seemed the *ne plus ultra*. The absurdity of judging paintings by the standards of photographic truth, and photographs by the degree to which they succeeded in imitating fine art was realized only after a great deal of trash had resulted.

Since the First World War a re-assessment of the functions for which each art is ideally suited inevitably led to the gradual withdrawal of the painter from representing the appearance of the outside

world. A hundred years after Delaroche, painting as he knew it was in fact dead—or at least confined to unprogressive academic circles. The bewildering number of styles and conflicting trends that followed each other in quick succession during the last sixty years aimed increasingly at divesting painting of any reference to reality, and left the recording of the visual world entirely to the still and cine-camera.

Photography and modern painting have become mutually exclusive in their subject matter: the photographer draws his inspiration from the observation of life, registering with the camera what he is guided to by the eye. The painter is preoccupied with the observation of his mind; he seems bent upon the intellectualization of art, creating the purely subjec-tive, abstract designs, which Moholy-Nagy pre-dicted in 1925 all painting would sooner or later be-come. An inevitable consequence of this develop-ment was that the artist lost touch with humanity, and the public grew more and more dependent on the camera.

'This powerful enemy' (wrote R. H. Wilenski a few years ago)[1] 'rejoicing in the rich completeness of his language, triumphant as an image-maker in the whole wide range of his narrative, dramatic and romantic subject matter, and master of immense dis-tributing resources, continually confronts all pain-ters; and the situation, as I see it, is just this. The

[1] Preface to the 1956 edition of *The Modern Movement in Art*.

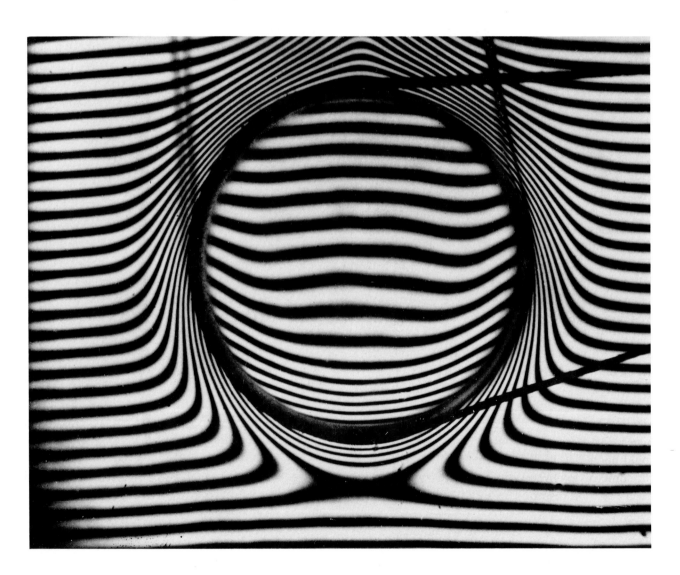

2. *Hubert Schardin. Temperature distribution around a heated metal tube, c. 1950*

art of painting can only conquer in this fight when the artists have finally abandoned to the camera and television men all the dramatic, sentimental, semi-erotic and descriptive material formerly used by painters, and when they have in fact invented a new and extensive symbolic pictorial technique which they can use to communicate to themselves their formal and other experiences.'

Judging from his chapter on 'The Camera's Influence', Mr Wilenski's knowledge of photography is limited to the old-fashioned type of Salon exhibition so much in evidence at the Royal Photographic Society. Thus he has formed as erroneous views about photography, as anyone basing his knowledge of painting solely on the summer exhibitions at the Royal Academy would have of painting. 'Art' photographers have long laboured under the delusion that they were elevating photography by distorting the image into a semblance of other forms of graphic art. Therein lies their conception of 'art'. Artists have committed no less serious errors of judgment as regards unsuitability of medium. (A recent example that comes to mind is the realistically modelled bronze chair with over-lifesize fruit and vegetables by Giacomo Manzu. The composition would have made an excellent photograph; as a nineteenth-century painting it might have been acceptable, but sculpture is the wrong medium for the subject.) Nevertheless a wise critic bases his opinions on the evidence of the positive qualities of an art, not on the failures of an outmoded clique. Yet this is exactly where his hostility to 'the enemy' has let Mr Wilenski down. He failed to enlarge his experience by studying the classic period of photography before the turn of the century, and is strangely unaware of the modern movement in photography which began just at the time he wrote his book in 1926.

Were it not for the fact that Mr Wilenski was one of the first art historians to discuss photography's influence on painting—whereas others simply failed to perceive it or ostrich-like tried to ignore it—I would not attach such importance to his statements. But some of his views on the aesthetics of photography are too distorted to be passed over. 'Today everyone recognizes that the camera cannot comment; that it cannot select.' I admit nothing of the kind. Photography is a constant process of selection, and in the power of commenting lies the reportage photographer's greatest strength.

I am equally confounded by Mr Wilenski's assertion that 'the camera cannot record a house, a tree, or a man. It can only record the momentary effects and degrees of light as affected by such physical objects and concrete things.' As proof he puts forward that 'a cottage recorded by the camera at ten in the morning is a different cottage from that recorded by the same camera in the same position at four in the afternoon, because the lights and shades—which constitute the camera's records—have entirely changed'. Of course it is different—not only to the camera but to any observer. Similarly a photograph taken from the top of a step-ladder is bound to give a different view of the cottage from one taken at the same (or any other) moment from the ground. If these examples prove anything, it is the great variety of possibilities at the photographer's disposal to record the cottage, but not his supposed inability to record its forms. A house not subject to such changes of light and apparent position does not exist.

It would be tedious to go into every point of this kind. I will only add that Mr Wilenski's claim that 'the camera can never represent motion' is no less fallacious than some of his other statements. No artist can suggest motion as well as a photographer, neither by the naturalistic technique as in Courbet's 'Wave' nor by symbolism such as the 'rocking-horse' attitude adopted by all nineteenth-century painters for fast-moving horses, until photography made this and other symbols (flashes of lightning, for instance) look ridiculous. Contrary to Mr Wilenski's view that 'the symbolic representational artist can always represent motion' (whereas the camera cannot), I consider that this obsolete artist's formula does not represent horses galloping, as perceived by the human mind. Surely we have to correct the *artist*'s impression, and not the *camera*'s records, as Mr Wilenski claims, even though the press photograph of race-horses reproduced in his book is not the best example of its kind. Movement is sometimes intentionally 'frozen' by press photographers in the knowledge that their editor, adhering to the popular misconception, would reject a photograph in which the moving objects were slightly blurred as 'technically imperfect'. Nevertheless we see daily photographs of fast-moving trains (*No.* 3), race-horses, motor racing, football players, birds, etc., conveying a perfect impression of movement by slight blurring

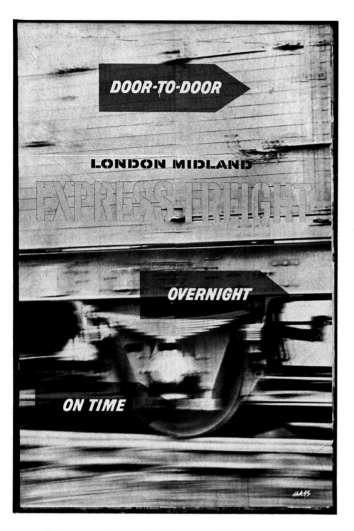

3. *A fast-moving train. Photographic poster*, 1960

the professor of art history at Cologne University libelled it, there is no denying that it has successfully taken over the traditional function of art as a means of communication.

Despite the constant comparisons of photography with painting, because of their mutual influence, they are two entirely different activities with different aims. Painting is concerned with recording the artist's experience of an event, photography with recording a selected aspect of the event itself. The camera intercepts images; the paint brush reconstructs them. Photographic technique is much more closely related to the processes of print-making, for photographs are usually small in size and lacking colour. Colour and large size play a very important part in the appreciation of painting. Their lack is not inherent in the photographic medium but has other causes. Good colour photographs can be taken any day but there is little demand for them as long as printing costs are prohibitive and the quality of reproduction fails to do justice to the original. Few photographs are nowadays made for exhibition purposes, so the need for impressive size does not arise either in black and white or in colour.

The rôle size plays as a psychological factor in the general appreciation of photography was clearly demonstrated by the exhibition of Ida Kar's portraits at the Whitechapel Art Gallery in spring 1960. The moment critics saw photographs the size of mural paintings they were unanimous in their verdict: this is art. It was, but size did not enter into the question. The trained eye can see the artistic value of a picture—whether a photograph or a painting—in a small print. On this basis all qualities bar colour do admit of, and frequently force, a comparative evaluation of a painting with a photograph—at least in descriptive painting.

As in engraving, etching, and lithography, the artistic effort in photography goes into the production of the original image, which is unique, and from which a large number of prints can be made on paper. Each medium has its appropriate tools that are guided according to the artist's conception. In photography, the tool is the camera.

The camera imposes its own visual laws—optical laws, which differ from the rules of linear perspective laid down in the Renaissance for painting. Optical perspective varies greatly with the focal length of the lens used, with its distance from the object, and the

either of the moving object, or of the background, the object itself being represented sharp.

To consider photography as the enemy of painting —which Mr Wilenski is not alone in doing—is an untenable view. In the nineteenth century it was the painter who stubbornly waged war on the photographer as his rival—the more so since he adopted his rival's technique. Today, the aims of photography and painting are no longer confused. Artists have long made the necessary adjustment, but those critics who, like John Berger, see in a return to realistic or descriptive painting the salvation of art from the contemporary chaos are equally mistaken. Realistic painting would stand no chance of survival in competition with photography. We must face the fact that this is the age of photography. Even if photography were only 'a waste product of art', as

angle from which the picture is taken. It can result in distortions which astonish any inexperienced person naïvely believing the time-worn slogan 'Photography cannot lie' (*No. 4*).

Having freed the photographer from traditional rules of composition the camera also provided him with unlimited freedom of movement, novel viewpoints, and a casualness enjoyed by no artist before. In short, it enabled him to present old subjects in a new light.

Yet not only visually has photography introduced an entirely new way of depicting the world around us. In subject matter, too, the cameraman has—with the exception of portraiture and views—departed from the traditional themes of the painter by concentrating on ordinary events and sights, and giving us close-ups and spontaneous slices of life—purely photographic subject matter. The new visual presentation, known as 'photographic vision', has conditioned us to a new kind of aesthetics. Many painters acquired it through their use of the camera, or through extensive study of photographs, foremost amongst them Degas, Toulouse-Lautrec, Utrillo, Sickert.

On the other hand the camera imposes limitations that do not exist for the graphic artist, who can draw on experiences, give rein to his imagination, make nature conform to his conception, and express himself in symbols. The photographer has none of these possibilities at his disposal, being bound to the depiction of existing objects, but he can use the camera in an interpretative manner to overcome the limitations of literalism—and that is where the creative element enters into an otherwise mechanical and reproductive technique.

For the creative photographer, the camera is an extension of his vision—and through his, the onlooker's. Even the latest fully automatic camera can only ensure a correctly exposed and sharp negative: it cannot distinguish between a meaningless snapshot and a significant picture. This distinction—the creative faculty—entirely depends on the man behind the camera. Where the mechanical photographer will merely *reproduce*, the creative photographer perceives essential qualities of form and composition and *interprets* effectively the mood and colour of a scene or object according to his taste, judgment and temperament. If photography were a purely mechanical reproduction of nature, half-a-

dozen photographers taking the same subject would produce six identical pictures. But quite on the contrary, their results will vary enormously according to their choice of viewpoint, camera angle, lighting (*Nos. 5 & 6*), the selection of certain details and the elimination of others, the stressing of one aspect of the subject as against another through differential focus, etc. Choice of lens (wide-angle, normal, telephoto), film (monochrome or colour), variations in developing and in the making of the positive print, allow the photographer additional latitude in interpretation. And these are only a few of the many ways in which he can express his personality in the picture.

It cannot be denied that the evolution of photographic picture-making was largely influenced by technical development: (*a*) the evolution of the

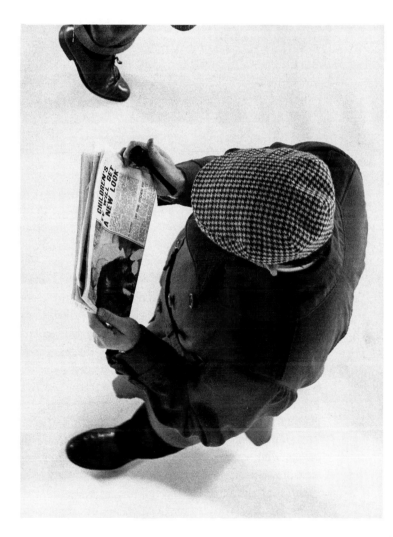

4. *Advertisement for Industrial Life Offices Association, c.* 1959

17

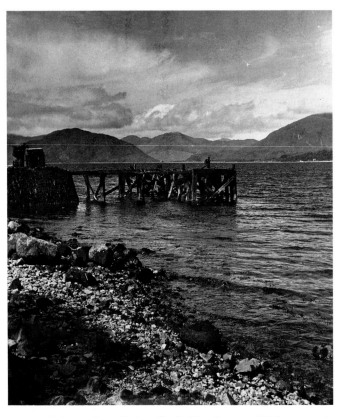

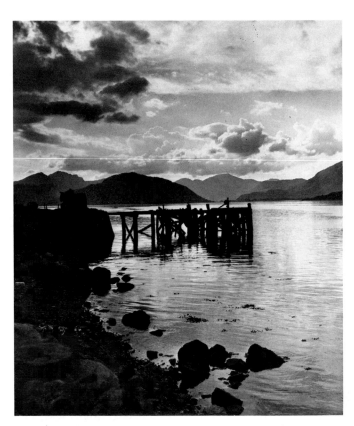

5. *Helmut Gernsheim. Loch Linnhe at mid-day.* 1946

6. *Helmut Gernsheim. Loch Linnhe, late afternoon.* 1946

camera from the cumbersome apparatus of Daguerre's day to the modern miniature camera; (*b*) the increasing sensitivity of the material at the photographer's disposal, and (*c*) the invention of auxiliary equipment such as stroboscopic light. For this reason photography is understandably considered first and foremost as a technique and technical aspects of it predominate discussions in photographic circles. Judging from the totally inadequate space accorded to the discussion and illustration of pictures in most photographic magazines, one is forced to the conclusion that training and outlook render most editors quite oblivious to aesthetic as distinct from technical qualities. Catering for. a largely uncultured readership, they provide the means rather than the end. The photographic industry has conditioned photographers to believe that the qualities of a photograph depend on instruments and materials, and no editor dependent on advertising revenue will proclaim the truth—that good photographs are the result of the perceptive powers and ability of the photographer and that technical data

are completely meaningless. It would not occur to anyone to ascribe the brilliance of a pianist to the outstanding qualities of his piano, and it would seem ridiculous were a painter to acknowledge the producer of his colours and brushes. Why, then, should we expect a photographer to mention his camera, lens, or shutter speed? The result obtained with one type of instrument or lens could have been just as well achieved with a different make.

To achieve artistically satisfying photographs requires an equally intensive study of art and cultivation of mind as any other artistic activity. The cultivation of taste by frequent visits to art exhibitions, and the study of the work of leading photographers and film directors form an essential part of the photographer's education. Some of the greatest photographers started with the advantage of having been artists in other fields first. But unfortunately, as in the case of photographic magazines, most European schools of photography neglect the art side, and are satisfied with turning out technically competent operators. This is one of the reasons

why the number of creative photographers is so comparatively small—out of all proportion, in fact, to those practising it. Another is the lamentably low level of general education and culture of those taking up photography professionally, particularly in this country, where it is still classified as a trade open to anyone and 'qualifications' are measured by the financial success of the business. Photography does not, however, form an exception to other professions in its mental requirements, and the sooner the erroneous idea dies that whoever has failed in everything else can still make the grade in photography, the better will it be for photography. In America the outlook for photography is much brighter: at least thirty Colleges and Universities give courses on photography as a creative art.

I am frequently asked why up to about 1900 Britain and France made the most important contribution to the development of photography. The explanation is simpler than most people suppose. Whereas in other countries photography was chiefly practised as a portrait business—and by the type of person nowadays engaged in it here—producing competent but uninspired work, in Britain and France there were in addition a large number of cultured amateurs of the professional middle and upper class, to whom photography was a hobby in the best sense of the word. Even when they adopted it as their profession they did so first and foremost from an urge to create; they photographed to satisfy their artistic urge and hoped thereby to elevate photography as an art. Taste and a critical faculty trained in classical art were perhaps their greatest assets. By far the largest group were former painters: D. O. Hill, O. G. Rejlander, James Anderson, Lake Price, Edouard Baldus, Charles Nègre, Gustave Le Gray. Adam-Salomon was a sculptor, Nadar and Carjat caricaturists, P. H. Delamotte a professor of drawing. Thomas Keith and Robert MacPherson were surgeons, Henry White and Roger Fenton lawyers, Maxime Du Camp, Théophile Gautier and Lewis Carroll were authors, Paul Martin a wood-engraver, Eugène Atget an actor, Hippolyte Bayard a civil servant. Others belonged to the upper class or aristocracy: Mrs J. M. Cameron, Lady Hawarden, Lady Caledon, Count O. Aguado, Girault de Prangey, John Shaw Smith, Camille Silvy, Count Flacheron, Count Primoli and many others.

The development of photography as a creative art testifies not only to the emergence of individual styles but also to the same aesthetic trends dependent on the *Zeitgeist* that are discernible in the other arts. To the critic acquainted with the work of great photographers there is evident as much difference in style, treatment of and preference for certain subjects, as a connoisseur of painting finds in the works of painters. Indeed, nothing but a wall of prejudice excludes photography from the fine arts, still defined by the *Oxford Dictionary* as 'those that appeal to the sense of beauty', although art has for several decades now expressed different ideals. Beauty is relative and takes on a different meaning with almost every generation. In Queen Victoria's reign morality and beauty became almost synonymous—an ideal first propounded by Kant, and responsible for much trash in art. In abstract art, the decorative element, the rhythm and vitality of form are its chief attraction. The subject painter, if he is true to our time, is bound to reflect its disharmony, violence and ugliness. Far from delighting the onlooker's senses, he may evoke nausea.

The creative photographer, too, has come to realize that conventional beauty only results in hackneyed themes. He goes in search of something subtler and deeper—the interest of everyday life, the vitality of action, the expressiveness of a situation, the beauty which lies in unusual form, texture and pattern, and above all, human relationships. Ugliness, poverty, and sympathy with humanity have inspired some of the most powerful photographs. In showing the world as it really is—not a glorified Hollywood version—the modern photographer sees his most important function. In his hands the camera is a weapon; by virtue of its stark realism the impact of a photograph can rouse human emotion to a degree to which no other graphic art can aspire (*No.* 7).

The chief difference, then, between photography and the other graphic arts lies not in their creative possibilities, but in the purpose underlying their production. Photographs are made for *use*, paintings to be *sold*. The photographer requires his pictures to be reproduced, whilst the painter's main concern is to find a buyer for his canvases. (The portrait painter and portrait photographer work exclusively on commission and therefore fall into a different category.)

European easel-paintings have been in existence for about five and a half centuries and have been

collected by patrons, connoisseurs and museums. Being symbols of wealth—apart from their intrinsic artistic value—a high proportion have survived. The world's leading art galleries pride themselves on their representative collections of the various schools.

Photography has only been before the public for 122 years. As in the case of the slightly older art of lithography, until recently[1] no very high value has so far been attached to individual photographs, except in the case of news scoops. Yet unlike the other graphic arts, photographic prints are hardly ever published in editions. Rarely are more than three or four copies made. Not being intended for wall decoration but as a rule for publication, photographs often die of neglect once they have served their purpose. The exhibition photographs that have survived from the early decades of photography are comparatively few. Until quite recently photographs were not considered worth collecting, with the result that vast quantities of nineteenth-century photographs have been lost for ever. This neglect has made early photography one of the scarcest fields for the collector, and now that a few perceptive people are becoming aware of the important part played by photography in aesthetic development and its influence on painting, the difficulty of retrieving what former lack of imagination cast aside is insuperable.

Far from trying to rectify the situation, our museums of art and applied art have adopted such an arrogant attitude towards photography that the entire field is left to the care and interest of museums of science and technology. Consequently the public only sees such photographs as show a phase in the technical evolution of photography, together with apparatus and chemical bottles. In Munich a museum of 'photography' is in course of establishment, but so far its contents consist of a thousand lenses! Photography, the cinderella of the arts, has so far failed to find a place in European art collections. There is not one museum where a representative selection of creative photography is on view to the public. The collection formed by the late Professor Stenger in Germany with lifelong devotion was bought by Agfa and put into storage. The outstanding French collection of nineteenth-century photography—the Cromer Collection—formed the nucleus of George Eastman House, Rochester, USA. The most important British collection—the Gernsheim Collection—lies in packing cases between exhibitions on the Continent. All this is symptomatic of the narrow traditional attitude in Europe which unaccountably ignores photography although it is today the most important means of communication and documentation.

In the New World photography has long been recognized as an independent creative art. The Museum of Modern Art, the Metropolitan Museum, the Museum of the City of New York, the Chicago Art Institute, the Palace of the Legion of Honour in San Francisco, and several others have all long ago established departments of photography. For half a century Americans have been more alive than Europeans to all manifestations of contemporary art. Some of the greatest works of modern art, particularly of the Impressionist and Post-impressionist periods, once viewed with horror in the countries of their production, have crossed the Atlantic for ever. Compare the riches of American galleries in contemporary and primitive art with the pitiful gaps in European museums. In Britain the Government grants to our national museums are woefully inadequate. Besides being insufficient for new acquisitions, lack of funds restricts the much-needed modernization of display, lighting and air-conditioning, and above all extensions to existing buildings.

It is hardly to be expected that in these circumstances the idea of a national collection of photography could command much attention. Yet the immense interest aroused everywhere by our exhibition 'A Century of Photography' raises the question whether photography has not stood the test of time considerably better than the general run of nineteenth-century painting. Apart from the Impressionists and Post-impressionists and a dozen or so outstanding, mainly French and English, artists in the first three-quarters of the century, there were innumerable once-famous or fashionable painters whose canvases plastered the walls of the Paris Salon, Burlington House, and the Royal Academies in other European capitals. Where are they now? Forgotten, cast into limbo. Their pictures are relegated to the store-rooms of the leading art galleries, or for lack of something better fill the wall-space of provincial museums. One thing is certain: a retrospec-

[1] At an auction in Geneva in June 1961 Mrs Cameron's portrait of Sir John Herschel attained the record price of over £300.

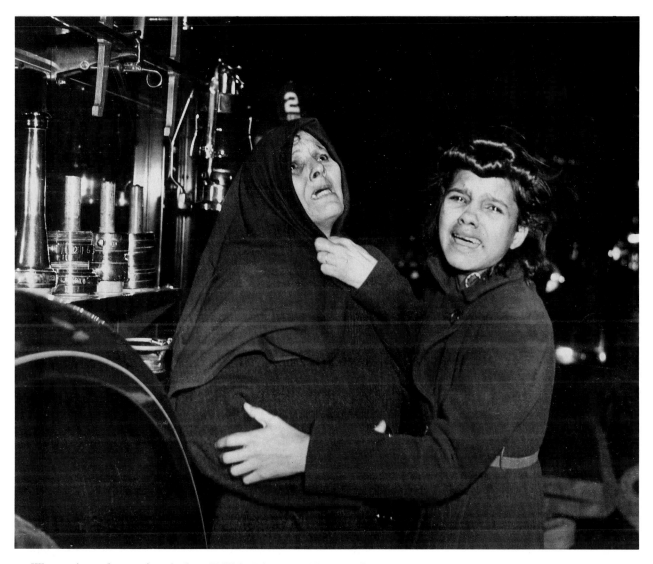

7. *Weegee (pseudonym for Arthur Fellig). Fire at a New York tenement, c.* 1939

tive show would not increase our appreciation of them. Even Whistler's magic has surprisingly faded, with the exception of a few old favourites.

The intrinsic value of a work of art is largely subjective. There is no absolute aesthetic standard; it is conditioned by the taste of each period. While Sir John Millais was making £40,000 a year—and was duly elected President of the Royal Academy— Van Gogh and Gauguin and Cézanne were struggling artists without recognition, unable to sell a picture. Modern opinion of these artists is exactly reversed. Ruskin accused Whistler of 'asking 200 guineas for flinging a pot of paint in the public's face'. Today, action painters literally fling paint on canvas, and some get considerably more for this random daubing. Not so long ago Expressionism and Cubism were officially branded as 'decadent art' in Nazi Germany, and considered so in many circles elsewhere. Twenty-five years later there is an absolute craze for these pictures, particularly in the very country that had enforced their sale abroad. Examples could be multiplied a thousandfold.

If there is so much uncertainty surrounding the old art of painting, it is not surprising that there is still a wide divergence of opinion about the new art of photography. Lack of understanding and appreciation have their origin fundamentally in general ignorance of photography's artistic achievements.

Sargent received a thousand guineas for a commonplace group of officers when a one guinea photograph would have been more apt for the purpose as well as doing the job better. Glaring stupidities of this sort are not isolated instances, but we are no nearer the solution proposed by Roger Fry thirty-five years ago:

'One day we may hope that the National Portrait Gallery may be deprived of so large a part of its grant, that it will turn to foster the art of photography, and will rely on its results for its records, instead of buying acres of canvas covered at great expense by fashionable practitioners in paint.'[1]

A few significant events in recent years point, however, to the emergence of a re-assessment.

The most important event in post-war photography was the World Exhibition of Photography held in Lucerne from May to August 1952. The entire art gallery was placed at the disposal of the chief organizer, Emil Bührer (now art editor of *Camera*), who succeeded in giving an exhaustive review of photography's rôle in modern civilization. Two thousand five hundred well-chosen photographs from all over the world were grouped into sixteen fields of activity and arranged in a modern setting. It was the largest photographic show ever staged, and the visitor was immediately gripped by the striking demonstration of the power of creative photography. For me, it was an experience that I have not felt at any other photographic exhibition.

Edward Steichen restricted himself to one theme in 'The Family of Man' (1955), and few people who have seen this exhibition can have remained unmoved by its tremendous impact. I have long felt that the usual exhibitions of unrelated photographs that have been traditional for the last hundred years have out-lived their purpose, except for one-man shows. At 77, Steichen pioneered a new kind of exhibition, that must be further developed if photography is to fulfil its most important function as a medium of communication. The fine cultural exhibitions on particular themes arranged by L. Fritz Gruber as part of the various *photokina* trade fairs in Cologne during the last ten years have also made a significant contribution in this field.

In 1956 the Louvre made history by showing for the first time an exhibition of photographs—by Henri Cartier-Bresson. Leading art museums in Britain, Sweden, Holland, Germany, Switzerland and Italy, which had up to a few years ago repudiated photography, have on the evidence of the Art Council's sponsorship, and convinced by the artistic quality of our collection, opened their doors to our exhibition. In a television interview in June 1959 Sir Kenneth Clark concurred with the growing opinion that photography can be an art. The Metropolitan Museum of Art in spring 1959 put on an exhibition of great contemporary photographs with the intention of demonstrating photography's place in the fine arts. Even if these exhibitions were only a first, though important, step in the direction of a serious and sustained effort for the widest possible acceptance of fine photography as fine art, they came as a revelation to art critics and public alike and laid the foundation for the furtherance of a better appreciation of photography. It can only be a question of time before 'great photographs will find a permanent place in the leading galleries of the world, along with great paintings, pieces of sculpture, and the graphic arts'.[2]

London HELMUT GERNSHEIM
December 1960

[1] Virginia Woolf and Roger Fry. *Victorian Photographs of Famous Men and Fair Women*, London, 1926.

[2] *The Saturday Review*, 16 May 1959. The entire issue was devoted to the cause of photography as a fine art.

I

THE MIRROR OF NATURE

Nowadays photography is so completely taken for granted that it is difficult for us to realize how startling the idea seemed to Daguerre's contemporaries that Nature could be made to produce a spontaneous picture. 'The self-operating process of Fine Art',[1] as one critic called the daguerreotype, was in fact as revolutionary an invention as Gutenberg's printing press.

Daguerre's first successful photograph—a still-life taken in his studio in 1837 (*No. 8*)—is a purely painterly, as opposed to a photographic composition, but the harmonious distribution of light and shade, the use of light to give depth to the whole group;

[1] *The Spectator*, 2 February 1839.

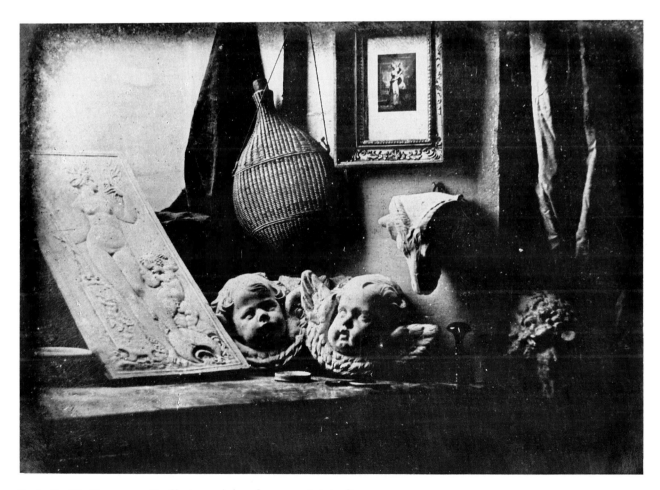

8. *L. J. M. Daguerre. Earliest surviving daguerreotype, 1837*

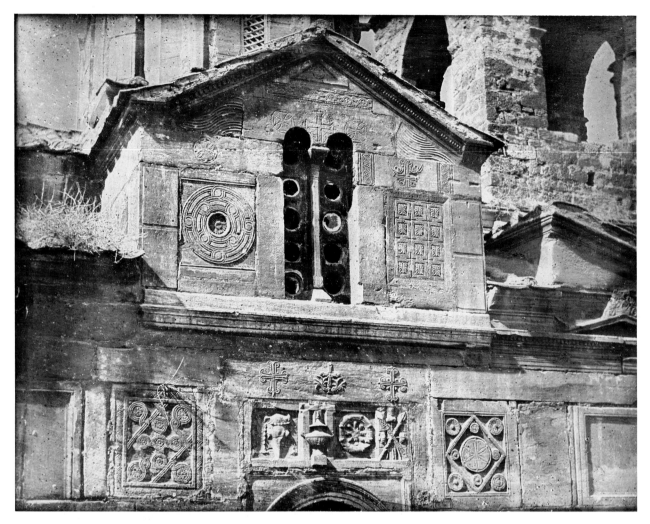

9. *J. P. Girault de Prangey. The Metropolitan Church in Athens, detail. Daguerreotype,* 1842

bringing out detail and rendering the surface and form of each object by means of tone gradation instead of line—these are qualities characteristic of photography.

In his official report to the French Government, Paul Delaroche, the most celebrated French painter at the time, affirmed:

'Daguerre's process completely satisfies all the demands of art, carrying certain essential principles of art to such perfection that it must become a subject of observation and study even to the most accomplished painters. The pictures obtained by this method are as remarkable for the perfection of the details as for the richness and harmony of the general effect. Nature is reproduced in them not only with truth, but also with art. . . . When this method is made known, it will no longer be possible to publish inaccurate views, for it will then be very easy to obtain in a few moments a most exact picture of any place.'[1]

The daguerreotype's power of rendering detail, texture and form with marvellous clarity and exactitude, and with comparative ease and quickness, was considered its greatest asset. Again and again in going through contemporary accounts one comes across the same wonderment at the minuteness of photographic detail when examined under the magnifying glass. This was 'the mirror of Nature'—

'Drawing carried to a degree of perfection which art can never attain. What fineness in the strokes! what knowledge of *chiaroscuro*! what delicacy! what exquisite finish! How admirably are the foreshortenings given: this is Nature itself. We distinguish the

[1] Letter from Delaroche to Arago, partly quoted in the latter's report to the Government. Published in *Bulletin de la Société Française de Photographie*, April 1930.

24

smallest details: we count the paving stones, we see the dampness caused by the rain, we read the inscription on a shop sign.'[1]

Understandably, the invention aroused immense enthusiasm all over the civilized world. Had not men famous in science and art agreed with François Arago's declaration: 'The daguerreotype does not demand a single manipulation that is not perfectly easy to everyone. It requires no knowledge of drawing, and is not dependent upon any manual dexterity. Anyone may succeed with the same certainty and perform as well as the author of the invention.'[2]

When at length on 19 August 1839 the scientist and politician François Arago revealed the technique at a joint session of the Académies des Sciences and Beaux-Arts, Parisians were seized with daguerreotypomania. The moment the 'secret agents of light' that brought forth the miracle were known, opticians' shops were besieged, but could not rake together enough apparatus to satisfy the onrushing army of would-be photographers.

'Everyone wanted to copy the view from his window, and very happy was he who at the first attempt obtained a silhouette of roofs against the sky: he was in ecstasies over the stove-pipes; he did not cease to count the tiles on the roofs and the bricks of the chimneys; he was astonished to see the cement between each brick; in a word, the poorest picture caused him unutterable joy.'[3]

Owing to the length of the exposure (10–15 minutes) inanimate nature—architecture, monuments, landscapes, still-life—was at first the only class of subject possible. An enterprising Parisian optician, N. P. Lerebours, at once equipped a number of artists—among them the historical painter Horace Vernet—with daguerreotype outfits and sent them as far afield as Egypt and Syria. Altogether over 1,200 views were taken. Less than one-tenth of these were copied as steel engravings (with inevitable loss of photographic halftone) and published under the title *Excursions Daguerriennes: vues et monuments les plus remarquables du globe* (1841–2). The original daguerreotypes were offered for sale in Paris, London and other capitals as a great novelty and at high prices.

Independently, a number of (mainly French) amateurs took views at home and abroad. J. P. Girault de Prangey, a French landowner and expert on Arabian architecture, brought home from a three years' tour of the Middle East and Mediterranean countries over a thousand fine daguerreotypes. His close-up of the Metropolitan Church in Athens (*No. 9*), taken in 1842, fulfils the requirements of a good architectural photograph which Ruskin had in mind when he exhorted amateur photographers to take architecture 'not merely when it presents itself under picturesque general forms, but stone by stone, and sculpture by sculpture, seizing every opportunity afforded by scaffolding to approach it closely'.[4] Ruskin was a great admirer of the daguerreotype. Comparing his own view of Venice with a painting by Canaletto made from the same standpoint, he declared himself decidedly in favour of the daguerreotype 'in which every figure, crack and stain is given on the scale of an inch to Canaletto's three feet'.[5]

The mirror-like fidelity of the daguerreotype came at a time when the reproduction of nature seemed to be the ideal of art. It no doubt increased the painter's ambition to attain a similar semblance of actuality, the ideal towards which most artists of the previous half-century had painstakingly striven in their desire to please the new patrons of art: the middle class. As at all times when artists work largely for their fellow citizens (for example, Flemish and German portraits of the fifteenth and early sixteenth century, Dutch painting of the seventeenth century, Russian painting today) the art of the late eighteenth and early nineteenth century served less aesthetic needs than a desire for true-to-life illustrations, and the artist's ability was judged accordingly.

The greatest demand of the *bourgeoisie* was naturally for good, inexpensive portraits. For centuries portraits in oil had been the privilege of the aristocracy and the prosperous merchants, who commissioned leading artists. The less affluent patronized local talent or were satisfied with a miniature. Silhouettes, wax portraits and physionotrace portraits, fashionable between about 1770 and 1830, had been poor substitutes, for these small expressionless profiles were mere phantoms of the sitter's personality. It is understandable, therefore, that in the field of portraiture the daguerreotype filled an urgent

[1] *Le Moniteur Universel*, 14 January 1839.
[2] Arago's Report to the Chamber of Deputies, 3 July 1839.
[3] M. A. Gaudin, *Traité pratique de Photographie*, Paris, 1844.

[4] John Ruskin, *The Seven Lamps of Architecture*, 1849.
[5] ibid, *Modern Painters*, Vol. II, 1846.

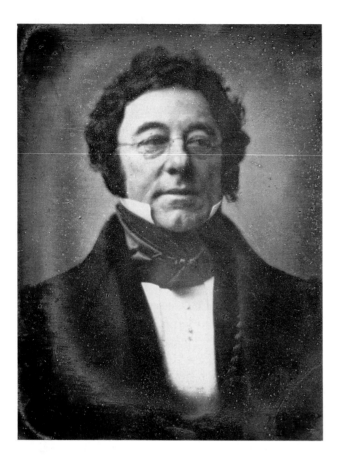

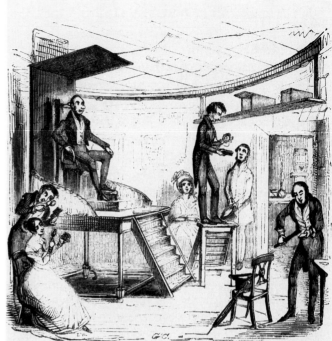

PHOTOGRAPHIC PHENOMENA, OR THE NEW SCHOOL
OF PORTRAIT-PAINTING.

" Sit, cousin Percy ; sit, good cousin Hotspur !"—HENRY IV.
" My lords, be seated."—*Speech from the Throne.*

10. *Richard Beard. Daguerreotype of a gentleman, c.* 1842

11. *Interior of the first public daguerreotype studio in Europe, opened by Richard Beard on the roof of the Polytechnic Institution, London, in March* 1841. *Woodcut by George Cruikshank,* 1842

need and found its most widespread application.

In Europe, by spring 1841, improved lenses and chemicals had reduced the exposure from 10–15 minutes to a minute or less, according to the brightness of the day and the size of the portrait. The first public portrait studio in Great Britain—possibly in Europe—was opened by Richard Beard in London on 23 March 1841, a year after Alexander Wolcott's 'Daguerrean Parlor' in New York (*No.* 10). Clamped in a head-rest, the sitter sat motionless. Thus posed, he would regard last-minute adjustments with much the same feeling of distrust as he would those of a dentist. His breathing would become heavier and quicker as the critical moment of uncapping the lens drew near, his heart would beat visibly beneath this waistcoat, and a hazy film seemed to form before his eyes. Just when he felt least like it, he was asked to put on a pleasant smile. The operator counted the seconds (*No.* 11).

Apollo's agent on earth, when your attitude's right,
Your collar adjusted, your locks in their place,
Just seizes one moment of favouring light
And utters three sentences: 'Now it's begun'—
'It's going on now, sir'—and 'Now it is done'.
And lo! as I live, there's the cut of your face
On a silvery plate
Unerring as fate,
Worked off in celestial and strange mezzotint
A little resembling an elderly print.
'Well, I *never*!' all cry; 'it is cruelly like you!'
But truth is unpleasant
To prince and to peasant.
You recollect Lawrence, and think of the graces
That Chalon and company give to their faces;
The face you have worn fifty years doesn't strike
you![1]

[1] 'The New School of Portrait-painting' by S. L. Blanchard, in *George Cruikshank's Omnibus*, London, 1842.

26

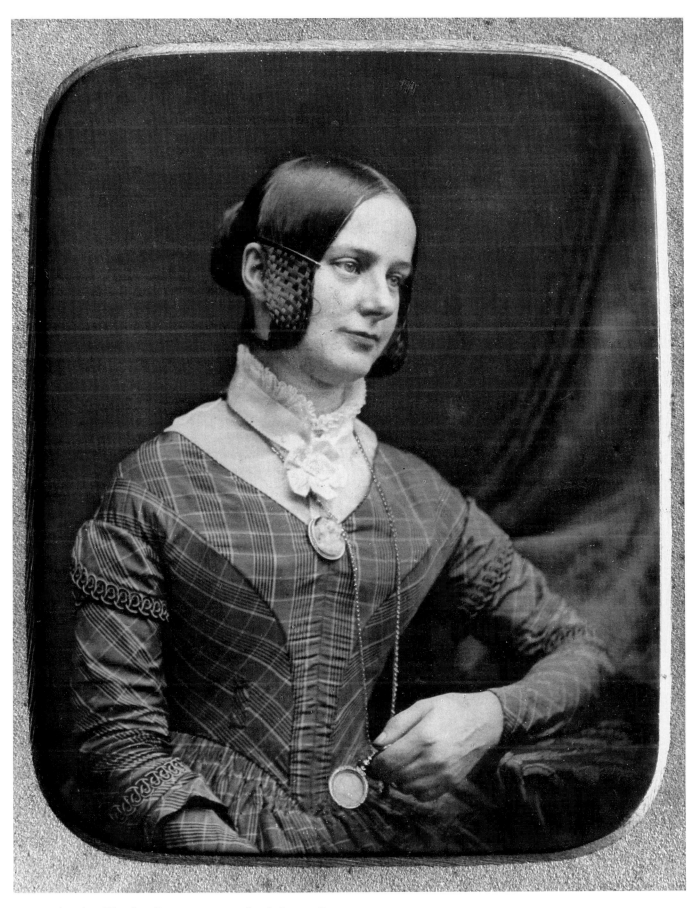

12. *Antoine Claudet. Daguerreotype of a lady, c. 1845*

The realization that the photograph revealed the sitter with uncompromising truth, dispelling cherished illusions of youth, beauty, grace and intelligence, was unpalatable at first, especially to women. The demands of the sitter for a good likeness and at the same time a beautiful portrait were—and still are—usually incompatible. Fashionable miniature painters had encouraged their sitters' whims, and traded on deceit. Suspecting, perhaps, that Alfred Chalon had made her quite unrecognizable by excessive flattery, Queen Victoria asked her court painter one day whether he were not afraid that photography would ruin his profession. Chalon's confident rejoinder: 'Ah, non, Madame! photographie can't flattère' was typical. Nevertheless, the heyday of miniature painting was over. To all except the incurably vain the intimacy of the actual image of life was its chief attraction. It was this quality that made Elizabeth Barrett

'long to have such a memorial of every being dear to me in the world. It is not merely the likeness which is precious in such cases—but the association and the sense of nearness involved in the thing . . . the fact of the *very shadow of the person* lying there fixed for ever! It is the very sanctification of portraits I think—and it is not at all monstrous in me to say, what my brothers cry out against so vehemently, that I would rather have such a memorial of one I dearly loved, than the noblest artist's work ever produced.'[1]

The best daguerreotypists produced such splendid portraits that Ingres avowed: 'It is to this exactitude that I would like to attain. It is admirable—but one must not say so.' Henceforth he had preliminary photographs taken of his sitters.

Whilst the photographer does not take any credit for the exact delineation of the features, his ability to portray the characteristics of the sitter and to coax from him an animated expression were achievements for which critics were unanimous in considering photography unrivalled. 'If there is one thing more than another that the magic power of the daguerreotype is valuable for, it is this limning the fleeting shades of expression in the human face: for here the art of the painter, however great his skill, is most at fault.'[2]

[1] Letter to Mary Russell Mitford in 1843, quoted in *Elizabeth Barrett to Miss Mitford* by Betty Miller, London, 1954.
[2] *The Spectator*, 30 July 1842.

Strange to say, it was not an artist but a distinguished scientist, Antoine Claudet, FRS, who was considered the most artistic daguerreotypist in Britain. His portraits have grace, charm, and elegance; he knew how to capture the best aspect of the sitter without loss of likeness and naturalness (*No.* 12). 'They are truly and undoubtedly *works of art*; or we should rather characterize them as the beautiful results of Nature and Art combined.'[3] 'What Lawrence did with his brush, M. Claudet appears to do with his lens. What can the miniature painter do against the Sun?'[4] What indeed could he do against this dangerous rival, but adapt himself as quickly as possible to the new situation?

The simplest way out of the *impasse* was to exploit the new mode of portraiture; others found employment tinting daguerreotypes for clients who preferred 'twopenny coloured' to 'penny plain'. Coloured powders were lightly laid on, in no way obscuring the delicacy of the image, and done with taste, colour imparted warmth to the portrait. More questionable was the value of another idea taken over from miniature painting and designed to give portraits a picturesque and imposing effect and at the same time to relieve the plainness of the daguerreotype. This was the introduction of painted backgrounds, patented by Claudet in December 1841. Actually, backgrounds of landscapes or interiors rather detract from the sitter, instead of enhancing his personality. When the whole picture is painted, backgrounds are part of the artist's conception, but in photography this combination frequently introduces a false note. The majority of daguerreotypists, however, did not follow this trend—not for aesthetic reasons but, unless they were painters themselves, for economy—and against a plain background the figure stands out clearly (*No.* 13).

In choice of pose, size of portrait, style of frame or case, daguerreotypists at first followed the traditions of the miniaturist, hence the popular name of their portraits—'daguerreotype miniatures'. Up to the mid-'forties they are usually bust or half-length, but from then onward larger portraits could be taken, and these frequently show a threequarter-length figure, one arm resting on a table, with a vase of flowers, a book or ornament to fill the composition. As the 'fifties progressed furniture and curtains

[3] *The Art Union*, July 1846.
[4] *The Athenaeum*, 30 August 1846.

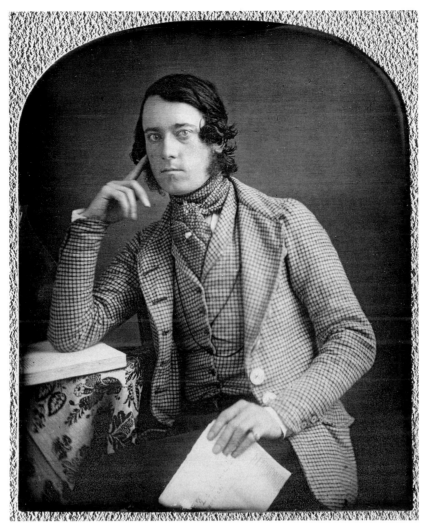

13. *Daguerreotype of a gentleman, c. 1845*

were frequently added for effect, but the background in these late daguerreotypes still remained plain. The charges were about the same as for a miniature. It was therefore not the cheapness of the daguerreotype that caused it to supplant the miniature, then in artistic decline, but its greatly superior quality. The comparatively high price also restricted sitters to the middle and upper classes.

As is to be expected, people who took up photography without preconceived notions about posing and arrangement made on the whole freer and more natural portraits than the former miniaturists. One need only compare the casual group of men taken by a French amateur (*No.* 14) with the carefully arranged classical triangle of C. F. Stelzner (*No.* 15). Stelzner and Hermann Biow, both former painters in Hamburg, made the most artistic portraits in

Germany during the early period. Biow, commanded to Berlin in 1847 by King Frederick William IV of Prussia, who had a studio prepared for him in the royal palace, took portraits of all the celebrities of the capital. With the intention of building up a national photographic portrait gallery, Biow in the following year went to Frankfurt to photograph the delegates to the first German Parliament. Over 125 lithographs copied from his portraits were published in 1849 under the title 'Deutsche National Galerie', but lack of support put a stop to Biow's great conception. Similar shortsightedness led to the eventual sale of Mathew Brady's famous 'Gallery of Illustrious Americans' to the U.S. War Department, in whose 'care' the majority of these daguerreotypes were spoilt.

At the Great Exhibition in London, 1851, the

14. *French daguerreotype*, 1844 *(reproduction)*. Left, *Friedrich von Martens (inventor of panoramic daguerreotype, 1845)*. Right, *the optician N. P. Lerebours.* Standing, *the chemist Marc-Antoine Gaudin*

15. *C. F. Stelzner. Daguerreotype, c. 1843.* Left to right, *Fräulein Reimer, Frau Stelzner, Fräulein Mathilde von Braunschweig*

Americans were considered the most brilliant technicians, and some of the portraits emanating from leading establishments such as Southworth & Hawes are really striking and on a par with the best European examples. Since the Talbotype made no headway in the States, the daguerreotype reigned supreme until about 1860. This circumstance accounts for the far greater number of American daguerreotypes of landscapes and architecture, which in Europe would have been taken by the Calotype or by the waxed paper process. Some very attractive landscapes with figures were produced by Babbitt, who in 1853 was granted a monopoly for photography on the American side of the Niagara Falls. In this beautiful setting he used to take tourists unawares while they admired the Falls from the edge of the cliff (*No. 16*). Babbitt's superb rendering of atmosphere could hardly be improved today—an achievement for the time, for no one in Europe had yet succeeded in depicting clouds. The very bright reflection from the water enabled the photographer to give an almost instantaneous exposure—a circumstance which Gustave Le Gray discovered independently in 1856 (see page 47).

Although daguerreotype portraits were always taken by professionals, they rarely bear the photographer's name. Some leading professional daguerreotypists, in addition to those already mentioned, include: (in France) Auguste and Louis Bisson, N. P. Lerebours, Friedrich von Martens, Victor Plumier, Richebourg, I. Thierry, Vaillat; (in America) Edward Anthony, Jeremiah Gurney, Frederick and William Langenheim, M. M. Lawrence, Meade Brothers, M. A. Roote; (in England) C. Jabez Hughes, W. E. Kilburn, J. E. Mayall, William Telfer, T. R. Williams; (in German-speaking countries) Carl Dauthendey, Philipp Graff, J. B. Isenring, Johann and Josef Natterer.

One would assume that the first photographic method given free to the world (except England, Wales and the British Colonies), and published in such auspicious circumstances, would have attracted large numbers of amateurs to take up the new art. But this was not the case. After the initial excitement had died down, the realization that the technique was far more complicated than Arago's remark had led them to believe, and that it was no pleasure taking pictures that required the endurance and patience of asses (as caricatured by Daumier in

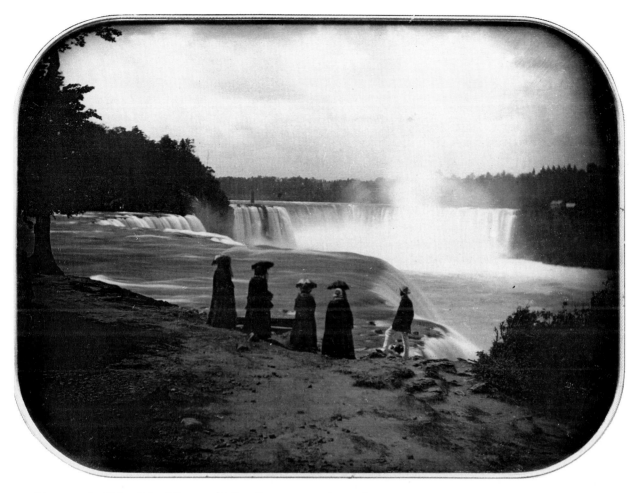

16. *Platt D. Babbitt. The Niagara Falls. Daguerreotype, c.* 1853

July 1840), led all but the most persevering to abandon photography. So far, only three amateur daguerreotypists of unusual merit have become known. All three, Girault de Prangey, Baron Gros and Hippolyte Bayard, were French, and their subjects, architecture and picturesque views. No doubt there were others, but 120 years of neglect, and the circumstance that the little that has survived is scattered amongst numerous collections whose contents are unpublished, makes it impossible to form any idea of what is extant. This remark applies to professional daguerreotypists almost as much, for the names and work of only a few are known out of the thousands who were active all over the world.

II

THE PENCIL OF NATURE

Concurrent with the daguerreotype was the Calotype patented by W. H. Fox Talbot in February 1841. Unlike Daguerre's technique, which gave a unique direct positive on a silver-coated copper plate, Talbot's was based on the negative/positive principle. The picture was taken on sensitized writing-paper which, after exposure and development, produced a negative from which a large number of positive copies could be made. Owing to the structure of the paper, a certain softness of outline was inevitable, giving broad effects of light and shade. The Calotype had an attractive warm reddish to purplish brown colour, compared with the cold polished silver of the daguerreotype. In short, the Calotype was the antithesis of the sharply detailed daguerreotype, and lent itself much better to artistic

17. *W. H. Fox Talbot. 'The Open Door.' Calotype, c.* 1844

32

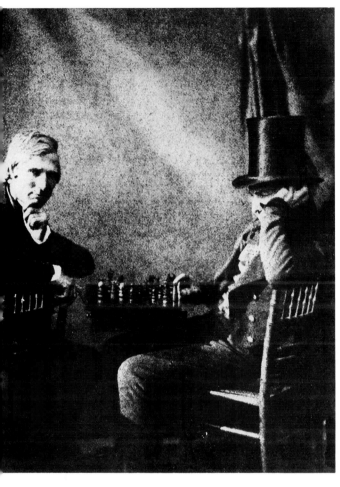

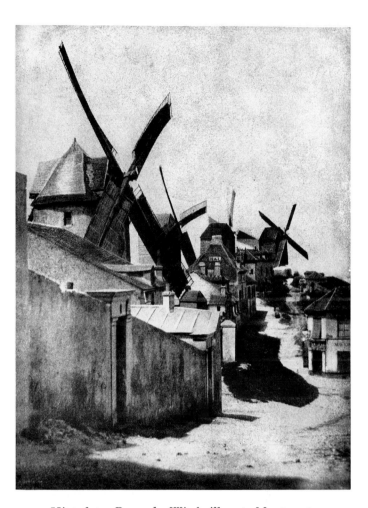

18. *W. H. Fox Talbot. 'The Chess Players.' Calotype,* 1842

19. *Hippolyte Bayard. Windmills at Montmartre,* c. 1842

expression, so that paper photographs were often called 'sun drawings'. Though never as popular as the French invention—largely due to Talbot's tight hold on his patent rights—some of the finest photographs ever made were Calotypes.

Most of Talbot's pictures are rather matter-of-fact records, clearly showing the scientist at work, but a few are fine compositions. The difference in style may be accounted for by the fact that for some pictures Talbot had the collaboration of Henry Collen, a miniature painter.

Talbot's favourite subjects were at and around Lacock Abbey, his country seat in Wiltshire. Passing the stables one day, he—or Collen—noticed the attractive play of light and shade on the open door, and, leaning the broom against it to enhance the picturesque effect, created one of the classics of photo-

graphy (*No. 17*). Every detail is right: the lantern balancing the broom, the bridle breaking the shadow at the top of the door, the faint light from the stable window preventing the shadow from becoming an opaque dark mass, the diagonal of the broom, and the parallel lines of shadow on the door breaking the vertical lines of the door and its frame. 'The Open Door' is a photograph to which one may apply Talbot's sensitive observation in his book *The Pencil of Nature* (1844): 'A painter's eye will often be arrested where ordinary people see nothing remarkable. A casual gleam of sunshine, or a shadow thrown across his path, a time-withered oak, or a moss-covered stone, may awaken a train of thoughts and feelings, and picturesque imaginings.'

'The Chess Players' (*No. 18*) is another deliberate attempt by Talbot to use the camera creatively. It is

one of the earliest Calotypes with figures, and one would hardly guess from the natural pose of the sitters that the exposure lasted 2–3 minutes. For this reason both men support their heads on their hands. As the picture had to be taken out of doors in sunlight, white and dark hangings were arranged to shut out any disturbing background, and incidentally the light reflected from the folds of the white material plays an important part in holding the composition together. The structure of the paper is very noticeable in this picture, as it is also in Bayard's windmills at Montmartre (*No. 19*).

Hippolyte Bayard, independently of Talbot, invented a photographic process on paper giving direct positives, and exhibited thirty photographs of architecture, sculpture and still-life in Paris in June and July 1839. The Académie des Beaux-Arts preferred Bayard's process to Daguerre's on account of 'the artistic superiority of paper over metal for photography', but it was about eight years before their undoubtedly correct opinion began to prevail.

An interesting point raised in Raoul Rochette's report on Bayard's process to the Académie des Beaux-Arts in November 1839 was that under-exposed paper photographs would be useful for artists as a basis to paint on. It was solely for this purpose that the miniature painter Henry Collen took out from Talbot in 1841 the first licence to Calotype, in the mistaken belief that a combination of the old and new methods of portraiture would result in a more perfect picture. 'He corrects any imperfection in the drapery or supplies any defects in the figure, so that his works have an entirely different aspect from those of the amateur, who must, generally speaking, be content with the results which the process gives him.'[1] Painting over paper photographs constitutes a most injudicious combination of two completely different artistic media which is practised by many inferior painters to this day. Tinting daguerreotypes, on the other hand, interfered as little with the 'drawing' of the photographic image, as does colouring prints, but painting over a purposely weak image obliterates it altogether.

Without doubt the finest Calotype portraits were produced in Scotland. The works of few nineteenth-century photographers have had such a strong and universal appeal to generation after generation as the portraits of David Octavius Hill and his collab-

[1] *The Edinburgh Review*, January 1843.

orator Robert Adamson. It is an interesting phenomenon that in the very infancy of the art these two Scottish photographers reached the highest peak in portraiture of which the photographic medium is capable. The artistic spirit with which their Calotypes are imbued cannot fail to impress. Clarkson Stanfield remarked in 1845, 'I would rather have a set of them than the finest Rembrandt's I ever saw,' and since then artists and critics, though refraining from such dramatic comparisons, have been no less sincere in their admiration.

David Octavius Hill, a successful Scottish landscape painter, originally turned to photography only in order to obtain good likenesses as studies for a monumental painting to commemorate the resignation in May 1843 of 474 ministers of the Church of Scotland on a matter of principle. Soon, however, he became so engrossed in the new art that he took photographs for their own sake, which he exhibited alongside his paintings at the Royal Scottish Academy, Edinburgh, of which he was secretary for forty years.

Many distinguished people came to have their photographs taken, among them the Marquis of Northampton (President of the Royal Society, London), Sir Francis Grant (President of the Royal Academy, London), the artist William Etty, James Nasmyth (inventor of the steam-hammer), Sir John McNiell (British Ambassador to Persia), and visiting royalty—the King of Saxony.

In order to attain a reasonably short exposure of one or two minutes, direct sunshine was essential, and consequently the sitters were posed outside the studio on Calton Hill (*No. 20*), an arrangement of curtains, furniture and books conveying a convincing impression of an interior (*No. 21*).

It was an ideal collaboration in which both partners played an equally important rôle. Adamson was a professional Calotype portrait photographer in Edinburgh, and his technical skill was indispensable to Hill, who revealed an artistic conception of an unusually high order, and a masterly sense of grouping and arrangement of accessories. Above all, he had a sure instinct for the massing of light and shade. Details of dress and accessories are subordinated in the concentration on head and hands. There is nothing strained or theatrical in pose. The portraits are powerful in characterization; they have a grandeur reminiscent of the quality of Old Masters.

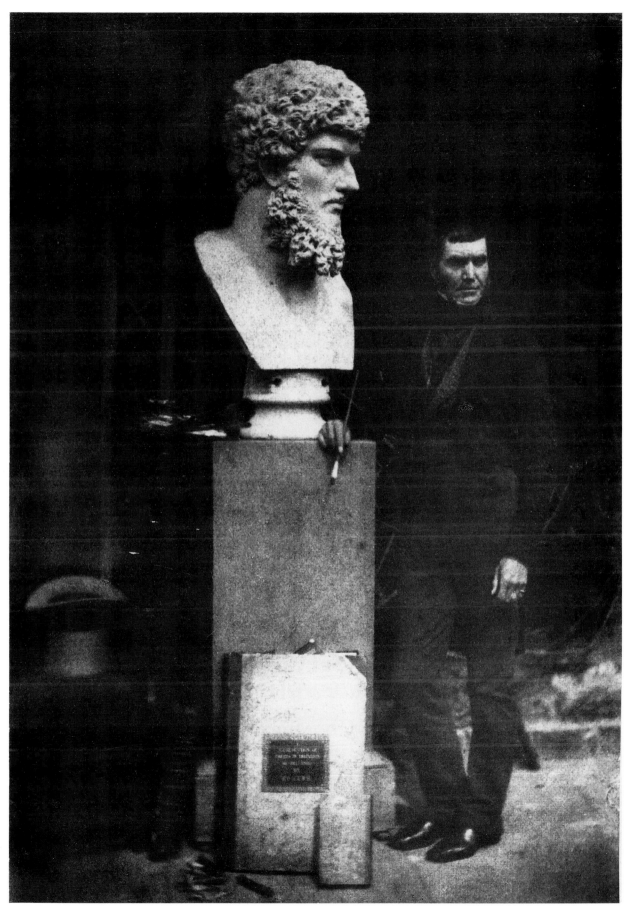

20. *D. O. Hill and R. Adamson. The sculptor John Stevens and bust of Lucius Verus. Calotype,* 1843–5

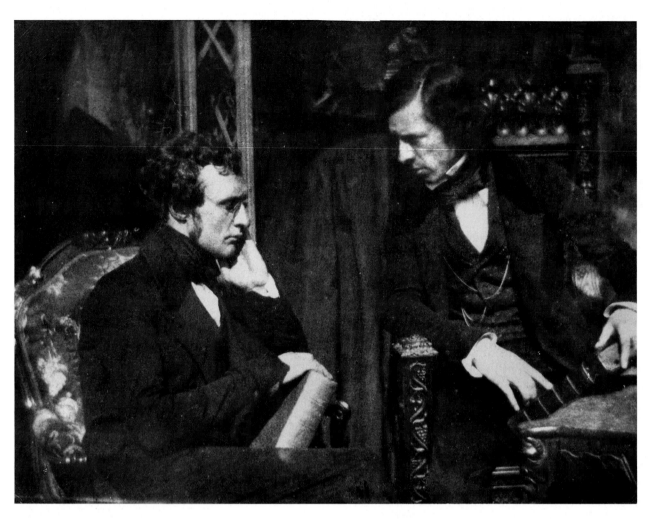

21. *D. O. Hill and R. Adamson. Rev. George Gilfillan and Dr Samuel Brown. Calotype, c.* 1843

As a landscape painter Hill showed a preference for wild scenery with ancient castles, rugged mountains, romantic glens with waterfalls, gnarled trees, poetic sunsets that were part and parcel of the Romantic movement. Such subjects reflected contemporary taste, nurtured on the poems of Byron and the novels of Sir Walter Scott. It is surprising, therefore, that scenery was not apparently a subject that appealed to Hill in photography. There are only a few dozen photographic landscapes in the joint *opus*, and most of these are signed by Adamson alone. Greyfriars Churchyard, Edinburgh, with its ivy-clad walls and monumental tombs was, however, much favoured as a picturesque background for small groups. A few of the portraits and *genre* pictures are imbued with a similar romantic quality. Contrary to his practice in painting, Hill never im-

pressed a preconceived style on photography, but varied it according to the subject.

Sometimes Hill and Adamson took their camera to nearby Leith harbour or the fishing village of Newhaven. Like an artist with sketchbook, Hill seized on anything that appealed to his sense of the picturesque, each time superbly interpreting the mood of the subject, whether it were fishing boats, old stone cottages, fishwives in their traditional costume (*No.* 22) or a group of sailors in top-hats (*No.* 23). The last-mentioned picture has the spontaneity and unselfconsciousness of a modern reportage photograph, though of necessity posed, and shows a wonderful balance of light and dark masses. It has the power of a Daumier lithograph.

The group of Highlanders at Edinburgh Castle (*No.* 24) shows a similar intention to capture a spon-

36

22. *D. O. Hill and R. Adamson. Elizabeth Johnstone, the beauty of Newhaven village. Calotype, c.* 1845

23. *D. O. Hill and R. Adamson. Sailors. Calotype, c.* 1845

taneous scene, before photography was technically capable of it. The necessary under-exposure caused the halftones to be lost, so that only a ghostly pattern of light and dark remains which, combined with the unsharp outlines and the fibre of the paper, resulted in a strange impressionistic effect. It is perhaps not a coincidence that fifty years later when Impressionism became the fashion among *fin-de-siècle* photographers, the Hill/Adamson *opus* was 'rediscovered' by J. Craig Annan, one of the group.

When Robert Adamson died early in 1848 Hill returned to painting, though he did not altogether lose interest in photography. About 1860 he entered for a short time into collaboration with another Edinburgh portrait photographer, A. Macglashon, but their intention to further 'the development of Fine Art in photography' only resulted in mediocre anecdotal illustrations. The originality and fine quality of the 1840s had vanished.

The artistic failure of Hill's short comeback to photography with another collaborator may also indicate that Adamson's rôle had been more than that of a technician, although Hill used to exhibit their pictures at the Royal Scottish Academy and elsewhere as 'Calotype portraits executed by R. Adamson under the artistic direction of D. O. Hill'. Significantly also, Hill portrayed himself with sketchbook and pencil and Adamson with the camera, in his enormous historical painting 'The First General Assembly of the Free Church of Scotland', on which he worked on and off for twenty-three years. Yet neither this horribly overcrowded canvas, resembling a 'photographic mosaic', nor the few quite charming landscape paintings that have survived, would rescue his name from oblivion: D. O. Hill's fame rests solely on the 1,500 or so Calotypes taken during his $4\frac{1}{2}$ years' collaboration with Robert Adamson.

38

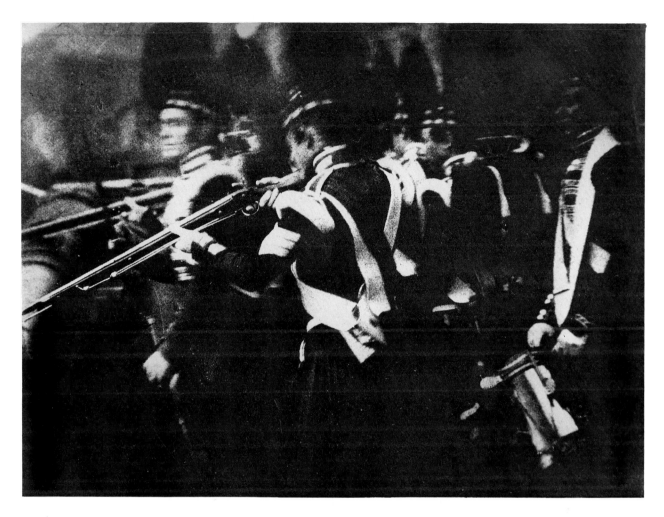

24. *D. O. Hill and R. Adamson. Highlanders at Edinburgh Castle. Calotype,* 1843–7

III

TOPOGRAPHY AND INTERPRETATION

Photography on paper was brought to its culmination in the 'fifties by Gustave Le Gray, a painter and photographer. His waxed paper process made known in December 1851 was preferred by many to the Calotype because it gave much finer detail. Moreover the paper could be sensitized several days in advance and the picture developed several days after it had been taken—important advantages over the Talbotype, particularly on excursions. Whilst Calo-

type negatives were sometimes waxed on the back to subdue the grainy effect and speed up printing (by making the paper transparent), in Le Gray's process the picture was taken on paper already impregnated with wax, which filled the pores and gave it almost glass-like transparency. The use of thin French paper also contributed to a much sharper and finer image, so detailed in fact that a positive printed from a waxed paper negative such as John

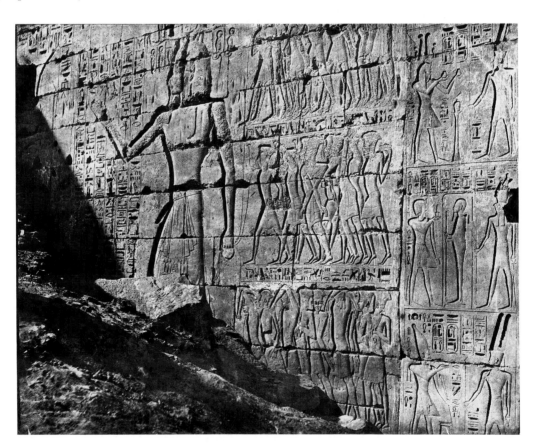

25. John Shaw Smith. Relief on a temple at Thebes. Waxed paper, 1851

40

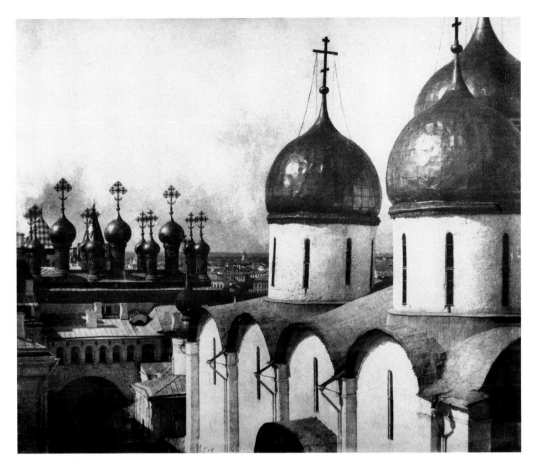

26. Roger Fenton. Domes of the Cathedral of the Resurrection, the Kremlin. Waxed paper, 1852

Shaw Smith's photograph of a relief on a temple at Thebes (*No. 25*) cannot be distinguished in clarity from one printed from a glass negative.

The waxed paper process was particularly favoured by travellers, and in the summer of 1852 began a brief flowering of photography on paper before its eclipse by photography on glass. During that summer Roger Fenton, a painter, solicitor and professional photographer for eleven years, made a photographic tour in Russia, visiting St Petersburg, Kiev and Moscow. The most outstanding and original view of the series shows the domes of the Cathedral of the Resurrection in the Kremlin (*No. 26*). Whilst at that period most artists and photographers would have taken a complete view of the cathedral from street level, Fenton sought a vantage point which provided him with a less obvious view over-looking the roofs and domes.

Unlike his friend D. O. Hill, Dr Thomas Keith took no portraits, but concentrated on picturesque bits of old Edinburgh, and the surrounding countryside, during the few years he practised photography in his spare time. His photograph of willow trees (*No. 27*) is so modern that it might have been taken by the founder of New Objectivity himself. In fact it perfectly stands up to Albert Renger-Patzsch's rendering of the same subject illustrated in his book *Die Welt ist Schön* (1928). Equally advanced is Keith's 'Reflections in a pond' (No. 28). Yet what a world of difference between this straightforward rendering, Alvin Langdon Coburn's impressionistic interpretation (*No. 142*) and Arno Hammacher's modern version (*No. 214*).

Apart from those already referred to, leading artistic photographers using one or other of the paper processes include: (in France) Edouard Baldus, L. Blanquart-Evrard, Maxime Du Camp, Comte F. Flacheron (active in Italy), Henri Le Secq, Charles Marville, Baron Humbert de Molard, Charles Nègre, Eugène Piot; (in Britain) Philip H.

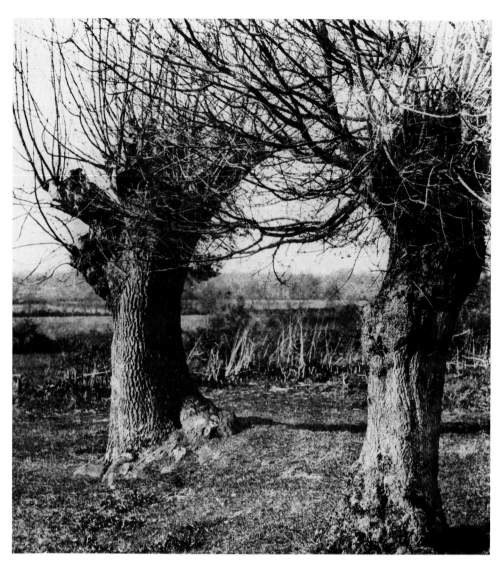

27. *Dr Thomas Keith.*
Willow trees. Waxed
paper, c. 1854

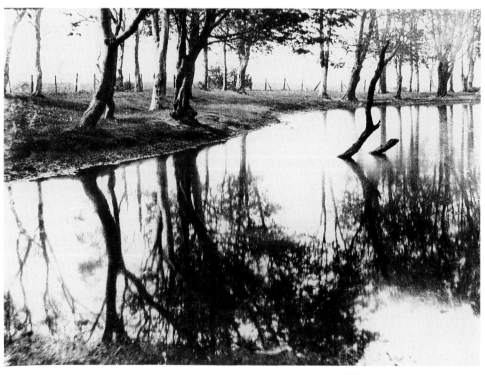

28. *Dr Thomas Keith.*
Reflections in a pond
at Blackford Farm
near Edinburgh.
Waxed paper, 1855

Delamotte, J. Forbes-White, Nicholaas Henneman, Hugh Owen, William Pumphrey, Benjamin Bracknell Turner; (in Germany) Alois Löcherer.

The collodion process on glass introduced by Frederick Scott Archer in 1851 owed its popularity not to any simplification of technique but to the fact that it was several times faster than the previous processes. For the landscape and architectural photographer the necessity of transporting the entire darkroom equipment, glass plates and chemicals weighing up to 120 lb. imposed a burden that only real enthusiasts cared to undertake (*No.* 29). Even if the photographer hired a man to act as porter, or a cab for the transportation, the equipment had still to be carried to a good viewpoint, and the dark-tent pitched. The various preparations before a picture could be taken, and the necessity of developing and fixing it while the collodion was still moist, were so time-consuming that very few pictures could be taken on one outing. In these days of factory-produced roll-films and plates we can hardly imagine the immense difficulties the photographer of the wet collodion period had to contend with. Yet these very difficulties were indirectly the cause of the high quality of the pictures produced. Obviously a far greater mental effort was made to get a well-composed picture of a worth-while subject, and this took shape in the photographer's mind before he even began to unpack his equipment.

At that period educated people received more art instruction than is usual today, and any photographer who had not,

'if he be possessed of a grain of sense or perception, will never rest until he has acquainted himself with the rules which are applied to art . . . and he will make it his constant and most anxious study how he can apply these rules to his own pursuit. . . . The student should bear in mind that what he has to aim at is not the production of a large number of *good* pictures, but if possible, of *one* that shall satisfy all the requirements of his judgment and taste. That one when produced will be, we need not say, of infinitely greater value to his feelings and reputation than a lane-full of merely good pictures.'[1]

Photography is too cheap and easy today. With thirty-six exposures on a roll, the temptation to snap-shoot haphazardly is overpowering to the majority of

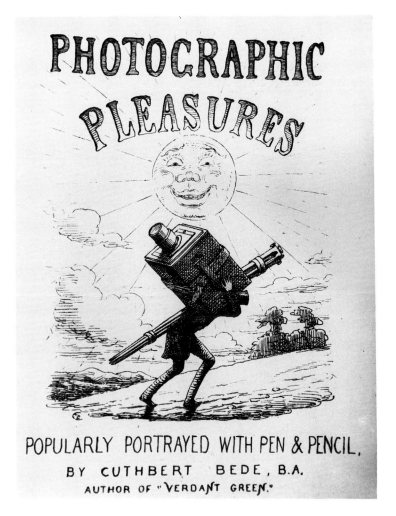

29. 'Cuthbert Bede' (Rev. Edward Bradley). Title-page of 'Photographic Pleasures', 1855

camera users. But conditions were very different in the nineteenth century, when enlarging was not practicable. Those who wanted big pictures to hang in exhibitions, or for prints for sale, had to take them on paper or glass plates the required size. 12 in. × 16 in. was nothing out of the ordinary, and some professionals used 16 in. × 20 in. Under such conditions only the keenest and most capable photographers 'survived'. Wherever they carried their camera, they had a purpose: whether the subject were the desolate scene of a flood (*No.* 30) or the grandiose monuments of Rome (*No.* 31), whether the icy mountain passes of the Himalayas or the hot sands of Egypt (*No.* 32), whether they photographed a general view (*No.* 33) or a close-up of some wood-

[1] Francis Frith, *The Art of Photography*; *The Art Journal*, 1859, p. 71.

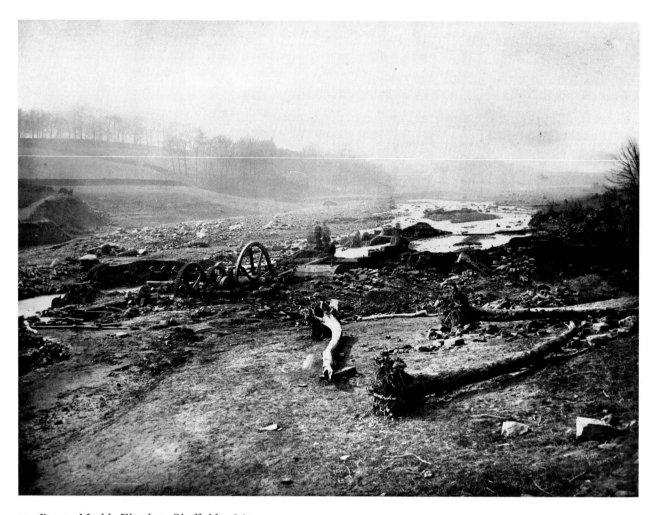

30. *James Mudd. Flood at Sheffield,* 1864

land plant (*No.* 34), or a detail of sculpture (*No.* 37), or a classical architrave (*No.* 35), they were explorers in the visual field and not mere topographers. Their representations of nature and architecture are personal expressions of men endowed with artistic sensibility seeking new forms and combinations for pictorial art. If the photographer is an artist it will show in his negative just as it would on his canvas if he were a painter. He interprets the scene and communicates to others the characteristics of the view that have impressed him. A beauty spot is nearly always disappointing in photography; either the camera cannot do justice to it because wide views are invariably ineffective, or at best it will result in a conventional picture-postcard.

Landscape seems to have appealed particularly to the country-loving English, who right through the nineteenth century were leading in this field. Some outstanding names include Francis Bedford, P. H. Delamotte, William England, Roger Fenton, Francis Frith, William Grundy, James Robertson (*No.* 36), Russell Sedgfield, James Valentine, G. W. Wilson, Henry White (*No.* 39). Samuel Bourne established himself in India, E. Muybridge in America, Charles Clifford in Spain (*No.* 38), MacPherson (*No.* 41) and Anderson in Rome. The two last-named are better known in the architectural field.

In France too there were many photographers of fine landscape and architectural views, foremost among them Edouard Baldus, the Bisson brothers, Adolphe Braun, C. M. Ferrier, Henri Le Secq, Charles Marville, Charles Nègre, and Gustave Le Gray, whose seascapes were a great technical feat. Though a photographer at Le Havre is reputed to have taken

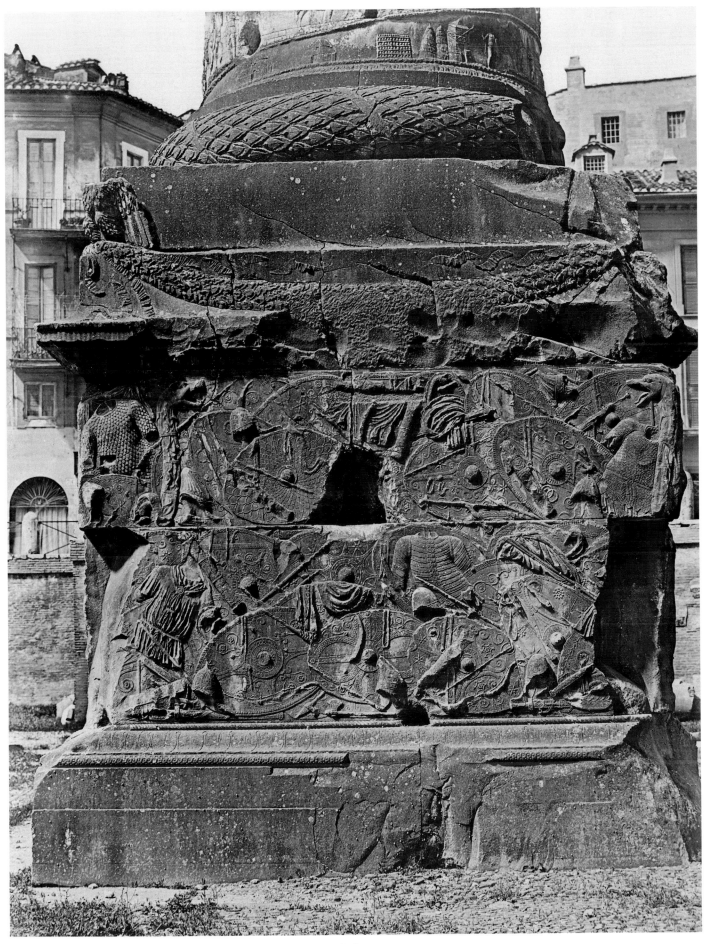

31. *James Anderson. Base of Trajan's Column, Rome, c. 1858*

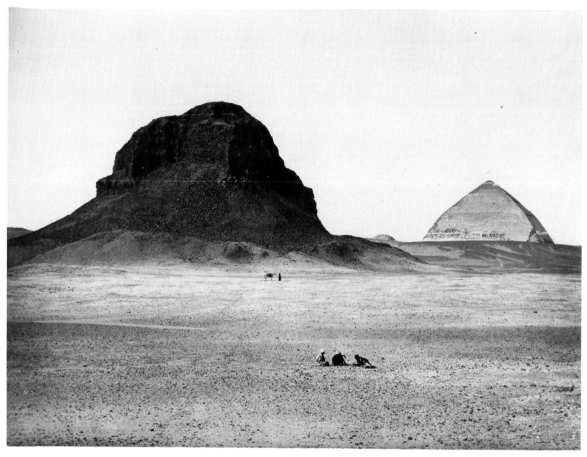

32. *Francis Frith. Pyramids of Dahshoor, 1857–8*

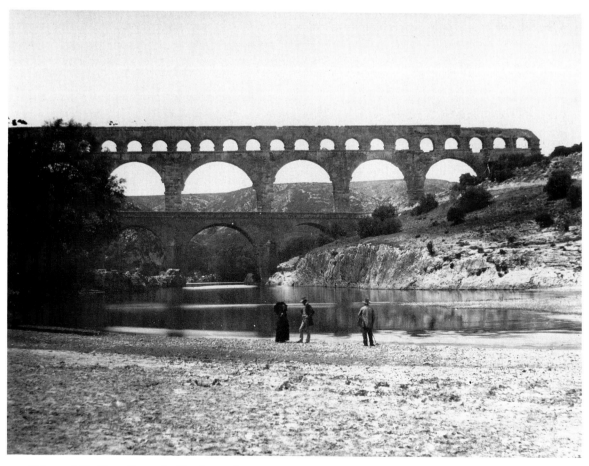

33. *Edouard Baldus. Pont du Gard, c. 1855*

34. *Royal Engineers Military School, Chatham (Photographic Department). Study of plants, c.* 1860

instantaneous photographs of rolling waves with ships sailing and clouds scudding across the sky in 1854,[1] Le Gray's 'Brig upon the Water' (1856) (*No.* 40) caused a sensation on account of its *contre-jour* effect. The passing gleam of sunlight on the water, produced by the transit of a fleecy cloud, aroused the wonder and envy of all photographers. The 'moonlight' effect, which was later imitated countless times, was due to the necessary under-exposure. Landscapes at that time were characterized by a blank white sky, and at first it was thought that the clouds had been printed in from a separate negative, but this was not the case. Le Gray's success was due to the bright sunlight reflected from the sea, and those who hoped to photograph clouds over an ordinary landscape were disappointed, for the contrast between green grass and foliage, to which the

then colour-blind negative material was not very sensitive, and the blue sky, to which it was over-sensitive, was too great. Either one had to expose for the sky, when the landscape became a mere silhouette, or if the exposure were correct for the landscape, the sky became so dense that it printed white. The impossibility of obtaining a harmonious combination of sky and landscape was a general complaint in the 1850s and '60s.

After seeing Le Gray's seascapes, photographers were no longer content with a blank sky. Many of them dabbed artificial clouds on the negatives; others printed in clouds from a separate cloud negative—an innovation suggested by Hippolyte Bayard in 1852. This interference with the camera's image was perhaps justified for aesthetic reasons. Unfortunately not every photographer took the trouble to make a cloud negative immediately before or after the landscape, as Silvy did. Laziness led some to use favourite

[1] *The Liverpool Photographic Journal*, Vol. I, 1854, p. 144.

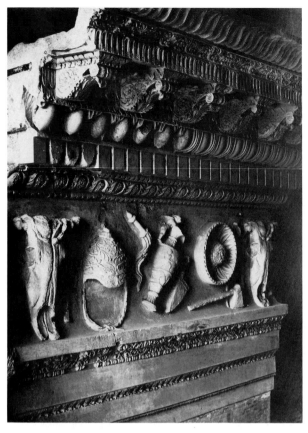

35. *Bisson frères. Temple of Vespasian, Rome, detail of architrave, c.* 1858

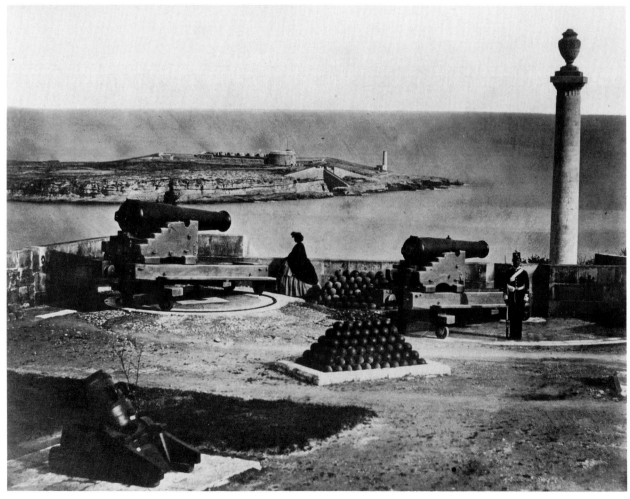

36. *James Robertson (attributed to). Malta fortress, c.* 1860

37. *Charles Nègre. Statue. Calotype, c.* 1852

cloud negatives for any scene, irrespective of whether it suited the landscape, weather, and lighting conditions. The situation became still more absurd after 1880, when cloud negatives were an article of commerce until the introduction of orthochromatic plates and light filters made such shams obsolete.

A few excellent architectural and landscape photographers in other countries deserve mention. Carlo Ponti in Venice (*No. 43*) and Luigi Bardi in Florence depicted tastefully the architectural treasures of their districts. Vittorio Sella of Turin specialized in Alpine views. In America, William Jackson is renowned for recording the opening up of the West.

The influence of landscape photography upon painting was profound, especially in France where academic painting was practically confined to enormous historical and allegorical canvases. Courbet's one-

man show entitled 'Le Réalisme', and consisting of paintings refused by the Salon, was held concurrently with the first big display of photographs in France, at the International Exhibition of 1855. As he had already shown in 'The Stone Breakers' five years earlier, Courbet was striving for an objective, unstylized reproduction of nature based solely on observation. In the first number of the magazine *Réalisme* in July 1856 the champions of the new tenet declared: 'For us, art is a real, existing, visible, palpable thing: the scrupulous imitation of nature.' The photographic truism that 'one cannot photograph what one does not see' became with the substitution of one word part of the new Realist manifesto: 'One cannot paint what one does not see.' For the photographer, landscape was a natural field, accepted by the public, but Courbet's aesthetic ideals signified a break with academic subject matter.

38. *Charles Clifford. In the park of the royal summer residence Capricho, near Guadalajara, Spain, 1855*

39. Henry White. Bramble and ivy, c. 1856

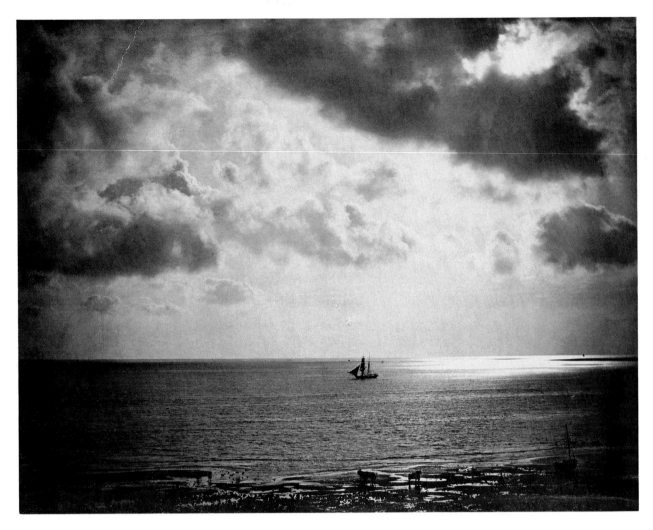

40. *Gustave Le Gray. 'Brig upon the Water'*, 1856

The strange thing is that, despite the fact that photographers and artists of the Realist school had an identical approach to nature, the Realist painters refused to consider photography as an art, just as their own works were denied recognition and sneered at as 'photographs'.

To Charles Baudelaire the doctrine of copying nature—whether by photography or by painting—was anathema. In a polemical essay on the occasion of photography's admission to the Salon of 1859, he slated it as 'the refuge of every would-be painter, every painter too ill-endowed or too lazy to complete his studies. . . . By invading the territories of art, this industry has become art's most mortal enemy. If photography is allowed to supplement art in some of its functions, it will soon have supplanted or corrupted it altogether.'[1] Baudelaire was, however, no less disparaging about the state of painting at the time, attacking in equally strong terms the banalities of the academic historical painters, and what he considered the trivialities of the naturalist and realist painters. Thoroughly disgruntled, the poet proclaimed, 'I consider it useless and tedious to represent what exists, because nothing that exists satisfies me. Nature is ugly, and I prefer monsters of my fancy to what is positively trivial.'

[1] Charles Baudelaire, 'The Salon of 1859: The Modern Public and Photography'; *La Revue Française*, June 1859.

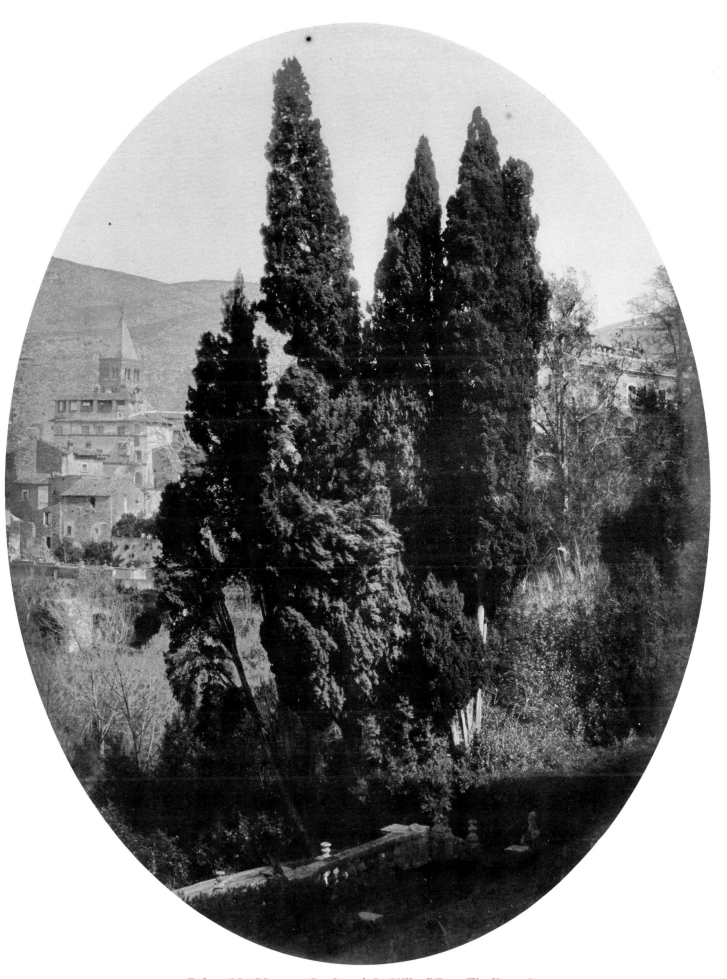

41. *Robert MacPherson. Garden of the Villa d'Este, Tivoli, c.* 1857

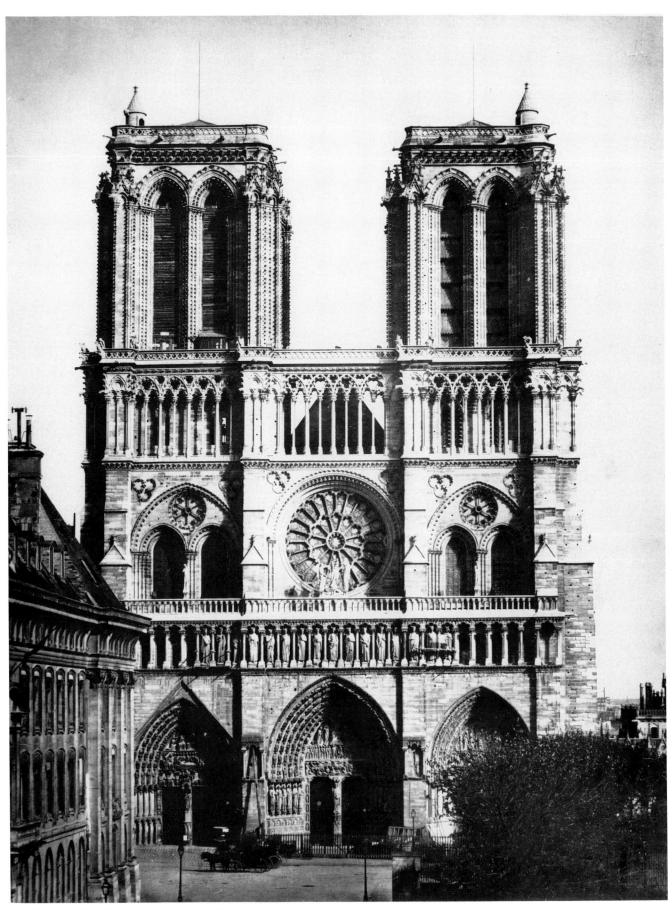

42. *Gustave Le Gray. Notre-Dame, Paris,* 1858

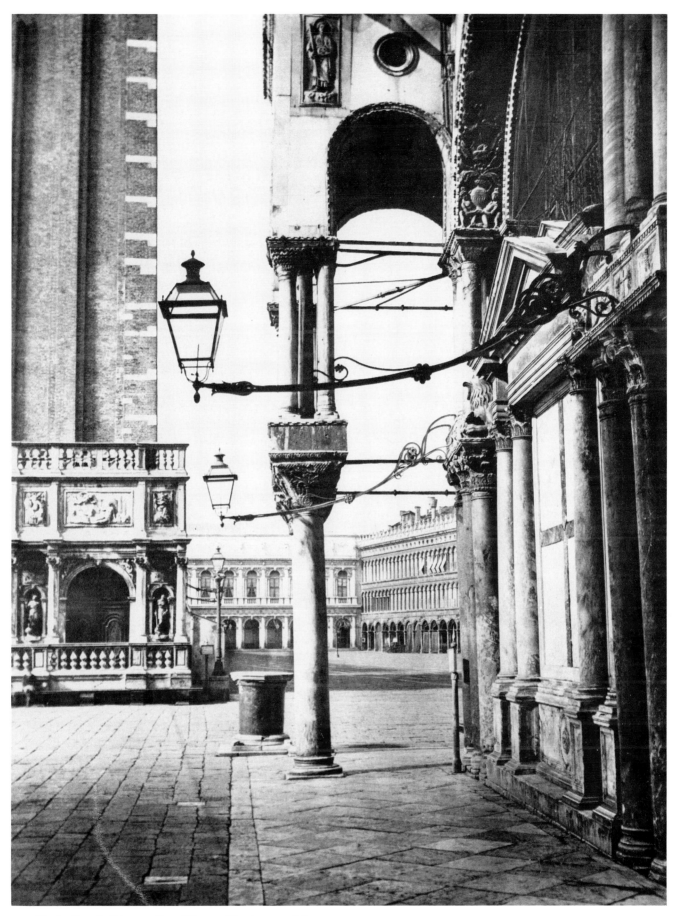

43. *Carlo Ponti. Piazza San Marco, Venice, c.* 1862

IV

A NEW INDUSTRY

Whilst landscapes, town views, and architecture were taken by professional and amateur photographers to an almost equal extent, studio portraiture remained understandably almost exclusively in the hands of professionals, as it does to this day.

Portraiture by the wet collodion process brought a large number of newcomers to the profession, partly on account of the constantly increasing demand for portraits, partly because collodion portraits could be produced more cheaply than daguerreotypes. In England there was an additional reason: the collodion process was the first to be free from patent restrictions, at any rate from the end of 1854.

The boom in portraiture is most clearly demonstrated by a few statistics. In 1851 there were only about a dozen portrait studios in London; in 1855 there were 66; two years later 155; in 1861 over 200; by 1866 the number had risen to 284. These figures do not take into account the less reputable photographers, uneducated people who took portraits as a remunerative sideline to their original trade or trades. The following amusing advertisement of a Manchester Jack-of-all trades is revealing of the new state of affairs. L. Russell was probably the first to propagate hire-purchase for portraits!

'Mr LORENZO HENRY RUSSELL
Professor of Singing and Music,
Miniature Painter, Phrenologist,
Taxidermist, Mesmerist, and Photographer.
Alexandra Studio (opposite the entrance to
Alexandra Park) and 2 Albion Terrace,
Harpurhey, Manchester.
'Mr Russell respectfully announces to the inhabitants of Harpurhey and neighbourhood that he has erected a first-class Studio, for the production of the best styles in every branch of the art of Photography.—Mr R. calls special attention to his New Opalotype Portraits, which, for beauty and delicacy of detail, are equal to Ivory Miniatures.—Wedding and other Groups taken at parties' private residences. Horses, Dogs, and other favourites photographed.—Cartes-de-Visite from 5s. per dozen copied to Life-size.—Old Faded Daguerreotype Portraits renovated and restored to their original beauty—having had upwards of thirty years' experience as an artist. The state of the weather is of no importance.—Family Residences, Machinery, &c. photographed on the shortest notice.—Families photographed at their own residences, without extra charge.—A Portrait Club, which enables every one to obtain a correct Portrait, coloured in Oil, in a gilt frame complete, and a dozen Cartes-de-visite for the low sum of £1 10s., payable at 1s. per week.—

'Busses from High Street run every five minutes, and alights passengers at the door.—Evening parties attended for Mesmeric Entertainments. Characters correctly delineated.—P.S. Birds and Animals preserved and stuffed on the most approved and scientific principles.—Lessons in Singing, with Pianoforte accompaniment.—Picture Frames of every description made to order.—A Respectable Young Lady or Youth Wanted, as an Apprentice, Premium required, nevertheless.

'Mr R. wishes to correspond with a young or middle aged Lady, must be fond of Children and Music, with a view to Matrimony. A widow Lady with Children not objected. He is 49 years of age, tolerably good looking, likes a glass of Beer, and has a particular wish to live 36 years longer, then go home and see his mother, where he will sing
God save the Queen and
John Brown, the piper.'
Every town of note, and even some villages, soon had one or more photographers, and travelling

LIKENESSES.

Have no more bad Portraits!

CAUTION!!!

All Persons are respectfully cautioned against the many SPURIOUS IMITATORS OF THE ART OF PHOTOGRAPHY, who not possessing the requisite knowledge of Chemicals,

CANNOT ENSURE

A Correct & Lasting Portrait!!

The consequence is, that thousands are dissatisfied with the Portraits, although they have paid High Prices for them. This evil can be entirely avoided by coming to

MR. & MRS. C. TIMMS,

PRACTICAL PHOTOGRAPHIC ARTISTS,

41, Newington Causeway.

Who are always at home to take portraits; the certainty of your being pleased is, you are requested not to pay until you are quite satisfied.

C. TIMMS offers advantages at his Establishment that are not to be had at any other in London, and without ostentation assures the Public that HIS PORTRAITS ARE SURPASSED BY NONE, and the Prices bespeak his determination to give complete satisfaction.—Many years experience has proved to him that a tradesman's success is commensurate with his honesty, he is therefore more desirous of gaining the gradually increasing confidence of the Public, than to excite a temporary influx of Customers at the expense of Truth. All Portraits are taken on the Ground Floor, so that the aged are not necessitated to ascend flights of Stairs.

It is particularly necessary to observe the Name over the Door.

☞ **C. Timms, 41, Newington Causeway.** ☜

An immense Stock of Gold and Bird's-eye Maple Frames to select from, also Best Silk Velvet, Fancy Morocco Cases, Lockets and Brooches made expressly for portraits.

ESTABLISHED TWELVE YEARS.

N.B.---The Waterloo Omnibusses bring you from the Station to the Elephant & Castle, when there, please to enquire for "TIMMS'."

44. *Cheap photographer's advertisement*, 1857

photographic vans made the round of outlying country districts. No longer was photography for the privileged few; it became an art for the million.

'Photographic portraiture is the best feature of the fine arts for the million that the ingenuity of man has yet devised. It has in this sense swept away many of the illiberal distinctions of rank and wealth, so that the poor man who possesses but a few shillings can command as perfect a lifelike portrait of his wife or child as Sir Thomas Lawrence painted for the most distinguished sovereigns of Europe.'[1]

Unfortunately a great many opportunists entered the field, who looked upon photography merely as a new industry. Most of them made ambrotypes, a simple form of collodion portrait enjoying great popularity on account of its cheapness (*No. 44*).

[1] *The Photographic News*, 18 October 1861.

In size (usually 3 in. × 4 in. or less) and style of framing these glass positives formed a substitute for the daguerreotype (*No. 46*). The leading establishments had less demand for ambrotypes, but supplied prints (usually 6 in. × 8 in. or 8 in. × 10 in.) from collodion negatives (*No. 45*). The inconvenience of the wet-plate process was, of course, negligible when the dark-room was next to the studio.

The gradual falling off in the demand for miniatures since the introduction of daguerreotype portraits in 1841 reached its lowest point in 1859, when for the first time no miniatures were shown at the Royal Academy annual exhibition. Even ordinary portrait painting was in the mid-fifties 'at one of the lowest ebbs in its history'.[2] This superseding by photography of painted portraits was not without evil effects upon portrait photography, for the public, accustomed to flattering portraits from painters, expected photographers to conform to the same practice. Whilst it was not possible to alter daguerreotype or ambrotype portraits, in the negative/positive processes—Calotype, collodion, and much later gelatine—retouching could be done. Women frequently complained that photographs made them look plain and older, and the photographer now found himself in the same dilemma as the portrait painter before him. Few had the moral courage and financial independence to follow their artistic conscience. Whilst it is quite legitimate to minimize the sitter's shortcomings by skilful posing and lighting, actual beautifying can only be done by drawing on the negative or print, and in doing so the photographer leaves his proper domain of drawing by light and becomes that undesirable hybrid, the painter-photographer.

The ease with which anyone with a little skill could add points of beauty or remove defects presented a dangerous temptation to photographers to flatter the sitter. It is strange that many people's idea of attractiveness can only be fulfilled by obliterating everything that is characteristic. In the late 1850s retouching and beautifying were carried to such extremes that some photographic societies stipulated that in the case of touched-up photographs the negative must be shown alongside the print in their exhibitions.

'The colorist', ran one instruction, 'may correct with his brush defects which, if allowed to remain,

[2] David Piper, *The English Face*, London, 1957.

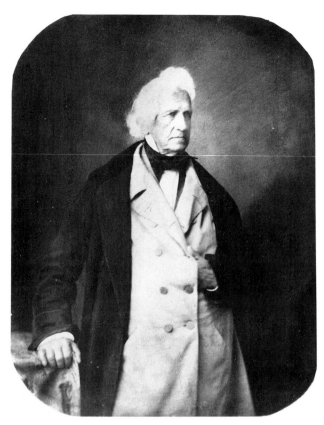

45. *C. Schwartz. Christian Rauch*, 1852

spoil any picture. For instance, where a head is so irregular in form as to become unsightly, soften those features which are the most strikingly deformed, and reduce the head to a greater semblance of beauty. Try to discover what good points there are—for all heads have some good points—and give these their full value.'[1]

[1] *The Photographic News*, 3 June 1859, p. 149.

The average photographer would try to make his sitter's features conform to the Victorian ideal of beauty.

(*For women.*) 'A handsome face is of an oval shape, both front view and in profile. The nose slightly prominent in the centre, with small, well-rounded end, fine nostrils: small, full, projecting lips, the upper one short and curved upwards in the centre, the lower one slightly hanging down in the centre, both turned up a little at the corners, and receding inside; chin round and small; very small, low cheekbones, not perceptibly rising above the general rotundity. Eyes large, inclined upwards at the inner angles, downwards at outer angles; upper eyelids long, sloping beyond the white of the eye towards the temples. Eyebrows arched, forehead round, smooth and small; hair rather profuse. Of all things, do not draw the hair over the forehead if well formed, but rather up and away. See the Venus de Medici, and for comparison see also Canova's Venus, in which latter the hair is too broad.'

(*For men.*) 'An intellectual head has the forehead and chin projecting, the high facial angle presenting nearly a straight line; bottom lip projecting a little; eyebrows rather near together and low (raised eyebrows indicate weakness). Broad forehead, overhanging eyelids, sometimes cutting across the iris to the pupil.'[2]

As to the most important part—at that period—of the female figure, the waist, one instruction interpreted retouching rather generously: 'The retoucher may slice off, or curve the lady's waist after his own idea of shape and form and size.'

[2] loc. cit.

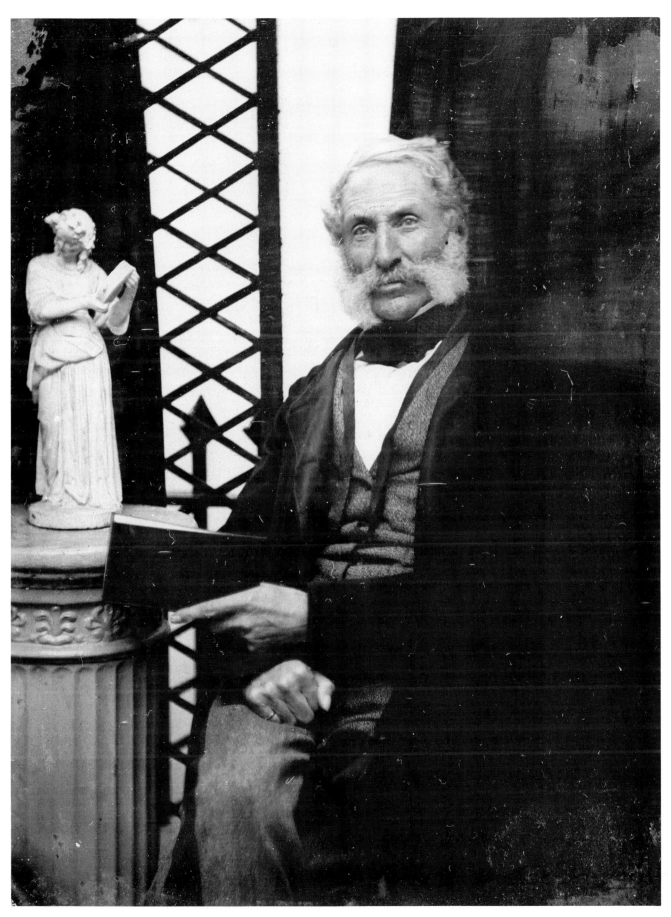

46. *Ambrotype of an old gentleman, c. 1857*

V

IMMORTAL PORTRAITS

The front rank photographers did not stoop to flattery by retouching. Many avoided the difficulty by refusing to photograph women and concentrating on famous men. It is no exaggeration to say that from these photographic portraits we receive a far truer and more intimate impression of those who left their mark on the last century than from painted portraits, particularly since the majority of these are only enlarged and coloured copies of photographs.

Those fortunate enough to portray famous con-

temporaries inevitably get all the limelight, and it should not be forgotten that many photographers whose names are unknown took no less excellent portraits (for example, *No. 46*). The photograph of I. K. Brunel (*No. 49*), the great civil engineer, standing in front of the launching chains of the *Great Eastern*, is an unforgettable portrait that has the quality of a modern reportage shot. Robert Howlett brought out the determination of the man, who was beset by one difficulty after another in the

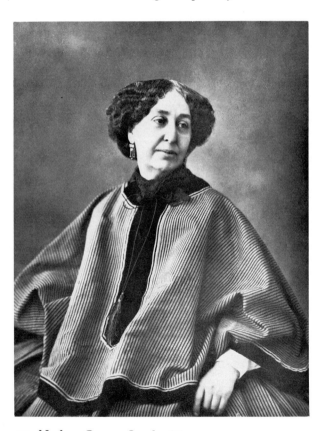

47. *Nadar. George Sand,* 1865

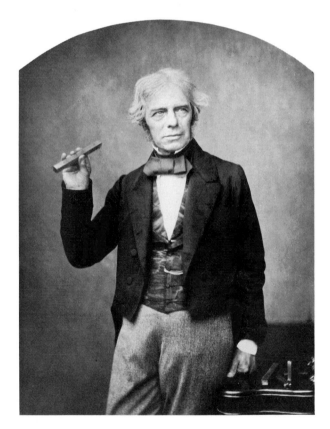

48. *Maull and Polyblank. Michael Faraday, F.R.S., c.* 1856. (*Faraday is holding a piece of optical glass in an iron container, used to demonstrate magnetic rotatory polarization of light*)

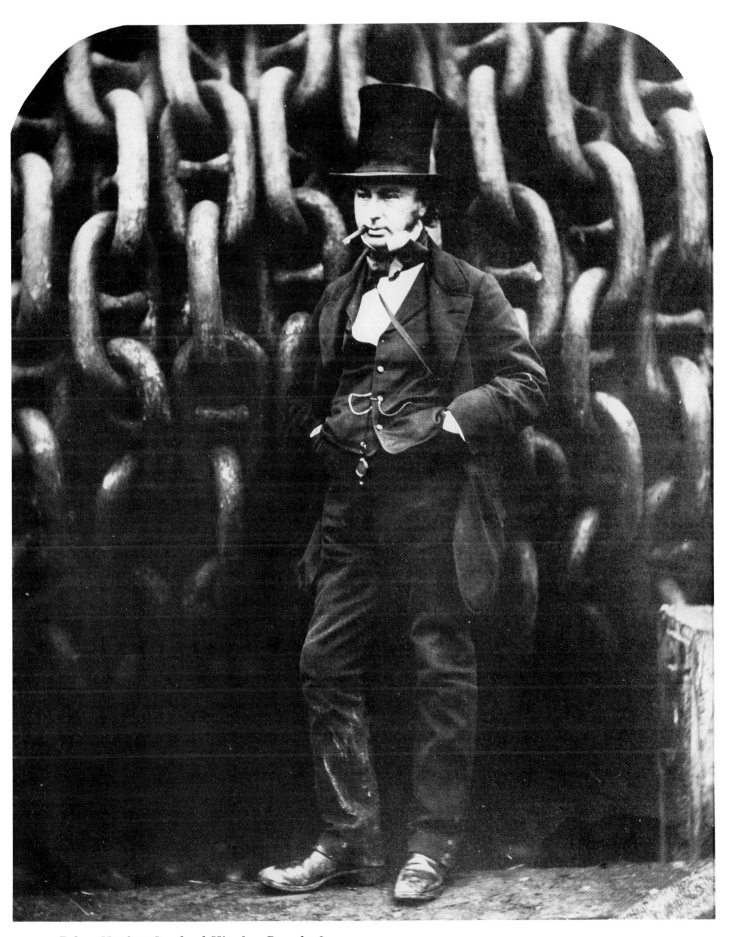

49. *Robert Howlett. Isambard Kingdom Brunel*, 1857

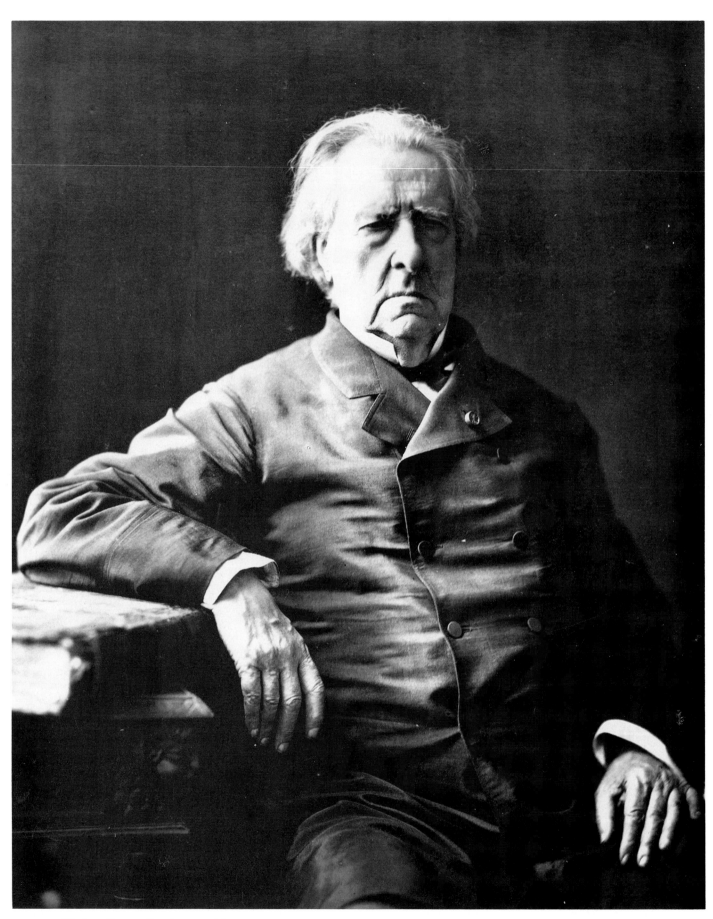

50. *Nadar. Baron Taylor, c.* 1865

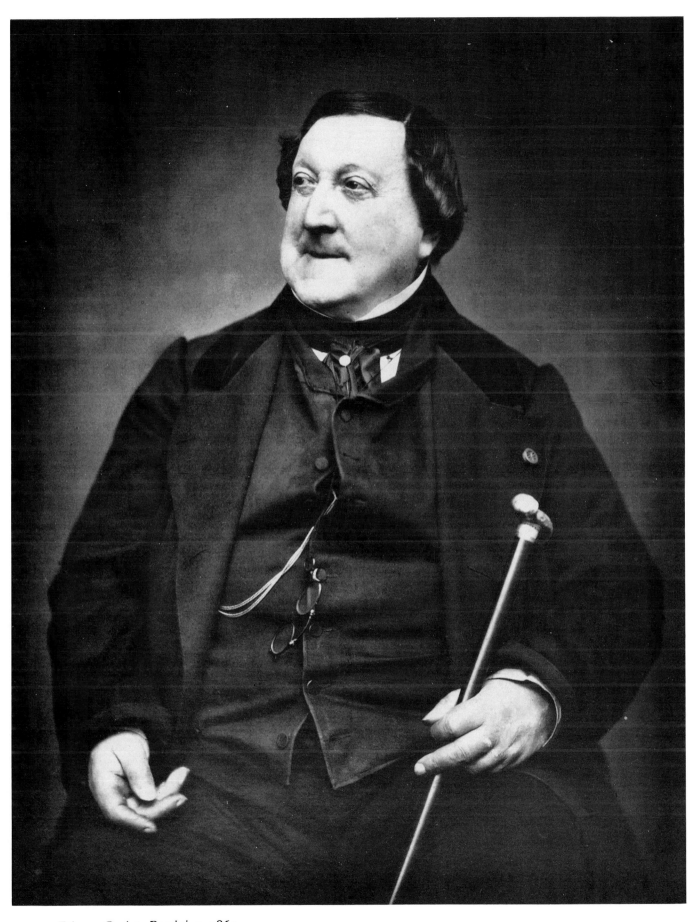

51. *Etienne Carjat. Rossini, c.* 1865

launching of this leviathan, the largest steamship of the nineteenth century. Equally impressive is a series of portraits of distinguished men taken at the same period by Maull & Polyblank (No. 48), Thomas Annan, and many others.

The caricaturist's ability quickly to seize upon the essential characteristics of his sitter was an asset to Nadar and Carjat, the two great French photographers, in immortalizing the famous. Following the tradition of the daguerreotypists, their portraits are simple and realistic, yet far more forceful and striking in their intellectual power.

Nadar, who was equally famous as an intrepid aeronaut, had of necessity to leave the general run of portraiture to assistants, reserving to himself the most distinguished sitters, many of whom were his personal friends. He might be called the photographer of the Second Empire and the Third Republic; only, being an ardent republican, Nadar shunned any connection with the imperial family and the court. Indeed, in his crowded lithograph 'Le Panthéon Nadar' published in 1854, he gave vent to his anti-royalist feelings. The last figure in the queue of celebrities, in the likeness of the Emperor, is being kicked out of the picture.

Nadar's studio in the Boulevard des Capucines was the meeting-place of intellectuals, not society. With very few exceptions he refused to photograph women, on the grounds that they were 'too beautiful to serve my art'—but this was only an excuse. To his friend George Sand (No. 47), whose novels moved with the spirit of the time from romantic passion to socialism, Nadar dedicated one of his many books, *Quand j'étais étudiant*. Gustave Flaubert, who found photography a pictorial equivalent to his literary realism; Baudelaire who hated photography; Alexandre Dumas, Victor Hugo, Sainte-Beuve, Champfleury, Baron Taylor (No. 50); Rossini, Berlioz, Meyerbeer, Wagner, Liszt, Gounod; Gustave Doré, Delacroix, Daumier, Millet, and the Impressionists, are only a few of the famous men to sit to Nadar. The only one, in fact, to refuse was Balzac, who feared that the camera might steal his soul: had not Nadar already stolen Gounod's eyes in his daring close-up? 'The good giant', as Léon Daudet called him, had a gift for friendship, and his kindness was remembered long afterwards by Monet, who recalled Nadar's generous and typical gesture in lending his studio (from which he had just moved) to the

Impressionists for their first exhibition in 1874. The exhibition of the innovators opened on April 15 and was a complete failure. The press as well as the public showered insults and scorn on the artists, whom the critic Louis Leroy dubbed 'Impressionists,' after Monet's painting *Impression—Soleil levant*, showing a luminous haze of sunshine through which a few ships' masts appear. By nature a revolutionary (his house was painted bright red), Nadar was not at all put out by the uproar the exhibition caused in the art world: he enjoyed it.

Etienne Carjat had a photographic studio for about twenty years, from 1855 onward. Not striving for worldly success, and without assistants, his output was small compared with Nadar's, who was active as a photographer for about thirty-four years. Some famous men sat to both photographers and though Carjat was overshadowed by the publicity-minded Nadar, many of his portraits—Rossini (No. 51) and Baudelaire, for example—seem to go deeper in characterization. The publication of *Galerie Contemporaine* made a large number of outstanding portraits of great Frenchmen available to the public at a low price and provides the best source to study the work of these and other leading Parisian portrait photographers of the 1860s and '70s: Adam-Salomon, Bertall, Fontaine, Franck, Klary, Mulnier and Pierre Petit.

A. S. Adam-Salomon was considered by his numerous admirers the premier portrait photographer in France. A successful sculptor of portrait busts, he devoted only two hours a day to photography. Critics praised the effect of relief and modelling in his photographs, which they ascribed to the sculptor's experience in lighting the sitter. But I think they imagined it; frankly I fail to discern a greater plastic effect in Adam-Salomon's portraits than in Nadar's and Carjat's. In modelling with light Julia Margaret Cameron showed a mastery that remained unmatched.

Adam-Salomon's mannerism of draping the sitter in velvet, posing him in the style of Rembrandt, Van Dyck or other Old Masters, appealed to people who failed to appreciate the camera's different, straightforward approach, and believed that by this kind of affectation photography became art. The poet Lamartine, who had hitherto despised photography as 'a plagiary of nature by optics', was completely converted by Adam-Salomon's portraits.

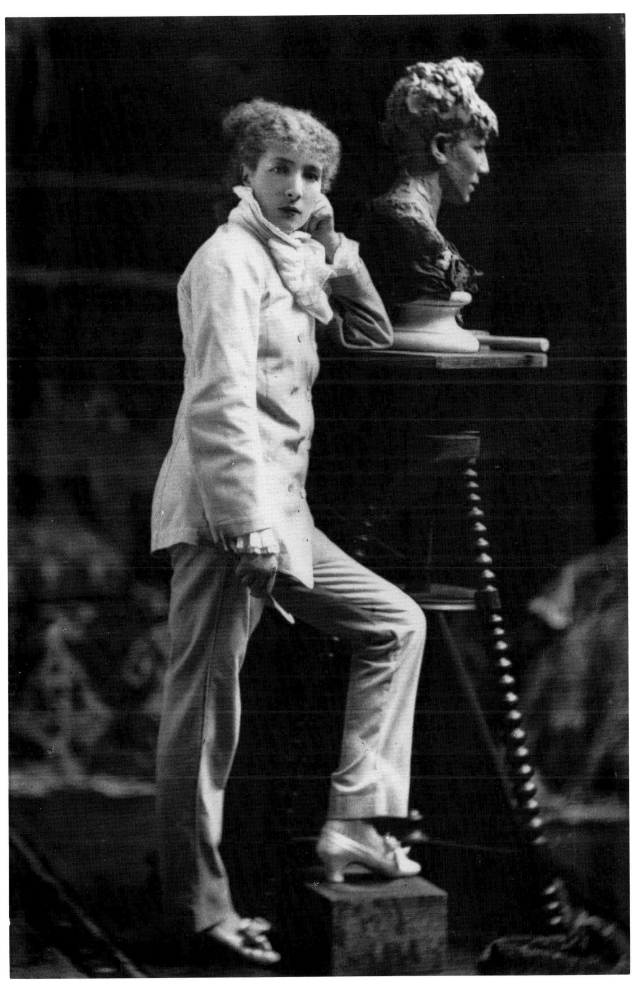

52. *Mélandri. Sarah Bernhardt with her self-portrait bust, c. 1876*

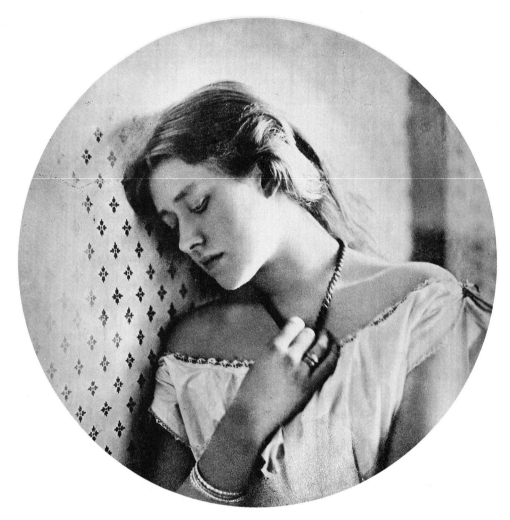

53. *Julia Margaret Cameron. Ellen Terry,* 1864

'We no longer say photography is a craft, it is an art; it is better than an art, it is a solar phenomenon in which the artist collaborates with the sun.'[1] This last statement was literally true, for Adam-Salomon made liberal use of the brush on his negatives. He had taken lessons from Erwin Hanfstaengl, who introduced negative retouching at the International Exhibition in Paris, 1855.

The changed outlook today calls for a re-assessment of Adam-Salomon's work. His portraits fail to come alive; there is no attempt at characterization. Many of them do not even rise above the average *carte-de-visite* level, through over-reliance on studio properties, which have a tendency to reduce the sitter to a figure in a composition instead of making him the composition itself. When Mélandri photographed Sarah Bernhardt in her own studio before the bust she modelled of herself (*No.* 52) there was a

[1] A. de Lamartine, *Cours familier de Littérature*, Vol. vii, p. 43, Paris, 1859.

purpose in the *staffage*. His is a brilliant exploitation of an historic moment, in the way Howlett's portrait of Brunel is.

Julia Margaret Cameron deplored the shallowness and lack of individuality in the professional portraits of her famous friends. They lacked any attempt at characterization, there was no endeavour to record what she called 'the greatness of the inner as well as the features of the outer man'. This feeling became a resolve when she was presented with a photographic outfit in 1863. Characteristically Mrs Cameron threw herself into this new occupation with enthusiasm and ambition. Photography was far more to her than a pastime; at last at the age of 48 she felt she had found her true purpose in life. Here was a means by which she could create beauty like her many artist friends, and for her, photography became a 'divine art'.

Self-taught, Mrs Cameron had perhaps too little regard for technical perfection, but her artistic con-

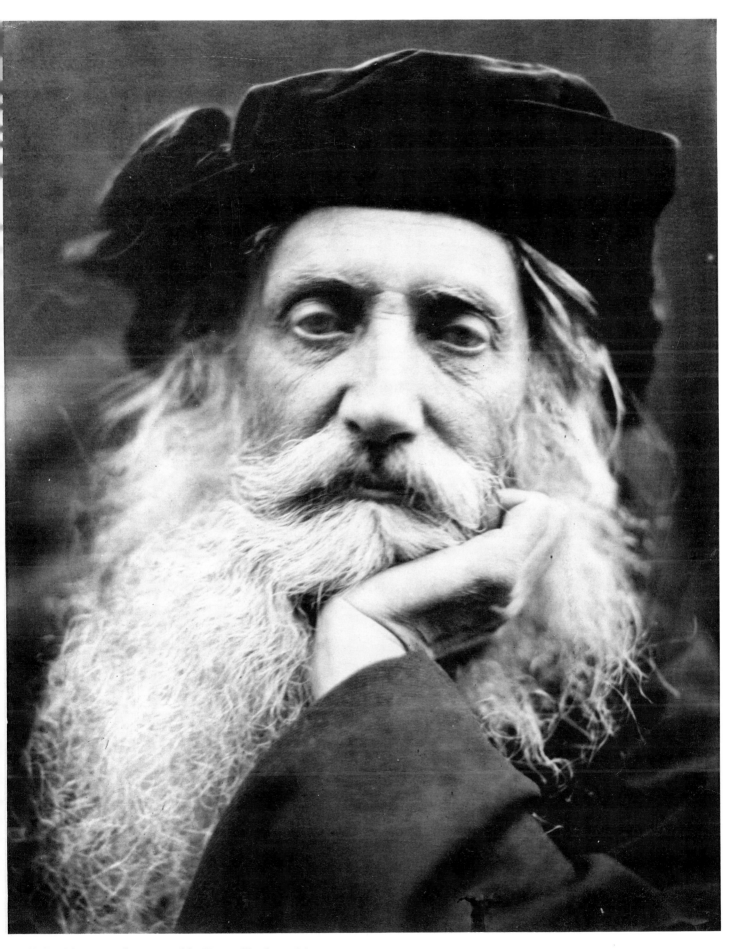

54. *Julia Margaret Cameron. Sir Henry Taylor,* 1867

ception was far above that of most contemporary professional photographers. Working for her own satisfaction and not for a living, Mrs Cameron could afford to go her own way, and became a pioneer in a new kind of portraiture—the close-up. Influenced at first by David Wilkie Wynfield, a painter and amateur photographer whose costumed half-length portraits of well-known artists she admired, Mrs Cameron soon developed her own style and so far surpassed her model that only a superficial resemblance exists between their work. Mrs Cameron disdained grandiose effects. Her large head studies (usually 12 in. × 16 in.) did not need elaboration by meaningless accessories, and the intellectual force of her sitters comes out so much the stronger.

In order to cut down exposures to the minimum, most professional portrait photographers let the light stream into their glasshouse from all sides, and this diffusion of light accounts for the flatness of the majority of their portraits. Mrs Cameron, on the other hand, shut out most of the light by curtains and directed it to model the features and to emphasize the characteristics of the sitter, but she never let her posing or lighting become a mannerism. On the contrary, her striving to express individuality constantly set her fresh problems, in the handling of which she eventually developed a mastery that sets her work apart from that of other photographers. At exhibitions Mrs Cameron's photographs always aroused vehement discussion. Such work had never been seen before. Photographers on the whole did not take kindly to it, but some of the most famous artists and writers of the day were exceedingly enthusiastic in their praise.

A member of intellectual society, Mrs Cameron had many opportunities of meeting the eminent during the twelve years of her photographic activity, and they were pressed into her service, sometimes by persuasion, sometimes coerced into submission. Her portraits of Tennyson, Browning, Longfellow, Carlyle, Trollope, Herschel, Darwin, Watts, Ellen Terry (No. 53), Sir Henry Taylor (No. 54) and many others have won a lasting place in the history of an era. They are the works of a great personality—the most vigorous and expressive documents we have of the great Victorians, for Mrs Cameron had the real artist's gift of piercing through the outward structure to the soul of the individual. Although the impressiveness of her portraits may owe something to the personality of the sitter—and this remark applies generally to portraits of famous people—her large head studies have a boldness which fills us with admiration and astonishment. They are startling in their originality of conception, and reveal such artistic feeling and depth of human understanding that they are in every case superior to the painted portraits of the same sitters by leading artists of the time. To Roger Fry it was evident that 'Mrs Cameron's photographs already bid fair to outlive most of the works of the artists who were her contemporaries',[1] and the same is true of the portraits of Hill and Adamson, and indeed of a great many other good portrait photographers of the present as well as of the last century.

Our greatest contemporary representative of studio portraiture in the classical tradition is Yousuf Karsh of Ottawa. His famous wartime portrait of Sir Winston Churchill will, I am convinced, outlive all other representations of the great man in any medium, for the simple reason that it is more characteristic of him than any other portrait I know. And I should know, for no fewer than 80,000 portraits of Churchill passed through my hands when I was compiling my pictorial biography of him.

What I have said about Karsh's photograph of Churchill applies equally to his fine studies of G.B.S. and other prominent men whom he photographed during the war for the Canadian Government. Karsh's 'Faces of Destiny' are full of vitality, and free from the mannerisms and over-glamourized effects he deemed necessary for smaller fry.

[1] Virginia Woolf and Roger Fry, *Victorian Photographs of Famous Men and Fair Women*, London, 1926.

68

VI

THE PHOTOGRAPHER AS STAGE MANAGER

The good professional portraitists had to face heavy competition from the cheap *carte-de-visite* which became the rage in Paris in 1859 and rapidly spread throughout Europe and America.

Realizing that the usual charge of 50 to 100 francs (£2 to £4) for a single 10 in. × 8 in. portrait was too high for the general public, A. E. Disdéri, one of the new cheap traders in photography, hit upon a brilliant idea to reduce prices and thereby bring photography within reach of the multitude. In his patent of 1854 Disdéri described a method of taking ten photographs on one glass plate 'so that all the time and expense necessary to obtain one print from the negative are divided by ten, which reduces to very little the price of each of these ten prints'. In practice, by means of a special camera with four lenses and a moving plate-holder, eight (not ten) photographs were taken on one negative (*No. 55*). The resulting contact print was cut up into the individual portraits, which were then mounted on pasteboard the size of a visiting card. An additional saving in production cost was achieved because in these small pictures, usually of the full-length figure, the sitter's head was so small that retouching could be dispensed with. By this mass-production method Disdéri could offer a dozen *cartes-de-visite* for 20 francs, thus tremendously undercutting all the other photographers.

The new format did not catch on until Napoleon III made it fashionable. In May 1859, riding at the head of the army corps departing for Italy, he halted his troops on a sudden whim at Disdéri's studio and had his portrait taken. This rather ludicrous incident was the best publicity Disdéri could wish for. He found himself famous overnight. The whole of Paris followed the Emperor's example, and so great was the demand that appointments had to be booked weeks in advance. Henceforth, the imperial family were often photographed by Disdéri, who was appointed court photographer (*No. 56*). As expected he was compensated a thousandfold for the smaller amount received from each client, by the much larger number of sitters. The middle and lower middle class could now afford to have their portraits taken in the same elegant and luxurious surroundings as the nobility and gentry.

A few photographers found the mass-production of *cartes* distasteful and retired; the majority had no choice but to follow Disdéri's example.

Not only in its small size, but also in the aesthetic sense, the *carte* started a new style in photography. In the degree to which the portrait itself was reduced in size, its setting increased in importance. The photographer's studio became a stage with interchangeable properties and backgrounds in which the sitter was merely a figure in a landscape or drawing room.

Carte pictures of women were often in the nature of a small fashion-plate. The sitter was usually represented full length to show off her crinoline, and as in all fashion-plates, head and body were only pegs on which to hang clothes. Facial expression was of minor importance, since only a tiny representation of the head appeared in the picture, and all the skill and flattery of the photographer was directed towards the arrangement of the pose, and his elegant interior decoration.

At first the background was usually the classical column with curtain drawn back to reveal a landscape—an elegant framework which had served painters of royalty and the aristocracy from Van

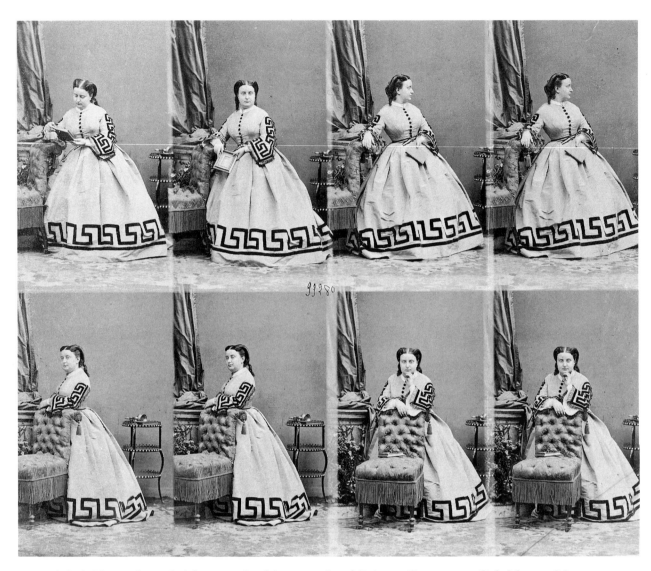

55. *Disdéri. Uncut sheet of eight carte-de-visite portraits of Princess Buonaparte-Gabriele, c.* 1862

Dyck to Winterhalter. Society photographers like Camille Silvy managed their decorative arrangements very tastefully. Silvy, 'the Winterhalter of photography', frequently designed painted backgrounds specially to suit a particular sitter (*No.* 57): a view of St Paul's Cathedral for the Dean, the Wellington Arch for the Duchess of Wellington, a view of Buckingham Palace for the Princess Royal, a grand staircase for Lady Leicester, a wild Scottish glen for Lady Airlie. An oriel window and a Gothic chair seemed just right for a bishop, and so did a library for an author.

Photographers with less taste, or giving way to every whim of their clients, sometimes produced remarkably ludicrous effects: a country squire posing with his gun and a dead hare, an animal-lover holding her dog's paw, children and even men sitting monkey-like on top of columns, and Queen Victoria holding an open umbrella indoors.

People were frequently depicted in positions and surroundings totally different from those in which their friends knew them. But a magnificent effect was exactly what was wanted in this ostentatious period when people strove to appear above their station. The humbler the home, the stronger the desire for splendour; and the grander the studio, the more business a photographer could expect to do.

Certain sixteenth-century paintings show a similar incongruity of middle-class sitters in palatial *décors* or with obviously unsuitable accessories. Paulo

70

Lomazzo complains in his 'Treatise on the Arts of Painting, Sculpture and Architecture' (1585) that it has become the practice to represent merchants and money-changers whom one only knew in business coat, with a pen behind their ear, in a grandiose pose holding a marshal's baton. Some of the Dutch merchants painted by Frans Hals are pompously posed in aristocratic attire in front of imaginary palatial backgrounds. So this was after all only a pictorial revival of the age-old desire to appear more important than one really is.

The fact that most studio properties were supplied by a few wholesalers reduced the chances of individuality. Seavey's backgrounds and accessories imported from New York catered for every taste. Screens painted with interiors, landscapes and seascapes, were offered in great variety. Balustrades and staircases in French Renaissance style were advertised as 'accessories for the most fastidious', whilst rock-walls, stiles, rustic bridges, cottage and oriel windows, trees and rocks, were guaranteed modelled direct from nature.

Smedley & Co. of Blackburn supplied a very popular background, 'The Conservatory and Palmhouse showing palatial entrance to drawing room, one end draped with curtain, opposite side Gothic window'. They also offered a remarkable selection of chairs and settees, carved and upholstered, painted and inlaid, in hybrid styles which will one day puzzle antique dealers, for none has ever been seen or heard of outside photographic studios.

Photographers who specialized in military *cartes* had a rampart, with gun and cannon balls, or a distant castle with storming party. For portraying naval personnel, £7 would buy the deck of a steamship, wheel, cannon, funnel, bulwarks and all; or for less than half that sum the photographer could buy a ship's mast complete with rigging. The nautical

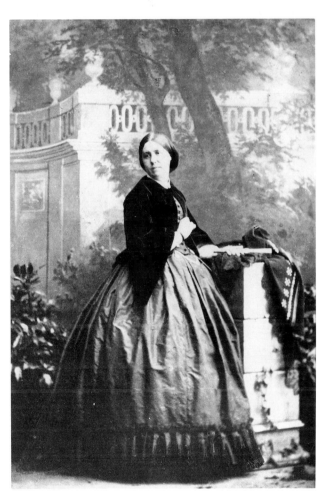

56. *Disdéri. Napoleon III, the Empress Eugenie and the Prince Imperial, 1859–60*

57. *Camille Silvy. The Countess of Caledon, c. 1862*

craze began in 1869 when a Winchester photographer advertised: 'W. Savage has a large pool of water, on which is a beautiful pair-oared boat, backed by immense gnarled roots of trees, planted with ferns and their allies [*sic*], which will form most interesting pictures'. Photographers without a garden did not allow themselves to be outdone: a boat was introduced into the studio, together with papier-mâché rocks.

Each decade in the *carte*, and later Cabinet, period was typified by some fashionable accessory. In the 'sixties the balustrade, column and curtain were ubiquitous. In the 'seventies rustic bridges and stiles were popular; in the 'eighties came the hammock and swing (for ladies), and on the Continent the railway carriage (first-class, of course) was discovered as a setting. The naughty 'nineties went exotic with palm-trees and cockatoos, and for the New Woman there was the bicycle. When motoring became an aristocratic sport, a real motor-car in the studio had an irresistible appeal to snobs.

At Alexander Bassano's studio in Old Bond Street the sitter could choose a background from a large variety painted on a roll 80 ft. long. This background cloth, containing indoor and outdoor scenes suitable for all reasons of the year, was mounted on rollers like a moving panorama. For a lady in furs a winter scene was unrolled, and paper 'snow' sprinkled on her added a touch of 'reality'.

The palm for photographic scenery must, however, be handed to William Notman, famous for his studies of Canadian life taken in his Montreal studio. Sledge and hunting parties were so expertly arranged that the unwary are completely deceived. Trees, logs, and rocks were brought into the studio, and tents, camp-fires, (stuffed) deer and bears arranged so that the armed trappers waiting for their kill seemed genuinely on the trail (*No. 58*). Salt made a convincing substitute for snow.

Thus the general run of photographers were constantly searching for novelties in presentation to attract new clients and obtain fresh sittings from old ones.

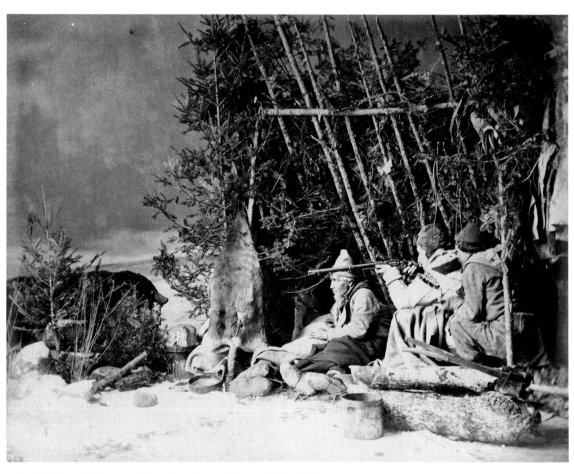

58. *William Notman. Bear hunt (posed in studio)*, 1867

VII

'FINE ART' PHOTOGRAPHY

Most early photographs have a direct approach that particularly appeals to us today. In the first fifteen years or so of photography only one attempt was made to deviate from the recording of reality which is its true function. The earliest exponent of 'Fine Art' or composition photography was John Edwin Mayall, an American daguerreotypist who settled in London in 1846. At the Great Exhibition of 1851 Mayall showed a series of ten daguerreotypes illustrating the Lord's Prayer which he had taken in Philadelphia six years earlier. Apparently they have not survived, but the following extract from Mayall's brochure conveys an idea of the sentimentality and tastelessness of these compositions.

'These are the first efforts in developing the new branch of *photographic fine art*. . . . Female figures (some of the most beautiful and talented ladies of Philadelphia) have been chosen to embody the precepts of this Divine Prayer. "Our Father Which Art in Heaven"—the illustration is a Lady on her knees before the Altar, her eyes directed to the Catholic emblem of the Redeemer, the Saviour on the Cross; the pure expression of humility and penitence in the countenance and attitude, finely embodies the opening sentiment of the prayer . . . "Give us this Day our Daily Bread"—a way-worn Pilgrim, with staff in hand, weary with fatigue, is receiving two loaves from the hands of a beautiful child.'[1]

Mayall also showed at the Crystal Palace other 'Daguerreotype pictures to illustrate poetry and sentiment': a set of six daguerreotypes taken in 1848 illustrating Thomas Campbell's poem 'The Soldier's Dream', and 'The Venerable Bede blessing an Anglo-Saxon Child'. In some of them, the landscape

[1] J. E. Mayall, *Daguerreotype Institution*, London, 1848.

or background was painted in with a fine brush; in others, the models had been posed in front of painted scenery 'to make the whole harmonize together'. *The Athenaeum*, which was full of praise for Mayall's portraits, cautioned its readers concerning his assertion that the daguerreotype was capable of illustrating legends. 'It seems to us a mistake. At best, he can only hope to get a mere naturalistic rendering. Ideality is unattainable—and imagination supplanted by the presence of fact.' Mayall perhaps recognized the validity of this criticism, for apart from a 24 in. × 15 in. 'Bacchus and Ariadne' he abandoned this hybrid art-photography, in spite of Prince Albert's encouragement.

After the defeat of Talbot's claim to Scott Archer's collodion process in December 1854 and the lapse of his Calotype patent, the number of photographers, both amateur and professional, greatly increased, and with the foundation of photographic societies in the 'fifties, the ambition to compete with one another in exhibitions naturally followed. Up to that time, photography had been chiefly valued for its usefulness to artists, and for its various practical applications. Few people can have thought of it as an independent art medium; the public in general knew only daguerreotype portraits, and were inclined to consider these small portraits as productions of industry rather than as pictures appealing to the aesthetic sense. It was not until the Great Exhibition that the public could gain any idea of the achievements of photography in other fields than portraiture, and in particular in other countries.

Whilst the Great Exhibition aroused much interest in the new art, the first exhibition entirely devoted to

photography, held at the (Royal) Society of Arts in London in December 1852–January 1853, made a deep impression both by its size (over 800 photographs) and by the quality of the photographs shown. Daguerreotypes were entirely absent, and the visitor saw large paper prints, which had an appeal as pictures.

Nearly twice the number of photographs was shown at the first exhibition of the Photographic Society of London (now the Royal Photographic Society of Great Britain) which was founded in January 1853. The fact that no less a person than the President of the Royal Academy, Sir Charles Eastlake (soon to become also Director of the National Gallery), had accepted the position of President of the Photographic Society, and that Queen Victoria and Prince Albert had become its patrons, conferred upon photography a new status in the art world.

Owing to the circumstance that many men famous in art or science were either council or ordinary members, it was thought desirable to define the two aspects of photography. This task fell to the Vice-President, Sir William J. Newton, R.A., who at the Society's first meeting on 3 February 1853 rose to discourse 'Upon photography in an artistic view and its relations to the arts: with a view to establish that photography can only be considered as a science to those who investigate its properties, but that to the public its results, as depicting natural objects, ought to be in accordance (as far as possible) with the acknowledged principles of Fine Art'. Unfortunately Newton's admirable though lengthy definition went no further than the title of his paper. He simply gave an exposition of the aspect nearest his heart: the usefulness of photography to the painter. It had been pointed out, he said, that 'a photograph should always remain as represented in the camera', but he was 'desirous of removing such false and limited views' and propounded the controversial opinion that negatives might be altered 'in order to render them more like works of art'. In fact, any means were justified to attain that end, whether by a chemical or other process. Newton also recommended that 'the whole subject might be a little *out of focus*, thereby giving a greater breadth of effect, and consequently more *suggestive* of the true character of Nature'.[1]

A storm of protest caused Newton to explain

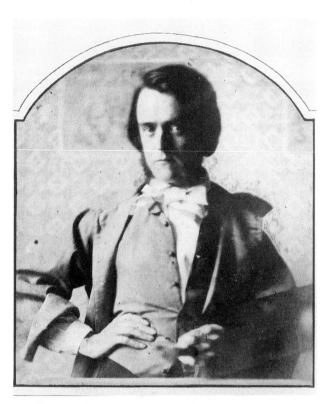

59. *John Leighton. Self-portrait, aged 30. Calotype,* 1853

later that his remarks were only intended for artists, in the expectation that 'by the united exertions of the arts and sciences . . . photography may be applied in a variety of ways not yet contemplated'. Yet the feeling gained ground that he had laid down the ideals for artistic photography, and his opinions had far-reaching repercussions. John Leighton and other artists who had joined the Society supported Newton's heretical views, for they found photographs 'too literal to compete with works of art'. Considering themselves followers of Reynolds' style, they desired broad effects, not detail, in photographs (*No. 59*). Artistic photographs, Leighton recommended, 'may be out of focus, the distance fading away, the foreground indistinct, trees appearing in masses and figures obscured by shadows'. For admirers of the Pre-Raphaelite School it must have come as a shock to learn 'Art cannot rival Nature, and should not attempt to compete with her. The marvellous detail of microscopic photographs defies human imitation; but these are not works of art. Only in the lowest walks of art is direct imitation attempted.'[2]

[1] *The Photographic Journal*, 3 March 1853.

[2] John Leighton, *The Photographic Journal*, 21 June 1853.

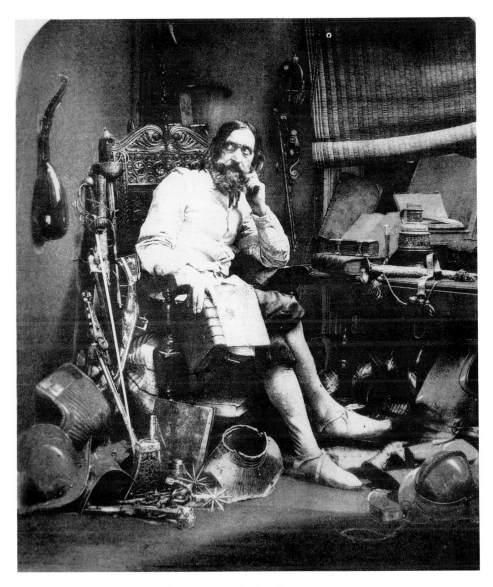

60. *William Lake Price. 'Don Quixote in his Study'*, 1855

To avert the danger of the controversy he had started getting out of hand, Sir William Newton tried to bridge the ever-widening rift with the liberal statement: 'Photography is a wide field; each may take from it what he requires; he is not bound or tied down to any rule that I know of; let every photographer take his own course, by which means photography will be improved and Art considerably advanced.'

Apart from Newton's influence, the blame for the perversion of photography rests to a large extent with critics, who had hitherto reviewed art exhibitions and were now also assigned to cover photographic exhibitions. Before long they found the con-

stant repetition of portraits, views and still-lifes monotonous. These were, however, the only subjects possible with the large cameras and rather slow negative material then available. Deprecating the lack of imaginative subjects, critics pompously urged photographers to strive for loftier themes which would 'instruct, purify and ennoble', and to compose pictures worthy of being considered in the same class as paintings.

'Photography is an enormous stride forward in the region of art. The old world was well-nigh exhausted with its wearisome mothers and children called Madonnas; its everlasting dead bodies called Entombments; its wearisome nudities called Nymphs

and Venuses; its endless porters called Marses and Vulcans; its dead Christianity and its deader Paganism. Here was a world with the soil fainting and exhausted; worn by man into barrenness, overcrowded, over-housed, over-taxed, over-known. Then all at once breaks a small light in the far West, and a new world slowly widens to our sight—new sky, new earth, new flowers, a very heaven compared with the old earth. Here is room for man and beast for centuries to come, fresh pastures, virgin earth, untouched forests; here is land never trodden but by the angels on the day of Creation. This new land is photography, Art's youngest and fairest child; no rival of the old family, no struggler for worn-out birthrights, but heir to a new heaven and a new earth, found by itself, and to be left to its own children. For photography there are new secrets to conquer, new difficulties to overcome, new Madonnas to invent, new ideals to imagine. There will be perhaps photograph Raphaels, photograph Titians, founders of new empires, and not subverters of the old.'[1]

Artists and photographers alike were advised to combine photographic realism with the idealism of the Italian Renaissance masters. Yet attempts to illustrate scenes from literature, drama, and history, or allegorical subjects, by a medium whose chief contribution to art lies in actuality, inevitably result in incongruous effects.

'There is a terrible truthfulness about photography that sometimes makes a thing ridiculous', warned G. Bernard Shaw, himself a keen amateur at a later period. 'Take the case of the ordinary academician. He gets hold of a pretty model, he puts a dress on her, and he paints her as well as he can, and calls her "Juliet", and puts a nice verse from Shakespeare underneath, and puts the picture in the Gallery. It is admired beyond measure. The photographer finds the same pretty girl; he dresses her up and photographs her, and calls her "Juliet", but somehow it is no good—it is still Miss Wilkins, the model. It is too true to be Juliet.'[2]

It was a most unfortunate circumstance both for art and for photography that up to World War I the public, artists, and art critics alike were inclined to judge painting by photography—in its capacity for rendering detail—and photography by painting—in the sphere of imaginative composition. This confusion about the aims of photography and painting led to shocking errors of taste in both media, and the good that each might have derived from the other was lost to both.

The idea of elevating photography to the regions of Fine Art attracted chiefly former painters who found it easier to make a living with the camera than with the brush. In 1855 William Lake Price, a watercolour artist, astonished the world of art and photography with his 'Don Quixote in his Study' (No. 60), 'The Baron's Feast' and other compositions in the chivalric style of George Cattermole and other academic painters of the day. Most people agreed that this was *picture-making* by photography, though few realized the literal truth of their verdict, for some of these elaborate compositions were actually pieced together from several negatives. Lake Price followed up these successes with a series of photographs illustrating the adventures of Robinson Crusoe. 'A Scene at the Tower' (1856) (representing the deposed boy-King Edward V and his brother, who were murdered at the instigation of Richard III) was much admired by Lewis Carroll, who had just taken up photography as a hobby. He entered in his diary, 'This is a very beautiful historical picture—a capital idea for making up pictures.' *The Literary Gazette*, on the other hand, rightly considered the attempt to emulate the historical painter a mistake.

Oscar Gustave Rejlander was a portrait painter and copyist of Old Masters before he became a professional photographer. Once in a lively discussion with a painter on whether or not photography were an art, the latter argued that it would never succeed in producing pictures like Raphael's. Instead of explaining that religious subjects are unsuitable for photography, Rejlander was spurred on to convince his friend of his capability by producing a photographic version of the Sistine Madonna. I do not know to what extent he succeeded, but the cherubs (No. 61)—one of the studies for his *Ersatz*-Raphael—were eulogized as 'testing Raphael by nature and beating him hollow!'[3] *The Literary Gazette* pointed out that 'We admire a Madonna by Raphael not

[1] *The Photographic Journal*, 21 February 1857, p. 217. Attributed to Joseph Durham, ARA, a member of the Photographic Society.

[2] G. B. Shaw, lecture on 'Photography in its Relation to Modern Art' at the Photographic Salon, 18 October 1909.

[3] 'The Atelier of the Sun'; *The Irish Metropolitan Magazine*, Vol. ii, Dublin, 1858.

because he has faithfully copied a woman and child in a certain position, but because we see in its depth and purity of feeling a noble realization of an original and poetic idea. A photograph of the models Raphael used in the positions he placed them, and surrounded by all the accessories he introduced, would no doubt form a valuable study for a painter, but it would be a sorry substitute for his picture. What gives his picture all its value is that which he added to its models, and not what he found in them.'

Unfavourable criticisms were few, however. Lake Price, Rejlander and others were convinced that they were ennobling photography, and Prince Albert extended his patronage by placing standing orders for their exhibition prints.

Rejlander set out to rescue photography from the reproach, often made by its critics, that it was a mechanical art, and the big Manchester Art Treasures Exhibition of 1857 was the immediate *raison d'être* of 'The Two Ways of Life'—the most ambitious allegorical photograph ever made. For the first time, photographs were to be displayed alongside paintings, drawings, sculpture, and engravings, and Rejlander wanted to create a picture worthy of the place accorded to photography. 'The Two Ways of Life' bears a certain resemblance to Thomas Couture's 'Les Romains de la Décadence' (1847) in the Louvre, but the similarity of the compositions probably lies in their authors' inspiration by the Italian Renaissance: Couture by Veronese, Rejlander by Raphael. Raphael in 'The School of Athens' contrasted Philosophy and Science; Rejlander's 'Two Ways' are Industry and Dissipation.

The picture was a sensation at the Art Treasures Exhibition, partly because it had never been thought possible to produce such a painterly composition by photography, and partly on account of the semi-nudity of some of the models. It was the first time in England that nudes depicted by the realistic medium of photography were shown in public, and some prudish people objected to this as 'indelicate', although the seal of royal approval was set on the picture (*No.* 62) by Queen Victoria's purchase of it, deeply impressed by its moral content.

Two youths on the threshold of life are brought from the country (indicated in the far distance) to the city by a philosopher. The one on his right cannot resist the temptations of a life of idleness and dissipation, and rushes eagerly into the pleasures of lust,

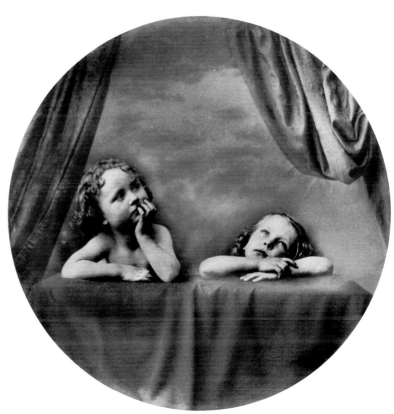

61. *O. G. Rejlander. Composition after a detail in Raphael's Sistine Madonna, c.* 1856

drinking and gambling, that lead to despair. His wiser brother chooses the path of industry, education and good works. The partly nude veiled woman in the centre represents Penitence, turning from the evil way of life to the good.

At that time it was technically impossible to photograph a large group of people in difficult poses in one rather long exposure, for one or other of the models would certainly have moved and spoiled the picture. Rejlander took over thirty separate negatives of the various figures and parts of the background, and printed them skilfully on to two joined sheets of paper, as none was made large enough for the complete picture measuring 31 in. × 16 in. The production of the picture took Rejlander and his wife over six weeks.

'My ambition has been that this composition should be solely photographic', Rejlander explained, 'and I think that as far as the conception of a picture, the composition thereof, with the various expressions and postures of the figures, the arrange-

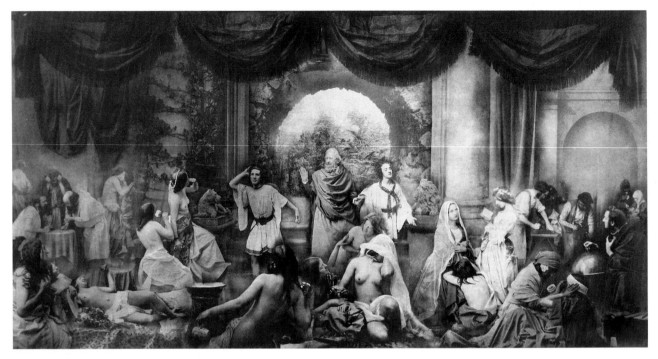

62. *O. G. Rejlander. 'The Two Ways of Life' (size 31 in. by 16 in.), 1857*

ment of draperies and costume, the distribution of light and shade and the preserving it in one subordinate whole—that these various points, which are essential in the production of a perfect picture, require the same operations of mind, the same artistic treatment and careful manipulation, whether it be executed in crayon, paint, or by photographic agency.'[1]

Today 'The Two Ways of Life' strikes us as an absurdity, but a painted picture of this subject would be equally unacceptable to modern taste.

Those of Rejlander's contemporaries who approved of his 'masterpiece' considered it 'the symbol of a new era in photography'. His detractors objected to it not on the ground that it depicted an allegory photographically, but rather on account of the technique of combining a number of negatives in one composite photograph. Above all, it was the semi-nudity of some of the models that brought forth the strongest protests. It is difficult to understand why the Victorians were so shocked at these discreetly draped figures; yet the intention of exhibiting the picture at the Photographic Society of Scotland nearly resulted in its disruption. This disaster was averted at the eleventh hour by a typically

[1] *The Photographic Journal*, 21 April 1858, p. 192.

British compromise: the respectable half of the picture, Industry, was shown alone!

Rejlander followed up 'The Two Ways of Life' with a few other composite pictures, though nothing on so large a scale nor of so controversial a nature. 'Judith and Holofernes', 'The Head of St John the Baptist' and 'Home, Sweet Home' are a few of the titles. Then in January 1859 he wrote to H. P. Robinson, a rising star in the field of picture-making by photography, 'I am tired of photography-for-the-public, particularly composite photos, for there can be no gain and there is no honour, only cavil and misrepresentation. The next exhibition must only contain ivy'd ruins and landscapes *for ever*—besides portraits.'

Ceasing to build up composite photographs from more than one negative did not mean giving up composition photography: on the contrary, Rejlander delighted in anecdotal and *genre* pictures, and in making studies for artists to paint from. The time involved in arranging symbolical, allegorical, biblical and classical figure studies for artists, plus the model's fee, was often worth more than he earned for these photographs, but they provided a welcome relaxation from commercial portraiture. His artistic feeling despised a business-like attitude to photo-

graphy, as it also revolted against photographing clients whose faces he disliked. Portraits by Rejlander are therefore comparatively rare, whereas his surviving *opus* includes numerous figure studies, both draped and nude.

Henry Peach Robinson was the most influential of all the art-photographers. In his youth he was an amateur painter and like Fenton, Lake Price, Rejlander and some other photographers, exhibited at the Royal Academy. Making his living by stereotyped *carte-de-visite* portraits, art photography offered a way of enhancing his prestige, and that of photography, by demonstrating the falseness of the view prevalent among artists that 'a photograph could have no influence on the feelings and on the emotions, that it had no soul'. Robinson's first composition, 'Fading Away' (*No. 63*), exhibited in 1858, was admittedly 'calculated to excite painful emotions', and he fully succeeded in his intention. Whereas 'The Two Ways of Life' was objected to by some people for 'appealing to the passions', 'Fading Away', which depicted a 'dying' girl surrounded by her grieving mother, sister and fiancé, was criticized

for its 'morbid sentiment'. But no one found fault with the artificiality of the photograph as such, for after all the whole thing was staged, and made up from five negatives. 'Fading Away' enjoyed enormous success in exhibitions and this encouraged Robinson henceforth to produce every year one or more elaborate compositions for the annual exhibition of the Photographic Society. The result was unfortunate for photography, since Robinson's exhibition pictures were contrived, and the praise and awards accorded to them, not only in England but also on the Continent and in America, led to a craze for artificial picture-making, from which photographic salons all over the world have hardly recovered.

'The Lady of Shalott' (1861) (*No. 64*), a bold attempt to illustrate Tennyson's romantic poem, owes more to Millais' 'Ophelia' than to the Poet Laureate. This imaginative picture, made up from two negatives, is 'very Pre-Raphaelite, very weird, and very untrue to nature'. Robinson himself condemned it many years later as 'a ghastly mistake to attempt such a subject in our realistic art, and with the exception

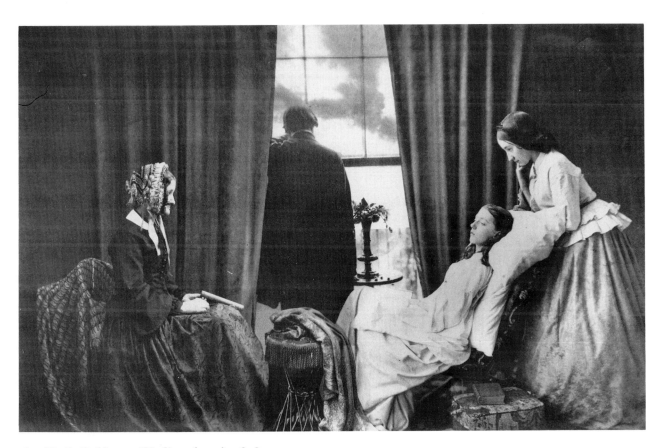

63. *H. P. Robinson. 'Fading Away'*, 1858

of an "Ophelia" done in a moment of aberration, I never afterwards went for themes beyond the limits of the life of our day'.[1] Yet whilst this deliberately artificial picture succeeds in conveying something of the romantic spirit of Tennyson's poem, Robinson's favourite rural subjects, which usually include professional models dressed up as village maidens in smocks and sunbonnets (because he found genuine country people too clumsy), strive after naturalism and fail completely. It seems hardly credible that contemporary critics were deceived by the 'genuineness' of these rustic scenes. 'Mr Robinson avoids all appearance of trick, and all theatrical effect, by never troubling the costumier, or "dressing" his figures. They are presented in the homely garb of actual life which seems to befit them as naturally as the leaves belong to the trees.'[2]

In contrast to Rejlander's purely photographic technique, in which the figures were printed direct on to the sensitive paper, Robinson's picture-making was a scissors and paste-pot photo-montage job. His

[1] *The Practical Photographer*, Bradford, March 1897.
[2] *The Photographic Journal*, 15 December 1863.

procedure, quite contrary to the aesthetics of photography, was to build up the picture in stages. After making a preliminary sketch of the composition he photographed individual figures (*No. 65*), then cut them out and pasted them on the separately photographed foreground and background. After careful retouching of the outlines so that no joins remained visible, the whole picture was rephotographed for the final version.

In 'The Lady of Shalott' the chance of seizing a windless day that would not cause the boat to drift was remote. So Robinson took the landscape, and the boat with the model, separately, the latter probably in the garden behind his studio. Twenty years later, when the much faster gelatine dry plates were beginning to supplant wet collodion. Robinson laid down the axiom that no photograph that could be obtained in a single exposure should be produced from several negatives, and that combination printing should be reserved for effects that could not be obtained otherwise (such as 'Dawn and Sunset'). However, picture-making by photography had become such an obsession with him by then that even 'Carrolling' (1887)

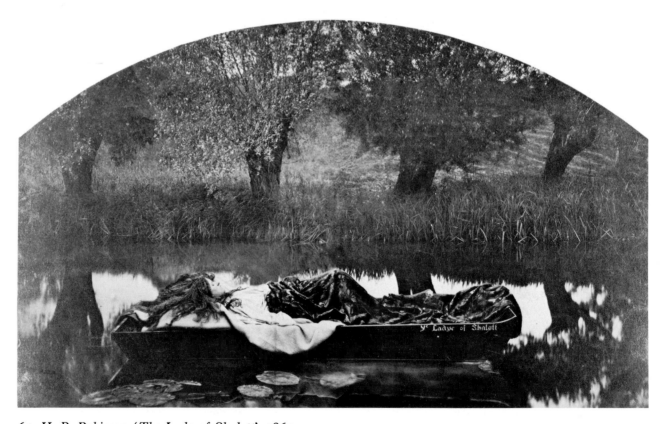

64. *H. P. Robinson. 'The Lady of Shalott'*, 1861

65. *H. P. Robinson. Preliminary sketch with photograph inserted, c.* 1860

—two girls and a flock of sheep in a summer land-scape—is a photo-montage. It is a picture that could easily have been taken instantaneously at that date, but separate studies for it in our collection prove it to have been a premeditated composition, in which the figures were printed into the landscape.

'Dawn and Sunset' (1885) (*No.* 66), made up from six negatives, leaves no doubt as to Robinson's skill in photo-montage. It could be argued that it was technically impossible to make this ambitious pic-ture, measuring $29\frac{1}{2}$ in. \times 21 in., without resorting to photo-montage, but I feel that this is no justification for going beyond the limitations of photography. The great contrast between the dark cottage interior and the light streaming in through the window (at a time when plates were not backed against halation) neces-sitated combination printing, and Robinson achieved a perfectly harmonious effect; no one would suspect

that the picture was not taken in a straightforward way. Despite a strong resemblance between this and other compositions to certain paintings by Jozef Israëls and the Düsseldorf School, Robinson was not influenced by any particular artist. Similarity in subject matter is due to the spirit of the time.

A prolific writer, Robinson contributed articles on pictorial photography to practically every photo-graphic journal in the English language. In addition he published a number of books expounding his theories, of which *Pictorial Effect in Photography* (1869) and *Picture Making by Photography* (1884) are the best known, appearing in edition after edition, the latter as late as 1916. Both books were translated into French and German, and studied wherever pic-torialists were at work. Robinson's prestige was enormous and the harm done by his teaching incalculable.

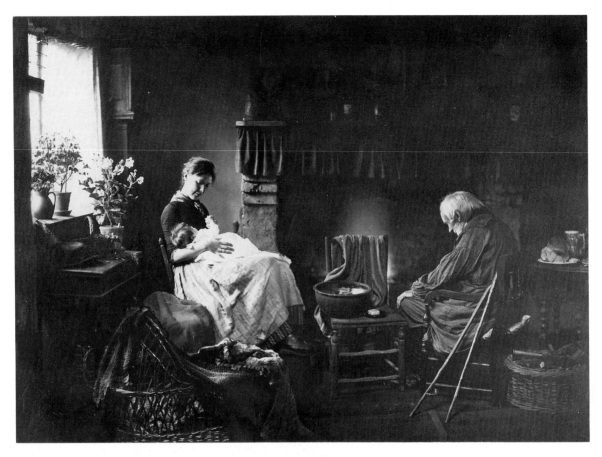

66. *H. P. Robinson. 'Dawn and Sunset', 1885 (size 29½ in. by 21 in.)*

Roger Fenton, who had also been an exhibitor at the Royal Academy in his youth, urged members of the Photographic Society not to make up pictures artificially but to photograph direct from nature. Nothing shows better the sincerity of his advice than his fine landscapes and photographs of English cathedrals, and above all his famous reportage of the Crimean War. Yet influenced by the taste of the period, Fenton was occasionally tempted to portray by photography anecdotal subjects like 'The Confessional', as he had earlier in painting. In contrast to contemporary critics, who bestowed unstinting praise on these compositions when shown at the Photographic Society's exhibition in 1859, today we regard Fenton's 'Nubian Water-carrier' and 'Egyptian Dancing-girl' as failures, because the English models betray by their selfconsciousness that the Eastern costume and attitudes are alien to them.

Julia Margaret Cameron's splendid close-ups of the great Victorians constitute unfortunately only a small proportion of her total *opus* during the twelve years she devoted to photography. Her fine art com-

positions seem unbearably pretentious, ludicrous, and amateurish, and must on the whole be condemned as failures from the aesthetic point of view. Yet they reminded the critic of the *Art Journal* of 'Caravaggio, Tintoretto, Giorgione, Velasquez and other princes of their art. The aggroupments and figures are so skilfully arranged that it is difficult to determine what they could gain by being painted.'[1] Another art critic called Mrs Cameron's allegorical compositions 'Faith', 'Hope' and 'Charity', 'the nearest approach to art, or rather, the most bold and successful application of the principles of fine art to photography'.[2]

No other photographer in the nineteenth century and only one in the twentieth (Henri Cartier-Bresson) has won such general acclamation from art critics and leading artists as Julia Margaret Cameron. George Frederick Watts, considered by his contemporaries as the nineteenth-century Titian (whom he incidentally strongly resembled in appearance)

[1] *The Art Journal*, February 1868.
[2] *The Illustrated London News*, May 1865.

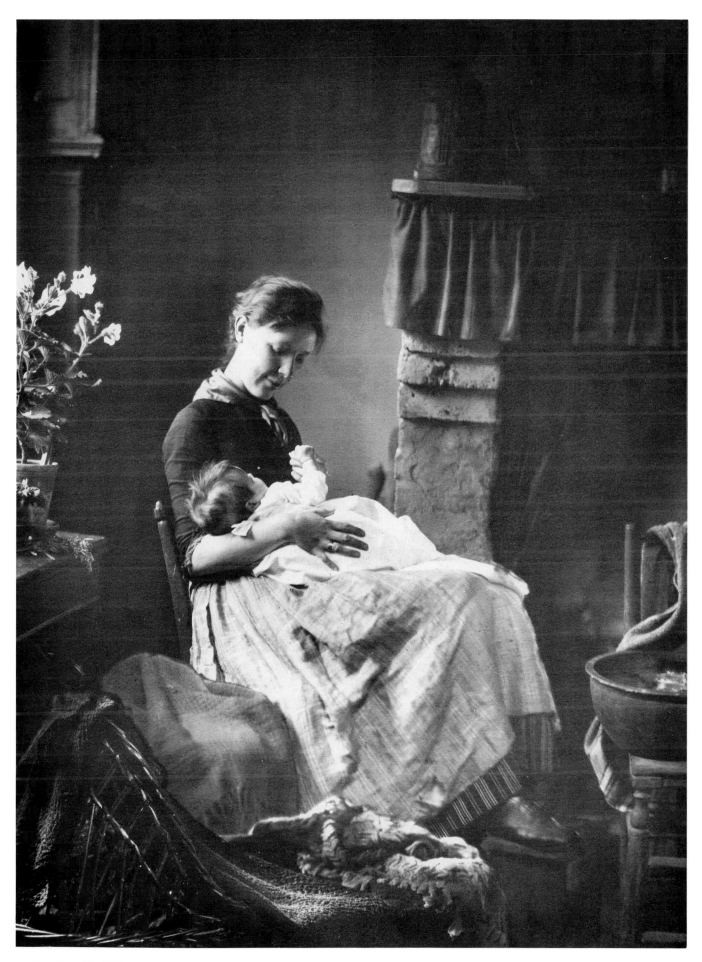

67. *Detail of 66*

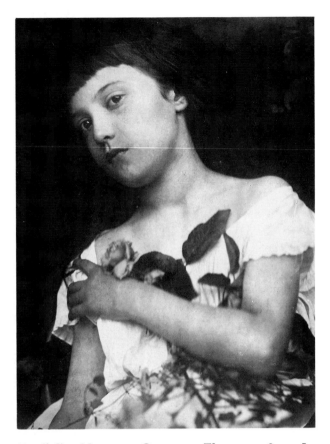

68. *Julia Margaret Cameron. Florence, 1872. Inscribed by G. F. Watts: 'I wish I could paint such a picture as this'*

(*No.* 136), believed 'her work will satisfy posterity that there lived in 1866 an artist as great as Venice knew',[1] and beneath one of Mrs Cameron's photographs of Florence Fisher he wrote: 'I wish I could paint such a picture as this'. It is typical that Watts's enthusiasm was aroused by the more fanciful picture of the two (*No.* 68). Present-day taste would unquestionably choose the straightforward portrait (*No.* 69) as being the stronger. It is in fact one of Mrs Cameron's finest photographs.

The photographic press was too preoccupied with technique to appreciate the aesthetic qualities of Mrs Cameron's portraits, and they were no less reluctant to accept her fancy compositions. 'The Committee much regret that they cannot concur in the lavish praise which has been bestowed on her productions by the non-photographic press, feeling convinced that she will herself adopt an entirely different mode

of representing her poetic ideas when she has made herself acquainted with the capabilities of the art'.[2] Some of the wisecracks made in the photographic press are not without justification. 'In the two pictures of "The Wise and the Foolish Virgins" it is difficult to distinguish which are the "Wise" and which are the "Foolish", the same models being employed for, and looking equally foolish in, both pictures.'[3]

The unstinted admiration from art circles, and above all Watts's praise, naturally led Mrs Cameron to over-estimate her powers and to create pretentious compositions rivalling paintings. Watts's insistence on the importance of imaginative compositions, which he placed on a higher plane than portraiture, instilled in Mrs Cameron the idea that the noblest forms of art were symbolical, allegorical, literary, and religious subjects which 'uplifted the mind to higher spheres of devotion and contemplation'. Like her mentor, Mrs Cameron devoted her life to the beautiful. Like him, she was filled with admiration for the Italian Old Masters; hence her many Madonna studies and other compositions 'in the manner of' Perugino, Raphael, Michelangelo, Leonardo, etc.

Active in the mid-Victorian period, Mrs Cameron could not help being influenced by the *Zeitgeist* and by the Pre-Raphaelite painters. Victorian sentimentality is strongly evident in such compositions as 'Pray God, bring Father safely home' and 'Seventy years ago, my darling, seventy years ago'. They are examples of Victorian story-telling at its worst, akin to the academic narrative painting of the period. Any affinity of her work with that of the Pre-Raphaelites lies in sentiment and subject matter—for Mrs Cameron did not share their devotion to meticulous detail, preferring broad effects. Occasionally she borrowed an idea from a painting by her nephew Val Prinsep (a follower of Rossetti), Arthur Hughes, or some other contemporary artist. The study of her niece May Prinsep (*No.* 70) (later the wife of the second Lord Tennyson) bears, for instance, a close resemblance to the pose of Milly Jones in Whistler's 'Symphony in White No. 3' painted three years earlier, except that the direction of the pose is reversed. Of course, nobody saw any objec-

[1] Marie A. Belloc, 'The Art of Photography'; *The Woman at Home*, Vol. viii, 1897.

[2] Report of the exhibition committee, *The Photographic Journal*, 15 May 1865.
[3] *The Photographic Journal*, 15 August 1865.

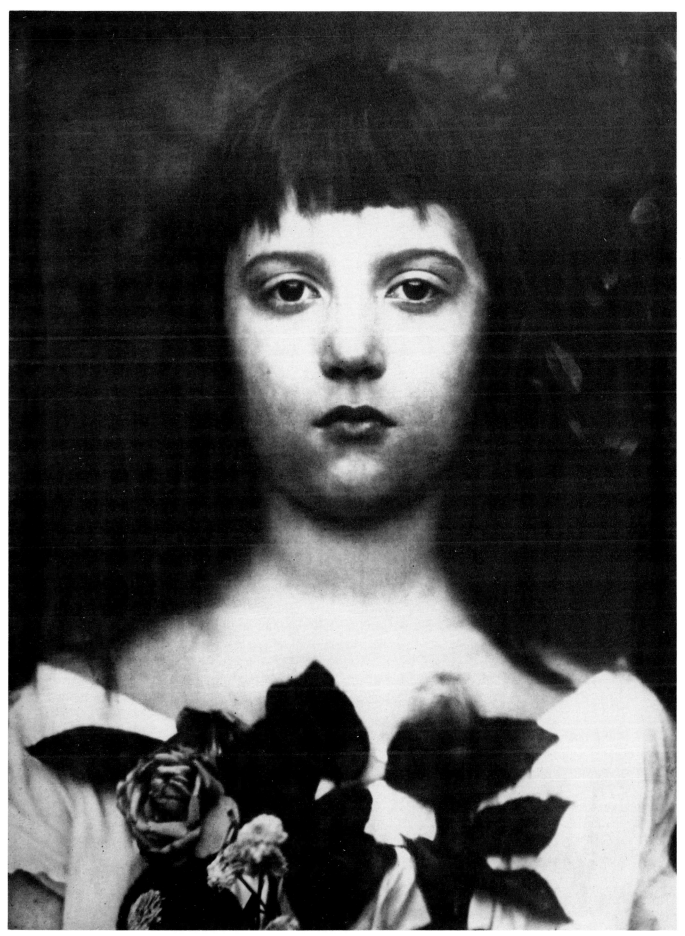

69. *Julia Margaret Cameron. Florence, 1872 (another pose)*

tion to such emulation, least of all artists, who constantly copied photographs, frequently even posing the sitter for the photographer, as Rossetti did in the characteristically Pre-Raphaelite study of Jane Morris (*No.* 71).

Many of Mrs Cameron's beautiful women have the strange emotional quality and melancholy expression that appears so frequently in Rossetti's models, but in contrast to his voluptuous types, Mrs Cameron always chose nice young girls whom she draped in robes of virgin whiteness, with their long hair flowing loosely. Though the virginity is beyond question the melancholy came of itself, for the rigours of Mrs Cameron's sittings were not conducive to an animated expression.

Whilst Watts was Mrs Cameron's chief adviser on artistic matters, Tennyson's romantic narrative poetry was one of the main sources of her inspiration. Both these great Victorians were close friends of Mrs Cameron and for many years her neighbours at Freshwater, Isle of Wight. Tennyson's verses

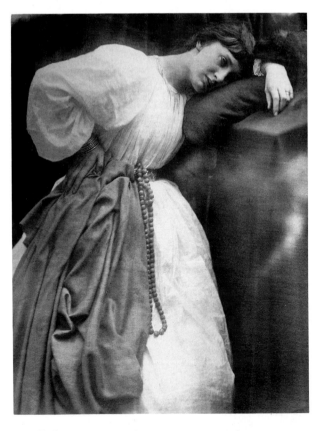

70. *Julia Margaret Cameron. May Prinsep, c.* 1870

touched her heart, and quotations from his poems constantly flowed from her lips. Her search for sitters to personify Tennyson's characters sometimes led to embarrassing moments, as when she met Bishop (later Cardinal) Vaughan, who seemed to her an ideal knightly figure. 'Alfred, I have found Sir Lancelot!' she cried in triumph, but Tennyson's bad sight prevented him from recognizing whom she was pointing out, and he replied in his deep, penetrating voice, which attracted the attention of all the other guests: 'I want a face well worn with human passion.'

The majority of Mrs Cameron's illustrations to Tennyson are free interpretations having little in common with the original except the title: 'Enoch Arden', 'The Princess', 'The Dedication', 'St Agnes', 'Oenone', 'Maud', 'The Rosebud Garden of Girls', 'The May Queen'. It is chiefly when she tries to follow the text literally, as in some of her twenty-four illustrations to 'The Idylls of the King, and Other Poems', taken at Tennyson's request, that the result is immediately reminiscent of amateur theatricals. 'The Passing of Arthur' (*No.* 73) is unsurpassed in this. In the stately barge (an ordinary rowing boat) lies the wounded King (a local porter) looking somewhat suspicious of his strange surroundings. Unfortunately the boat is too small to contain the three mourning Queens, so two of them have to stand behind it, trying to prevent the King from falling into the 'water' contrived out of white muslin curtains. Three hooded monks lurk uneasily in the background beneath the sails which do not stretch far enough, revealing odd corners and part of the studio roof, dominated by a waning moon scratched on the negative.

In my opinion the best illustration in the set is the heroic portrait of King Arthur (*No.* 72) 'with rage on his brow, and majestic defiance in his mien and gait, as though he should say "King am I, whatsoever be their cry".'[1]

In illustrating 'The Idylls of the King' Julia Margaret Cameron attempted the impossible, things photography cannot and should not be made to do, things better left to the imaginative power of a graphic artist like Gustave Doré, who also illustrated the 'Idylls'. Any attempt to illustrate the unreal by a medium whose main contribution to art lies in its realism is inevitably doomed to failure.

[1] From review in *The Morning Post,* 11 January 1875.

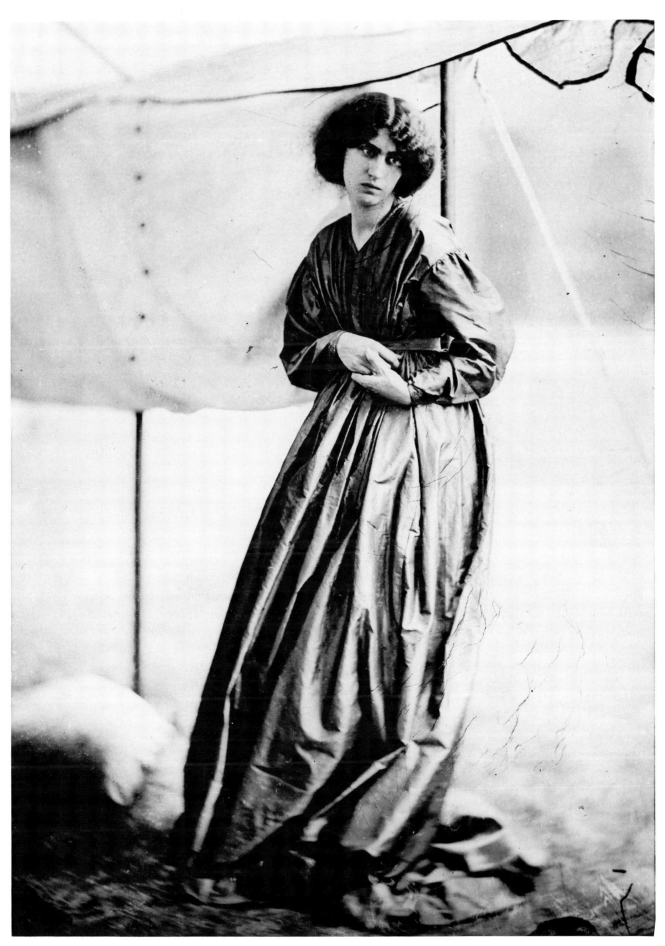

71. *Jane Morris posed by D. G. Rossetti, July 1865. Photographer unknown*

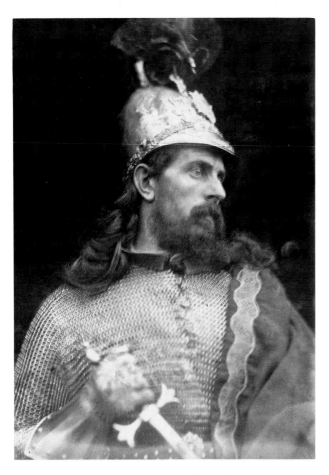

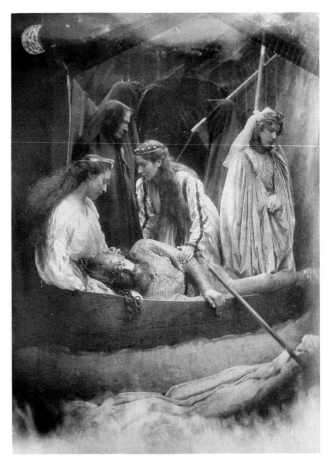

72. *Julia Margaret Cameron. 'King Arthur'*, 1874

73. *Julia Margaret Cameron. 'The Passing of Arthur'*, 1874

Tennyson, however, and some of his contemporaries were delighted with the book.[1] The *Morning Post* praised 'the rare dramatic quality of the artist's genius and her wonderful powers of composition. . . . They are distinguished in an eminent degree by the

[1] Part I was published at Christmas 1874, Part II in May 1875.

intellectual attributes all-essential in such a work— affluence of imagination, tenderness of sentiment, and idyllic grace of fancy. . . . The result is altogether satisfactory, the general character of the work being such as to entitle it to take rank among the finest achievements of photographic art.'[2]

[2] *The Morning Post*, 11 January 1875.

VIII

GENRE

England was the only country in which photography was perverted in a mistaken attempt to rival painting. In France—as elsewhere—a much sounder view prevailed as to what constituted art in photography, at any rate until the mid-'nineties. The Société Française de Photographie, founded in Paris in November 1854, gave no encouragement to artificial picture-making, nor to retouching. Its President, E. Durieu, laid down the doctrine of 'straight' photography, as well as condemning hand-work absolutely. 'To call the brush to the aid of the photograph under the pretext of introducing art into it, is doing precisely the opposite—excluding *photographic art*.'[1]

French painters who took up photography, like Constant Dutilleux, Gustave Le Gray, Vallou de Villeneuve and Charles Nègre, practised it for its

[1] 'Sur la retouche des épreuves photographiques'; *Bulletin de la Société Française de Photographie*, October 1855.

74. *William Lake Price. Partridge, c.* 1855

75. *O. G. Rejlander. Tossing chestnuts, c.* 1860

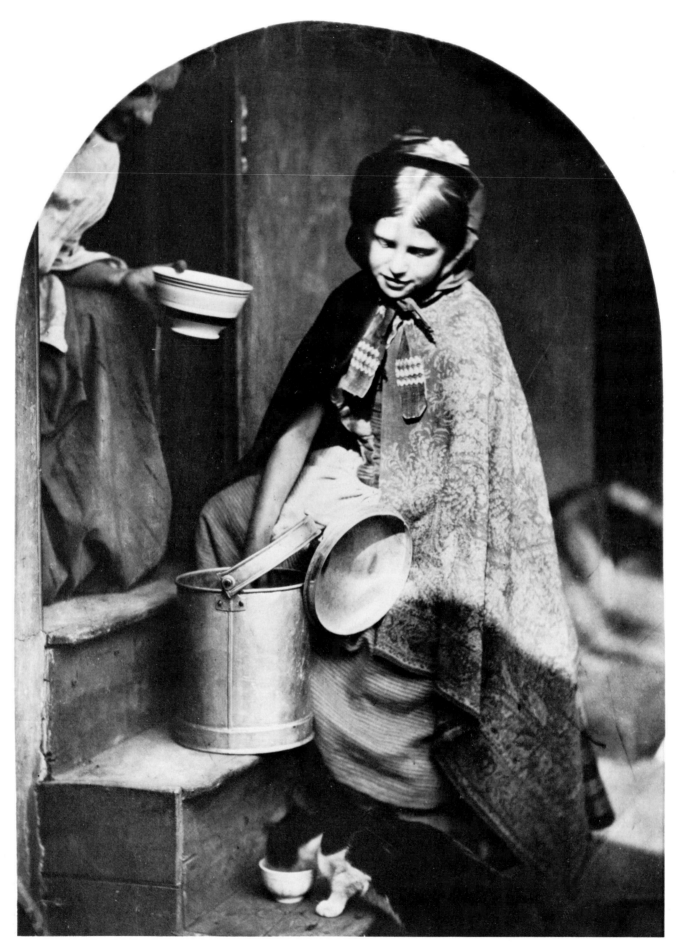

76. O. G. Rejlander. 'The Milkmaid', c. 1857

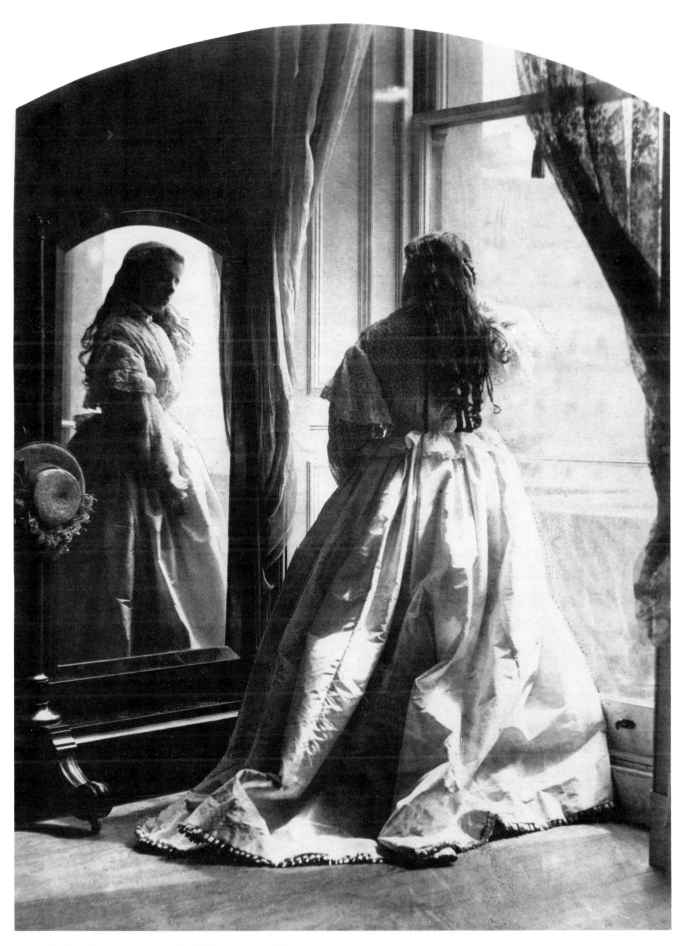

77. *Lady Hawarden. 'At the Window', c.* 1864

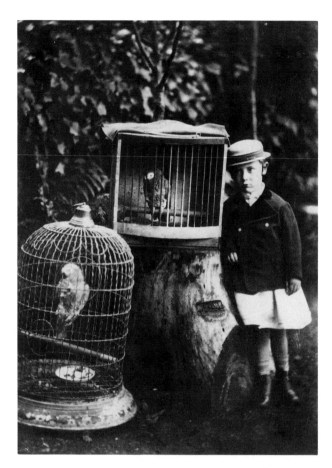

78. *Edward Draper. 'Boy with Parrots', c. 1865*

crowded canvases of their precursors, many of which are little more than a *tour-de-force*.

The fine art photographers' desire to advance the aesthetic side of photography was praiseworthy but their attempts to emulate painting ill-conceived. It was fortunate that lack of appreciation of his elaborate composite photographs directed Rejlander's endeavours into other fields. Many of his delightful and characteristic *genre* pictures show genuine slices of life. His photographs of poor ragged children like 'Tossing chestnuts' (*No. 75*), 'Homeless', 'The Matchseller', 'The Crossing Sweeper'; 'The Milkmaid' (*No. 76*), 'Have a Tune, Miss?', 'Washing Day', 'The Blind Fiddler' and 'The Wayfarer' reveal the observation and sympathy of a fine artist, who had the makings of a modern reportage photographer but was hindered by the inadequacy of the technical means available at the time. 'I should be very glad to possess a lens that did not need focusing. I should carry it [the camera] in my pocket, and with a dry collodion process I could catch positions and expressions in a crowd far better than with my own eyes. . . . The expression that is unpremeditated and unconscious [of the photographer's presence] is the best.'[1]

'At the Window' (*No. 77*) is one of the most charming *genre* pictures of the period, a clear attempt to create something that might appeal to the imagination. It shows one of the daughters of Lady Hawarden, a well-known amateur photographer whose pictures of children and other compositions Lewis Carroll greatly admired and collected.

Equally original are the 'Boy with Parrots' (*No. 78*) by another amateur, Edward Draper, or William M. Grundy's 'The Country Stile' (*No. 79*) whose pictures were compared with those of Teniers and Wilkie. These are well-composed pictures free from any pretensions to fine art, real gems of Victorian photography.

Photography was Lewis Carroll's chief hobby during the most important years of his life. As a producer of costume pictures he is almost always banal, but in imaginative portraits of children he showed remarkable originality and naturalness, achieving an excellence which raises his work far above that of his contemporaries in this field. Lewis Carroll did not aim at characterization, but at an attractive

[1] *The Yearbook of Photography and Photographic News Almanack for* 1880, p. 81.

own aesthetic appeal. They did not go beyond legitimate *genre* photographs of picturesque characters such as an organ-grinder by Nègre (which he copied as a painting for the Salon), or some Savoyard street musicians by Disdéri.

It is regrettable that in England, scenes of everyday life, still-lifes, and even unpretentious anecdotal pictures did not find much favour, and that the ambition of the serious art photographers was on the whole directed into wrong channels. Nevertheless, Roger Fenton's photographs of fruit and flowers and game have a delicacy and textural quality equal to the finest seventeenth-century Dutch still-lifes and flower paintings, and were deservedly honoured at the International Exhibition in London 1862. Fenton, Adolphe Braun and Lake Price (*No. 74*) were the acknowledged masters in this perfectly legitimate field of photography. The simplicity and lightness of their treatment, concentrating on a single or comparatively few objects, gives a dignity to these photographs, often lacking in the heavy, over-

79. *William M. Grundy. 'The Country Stile',*
1859

80. *Lewis Carroll. 'The Elopement', 1862*

design. He was a master of composition, the whole arrangement of the picture is expressive: the position of the figure, the placing of accessories, the disposition of the empty spaces around them, the trimming of the print—everything plays a part, and everything is arranged in a decorative way. Occasionally we share in a typical Carrollean game with his child friends. 'St George and the Dragon', 'It Won't Come Smooth' and 'The Elopement' are charming little anecdotal pictures in which the author of the 'Alice' books refrains from straining after artistic effect. They are visual expressions of his immense imaginative power, complementary to, though less known than, the fantastic stories he invented for his little girl friends and the delightful letters he wrote to them. In 'The Elopement' (*No.* 80)—perhaps a curious subject for a clergyman to choose—Lewis Carroll conjures up a theme suitable for a Hollywood script-writer. In spite of her solemn expression, posing for this picture no doubt amused his little cousin as much as it did the photographer. Presumably it was not as dangerous as it looks, standing with one foot on the rope ladder and dangling the other precariously in mid-air.

'It Won't Come Smooth' (*No.* 81) with Irene MacDonald, one of the daughers of the novelist and poet George MacDonald, is a charming pictorial interpretation of Lewis Carroll's little poem:

'My Mother bids me bind my hair
And not go about such a figure.
It's a bother, of course, but what do I care,
I shall do as I please when I'm bigger.'

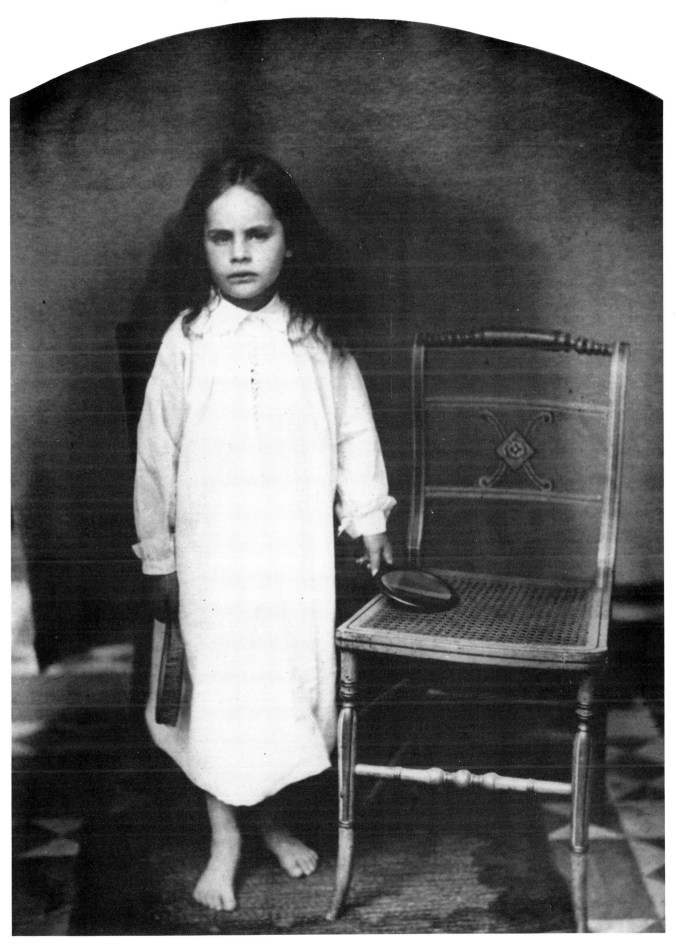

81. *Lewis Carroll. 'It Won't Come Smooth', 1863*

IX

THE NUDE BEFORE THE CAMERA

The nude is one of the most difficult subjects for photography, demanding unusual refinement of taste, for the borderline between naked and nude is narrow.

Before the days of photography Ingres produced some extremely banal nudes—proof that deterioration in taste had set in long before 1839. If anything, photography was an excellent mentor in correcting anatomical errors in representations of the body. Artists were, of course, the chief users of photographic figure studies. For one thing, they found it

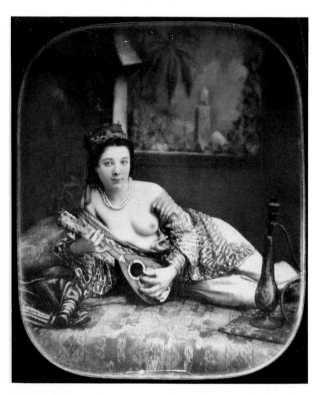

82. *Coloured French stereoscopic daguerreotype of an odalisque, c. 1853*

more economical to copy a photograph than to hire a model; for another, the photographer could record poses too difficult for the model to hold for any length of time for the artist.

N. P. Lerebours supplied the first 'académies' as early as summer 1840, before it was even possible to take portraits, for professional artists' models were the only people able to hold a pose for the 10–15 minutes' exposure then necessary. At this period Parisian models were nearly all dark Italian peasant girls from Naples or the Romagna, whose well-developed figures had not been distorted by the constraint of fashionable corsets. These girls modelled for leading artists for the popular pictures of odalisques or bathers, or holding a pitcher for 'La Source'. Ingres, Courbet, and Delacroix frequently made use of photographic figure studies, which also aided the pompous compositions of typical Salon artists like Henner and Benjamin Constant. Delacroix, a member of the French Photographic Society, considered photographs 'treasures for an artist' and confided to Constant Dutilleux in 1854: 'How I regret that such a wonderful invention arrived so late, as far as I am concerned. The possibility of studying such results would have had an influence on me of which I can only get an idea from the use they still are to me.' George Eastman House possessed two albums of photographic nudes that had been posed by Delacroix. Occasionally he also bought professional daguerreotypes. On 22 October 1854 he entered in his diary: 'Worked a little at the *Odalisque* I am doing from the daguerreotype.' The illustration (*No.* 82) is of a similar contemporary French daguerreotype of a model in oriental costume.

Naturally, photographs of nudes were made not only for painters, sculptors, and for use in art

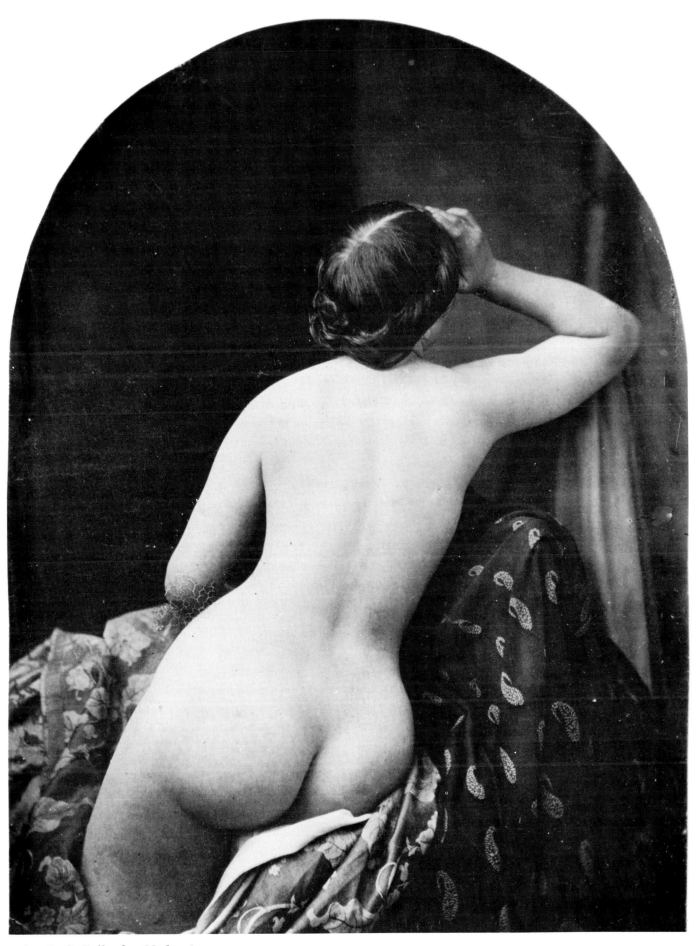

83. O. G. Rejlander. Nude, 1857

schools, but before long a trade began in typical Parisian souvenirs for tourists.

The introduction of stereoscopic photographs in 1851 added the sensation of viewing the figure in relief. But the more lifelike photographs became, the stronger grew the objection to figure studies. The licence granted to the artist with brush or pencil was withheld from the camera-man on account of the greater realism of his medium. 'Filthy', 'infamous productions' and 'pruriently indecent' thundered the Photographic Society of London, and since it was naïvely assumed that no woman would willingly pose in the nude, it was taken for granted that 'these miserable women are the wives and sisters of the photographers themselves, dragged down by their vile companionship into such depths of shamelessness'.

Rejlander was one of the few photographers who succeeded in posing the figure in such a way that the result would satisfy the most discerning critic (*No. 83*). There is nothing suggestive in complete nakedness when depicted with good taste. Yet some of Rejlander's fine nudes, which to me are equal to the best in painting, could not be sold owing to the action of the Society for the Suppression of Vice—and this at a time when every naked mediocrity executed in marble or oil paint enjoyed great popularity! The position is analogous at the time of writing, when we witness the prosecution of the publishers of *Lady Chatterley's Lover*, a genuine work of art, whilst sordid books of no literary merit escape prosecution only because they are suggestive rather than frank in their treatment of sex.

It is unlikely that prudish invective was hurled at Nadar's fine photograph of Christine Roux, the original Musette of Henri Murger's *Scènes de la Vie de Bohême* (*No. 84*), for it most probably served as a study for a painting and—like Moulin's photograph

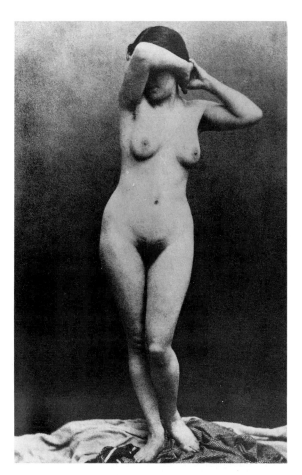

84. *Nadar. Christine Roux, the original 'Musette' of Murger's 'La Vie de Bohême', 1856*

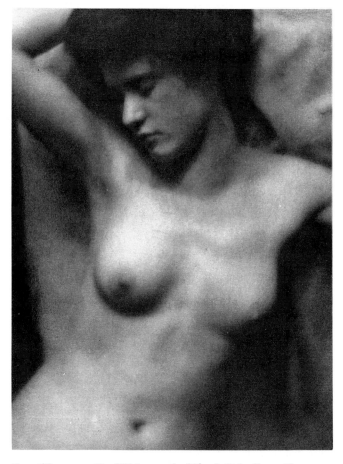

85. *Clarence H. White and Alfred Stieglitz. Torso, 1907*

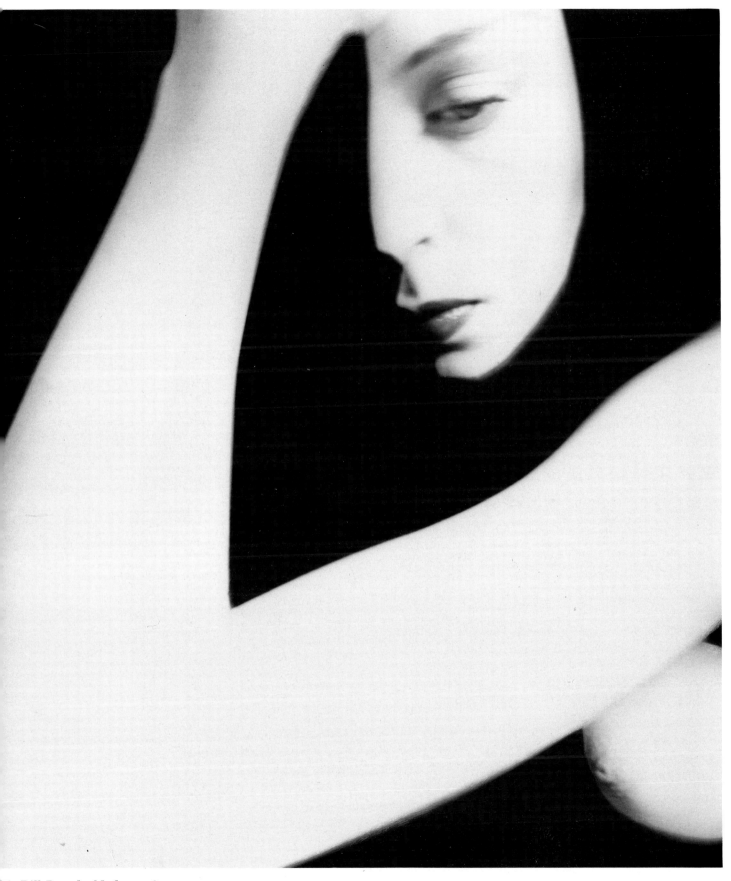

36. *Bill Brandt. Nude,* 1958

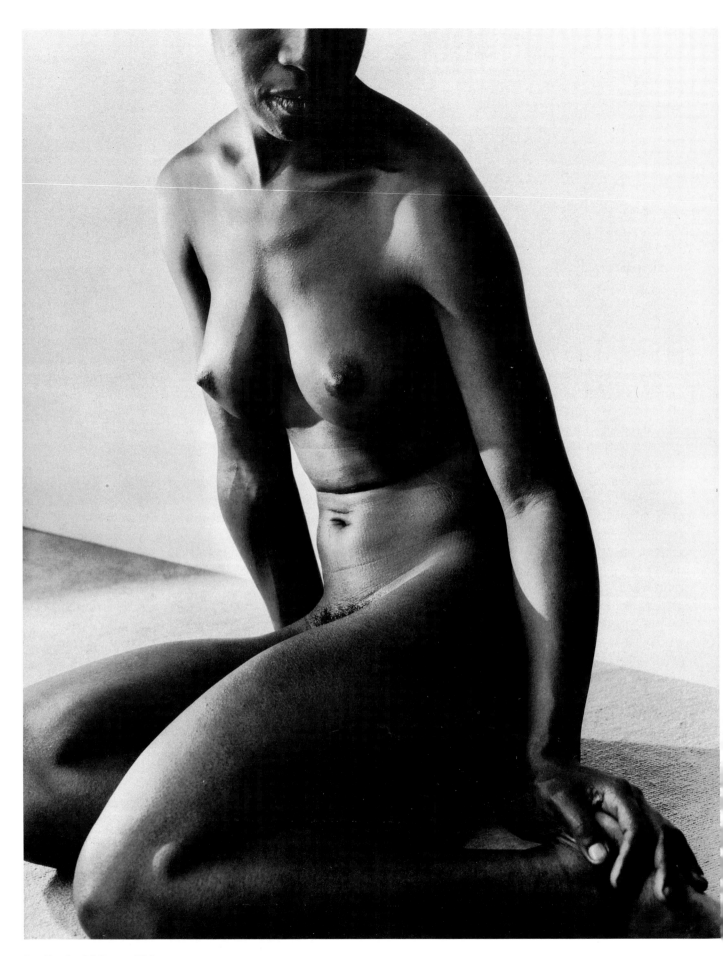

87. *Lusha Nelson. African woman,* 1934

of a nude model which Courbet used for his painting 'The Artist's Studio'—was never exhibited in its own right. Considering the uproar caused at the Salon of 1863 by Manet's 'Déjeuner sur l'Herbe', which Napoleon III declared to be indecent, and the public indignation aroused by the same artist's 'Olympia' two years later, the French can hardly be credited with greater broadmindedness than the English at that period. It is safe to assume, therefore, that Nadar's photograph of 'Musette' would have excited a comparable reaction, even though it lacks the suggestiveness so nakedly manifest in Manet's daringly naturalistic paintings—as they seemed to his contemporaries.

Nadar had known Christine Roux, the mistress of his friend Murger, in the Bohemian days of his youth. His photograph has the robust realism of a painting by Courbet, and if the pose is somewhat reminiscent of Ingres' 'La Source', painted in the same year 1856, it is because Ingres was in the habit of sending his sitters to Nadar's studio for preliminary photographs. We may assume, therefore, that this photograph belonged to a series of studies for 'La Source'.

Half a century later, Alfred Stieglitz and Clarence H. White photographed a beautiful torso slightly out of focus, producing broad, soft effects (*No. 85*). The contour of the figure is vague, against a light background, hazy and undefined as in Eugène Carrière's paintings. This effect seemed appropriate for such controversial subject matter, and opposition to photographic rendering of the nude melted away when the subject was not realistically treated.

The incursion of photography into pseudo-impressionism led the photographer to suppress nature to the utmost of his ability, and with all the characteristic shortcomings of the methods necessary for the transmutation of the pure camera image into an impressionist picture. Steichen's life studies look as though they were taken in a London pea-soup fog, or 'in coal-cellars' as Shaw sarcastically commented. 'He starts with brown, and gets no further than brown, and the parts of his figures which are obscured do not produce the effect of being obscured by darkness; they suddenly become indistinct and insubstantial in a quite unconvincing and unreasonable way.'[1]

The photographer's self-consciousness about nudity, which resulted in so many aberrations of taste,

led Shaw to advocate dropping this feeling of false shame. 'The camera can represent flesh so superbly that if I dared, I would never photograph a figure without asking that figure to take its clothes off.' Obviously sharing Goya's view that 'there are men whose faces are the most indecent parts of their whole bodies,' Shaw continued: 'It is monstrous that custom should force us to display our faces ostentatiously, however worn and wrinkled and mean they may be, whilst carefully concealing all our other parts, however shapely and well preserved. . . . Our fashionable books on African and Australian travel are full of photographs of dark ladies, undraped and unembarrassed, whose natural propriety passes unchallenged because their self-possession makes us forget our unnatural prudery.'[2]

When in the 1920s a reaction set in against the stuffiness and hypocrisy of the previous century, figure studies were no longer taboo and became a popular feature in photographic exhibitions. The objective photographer was no longer oppressed by the fear of giving offence with a sharp photograph showing the modelling of the body and realistic rendering of skin texture, which are the *raison d'être* of photographing the human form at all. Instead of suppressing nature to the utmost of his ability, he now strove to represent it as perfectly as he could. In simple, natural poses, all straining after effect was avoided. Edward Weston, André Steiner, André de Dienes, Emmanuel Sougez, John Havindon and Tateyuki Nakamura are a few of the photographers whose sensitive handling of the human figure and feeling for form led to aesthetically satisfying pictures in which harmonious composition, modelling and volume combine to transform nakedness into art.

Bill Brandt's anatomical details of bodies detached from their context, and distortions of whole figures, illustrated in his recent book *Perspective of Nudes*, mark a break with the conventional representation of the nude. Brandt aimed to get rid of the accepted image. His 'nudes' are as different, in fact, as wrought-iron figures are from cast or chiselled sculpture. They are abstractions, lacking human form, volume and texture. They are nevertheless striking new images, created by a fertile mind pioneering new ground, but 'nudes' is a misnomer, perhaps, for Bill Brandt's pictures, most of which are as far removed from the human form as Reg Butler's wrought-iron women (*No. 86*).

[1] G. Bernard Shaw, *The Amateur Photographer*, 16 October 1902.

[2] loc. cit.

X

REPORTAGE AND DOCUMENTATION

Contrary to general belief, documentary and reportage photography are not new developments. The wish to record life and events existed even in the days of the daguerreotype but remained, with a few exceptions, unfulfilled until the introduction of the binocular (stereoscopic) camera in 1853, and a number of other small plate cameras during the next decade. The greatest advance in this field, however, was due to fast gelatine dry plates, available in England from the late 1870s onward.

Undeterred by the difficulty of the undertaking, Alois Löcherer, a Munich photographer, recorded the transport and erection of the colossal statue 'Bavaria' in Munich in 1850. The 60 ft. high 'Bavaria' was the largest bronze statue of modern times, and Löcherer took six photographs of the operation, from the loading of the sections of Ludwig Schwanthaler's sculpture at the foundry (*No.* 89) to the setting up of the figure. It is one of the earliest reportages ever made, and Löcherer ingeniously arranged the people in active-looking poses to simulate an instantaneous effect, although the exposure cannot have been less than about a minute.

It is obvious that large plate cameras requiring lenses of long focus and consequently a small stop to obtain perfect definition from foreground to distance, were generally too slow for reportage work. The small binocular camera introduced in 1853 by J. B. Dancer, a Manchester optician, revolutionized photography in the mid-Victorian era, just as the miniature camera has in our own time. Fitted with lenses of short focus, it gave a sharp picture at almost open aperture, and the use of hypersensitive collodion reduced the exposure to as little as half a second.

For the first time it became possible to take more or less instantaneous views of street life and domestic scenes (*No.* 88), and even news photographs of unusual historical interest; though the opening of the rebuilt Crystal Palace at Sydenham by Queen Victoria on 10 June 1854 (*No.* 91) was taken with an

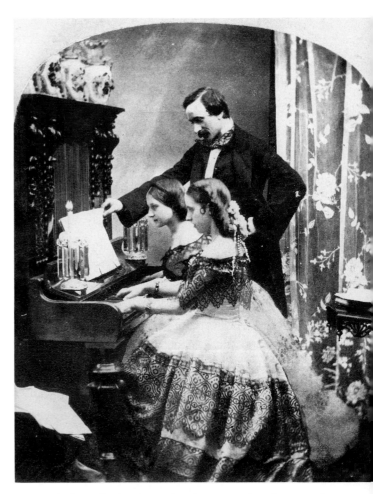

88. '*The Music Lesson*'. *Stereoscopic photograph, c.* 1857

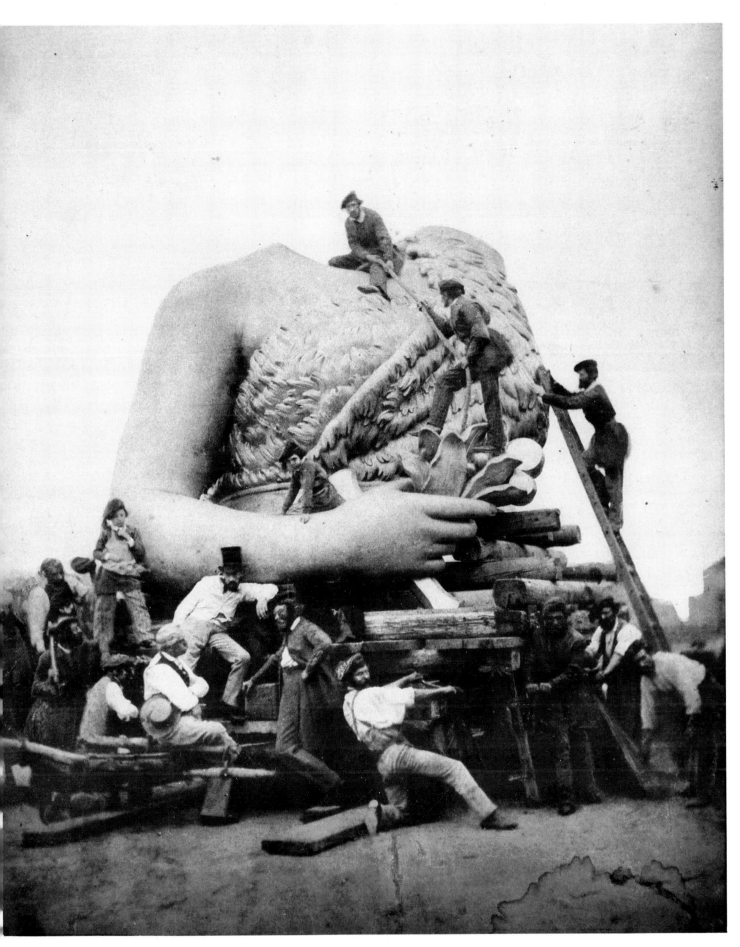

89. *Alois Löcherer. Transport of the colossal statue 'Bavaria', Munich,* 1850

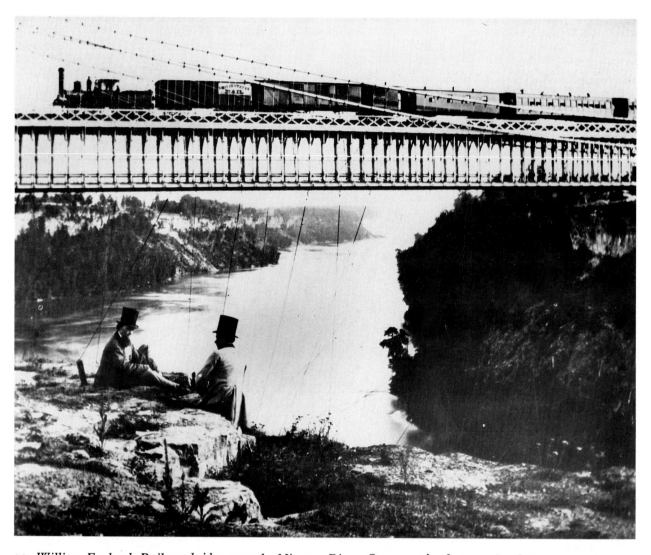

90. *William England. Railway bridge over the Niagara River. Stereoscopic photograph, 1859*

ordinary stand camera, an opportune moment occurring during the Archbishop of Canterbury's prayer.

The London Stereoscopic Company, founded in 1854, sent its staff photographers as far afield as the Middle East. Four years later it was in a position to advertise a stock of 100,000 different photographs: architecture and scenery, domestic life, customs and costumes of other nations, and subjects similar to those that a present-day photographer working for illustrated papers would take, provided the action could be 'snapped' within an exposure of a second. The importance of stereoscopic slides as a source of nineteenth-century documentation has so far been overlooked: they provide a wealth of information, quite apart from the pleasure they frequently give as exquisite miniature pictures. Illustrations of social activities of the upper classes had the same function

as some pre-war Hollywood films—to give a glimpse of luxurious living to those farthest removed from it. Although the great majority of these domestic scenes had to be staged (instantaneous photographs of indoor social events only became possible with the introduction of the 'Ermanox' camera in 1925 in conjunction with fast panchromatic plates), their value as social documents is in no way diminished since they are contemporary and made for a public which would have been critical of anything but a true-to-life picture.

In 1859 William England added to the thousands of stereoscopic photographs which he had taken for the Stereoscopic Company in many countries, a new series entitled 'America in the Stereoscope'. Being the first photographs of American scenery and architecture to come across the Atlantic they aroused

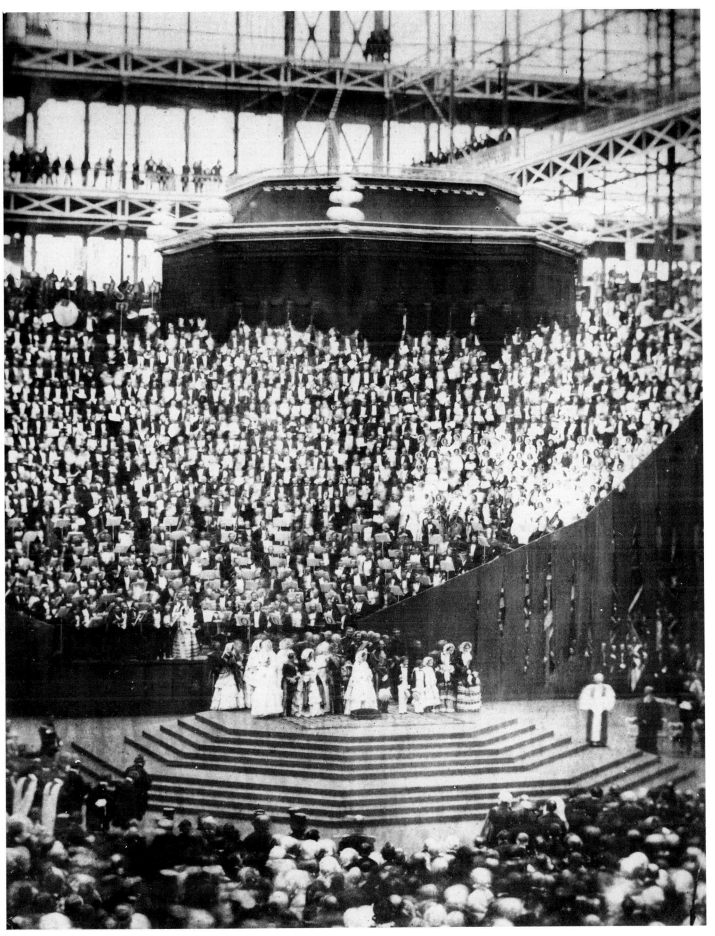

91. *P. H. Delamotte. Opening of the rebuilt Crystal Palace at Sydenham by Queen Victoria, 10 June 1854*

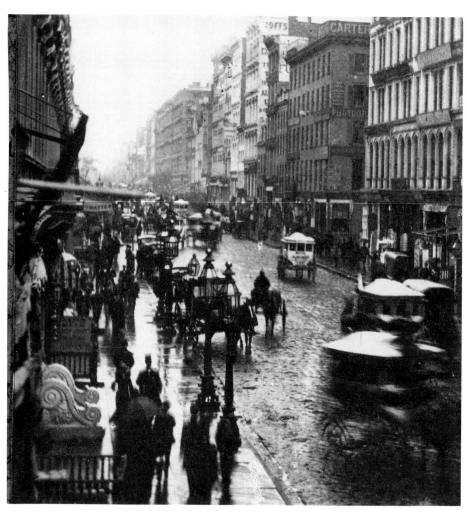

92. *Edward Anthony. Broadway, New York, on a rainy day. Stereoscopic photograph,* 1859

93. *Nomination of parliamentary candidates at Dover,* 1863

94. *P. H. Delamotte. Rebuilding of the Crystal Palace at Sydenham,* 1853

95. *Roger Fenton. Crimean War, cookhouse of the 8th Hussars,* 1855

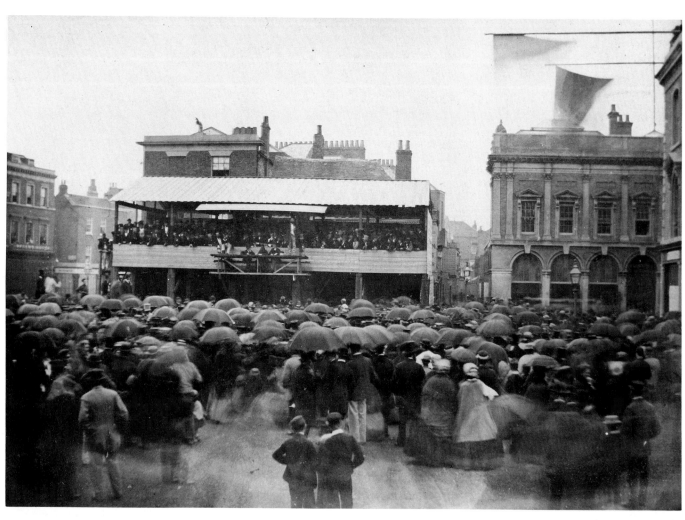

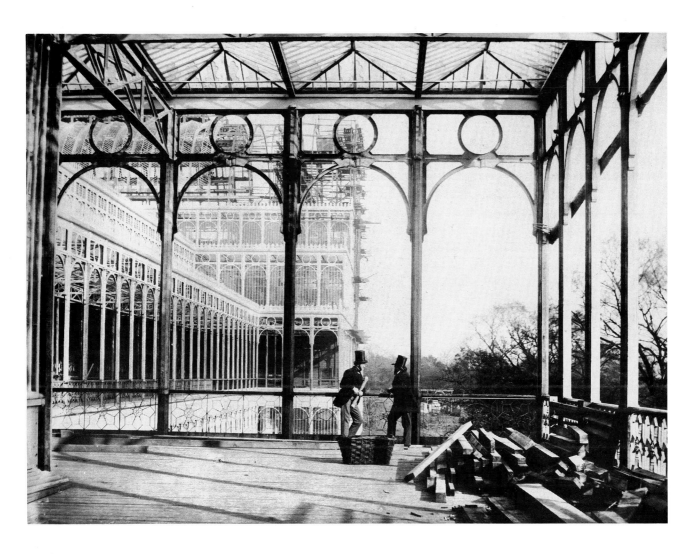

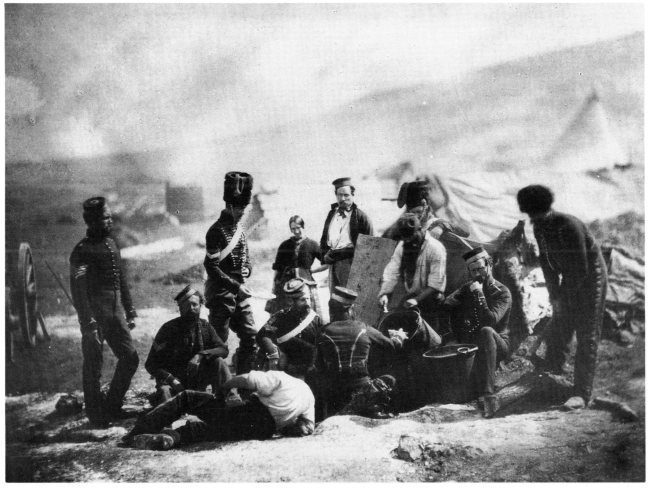

much interest, especially his well-composed action shot of a train steaming across the suspension bridge which links America with Canada across the Niagara river (*No.* 90). Edward Anthony's view of Broadway on a rainy day (*No.* 92) taken the same year was a technical feat that surprised people by the novelty of the subject matter. To avoid obtaining blurred outlines of fast-moving vehicles the photographer had to take his street views from some distance, usually a first- or second-floor window of a nearby house. Similar instantaneous street scenes appeared soon afterwards in other capitals. Adolphe Braun's photographs of Parisian boulevards were the forerunners of similar painted views by Monet, Manet, Renoir and Degas.

Even with ordinary plate cameras, some photographers managed to record an animated scene, as in the nomination of parliamentary candidates at Dover in 1863 (*No.* 93) in which the blurring of the crinolined ladies and the flags enhances, if anything, the atmosphere of the picture. Modern photographers have come to realize this, for although nowadays even the fastest movement can be 'frozen', they frequently give a longer exposure than necessary in order to obtain slight blurring, which conveys the impression of movement much more convincingly.

The first extensive documentation of which we have any knowledge was made by P. H. Delamotte, professor of drawing at King's College, London, and official photographer to the Crystal Palace Company, for which he took weekly photographs of the work in progress during the rebuilding of the Crystal Palace at Sydenham. The 160 photographs which Delamotte published in 1855 form an excellent survey (*No.* 94) of the building operations, from preparing the foundations to the opening by Queen Victoria already referred to.

In the same year Roger Fenton made his famous reportage of the allied troops before Sebastopol. The historic interest of this first war reportage is obvious, but only a photographer with an art training could have composed such natural groups, giving an impression of being instantaneous (*No.* 95).

Space unfortunately limits me to illustrating only a few of the numerous photographs that bring to life historic events in unforgettable pictures such as T. H. O'Sullivan's battlefield of Gettysburg (*No.* 97) during the American Civil War and the Butte de Montmartre during the Paris Commune (*No.* 98).

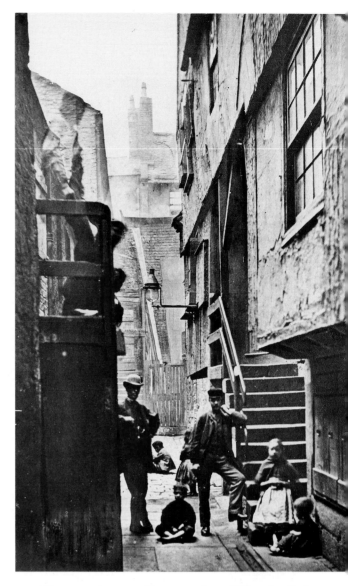

96. *Thomas Annan. Glasgow slum (No. 28, Saltmarket)*, 1868

The prototype of the Far Eastern reportages of Cartier-Bresson and Werner Bischof appeared in 1873–4 in London: *Illustrations of China and its People* is a four-volume work illustrated with 200 photographs by John Thomson, a well-known traveller and many-sided photographer who also pioneered social documentation (see p. 154) and 'at home' portraiture of celebrities.

Between 1868 and 1877 Thomas Annan took an interesting series of photographs of Glasgow slums for the Glasgow City Improvement Trust (*No.* 96). Much of his work goes deeper than the mere recording of a close or alley to be demolished, for the

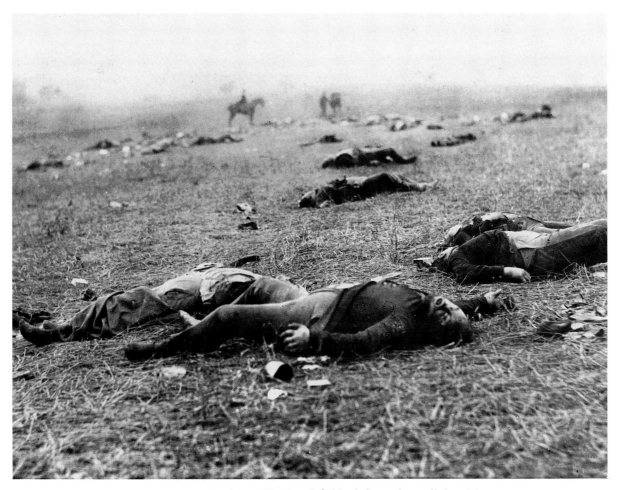

97. *T. H. O'Sullivan. 'The Harvest of Death'—battlefield of Gettysburg, July* 1863

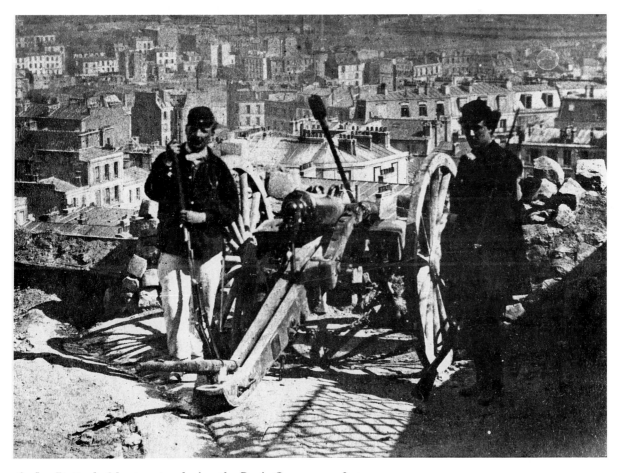

98. *La Butte de Montmartre during the Paris Commune,* 1871

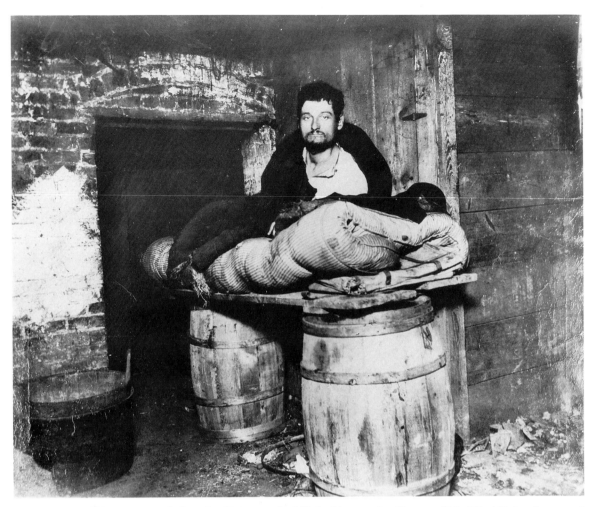

99. *Jacob A. Riis. New York slum dweller on makeshift bed in a coal cellar, c. 1888. Flashlight photograph*

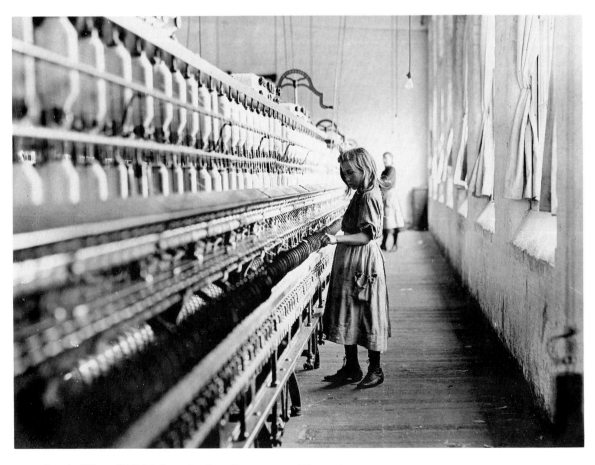

100. *Lewis Hine. Child labour in Carolina cottonmill, 1908*

poverty-stricken people outside their ramshackle wooden houses are a vivid reminder to society of its obligations towards those who work for it.

A similar intention moved Jacob A. Riis, a Danish carpenter who became a newspaper reporter of police-court cases, first for the *New York Tribune* and later for the *Evening Sun*. His work brought him into contact with the terrible conditions in New York tenements in the 'eighties (*No.* 99) particularly in Mulberry Bend, a notorious slum. Realizing that they were the main cause of the crimes he was reporting, and convinced that the camera would prove a mightier weapon than the pen against poverty and overcrowding, Riis took up photography in 1887 and became America's first photo-reporter. In articles, lectures and books Riis pictured 'How the Other Half Lives' and rallied support for their relief. His success was the best proof of the power of photography to awaken the social conscience, for Theodore Roosevelt, then Governor of New York State, instigated a number of social reforms, in addition to the demolition of Mulberry Bend and the rehousing of its inhabitants.

Lewis W. Hine, an American sociologist, also found the camera an indispensable aid in his work. At the turn of the century two million children worked in factories and mines. Six million grown-ups were out of work. Employers reasoned: Why pay a man a dollar when a child can do the job for ten cents? Hine's revelation of the exploitation of children in factories (*No.* 100) led to the passing of the child labour laws. Hine also exposed the miserable conditions of penniless immigrants after their arrival at Ellis Island. His human documents were a terrible accusation against the social injustice of the times, and had the desired effect.

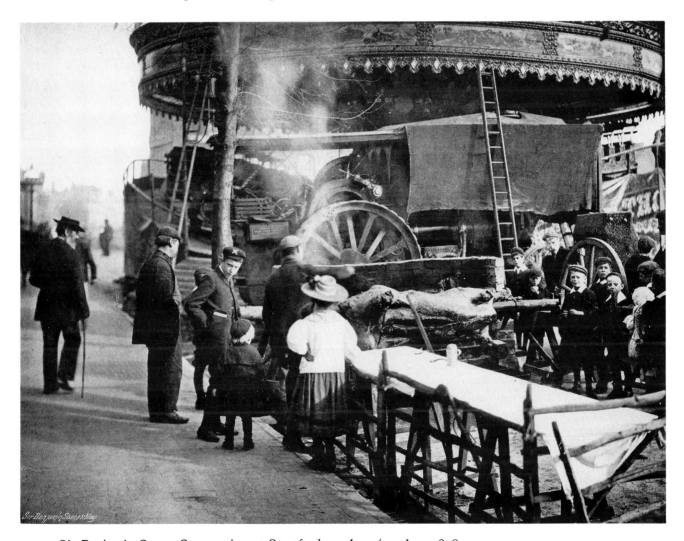

101. *Sir Benjamin Stone. Ox-roasting at Stratford-on-Avon 'mop', c.* 1898

In 1897 Sir Benjamin Stone, MP for Birmingham, founded the National Photographic Record Association with the aim of documenting the manners and customs of the English, picturesque festivals and pageants, and traditional ceremonies which were slowly dying out. He himself was the most active photographer in the Association, and at his death left a collection of 22,000 photographs—some desperately dull records, others scenes of lively activity (*No.* 101).

Arnold Genthe's photograph of the feeding of the San Francisco earthquake survivors (*No.* 103) looks at first sight like a still from a film on account of its theatrical effect. Having lost everything himself, Genthe borrowed a camera to record the conditions after the catastrophe, producing a set of pictures which are visually appealing and at the same time valuable historic documents.

Equally moving is Nahum Luboshez's picture of starving peasants (*No.* 104) taken during one of the recurring famines in Russia.

The greatly increased mobility, which fast negative material allowed, showed itself not only in outdoor reportage but also in photo-interviews. For the first time it was possible to photograph people in their own surroundings. This added considerably to the interest of a portrait, freeing the photographer from the danger of stereotyped effects. A pioneer in this field was John Thomson, who exhibited in 1881 a series of 'at home' portraits of well-known people at the London Photographic Society.

Photo-interviews with celebrities are also very much a feature of modern newspapers. Few people are aware that the first one took place as long ago as 1886 when Nadar interviewed the great scientist M. E. Chevreul on the eve of his hundredth birthday. A good beginning to the conversation was the centenarian's opening remark: 'I was an enemy of photography until my ninety-seventh year, but three years ago I capitulated.' Chevreul's lively answers to a great variety of questions put by Nadar were noted by a stenographer while at the same time Nadar's son Paul took a series of instantaneous photographs. When *No.* 102 was taken, Chevreul was just saying—referring no doubt to General Boulanger—'Herein lies the disadvantage of the philosophy of the day. It is the philosophy of demagogues; nothing but empty words.' Thirteen of the photographs were published in *Le Journal Illustré* in September 1886. Three years later the two Nadars

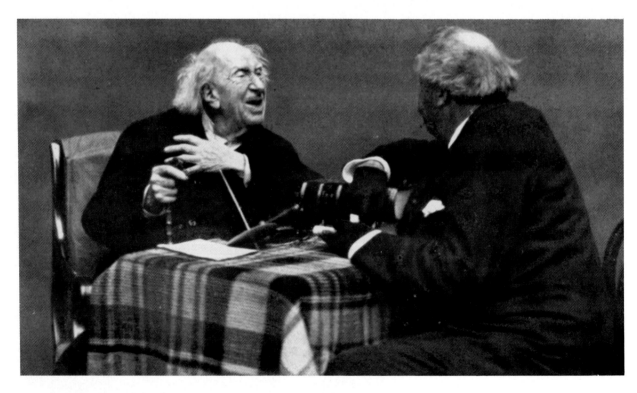

102. *Paul Nadar. The first photo-interview: Nadar (Gaspard Félix Tournachon) interviews the centenarian scientist M. E. Chevreul, August 1886*

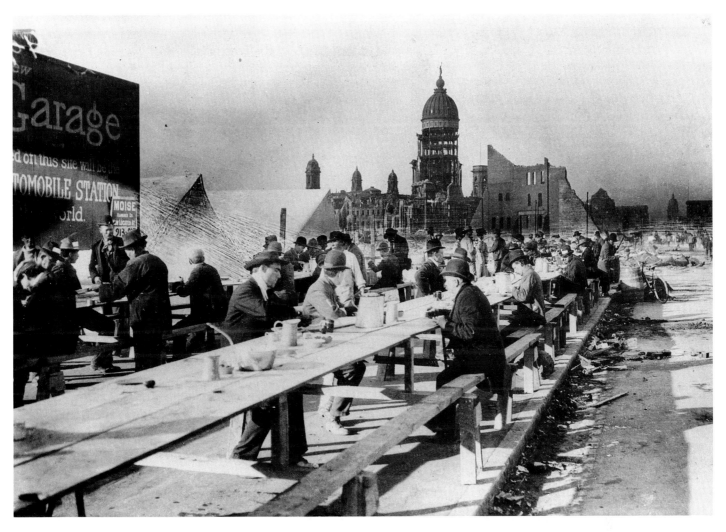

103. *Arnold Genthe. Public feeding after the San Francisco earthquake on 18 April 1906*

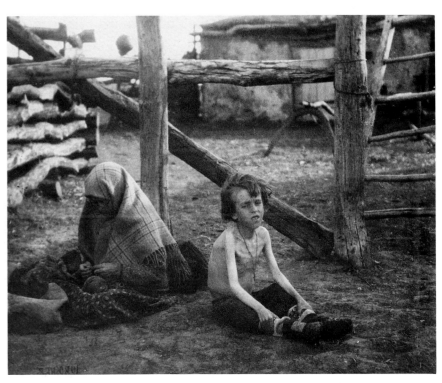

104. *Nahum Luboshez. Famine in Russia, c. 1910*

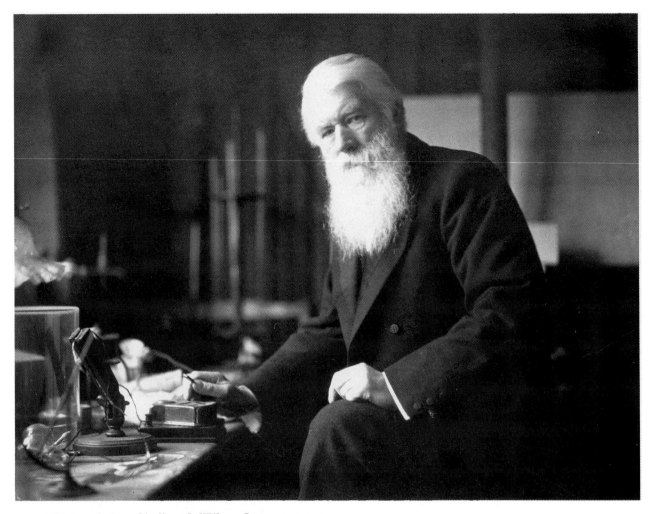

105. *Elliot and Fry. Sir Joseph Wilson Swan*, 1904

photo-interviewed General Boulanger for *Le Figaro*.

A remarkable book[1] of illustrated interviews with celebrities was published in 1904. The photographs by the author, W. B. Northrop, are very much on the lines of Elliot and Fry's portrait of Sir Joseph Wilson Swan (*No.* 105) taken in his laboratory in the same year. Today's 'portrait profiles' in the Sunday papers continue in this tradition. The reportage style of portraiture conveys the personality of the sitter through the atmosphere of his own surroundings and is particularly successful in the case of artists and scientists in their studio or laboratory because the objects present are bound to add to the meaning and expressiveness of the picture. This has

been especially successfully demonstrated in *Eight European Artists* by Felix H. Man, and in Ida Kar's exhibition at the Whitechapel Art Gallery. The power of her pictures springs from the simplicity of composition with which she creates a feeling of depth and spaciousness (*No.* 225), and this is as marked as her liking for black and white contrast.

With the exception of a comparatively few photographers making a living from portraying the highest and lowest in the social scale, amateur photography and modern reportage in their combined effect are gradually destroying the demand for the conventional studio portrait. Thus the professional portrait photographer, who fifty years ago more or less eliminated the portrait painter, is now in his turn ousted by the popular 'do it yourself' activity of our times.

[1] W. B. Northrop, *With Pen and Camera: Interviews with Celebrities*, London, 1904.

PUSH-BUTTON PHOTOGRAPHY

During the 1880s the general introduction of ready-made dry plates and films twenty times faster than any previous negative material, and of small cheap hand-cameras such as the Kodak, opened the door to hundreds of amateurs who had been deterred from learning to make pictures by the difficulties of the wet collodion process. For the first time in its history everything about photography was mass-produced, from the apparatus, negative and positive material, to the pictures themselves. The new machine-man was content to follow manufacturers' instructions implicitly, and rely on the camera and the developing and printing firm to make the pictures for him. He lacked the enthusiasm of the early pioneers, who felt impelled to make pictures, however difficult the task. Gone was the spirit of dis-

106. *Oscar van Zel. Skating, c.* 1887

107. *J. Bridson. Picnic, c. 1882*

covery, of experimentation, the fascination of watching the picture slowly appear as if by magic in the developing bath.

Clever advertising slogans like George Eastman's 'You press the button, we do the rest' inevitably lowered the status as well as the standard of photography. So easy had photography become that everyone who tried could produce a result of some kind. Eastman's persuasive statement that 'a collection of these [Kodak] pictures may be made to furnish a pictorial history of life as it is lived by the owner, that will grow more valuable every day that passes' was a brilliant application of mass psychology to business. This was, and is, all that the average camera user asks of photography. But the push-button method let loose many of the evils from which photography is suffering today.

Apart from a small group of serious amateurs who started the aesthetic movement in photography, most of the new generation of photographers were entirely devoid of artistic training and feeling. They were not interested in the camera as a means of expression.

The dangers of haphazard snapshooting were foreseen from the start by a few perceptive people. 'Whatever little notions of art a person might have in his head would certainly be driven out of it, for the knowledge that he could take an almost unlimited number of pictures would lead him to expose a sheet [of film] on every possible occasion, and probably 99 per cent of what he obtained would be thoroughly inartistic productions.'[1]

G. Bernard Shaw, one of the new amateurs, assured me that his classic remark 'The photographer is like the cod, which produces a million eggs in order that one may reach maturity' was based on personal experience.

[1] Sir W. de W. Abney, *Journal of the Society of Arts,* 26 March 1886.

116

No pursuit is better adapted than photography to cultivate the powers of observation, but this cultivation demands attention and reflection. However simple the manipulation, there is no short cut to artistic knowledge. Intelligence and care are as vital for the production of good photographs as for success in any other medium. The subjects within the range of the amateur photographer are so diverse and the aspects of even one subject so numerous, that the need for thought assumes greater importance than ever.

'The evidence is clear enough', wrote P. H. Emerson, 'that had the artists and scientists who were the promotors of the first English Photographic Society held their own, photography today would probably have been practised by artists and scientists alone—a noble and learned profession—instead of being practised, as is now only too often the case, by illiterate and ignorant tradesmen.'[1] Considering the mentality of the average snapshooter today I despair of the results if Moholy-Nagy's prediction came true: 'the ignoramuses of the future will be not only those unable to read or write, but also those ignorant of photography'.[2]

As we have seen, the purposeful amateurs did excellent work in social documentation and reportage

[1] P. H. Emerson, *Pictures from Life in Field and Fen*, London, 1887.
[2] L. Moholy-Nagy in *Modern Photography*, London and New York, 1935.

Paris International Exhibition, 1889: *under the Eiffel Tower*

opened up by the technical advance. They rejuvenated photography in other fields too. P. H. Emerson was one of the new amateurs, but a gulf separated him and others who sought to advance photography as an art, from the mass of push-button photographers. Indeed, the progress of photography in its picture-making aspect has at every period been largely due to the pioneer work of serious amateurs, for professionals are by nature unadventurous, preferring routine to ruin. Some amateurs made delightful spontaneous pictures (*Nos.* 106 and 107) that vibrate with life. Working by rule of thumb and using their eyes, they discovered that by a click of the shutter they could capture a slice of life for ever—as in this view of the Paris Exhibition 1889, with people half cut-off (*No.* 108). 'Horrible bungling amateur stuff', scoffed the pictorialists at the Photographic Society, but to me these rather free-and-easy snapshots have more aesthetic appeal than their well-composed affectations.

The pictorialists remained quite uninterested in the new range of subject matter. For them any photograph that showed life was 'record work'. They merely used the new simplified technique to indulge in fine art photography with greater facility. Their efforts to elevate photography by ambitious imitation paintings continued to fill photographic exhibitions with banalities on a par with those hung at the Royal Academy at the time. In the 'seventies and 'eighties there was a dearth of artistic photography, and the little that existed was confined to a clique of pictorialists dominated by H. P. Robinson. In the pursuit of a phantom, their pictures became more and more stereotyped.

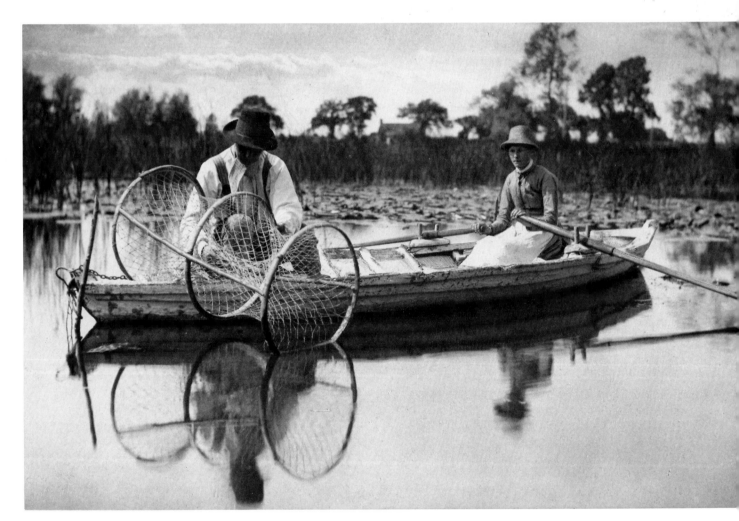

109. *P. H. Emerson. 'Setting the bow-net.' Platinotype,* 1885

XII

NATURALISTIC PHOTOGRAPHY

Desiring to regenerate photography, P. H. Emerson called for a return to nature, as the Barbizon School and Courbet had done a generation earlier in painting. 'Wherever the artist has been true to nature, art has been good; wherever the artist has neglected nature and followed his imagination there has resulted bad art. Nature, then, should be the artist's standard.' This was Emerson's anti-romantic Credo laid down in his book *Naturalistic Photography* (1889). He convincingly demonstrated in seven beautifully illustrated books on the Norfolk Broads (where he had a houseboat) that a photographer could imbue ordinary subjects with artistic quality bearing a personal stamp: consequently there was no need to resort to the artificialities of the fine art photographers.

With sensitive feeling Emerson rendered at all seasons of the year the atmospheric conditions of this low-lying land intersected with rivers and lakes. An admirer of J. F. Millet, who devoted his life to portraying the work of the peasants at Barbizon, Emerson depicted with similar insight and sympathy the simple life of the fenland people, setting and taking up their fishing-nets (*No.* 109), shooting duck and snipe, gathering reeds (*No.* 111), ploughing and harvesting. *Life and Landscape of the Norfolk Broads* (1886), the finest and rarest of Emerson's books, contains original platinum prints; the succeeding volumes, also published in limited editions during the next nine years, were illustrated with photogravures or photo-etchings—processes which he considered more artistic in giving a broader, softer rendering than a photographic print.

In contrast to the landscape photographers of the eighteen-fifties and sixties, whose aim had been a picture of all-over sharpness, Emerson advocated a certain degree of softness also in the negative through differential focusing (by which the principal subject of the picture was sharp and the remainder less so). Differential focusing, Emerson claimed, enabled the naturalistic photographer to give a subjective rendering of nature, whereas the realistic photographer recorded with objective, soulless precision. This was, however, only one of Emerson's many erroneous theories, for subjective photography as opposed to mechanical photography is dependent on the artistic ability of the photographer and not on soft or sharp rendering. The creative photographer will employ whatever method is best suited to the interpretation of the particular subject. Yet in spite of Emerson's wordy expositions of naturalistic photography, it is difficult to detect much difference in technique between the fine realist landscapes of the first generation of photographers and his own.

Pictures of East Anglian Life (1888), a copy of which Emerson gave to every English photographic society, was intended to elucidate his views set forth in his textbook *Naturalistic Photography*, which had no illustrations. It was, however, not so much Emerson's innovations that aroused consternation amongst the older generation at the Photographic Society of London, as the constant stream of invective directed against all who did not agree with him.

Emerson's contention that a soft photograph gives breadth of effect and is more suggestive of the true character of nature had in fact first been put forward, as we have seen, by Sir William Newton thirty-six years earlier. Now the controversial question soft *versus* sharp was revived with renewed vigour, based on the same arguments as before. To its opponents,

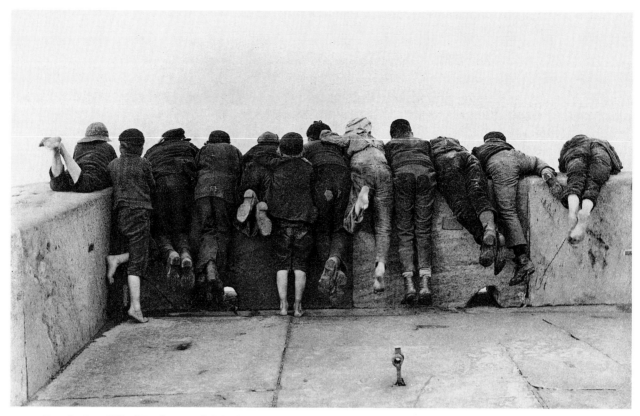

110. *Frank Sutcliffe. 'Excitement.' Platinotype,* 1888

the doctrine of soft focus attacked one of the fundamental principles of photographic optics. To its adherents, beauty of form and expression was injured by sharpness of outline. They maintained that photographs were too technically perfect to be artistic, and that broad masses of light and shade would indicate a subject sufficiently well, leaving some play for the imagination. To achieve this, the proposal to construct intentionally defective lenses, first raised in 1853,[1] was argued afresh. Dallmeyer's portrait lens of 1866 had in fact been designed in the vain belief that the slightly soft effect of Julia Margaret Cameron's portraits could be artificially imitated. Emerson was a great admirer of Mrs Cameron, and her work was again cited by the new advocates of soft focus. They did not realize that the softness noticeable in some of Mrs Cameron's portraits was not deliberate, but arose from her use of a lens of unusually long focal length (30 in.) which obliged her to work at open aperture to arrive at

[1] E. W. Dallas, *The Photographic Journal,* 21 April 1853.

exposures of manageable length. This resulted in differential focusing—sharp in the parts on which she focused, and rapidly falling off in the receding and projecting parts of the sitter. But, I repeat, there was no intentional softness for artistic reasons, as in the paintings and lithographs of Eugène Carrière, for instance.

Nevertheless Mrs Cameron's photographs, and the paintings of the Impressionists who had renounced objectivity and realistic representation, lent force to Emerson's arguments. But it was not until the public had become accustomed to the indistinct contours of the Impressionists that the idea of soft focus gained ground—and then it soon got out of control.

Meanwhile a new school of landscape photography came into being through Emerson's influence. Its most prominent members were the amateurs George Davison, Col Joseph Gale, A. Horsley Hinton, J. B. B. Wellington, B. Gay Wilkinson, and the professionals Lyddell Sawyer (*No.* 112) and Frank M. Sutcliffe (*No.* 110).

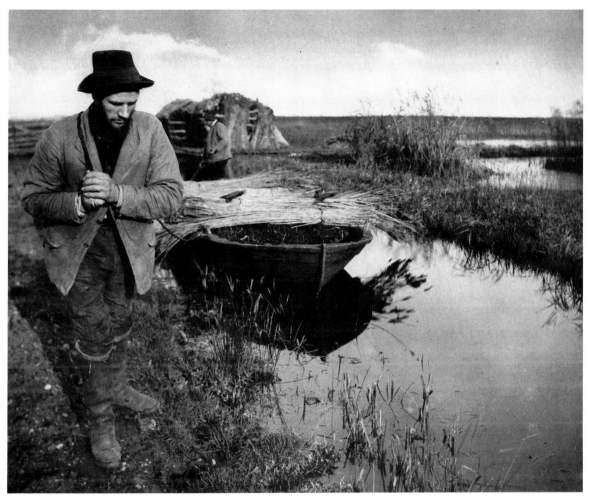

111. *P. H. Emerson. 'Towing the Reed.' Platinotype,* 1885

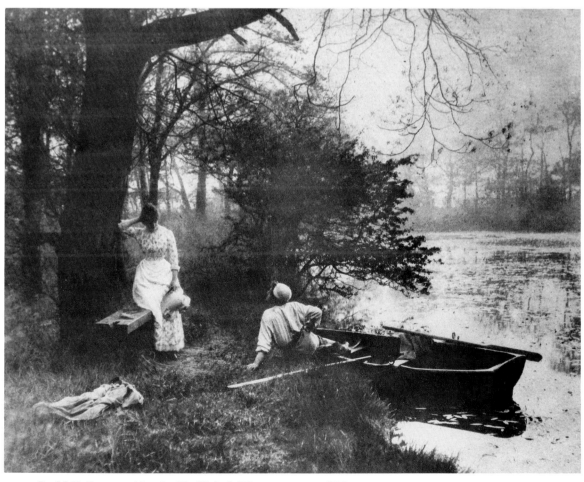

112. *Lyddell Sawyer. 'In the Twilight.' Photogravure,* 1888

XIII

IMPRESSIONISTIC PHOTOGRAPHY

George Davison, one of the naturalistic photographers, soon fell under the spell of Impressionism and went further than Emerson considered desirable in correcting the 'unpicturesque and lifeless exactitude' of landscape photographs. Davison aspired to produce such a rendering of nature as to convey the general impression created at first glance. His tenet that no object should be sharply in focus was achieved by using a 'pinhole lens', and to increase the 'fuzzy' effect the photograph was printed on the roughest drawing paper.

The earliest impressionist photograph, 'An Old

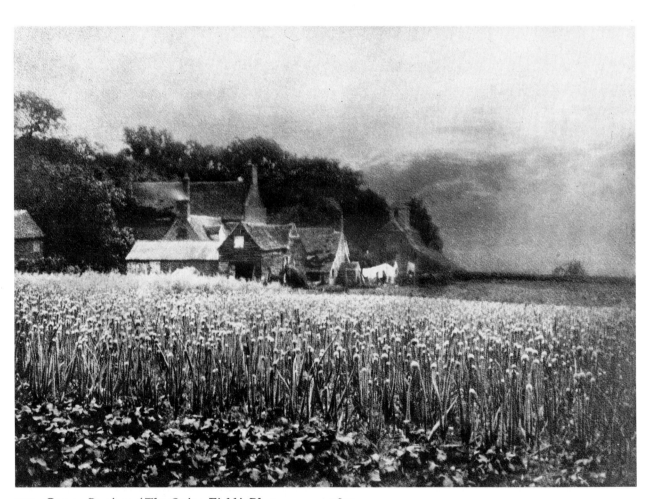

113. *George Davison. 'The Onion Field.' Photogravure*, 1890

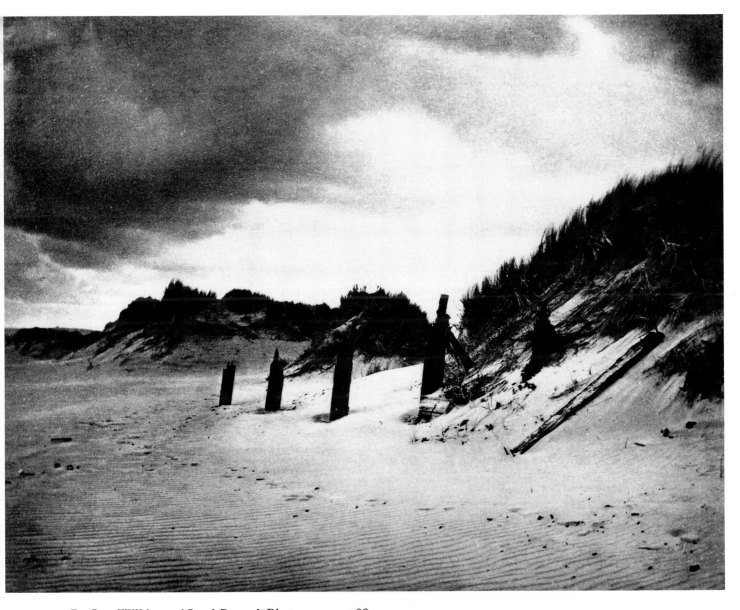

114. *B. Gay Wilkinson. 'Sand Dunes.' Photogravure*, 1889

Farmstead' (later entitled 'The Onion Field') (*No.* 113) caused a sensation when shown in autumn 1890 at the Photographic Society's annual exhibition, where surprisingly it was hung in a place of honour and awarded a medal.

'Perhaps no more beautiful landscape has ever been produced by photographic methods than Mr Davison's "Old Farmstead",' wrote *The Times*. 'In this, atmospheric effect is admirably rendered and, looked at from a suitable distance, the picture gives a wonderfully true rendering of the subject.' It is paradoxical that at a time when the most perfect lens

to date, the anastigmat, had just been introduced, Davison should dispense with a lens altogether and use instead a piece of sheet-metal punched with a small hole. The ruse of excessive diffusion of focus and flat, low tones to give the photograph the appearance of an impressionist painting was, of course, only yet another way of perverting photography in imitation of painting—throwing away the substance for the shadow. An impressionistic photograph did not really deceive anyone; it loooked at best like a monochrome reproduction of a painting. But whenever photographs resemble contemporary art they

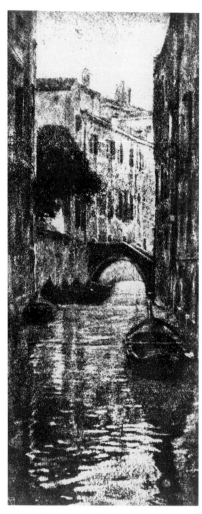

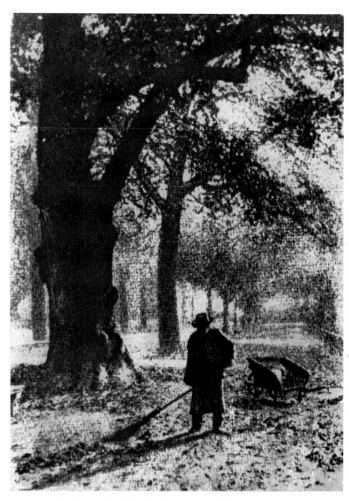

115. *Heinrich Kühn. 'A Venetian Canal.' Gum print (charcoal colour),* 1897 *(reproduction)*

116. *Lacroix. 'Park Sweeper.' Photogravure of a gum print, c.* 1900

obscure the critical faculty of art critics, who are quite incapable of judging photographs for their photographic qualities. The exquisite little photograph 'Sand Dunes' (*No.* 114) by B. Gay Wilkinson, shown in the same exhibition, treated a simple subject honestly and with more genuine artistry than Davison's painterly 'Old Farmstead'; yet it scarcely drew any attention from critics.

Impressionistic photography aroused fierce controversy, just as Impressionist painting had done before. The most vituperative attacks came from P. H. Emerson, for Davison had not only gone too far in his interpretation of naturalistic photography; he had dared, Emerson claimed, to lecture on 'Impressionism and Photography'[1] without giving credit

[1] Lecture at the (Royal) Society of Arts, December 1890.

to the master's fundamental theories on which impressionism was based. Emerson was enraged by Davison's assumption of leadership, and his renunciation of naturalistic photography in January 1891 in a black-bordered pamphlet entitled 'The Death of Naturalistic Photography'—Emerson was always inclined to theatrical gestures—was largely the outcome of violent egotism and offended vanity. The reasons put forward by Emerson for his *volte face* were unconvincing and his arguments confused. With the same fervour with which he had made exaggerated art claims for photography only two years before, he now denounced it as 'the lowest of all the arts'. Had he grasped the true aims and limitations of photography much of his book *Naturalistic Photography* and the whole of his recantation need never have been written. Surprisingly,

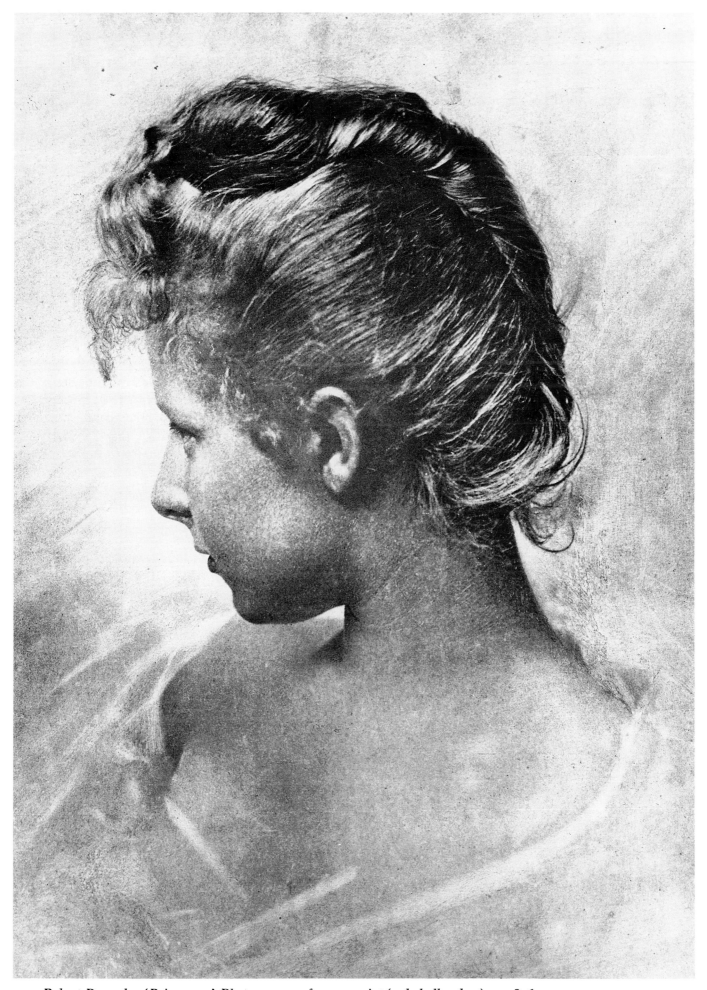

117. *Robert Demachy. 'Primavera.' Photogravure of a gum print (red chalk colour), c.* 1896

a third edition of *Naturalistic Photography* in 1899 by no means contradicted all that appeared in the first and second editions. Logic was not Emerson's strong point, as he had already shown in dedicating his book to the memory of Adam-Salomon, whose work was far removed from his ideals in photography.

Some photographers were content with 'Impressionism' as defined by George Davison. Blurring the image by optical means (a 'pinhole lens', a simple spectacle lens, or a specially constructed soft focus lens such as that designed in 1896 by T. R. Dallmeyer at the suggestion of J. S. Bergheim, a painter) and printing or enlarging it on coarse paper, was indeed still defensible as photographic technique. The erroneous notion, however, that even this failed to give an absolutely satisfactory rendering of nature led for the first time to a new conception of creative photography: modification. The painter, it was argued, is not bound by representation, he gives a free translation of the original, omitting or altering whatever impairs his design. A photographer striving to be an artist in his medium needs similar freedom. He must overcome the limitations of his instrument which restrict his powers of expression. Breaking up of the smooth halftones of the photographic image began to be considered inadequate in overcoming the 'unnaturalness' of photography. The required control, it was felt, could be brought about only by modifying the image through manual interference, which would rid photography at the same time of the never-ceasing reproach that it was a mechanical art. Hand-work, moreover, had the merit—so it was argued—of distinguishing the creative photographer from the ever-increasing tribe of thoughtless snapshooters.

The gum bichromate printing process introduced in 1894 by A. Rouillé-Ladévèze allowed the photographer the artistic licence he had hoped for. He could remove details, alter tone values, and by various means modify the image to such an extent that it could no longer be considered a reproduction of nature made by the camera. It was a new work owing its existence to the ingenuity of his interpretation. This was creative photography, and he felt entitled to style himself 'art photographer'. By adding different pigments and using rough drawing paper, the print could be given the appearance of a red chalk (*No.* 117) or charcoal drawing (*No.* 115). By exposing the negative initially to coarse canvas the photograph could be made to imitate a reproduction of a painting (*No.* 116). 'Precious daubs' and 'meretricious efforts', scoffed Emerson, justifiably, but to the 'paper stainers' and 'gum splodgers' this was photographic Art. Nothing delighted them more than the remark: 'By Jove, that doesn't look a bit like a photograph!'

I must admit that, in spite of not being pure photographs, the decorative quality of the best of these pictures gives them great charm. They are a remarkable manifestation of the *fin-de-siècle* decadence evident in art and literature. Robert Demachy's ballet dancer (*No.* 118) has the charm of a Degas pastel. Frau Nothmann's 'In the Garden' (*No.* 121) reminds one of a Renoir. Heinrich Kühn's 'Venetian View' (*No.* 115) is like a watercolour by Sargent. Edward Steichen's masterpiece (*No.* 119) expresses the genius of Rodin silhouetted against the luminous white of his statue of Victor Hugo and contemplating his 'Thinker': it is a more pretentious essay in impressionism.

When one art copies the characteristic of another, decadence inevitably sets in. Thus Impressionism, which began in painting as a great movement, dwindled in photography to empty aestheticism. Yet at no time during its entire history was photography held in such high esteem by painters as at the *fin de siècle*, photographically speaking the years of decadence. The modern painters in Munich (1898) and in Vienna (1902) opened the doors of their Secessions to the impressionist movement in photography. In Berlin the first Exhibition of Artistic Photography was held at the Royal Academy of Art in February–March 1899 (*No.* 120), so close had the relationship become. It was a marriage of convenience from which each partner expected to profit: the photographers by recognition, the painters by photographic subject matter, for by this time most painters had dark-rooms attached to their studios.

Although the creator of gum prints was frequently only a forger of painter's work, and at best an imitator of non-photographic techniques, he was looked upon as an artist, vastly superior to those who believed in, or had to be satisfied with, straight technique.

'The art photographers have rightly realized that in spite of the expression of their personality in the arrangement of the object, the finished picture is

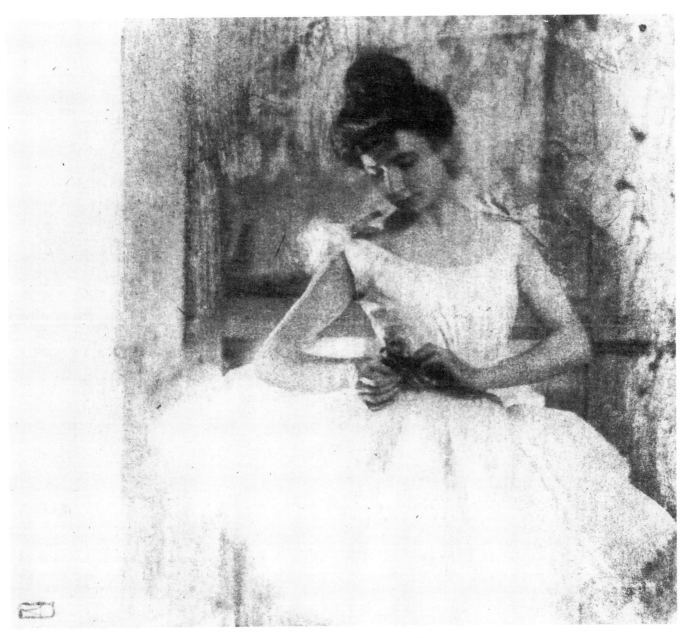

118. *Robert Demachy. 'Behind the Scenes.' Photogravure of a gum print,* 1904

due to a mechanical and impersonal apparatus. The picture has therefore the character of a mechanical, i.e. inartistic, reproduction. For this reason photographers made a big step forward. They interfered with the positive print, by no longer printing the negative as it appeared. By the choice of paper, omitting details, adding to or deepening lights and shades, and by an unending series of manipulations which depend upon their personal judgment, they alter the photograph to such an extent that one can no longer speak of a merely mechanical reproduction by the apparatus. A process long known but rarely used, the gum print, was recognized as the most suitable to allow these alterations to be made. Since the introduction of the gum print, the development of amateur photography has taken a surprising turn; indeed their results have no longer anything in common with what used to be known as photography. For that reason one could proudly say these photograpers have broken the tradition of the artificial reproduction of Nature. They have freed themselves from photography. They have sought the ideal in the works of artists. They have done away with photographic sharpness, the clear and disturbing repre-

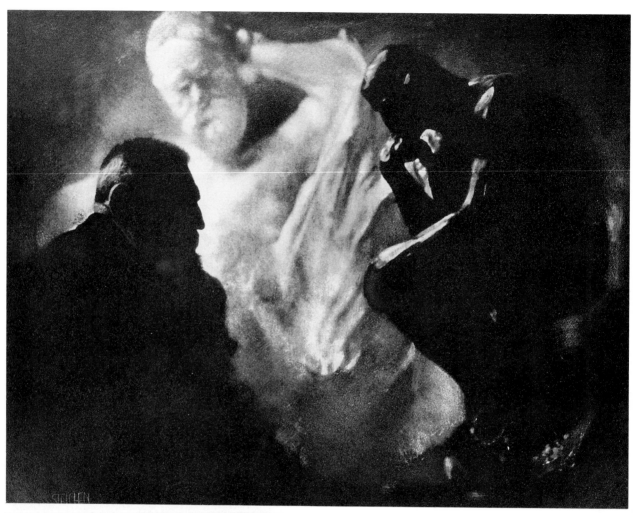

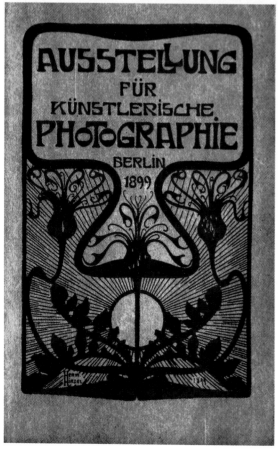

119. *Edward Steichen. Auguste Rodin with his sculpture of Victor Hugo and 'The Thinker.' Gum print, 1902*

120. *Cover of exhibition catalogue of artistic photography held at the Royal Academy of Art in Berlin, 1899*

121. *Frau E. Nothmann. 'In the Garden.' Photogravure of a gum print, c.* 1896

sentation of details, so that they can achieve simple broad effects.'[1]

Bernard Shaw had a better grasp of what was going on. A staunch supporter of photography as an art, he could not deny that impressionist photographs had a certain fascination, yet he knew that he ought to condemn trickery and the critics who hailed it.

'When the photographer takes to forgery, the press encourages him. The critics, being professional connoisseurs of the shiftiest of the old makeshifts, come to the galleries where the forgeries are exhibited. They find to their relief that here, instead of a new business for them to learn, is a row of monochromes which their old jargon fits like a glove. Forthwith they proclaim that photography has become an art.'[2]

Despite occasional criticism, Shaw was so impressed by the ever-widening scope of art photography that he made the audacious prophecy: 'Some day the camera will do the work of Velasquez and Pieter de Hoogh, colour and all. The artists have still left to them invention, and for a little while longer, colour. But selection and representation, covering ninety-nine-hundredths of our annual output of art, belong henceforth to photography.'[3] Like practically every other art critic before him, Shaw fell into the same error of measuring the artistic merits of photography by comparison with Old Master paintings, and in his own inimitable way tried to confirm Delaroche's opinion that painting was dead. Speaking of some photographic portraits of himself, Shavian exaggeration knew no bounds: 'Compare them with the best work with pencil, crayon, brush or silverpoint you can find—with Holbein's finest Tudor drawings, with Rembrandt's *Saskia*, with Velasquez' *Admiral*, with anything you like—if you cannot see at a glance that the old game is up, that the camera has hopelessly beaten the pencil and paintbrush as an instrument of artistic representation, then you will never make a true critic.'[4]

[1] Dr Karl Voll, *Münchner Allgemeine Zeitung*, 1 December 1898.

[2] G. Bernard Shaw, 'The Unmechanicalness of Photography': *The Amateur Photographer*, 9 October 1902.

[3] G. Bernard Shaw, *The Amateur Photographer*, 11 October 1901.

[4] ibid.

XIV

IMITATION PAINTINGS

In their successful fight to win recognition for photography as an art, the photographers at the turn of the century had recourse to a formula which had proved successful in each generation: the production of photographs in which painters and art critics find the same characteristics that they look for in paintings. (Even today, art critics too often tend to value most those photographs that closely resemble paintings.) Photographers not only freed themselves from photography, as the Munich art critic paradoxically put it, but they also sought the ideal in the works of artists. It is remarkable that the very artists who had found inspiration in photographs now inspired photographers, foremost Degas, Corot, Pissarro, Renoir,

122. *Fred Boissonnas. 'Faust in His Study', 1898 (reproduction).*

123. *J. C. Strauss. Photographic portrait in the style of Frans Hals, 1904 (reproduction).*

124. *Richard Polak. Photograph in the style of Pieter de Hoogh*, 1914 (*reproduction*)

but few well-known mid and late nineteenth-century painters were safe from photographic imitation. Paul Pichier, an Austrian photographer, created Böcklinesque landscapes with figures at San Vigilio on Lake Garda and at Ischia near Naples, which is considered the original of Böcklin's imaginative 'Island of the Dead'. Peasant interiors—typical subjects of Wilhelm Leibl—were favoured by other Austrian and German photographers. Men in armour appeared *à la* Lovis Corinth. Edward Steichen,

the photographer and painter, gave a remarkably clever photographic rendering of his self-portrait in the style of Lenbach, the painter and photographer, etc. etc.

Numerous painters made equally fruitful—or fruitless?—use of photographs, but I must resist the temptation to be sidetracked into a discussion of the interaction of painting and photography—a fascinating subject that demands separate treatment. In this review of aesthetic trends I must confine myself

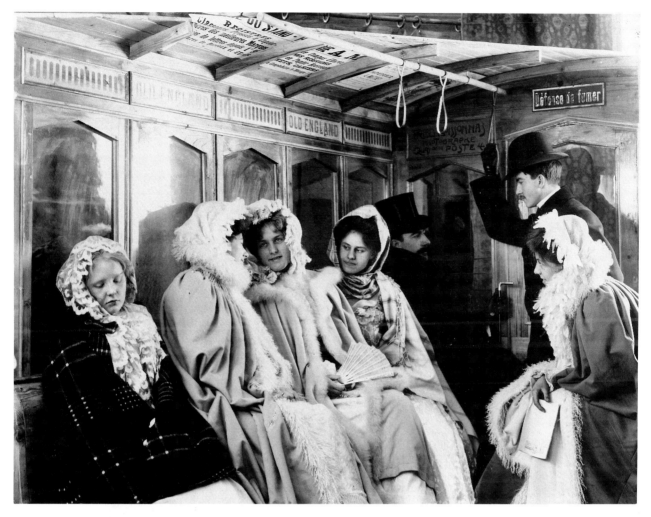

125. *Fred Boissonnas. 'Coming Home from the Theatre', 1900*

to mentioning that those who found impressionistic technique too difficult frequently turned to straightforward imitation of Old Master paintings as an alternative outlet for their 'ability'. Some photographers specialized in portraits after Rembrandt, Frans Hals, Van Dyck, Gainsborough, etc. The Italian photographer Guido Rey made *genre* pictures in the style of almost every century from Graeco-Roman *tableaux à la* Alma-Tadema to the French Empire, a period which also attracted the French amateur C. Puyo. The craze for these aberrations was international. F. Boissonnas of Geneva (*No.* 122), the Dutch-born Richard Polak (*No.* 124) and the American J. C. Strauss who started his series 'After the Old Masters' in 1904 (*No.* 123) are only a few examples. Though taking the utmost pains to achieve historical accuracy, sometimes to the extent of making direct imitations of a certain artist's style,

no photographer as far as I know, except Rejlander, ever attempted the reconstruction of a particular painting.

In his 'Coming Home from the Theatre' (*No.* 125) Boissonnas was undoubtedly influenced by popular pictures of similar subjects, in particular, I imagine, Daumier's several well-known illustrations of 'The First Class Carriage'. There is perhaps some justification for Boissonnas' studio reconstruction of a railway carriage, because a genuine scene of this kind could not be photographed before the introduction of modern miniature cameras.

Even sacred subjects suitable only for the artist with brush or pencil were attempted. Madonnas and saints more convincing than Mrs Cameron's appeared: Mrs Barton portrayed herself complete with halo as St Agnes.

The Americans F. Holland Day and Lejaren à

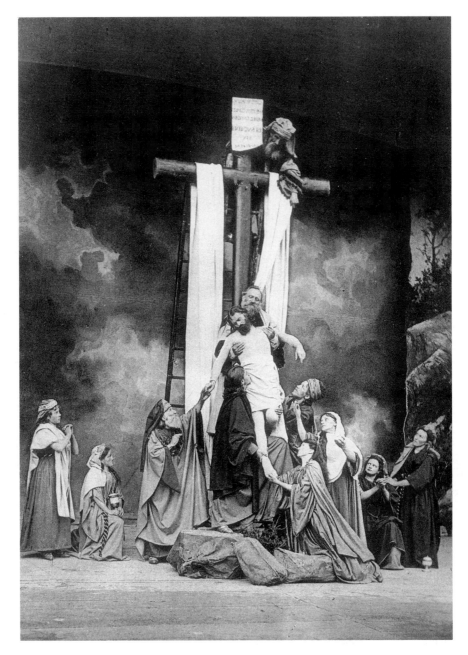

126. *Lejaren à Hiller. 'Deposition from the Cross', c.* 1910

Hiller (*No.* 126) and L. Bovier in Belgium depicted Entombments and Crucifixions—extraordinary aberrations of taste when arranged for exhibition purposes, but neither public nor photographers realized that, however accomplished, such productions completely failed to further the art of photography.

XV

THE AESTHETIC MOVEMENT

In September 1891 a dispute about the non-hanging of some photographs sent in late by George Davison to the Photographic Society's annual exhibition led to his resignation. With him went all the naturalistic photographers except Emerson, and even the famous old pictorialist H. P. Robinson. This was one of many secessions that occurred in the 1890s, in painting as well as in photography. Though personal animosities played some part the secessionists had all along been dissatisfied at the scientific bias the Society had taken on under its present and previous President. In May 1892 Alfred Maskell founded with fourteen others the Linked Ring Brotherhood, which soon included the most prominent foreign as

127. *Edward Steichen. 'Portrait of Lady H.' Photogravure of a coloured gum print, c. 1910*

128. *Hans Watzek. 'A Peasant.' Photogravure of a gum print, 1894*

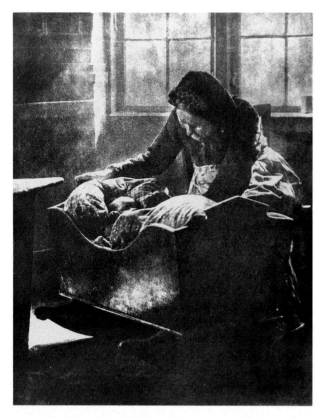

129. *Theodor and Oskar Hofmeister. 'Great-grand-mother.' Photogravure of a gum print, 1897*

well as British artistic photographers. It was a loose organization without a President or Council and anyone of marked artistic ability could be elected. By 1895 the Linked Ring consisted of about forty British and foreign members of which the best known were: (Britain) J. Craig Annan, H. H. Hay Cameron (son of Julia Margaret Cameron), George Davison, Frederick H. Evans, Col J. Gale, A. Horsley Hinton, Frederick Hollyer, Lyddell Sawyer, Frank Sutcliffe, J. B. B. Wellington, B. Gay Wilkinson; (France) Robert Demachy; (Austria) Dr Hugo Henneberg, Prof Hans Watzek; (America) Alfred Stieglitz.

A year after the foundation of the Linked Ring these independent amateur and professional photographers held their first Salon at the Dudley Gallery (formerly the Egyptian Hall) in Piccadilly, London. By its success the Salon established itself for the next fifteen years as the most important event in the photographic world. Horsley Hinton, editor of *The Amateur Photographer* and spokesman for the Linked Ring, never ceased in his propaganda for the recognition of photography as a means of artistic

expression, and his own fine landscapes lent force to his arguments. A strong yet tolerant personality, Hinton was admirably suited to unite men of widely differing interests and divergent views, a task of great importance considering that the British group, as initiators of the aesthetic movement and having the longest tradition in pictorial photography, were looked upon as natural leaders by foreign amateur organizations that were founded in Paris, Vienna, Hamburg, Brussels and New York. Some became allied to the Linked Ring and so for the first time pictorial photography grew into an international movement.

The French Salon formed by the fashionable Photo-Club de Paris in 1894 had a similar effect in France to the Salon of the Linked Ring in England. Its guiding spirits were Robert Demachy, Charles Puyo, René Le Bègue and Maurice Bucquet, its president. Demachy and Puyo with inventive genius and elegance of style—though not without occasional lapses of taste—portrayed feminine grace and took many delightful landscapes with figures. Le Bègue became famous for nudes; Bucquet depicted street life like a reportage photographer, achieving his effects by purely photographic means.

The most prominent members of the Vienna Camera Club, which organized its first international exhibition in 1891, were Heinrich Kühn (*No. 115*), Hugo Henneberg, Prof Hans Watzek (*No. 128*) and Dr Friedrich Spitzer.

Like most other countries apart from Britain and France, Germany had up to the mid-'nineties made no important contribution to artistic photography outside the field of portraiture. Hence the few people who were conscious of this lack were particularly vigorous in their support of the aesthetic movement. Ernst W. Juhl, founder of the Society for the Advancement of Amateur Photography in Hamburg and organizer of its international exhibitions from 1893 to 1903, and the art historian Prof Alfred Lichtwark, director of the Kunsthalle in Hamburg, were the influential men behind it. Fritz Matthies-Masuren, author, photographer, and editor of several photographic art magazines, was its leading spokesman.

No fewer than 6,000 amateur photographs were shown in the Hamburg Kunsthalle in 1893. The mere idea of a photographic exhibition in a leading art gallery seemed to the public at the time as incon-

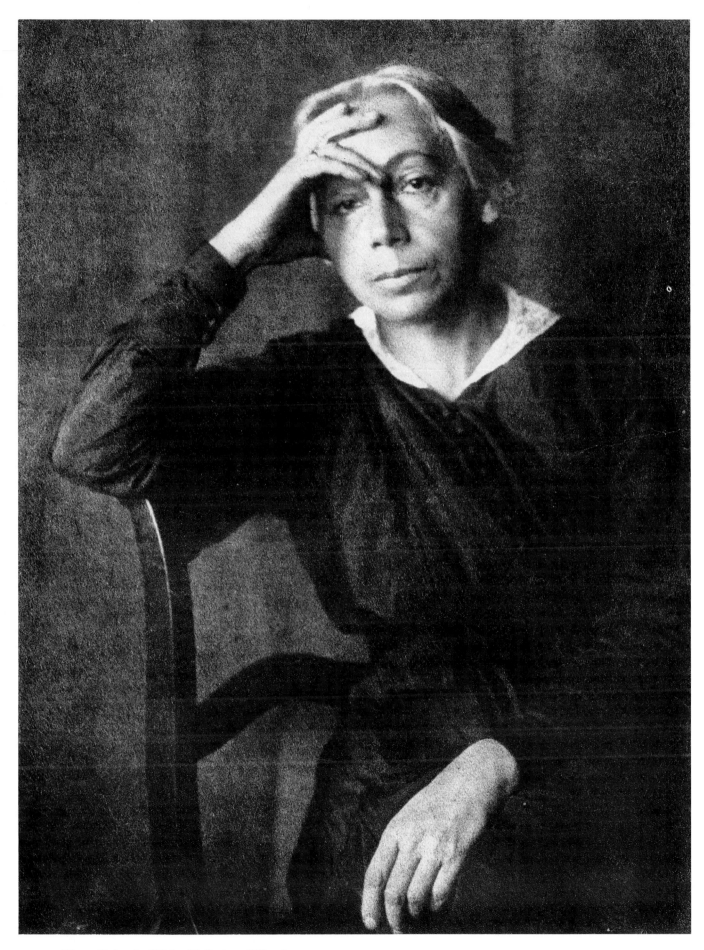

130. *Hugo Erfurth. Käthe Kollwitz. Oil-print, c.* 1925

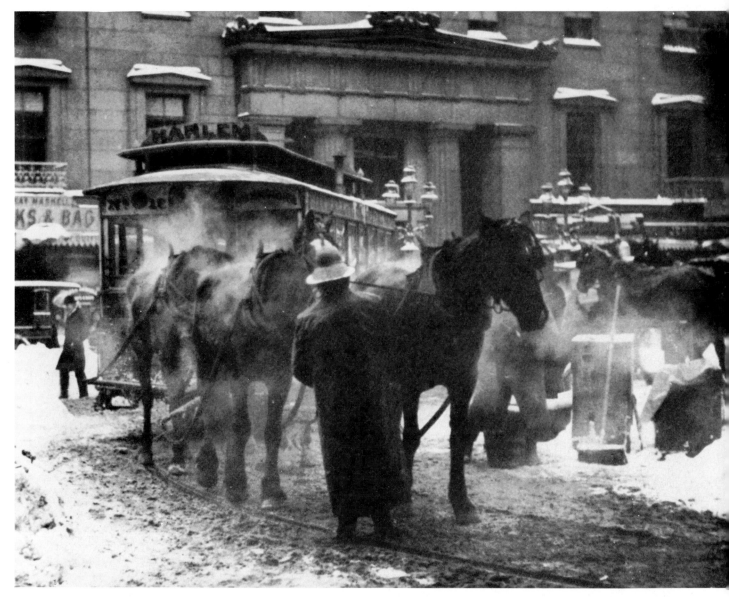

131. *Alfred Stieglitz. 'The Terminal.' Photogravure*, 1893

gruous as holding a scientific conference in a church. But Lichtwark made his gallery available in the hope that photography would revitalize painting, and especially portrait painting, which had almost died out. For the next decade the Hamburg exhibition established itself as an annual event. In 1899 Hill's and Adamson's portraits, seen for the first time outside Britain, were considered the highlight, despite the fact that the world's leading pictorialists were represented in force. It was realized that artistic photography had existed half a century before the modern aesthetic movement. In these old Calotypes, explained Lichtwark, the characteristics of the sitter

had not been interfered with by retouching, then in vogue with professional photographers, and as long as the public demanded and received flattering, and therefore characterless, photographic portraits, he feared they would not be able to appreciate truth in painting. This was a complete reversal of the situation during the early days of photography, when photographers complained that they were obliged to flatter the sitter because artists had made people accustomed to idealized portraits.

The influence of the exhibitions in Hamburg (*No.* 132) and other German cities was particularly marked in photographic portraiture, for in Germany

it was not so much amateurs like the brothers Theodor and Oskar Hofmeister (*No.* 129) as a number of professional portrait photographers who became the leading figures in the aesthetic movement: Rudolf Dührkoop of Hamburg, Hugo Erfurth (Dresden) (*No.* 130), Nicola Perscheid (Leipzig) and Wilhelm Weimer (Darmstadt).

Within a few years the exhibitions raised the standard and status of professional and amateur photography to an unprecedented level in Germany, winning for it official recognition in the highest circles. The Empress Frederick opened a big international exhibition of artistic photography in the Reichstag building in 1896, and three years later the Royal Academy of Art in Berlin opened its doors to a similar exhibition.

Lichtwark and Juhl had every reason to be satisfied with the results of their efforts. The former reported later that 'In barely five years the German

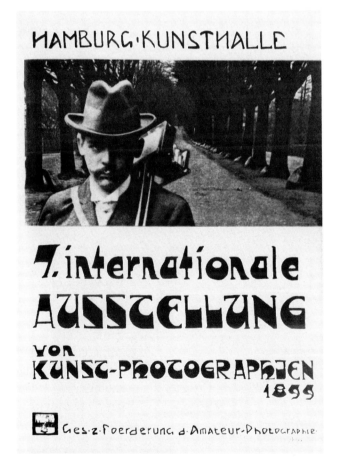

132. *Title-page of catalogue of photographic exhibition held at the Hamburg Kunsthalle (Art Gallery), 1899*

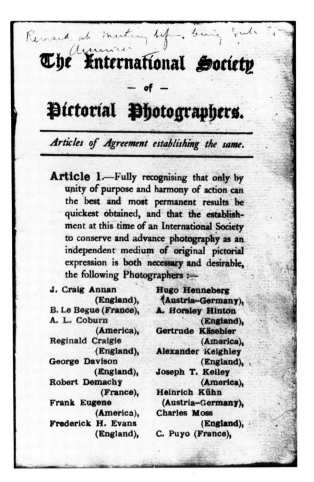

133. *First page of eight-page pamphlet of the International Society of Pictorial Photographers, 1904*

amateur photographers, until then the last, had come to the fore and brought to Germany, too, the decorative quality of photography as manifested in artistic expression and form.'[1]

In Italy realization that the camera could be used creatively became apparent for the first time at a photographic exhibition in Florence in 1895. This and subsequent exhibitions of artistic photography at Turin in 1897 and particularly in 1900—the first international exhibition of artistic photography to be held in Italy—aroused a widespread desire for photographic picture-making. Guido Rey was the most prominent of the Italian pictorialists, others being Cesare Schiaparelli, Giacomo Grosso and Gatti Casazza. Grosso was a painter; his *Il Supremo Convegno* was the succès de scandale of the first Biennale in Venice, 1895.

[1] Alfred Lichtwark, foreword to *Künstlerische Photographie: Entwicklung und Einfluss in Deutschland*, by F. Matthies-Masuren, Berlin, 1907.

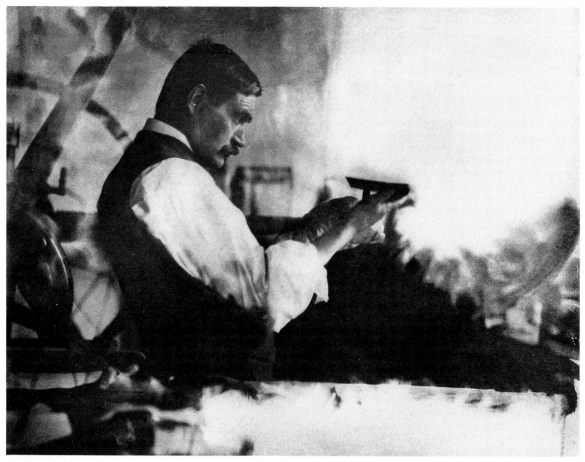

134. *J. Craig Annan. The painter and etcher Sir William Strang. Photogravure, c.* 1900

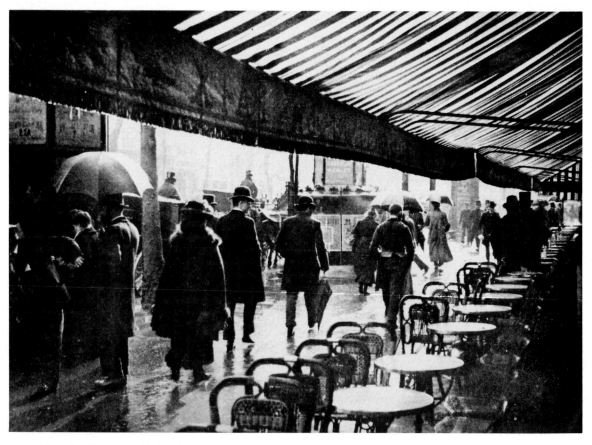

135. *Maurice Bucquet. 'Effet de Pluie', c.* 1899

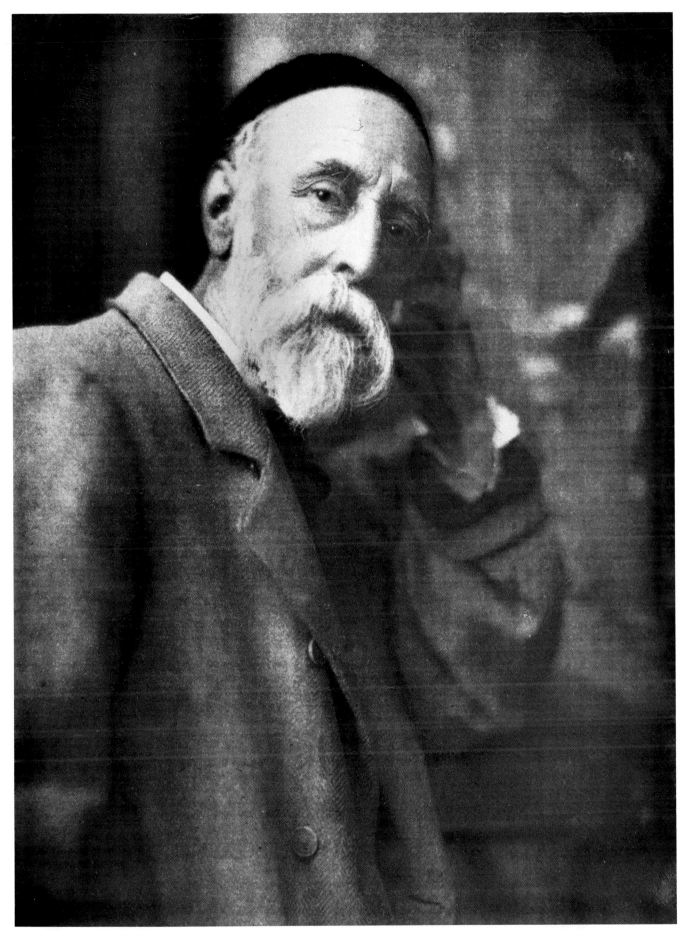

136. *H. H. H. Cameron. G. F. Watts. Photogravure, c. 1892*

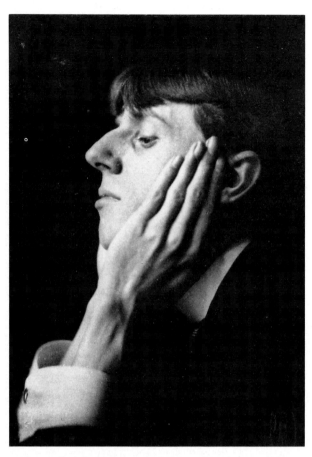

137. *Frederick H. Evans. Aubrey Beardsley. Platino-type, c.* 1895

The dominant figure of the Cercle d'Art Photographique established in Brussels in 1900 was Léonard Misonne. Like his better-known compatriot Vlaminck, Misonne became noted for his stormy views by late afternoon light. He was a master of *contre-jour* effects, and in many of his landscapes the sun is breaking through clouds after rain. This was by no means always the natural effect, for a few good sky negatives served Misonne for many gum prints and bromoils. Other well-known Belgian pictorialists were C. Puttemans, A. Bourgeois and M. Vanderkindere.

Whilst the German, Italian and Belgian groups were not affiliated to the Linked Ring, the Americans under Alfred Stieglitz formed its strongest and most progressive contingent. Stieglitz was a consistent advocate of the integrity of straight photography and owing to his influence a reaction set in in America against the manipulated print, which owed more to the ingenuity of the photographer than to photography. Realizing that ordinary everyday scenes had not been sufficiently explored, he set out to show that this was a field offering ample scope for the creative photographer, without the need to stoop to any artifices. Although some of Stieglitz's photographs taken in the 1890s still show a certain influence of impressionism in his preference for street scenes in wet or snowy weather (*No.* 131) or Monet-like railway stations—his approach was photographic.

Since his aims clashed with the more conventional outlook of the New York Camera Club, of which he was Vice-President, Stieglitz founded in 1902 the Photo-Secession, with Alvin Langdon Coburn, Frank Eugene, Gertrude Käsebier, Edward Steichen, Clarence H. White and forty-one others. Some of the secessionists still clung to the controlled printing processes, foremost Edward Steichen (*No.* 119) and Coburn; others shared their leader's belief in straightforward technique. All were agreed on two fundamental principles: the desirability of exploring photographic subject matter, and of concentration on rendering the subtleties of light.

'Let us use our instrument for the purpose for which it was intended: let us concentrate on doing the thing that we can do best, and not prostitute our medium by trying to do what we can accomplish only in a lesser degree, but what other mediums do easily and well. Let us do to the best of our ability that thing in which no other worker can rival us. Light, light, always light! . . . See and record its delicacy and daintiness in the upper ranges, its sombre play in the darks, its strength and vigour in the full scale, its infinite gradations, its infinite variety. . . . Ever and always use light to express your thought.'[1]

Camera Work, the Photo-Secession's luxuriously produced quarterly journal, was started by Stieglitz in January 1903 with the purpose of winning recognition for photography as art by publishing the work of leading contemporary American and European pictorial photographers. From 1908 onward he made the magazine the propaganda platform for modern art in general, for to him all manifestations of it were equally important. With Edward Steichen he opened in November 1905 the Photo-Secession Gallery at 291 Fifth Avenue, New York—later called simply '291'—for shows of the controversial Photo-Secession Group and leading European photographers of

[1] Paul L. Anderson, 'Some Pictorial History': *American Photography*, Boston, Vol. xxix, No. 4, April 1935.

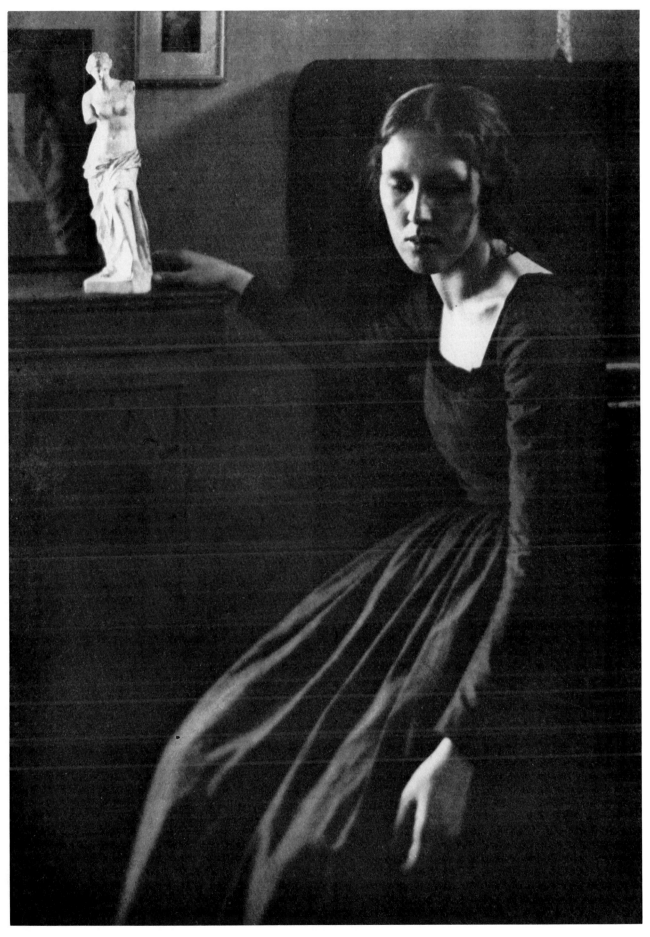

138. *Clarence H. White. 'Lady in Black.' Photogravure,* 1898

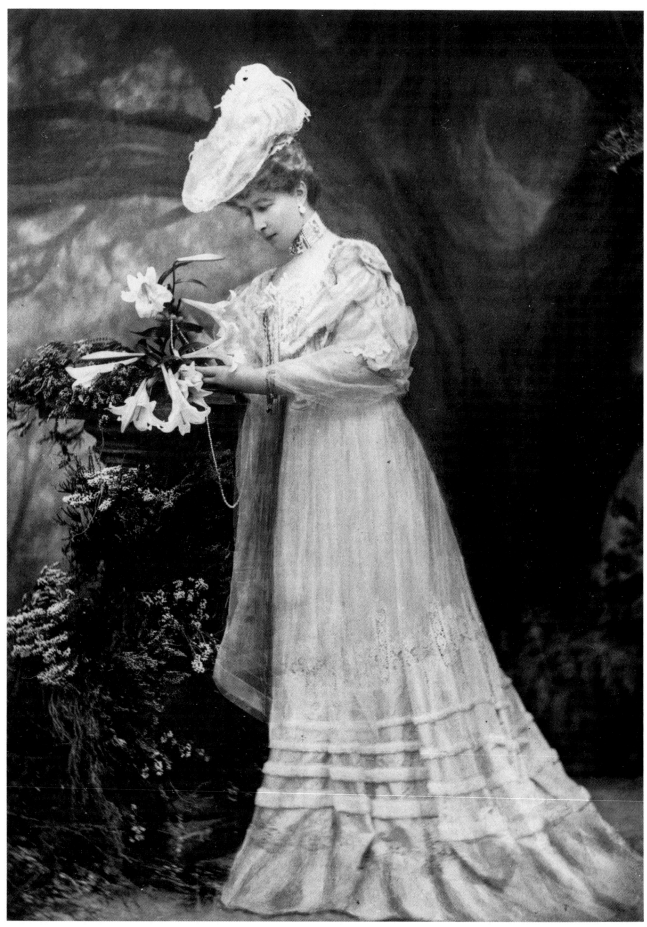

139. *Alice Hughes. The Arch-Duchess Stephanie (widow of Arch-Duke Rudolph of Hapsburg). Platinotype*, 1905

the aesthetic movement. Gradually he extended its scope to champion anyone breaking new ground in art. Stieglitz's artistic perception was far in advance of that of his contemporaries and made him the greatest protagonist of modern photography and modern art in the United States. It must be admitted that whilst the work of the artists still looks modern today, that of the photographers is—with a few exceptions—dated. The illustrations in *Camera Work* prove that the majority of Stieglitz's followers fall far short of his ideals, and one is sometimes puzzled how he could possibly have accepted their work so wholeheartedly. For most of it is arty, much of it sentimental, and some of it in questionable taste. The over-enthusiasm and conceit of the Photo-Secessionists knew no bounds. It is surprising that a serious editor could have passed for publication such ludicrous remarks as: 'One should not say he [Steichen] recalls Rembrandt but rather at this rate Rembrandt will, in time, remind us of Steichen.'

With the help of Steichen, who lived at the time in Paris, Stieglitz introduced to America the work of many now famous artists: Rodin drawings and works by Matisse (1908), John Marin and Toulouse-Lautrec lithographs (1909), Henri Rousseau and Cézanne (1910), Picasso (1911), Picabia (1913), Brancusi and Braque (1914), Severini (1917). Stieglitz also arranged the first exhibitions in the world of child art (1912) and Negro sculpture (1914) and furthered the development of what was later called Dadaism by publishing the magazine '291' during 1915–16. De Zayas, Picabia, Picasso, Man Ray, Max Jacob and Apollinaire were among the contributors, apart from Stieglitz and Steichen.

With his ever-increasing bias towards *avant-garde* art in *Camera Work* and at '291', the autocrat of the Photo-Secession alienated most of its members. One of them has described the shocked reaction of Americans to the paintings of 'blobby green females reclining on purple grass; magenta oceans and blue sunlight; paintings by children—and imbecile children at that; paintings of such a nature that only the maker could tell what they represented, and he had forgotten; pictures of the nightmares of *delirium tremens*; and pictures representing nothing that ever existed in the heavens above, or the earth beneath'.[1] No wonder, then, that by 1917 the sub-

[1] Paul L. Anderson, 'Some Pictorial History': *American Photography*, Boston, Vol. xxix, No. 4, April 1935.

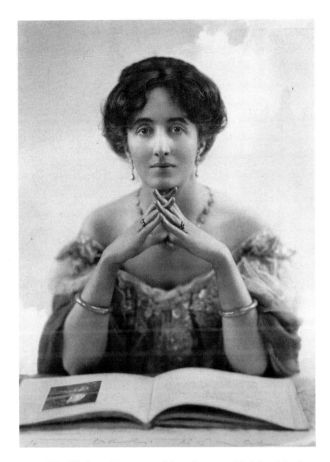

140. *H. Walter Barnett. Mrs Saxton Noble. Platinotype, c.* 1908

scribers to *Camera Work* had dwindled to thirty-six, and with America's entry into the war both magazine and gallery closed down. However, in 1925 Stieglitz renewed his influential activities at 'The Intimate Gallery' and later at 'An American Place', New York.

In Europe, the American Photo-Secession exerted considerable influence by participating in various international exhibitions of pictorial photography. In 1904 the English, French, German/Austrian and American groups combined in the formation of the International Society of Pictorial Photographers 'to conserve and advance photography as an independent medium of pictorial expression' (*No.* 133). Its first and only president was J. Craig Annan of Glasgow. The Society was a grand alliance held together by a common purpose, though there was a considerable divergence of opinion as to what constituted artistic photography.

Pictorial photographers at that period can be divided into three categories:

(1) A minority were purists in the full sense. They

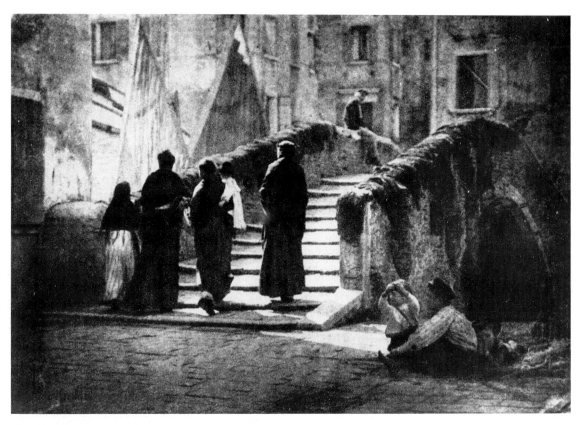

141. *Alexander Keighley. 'The Bridge.' Oil-print, 1906*

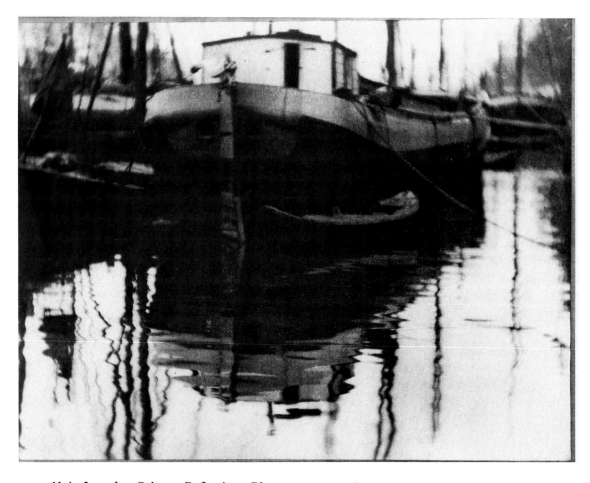

142. *Alvin Langdon Coburn. Reflections. Photogravure, 1908*

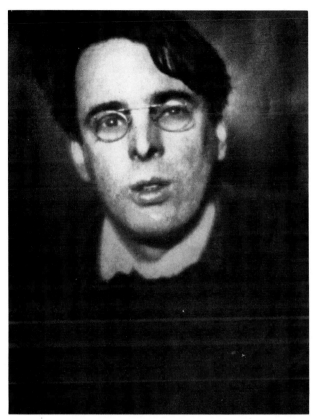

143. *Alvin Langdon Coburn. W. B. Yeats. Photogravure*, 1908

ployed as the printing process. (*Nos.* 142, 143, 144.)

Alvin Langdon Coburn, a Boston painter and a member of the Photo-Secession and the Linked Ring, in 1906 established his reputation as a photographer in England with a one-man show at the Royal Photographic Society, which included a good many portraits of famous men, including G. B. Shaw, who wrote the foreword to the catalogue:

'Mr Coburn can handle you as Bellini handled everybody . . . according to his vision of you. He is free of that clumsy tool—the human hand . . . and takes full advantage of his freedom, instead of contenting himself, like most photographers, with a formula that becomes almost as tiresome and mechanical as manual work with a brush or crayon.'

Whilst Coburn admirably brought out the character of his sitters, his portraits would, in my opinion, gain in vigour if they were less impressionistic and more like Bellini's. But he had the right outlook. In another one-man show, at the Goupil Gallery in

imbued ordinary subjects—landscapes, architecture, portraits, and everyday scenes—with an artistic quality based solely on sensitive interpretation, and rejected manual interference with negative or positive. Their prints were usually made on platinum paper, though hand-made photo-etchings and photogravures were also favoured. To this group belonged J. Craig Annan (*No.* 134), Maurice Bucquet (*No.* 135), H. H. H. Cameron (*No.* 136), Frederick H. Evans (*No.* 137), Frederick H. Hollyer (*No.* 145), H. C. Rubincam, Alfred Stieglitz and Clarence H. White (*Nos.* 138 and 144), Alice Hughes (*No.* 139), H. Walter Barnett (*No.* 140).

(2) The majority took similar subjects but made full use of the possibilities of modifying the negative image in the positive print. In addition to the gum print, a number of other controlled printing techniques were introduced. Of these, the oil process (1904) (*No.* 141) and the bromoil method (1907) were the most important.

(3) Some photographers strove for impressionistic effects by optical means alone. Usually the negative was taken out of focus and hand-photogravure em-

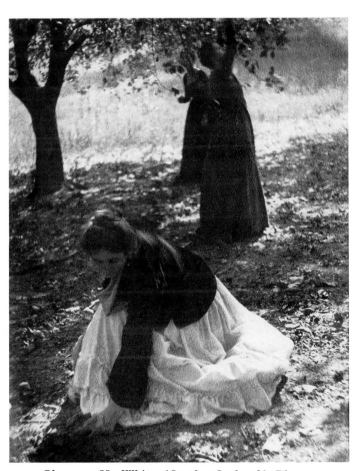

144. *Clarence H. White. 'In the Orchard.' Photogravure*, 1902

147

London in 1913, he included five photographs entitled 'New York from its Pinnacles'. Realizing that the novelty of these bird's-eye views might puzzle the public, Coburn persuasively asked in the catalogue foreword: 'Why should not the camera artist break away from the outworn conventions, that even in its comparatively short existence have begun to cramp and restrict his medium, and claim the freedom of expression which any art must have to be alive?'

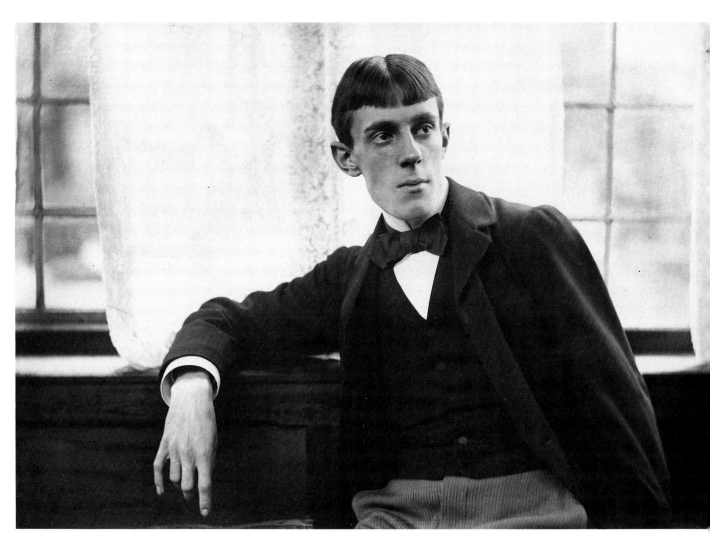

145. *Frederick H. Hollyer. Aubrey Beardsley*, 1896

XVI

THE BEGINNINGS OF MODERN PHOTOGRAPHY

Alfred Stieglitz's photographs 'Going to the Post' (*No.* 146) and 'The Steerage' (*No.* 149) are landmarks on the road to modern photography. So are 'The Circus Rider' (*No.* 147) by Harry C. Rubincam, another of the Photo-Secessionists, and above all the photographs of Paul Strand, who is in my opinion the most progressive—and incidentally the last—photographer to have an exhibition at the Photo-Secession Gallery. In devoting the last issue of *Camera Work* entirely to Strand's photographs, Stieglitz explained:

'In the history of photography there are but few photographers who, from the point of view of expression, have really done work of any importance. And by importance we mean work that has some relatively lasting quality, that element which gives all art its real significance. . . . Paul Strand has added something to what has gone before. The work is brutally direct. Devoid of all flim-flam; devoid of trickery and of any "ism"; devoid of any attempt to mystify an ignorant public, including the photographers themselves. These photographs are the direct expression of today.'[1]

A greater contrast than Paul Strand's original, unaffected, straightforward photographs of 1915–16 and the arty work of the aesthetic movement, which was an evasion of everything truly photographic, can hardly be imagined. Strand brought a new vision to photography, discovering in the most ordinary objects significant forms full of aesthetic appeal. Nearly all his pictures broke new ground both in subject matter and in its presentation. The white fence running across the entire width of the picture (*No.* 148) intentionally destroys all effect of perspective. A ram-

shackle suburban scene (*No.* 150), the backyard of a New York house in winter, a vertical view from a suspension bridge showing its shadow on the road beneath, were new kinds of subject. In the almost abstract design of kitchen bowls (*No.* 151) and the shadow of railings Strand showed for the first time the effectiveness of rhythmic repetition in pat-

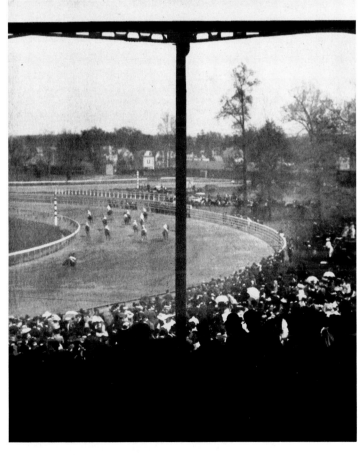

146. *Alfred Stieglitz. 'Going to the Post.' Photogravure,* 1904

[1] A. Stieglitz, *Camera Work*, Nos. 49–50, June 1917.

149

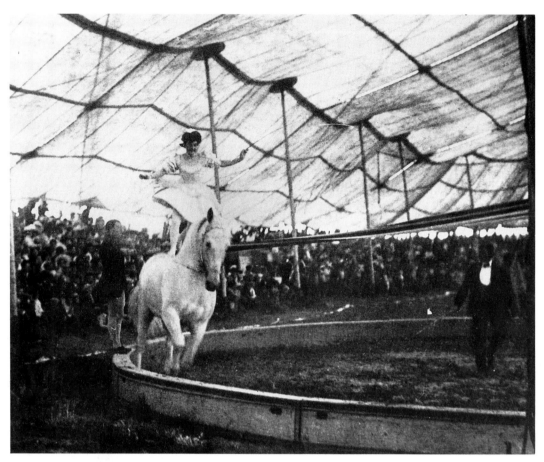

147. *Harry C. Rubincam. 'The Circus Rider.' Photogravure, 1905*

148. *Paul Strand. 'The White Fence.' Photogravure, 1916*

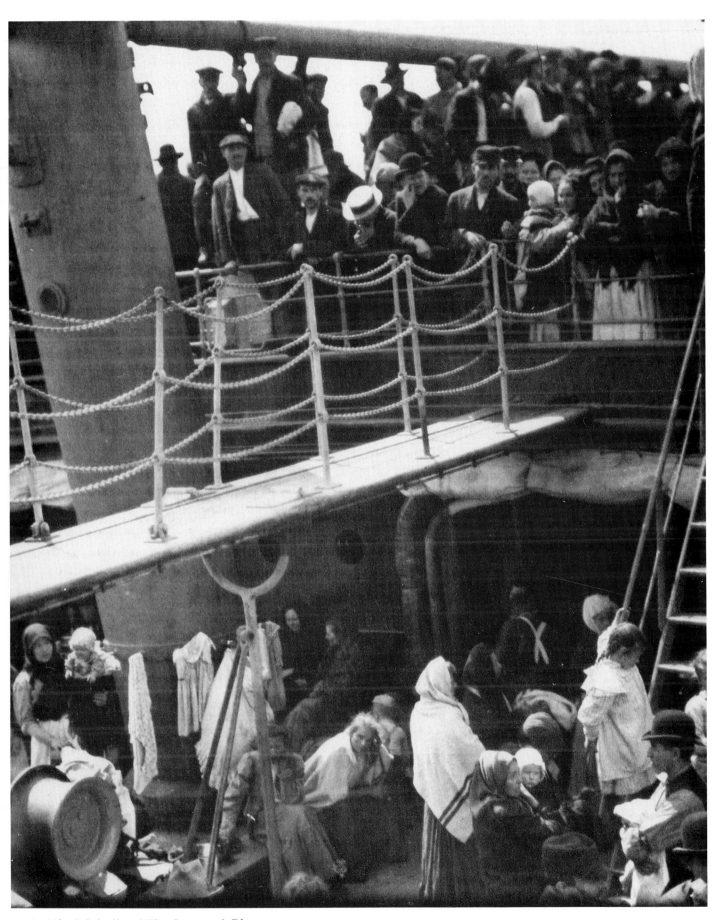

149. *Alfred Stieglitz. 'The Steerage.' Photogravure,* 1907

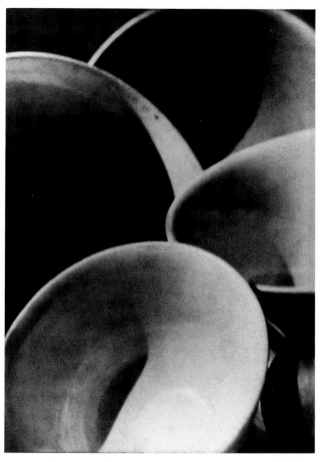

150. *Paul Strand. New York. Photogravure,* 1915

151. *Paul Strand. Abstract pattern made by bowls. Photogravure,* 1915

tern. The bowls and other experiments in abstraction were the result of Strand's seeing at '291' the work of Picasso, Braque, Brancusi and others.

'I was trying to apply their then strange abstract principles to photography in order to understand them. Once understanding what the aesthetic elements of a picture were, I tried to bring this knowledge to objective reality in the "White Fence", the "Viaduct" and other New York photographs. Nor have I ever returned to pure abstraction, as it had no further meaning for me in itself. On the other hand, subject matter all around me seemed inexhaustible. I began to explore the close-up. The portraits of New York street characters (*No.* 152) represent another trend in experimentation. This was to photograph people without their being conscious of being photographed. The technique I used at the time was a false lens screwed to the side of my $3\frac{1}{4}$ in. $\times 4\frac{1}{4}$ in. camera.'[1]

[1] Extract from a letter from Paul Strand to Helmut Gernsheim, 15 December 1960.

Strand's New York street scenes and characters and other everyday subjects are wonderfully alive, fragments of the kaleidoscopic variety of appearances which are so familiar that one is apt to overlook their photographic potentialities. They owe their vitality and expressiveness to the photographer's personal taste and artistic knowledge, showing the facts filtered through the subjectivity of the artist. Yet what makes these photographs so striking is their apparent objectivity.

'This objectivity is of the very essence of photography, its contribution and at the same time its limitation. The photographer's problem is to see clearly the limitations and at the same time the potential qualities of his medium, for it is precisely here that honesty no less than intensity of vision is the pre-requisite of a living expression. The fullest realization of this is accomplished without tricks of process or manipulation, through the use of straight photographic methods.'[2]

[2] Paul Strand, *Camera Work,* Nos. 49–50, June 1917.

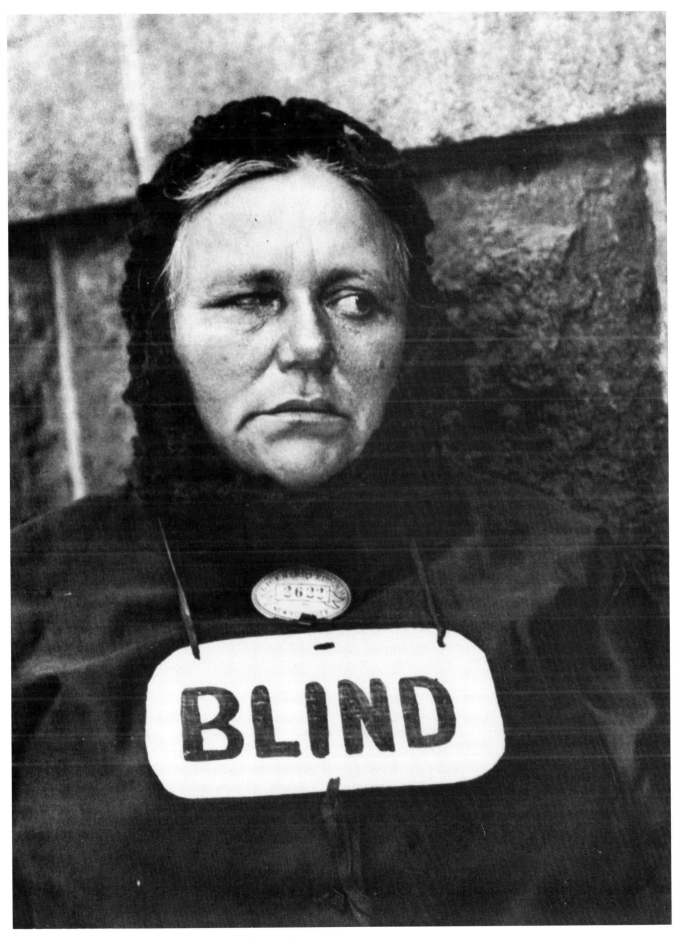

152. *Paul Strand. Blind woman in New York. Photogravure,* 1915

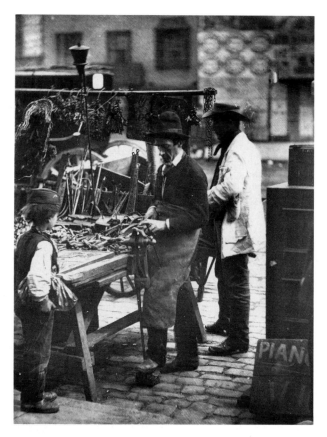

153. *John Thomson. Street locksmith,* 1876

Paul Strand was bringing back the original but long-forgotten conception of photography:

'Look at the things around you, the immediate world around you. If you are alive, it will mean something to you, and if you care enough about photography, and if you know how to use it, you will want to photograph that meaningness. If you let other people's vision get between the world and your own, you will achieve that extremely common and worthless thing, a pictorial photograph.'[1]

Paul Strand was as lucid and direct in his writing as in his photographs. He was more articulate in his views as to what constituted true photography than anyone before him. His approach was intellectual. Nevertheless there were a few photographers in England and France who had already arrived at the same goal by instinct. Remaining aloof from photographic exhibitions, they did not become self-conscious about the art claims of photography and consequently used the camera as objectively as Strand, or for that matter as the first generation of

[1] Paul Strand, 'The Art Motive in Photography': *The British Journal of Photography*, 1923, p. 613.

photographers. Owing to the circumstance, however, that they worked quietly for their own satisfaction, their excellent pictures remained unknown at the time, whilst those of exhibitors were discussed in photographic journals and reproduced in one form or another.

In their directness and aesthetic appeal John Thomson's photographs of street life in London in 1876 are on a par with those of New York taken by Paul Strand forty years later. Thomson's purpose was not to make pictures but to document the life of the poor, but the artistic impact of his photographs is no less immediate. His book *Street Life in London* (1877) may be considered a sequel to Henry Mayhew's monumental social survey. The thirty-six illustrations are particularly valuable in showing street traders in their natural surroundings, each photograph being accompanied by an article on the life and conditions of the subject: street musicians, a shoe-shine, a quack doctor, a locksmith (*No.* 153), a chimney sweep, an old clothes dealer, a bus conductor, Italian ice cream seller, recruiting sergeants, etc. In the down-and-out woman who looked after the babies of working women (*No.* 154) Thomson has caught the misery of semi-starvation, producing a picture that could not be improved upon today.

As pointed out in Chapter XI, some amateurs had discovered long before the art photographers the fascination of spontaneous photographs that capture a slice of life, and Paul Martin and F. W. Mills are the classic examples of candid camera-men active long before that expression came into use. With a 'detective' camera got up to look like a parcel and a reflex camera respectively, they roamed in the mid-nineties the streets of London and the beaches of Yarmouth and other popular seaside resorts, to capture unobserved revealing moments (*No.* 155) and the expressions of people enjoying themselves (*No.* 156). Hampstead Heath on Bank Holiday, a Punch and Judy show, children dancing to a barrel-organ, the Crystal Palace grounds at Sydenham, etc., provided many intimate pictures, and in every case it is obvious that no one suspected that the ordinary-looking parcel, which Martin carried so carefully, concealed the all-seeing eye of a camera.

Similar candid street life photographs were taken about the same period by an unknown photographer in New York (*No.* 157) and by Maurice Bucquet (*No.* 135) and Eugène Atget in Paris. With the excep-

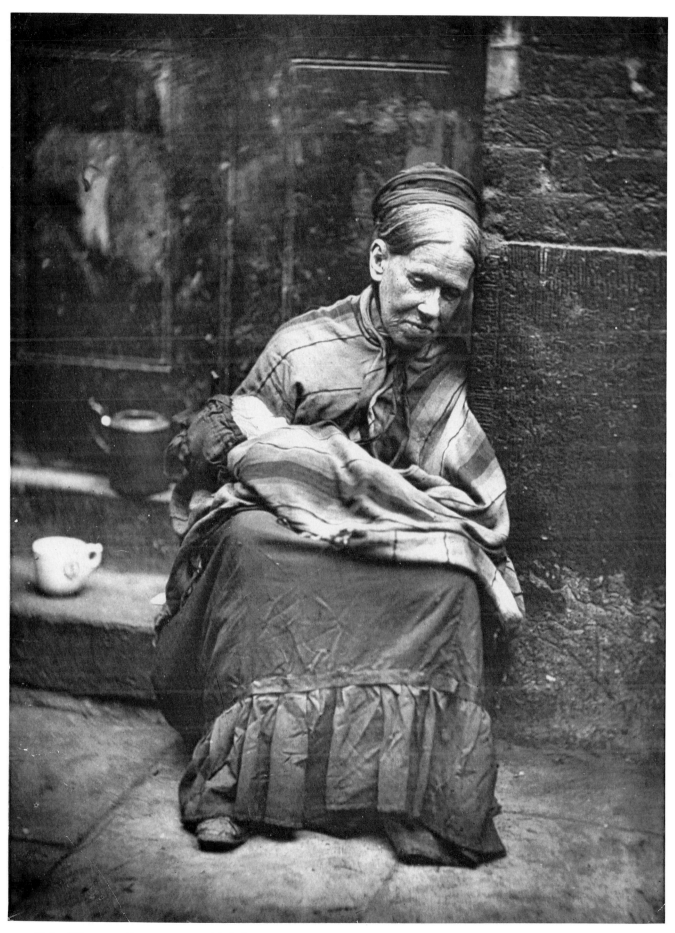

154. *John Thomson. Poor woman with baby, 1876*

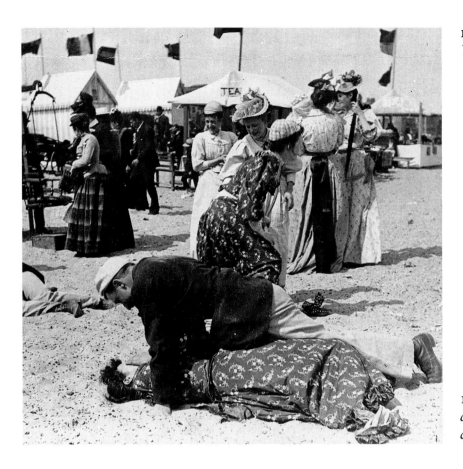

155. *Paul Martin. Flirtations on Yarmouth beach, c. 1892*

156. *Paul Martin. Listening to a concert party on Yarmouth beach, c. 1892*

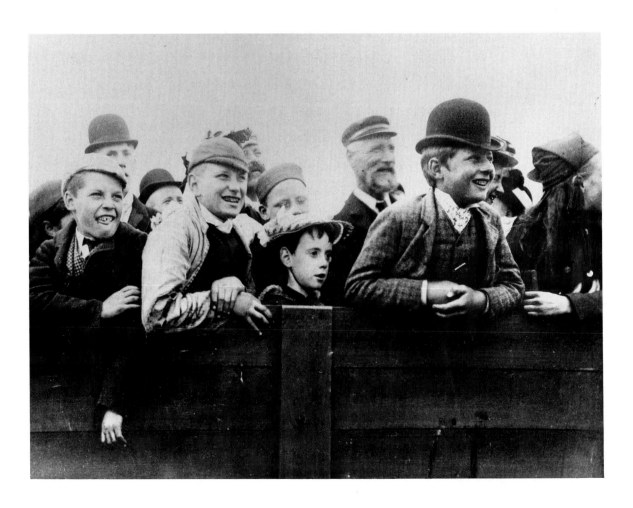

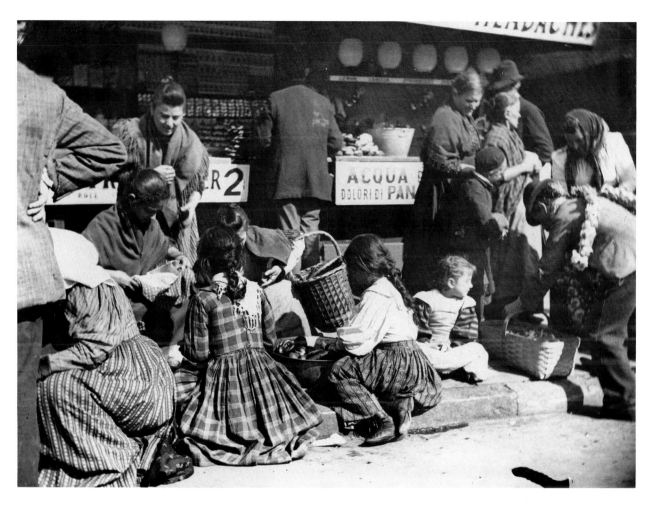

157. *Anon. Young children selling food in New York slum quarter, Mulberry Bend,* 1897

158. *Eugène Atget. A prostitute at Versailles,* c. 1920

159. *Eugène Atget. Tree roots at St Cloud, c.* 1905

tion of Bucquet, a member of the Photo Club of Paris, none of these photographers was concerned with photography as an art.

Atget was obsessed by the need to document everything of interest in a Paris that was vanishing. Whereas others extolled the grandeur of the capital, Atget's interest inclined towards the unattractive and even seamy side of the metropolis. His pictures include every kind of street trader from an umbrella seller to a prostitute (*No.* 158); every kind of

wheeled vehicle from a baker's barrow to a cab; curious shop window displays (*No.* 160), the gaudy and fantastic decorations of shop signs and merry-go-rounds; the narrow streets of Montmartre and of the Quartier Latin; porticoes, staircases, door-knockers, wrought-iron grilles, and ornate stucco ornamentation of houses that had seen better days— all caught Atget's roving eye and were documented for posterity in thousands of photographs. With the same zeal he took numerous views of the beautiful

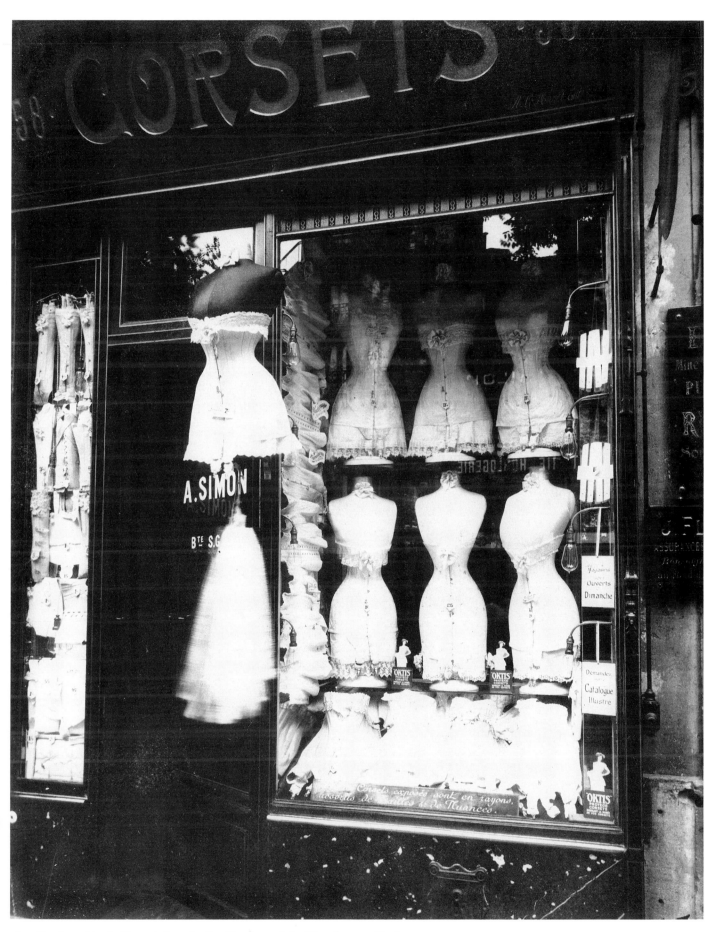

160. *Eugène Atget. Corset shop in the Boulevard de Strasbourg, Paris, c. 1905*

gardens and statues of the Palais du Luxembourg, Versailles, Fontainebleau and St Cloud. Above all, Atget loved the close-up, recognizing it as the most characteristic form of photography expressing the very quintessence of the object. His work includes countless close-ups of unusual forms and patterns of flowers and gnarled tree roots (*No.* 159) that were to become favourite themes with Renger-Patzsch, Paul Strand, Weston and others in the 1920s, but had only occasionally attracted photographers in earlier periods.

Only a man with enormous faith could have pursued his aims so singlemindedly, for Atget received little encouragement from official circles and lived the life of a recluse in extreme poverty. After his death in 1927 about ten thousand photographs, neatly numbered and classified, were found in his flat. At the time few people could comprehend their purpose but today Atget's influence is apparent in all modern documentary photography. He has even been called 'the father of modern social documentation', though this designation would be more correctly accorded to John Thomson.

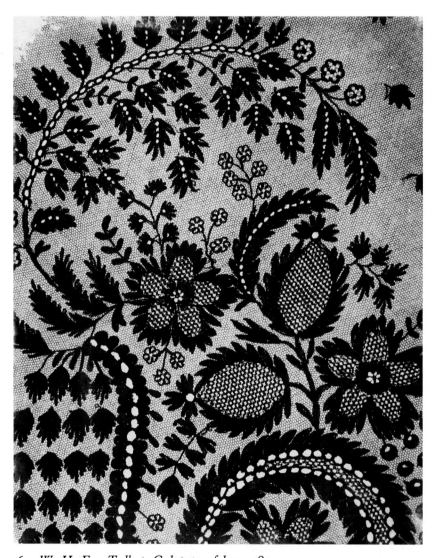

161. *W. H. Fox Talbot. Calotype of lace,* 1842

XVII

PHOTOGRAPHY IN THE RETORT

At the end of World War I cynicism, disillusionment, and contempt for the established order led not only to political upheavals but also to a disintegration of accepted conventions in art. It was a trend that had started well before the war with the Cubists, Futurists, Expressionists and les Fauves, who cast traditional rules of composition and colouring aside in their search for new forms of expression.

Under the influence of his friend the Cubist painter Max Weber, Alvin Langdon Coburn felt a similar urge to experiment. 'I do not think we have even begun to realize the possibilities of the camera' he told photographic colleagues in 1916. 'The beauty of design displayed by the microscope seems to me a wonderful field to explore from the purely pictorial point of view.' And he expressed the hope that photo-

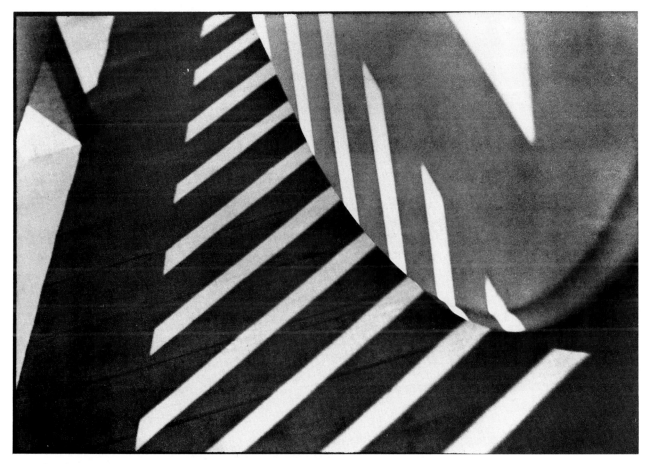

162. *Paul Strand. Shadow pattern. Photogravure, 1916*

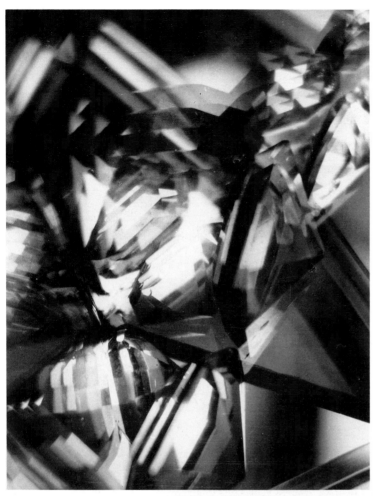

163. *Alvin Langdon Coburn. Vortograph: the first abstract photograph, January* 1917

164. *Christian Schad. Schadograph,* 1960. (*Replica specially made for this book*)

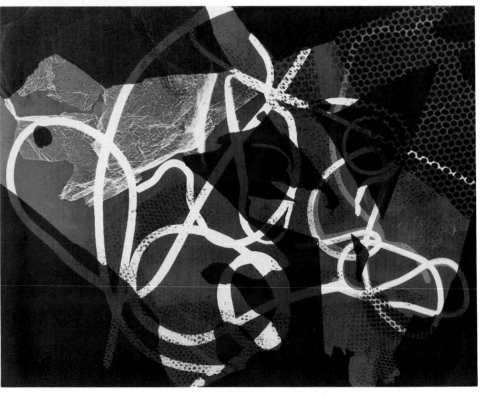

graphy might fall in line with all the other arts and 'with her infinite possibilities do things stranger and more fascinating than the most fantastic dreams. . . . I want to see photography alive to the spirit of progress; if it is not possible to be "modern" with the newest of all the arts, we had better bury our black boxes.'[1] As a start Coburn suggested an exhibition of abstract photography to which no work would be admitted in which the interest of the subject was greater than the appreciation of the extraordinary. Such a photograph is Paul Strand's kitchen bowls (*No.* 151) and his shadow pattern (*No.* 162), both dating from 1916.

Coburn experimented with multiple exposures on the same plate and with the use of prisms for the splitting of images into segments, by placing the camera lens inside an arrangement of three mirrors forming a triangle, through which bits of wood, crystals and other objects were photographed. In this way he created in January 1917 the first abstract photographs, which he called 'Vortographs' (*No.* 163), after Vorticist, a term devised by Ezra Pound to denote a group of painters and poets of which he was one of the chief exponents. The following month eighteen Vortographs were shown together with thirteen of Coburn's paintings at the London Camera Club.[2] The catalogue foreword was by Ezra Pound.

Two years later the driving spirit of the Geneva Dada group turned to photography, trying to mould it to his own ends. Christian Schad, a German painter, made abstract designs somewhat on the lines of Fox Talbot's photogenic drawing process by laying flat opaque or semi-transparent objects and strips of ordinary paper on photographic plates or photographic paper and exposing them to a lightsource that could be veiled or shaded (*No.* 164). Whereas Talbot had only been concerned with *copying* plants, feathers, lace, etc. (*No.* 161), Schad felt that this technique offered great possibilities for creating interesting designs simply and cheaply. Tristan Tzara, the spokesman of the Dada group, called these compositions 'Schadographs' after their originator (not 'Shadowgraphs' as they are sometimes mistakenly called).

'Schadographs were made at a period when I had a liking for any trifles that could be picked up in the

street, in shop window displays, in cafés, and even in dustbins. Most of these objects I found attractive and useful, particularly if they were damaged. Then they had a patina, and held a kind of magic for me. Having found them, it was a matter of making a composition in such a way that something new resulted, and a fresh immediate reality emerged. An unimportant object can take on a new form by being worked upon, distorted, made into a *collage*, or turned upside down. It all depends! There are a great many possibilities of varying the effect, for one can also draw or paint on the composition.'[3]

George Grosz and John Heartfield in 1915 revived photo-montage in a new combination of photography with graphic art and painting. In this they

[3] Description of Schadographs sent to Helmut Gernsheim in August 1960. See also Schad's autobiographical notes contained in the postscript to Walter Serner's novel *Die Tigerin*, Munich, 1971.

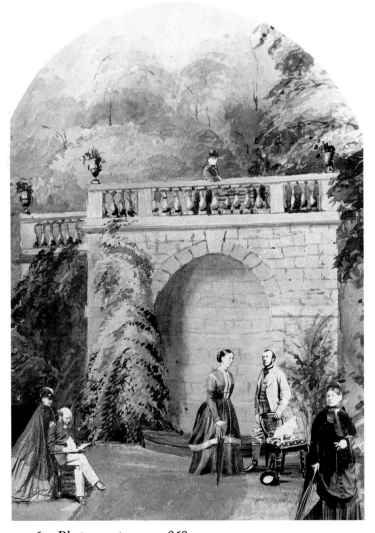

165. *Photo-montage, c.* 1868

[1] Alvin Longdon Coburn, 'The Future of Pictorial Photography': *Photograms of the Year*, 1916.

[2] Two Vortographs were published for the first time in *The Sketch*, 14 March 1917.

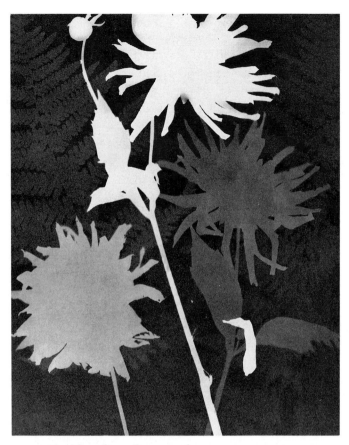

166. *Man Ray. Rayograph*, 1921

three-dimensional opaque and translucent objects on photographic paper. In these abstract patterns of light and shade, appropriately called 'Rayographs', the physical form of the objects is reproduced more or less recognizably, but the negative image inevitably and intentionally lacks any gradation of tone (*No.* 166).

The following year Tzara showed László Moholy-Nagy, a Hungarian abstract painter living in Berlin, a set of twelve 'Rayographs' Man Ray had just published, to which he, Tzara, had contributed a preface.[1] Moholy-Nagy was very impressed by these novel abstract light-pictures and at once set to work to produce similar designs with three-dimensional objects which he called 'photograms' (*No.* 167).

[1] *Champs Délicieux*, an album of twelve original Rayographs by Man Ray, with preface by Tristan Tzara (limited to 40 copies), Paris, 1922.

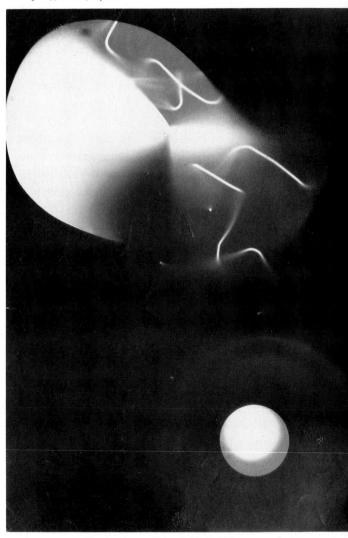

167. *L. Moholy-Nagy. Photogram*, 1922

had possibly been inspired by mid nineteenth-century photo-montages in which cut-out photographs were either combined with one another to make a new composition (see H. P. Robinson, page 81) or—more usually—pasted on a watercolour. A painted landscape was peopled with photographic figures either in a naturalistic way (*No.* 165), or an intentionally incongruous or surrealist effect was sought (see Chapter XIX). Never before, however, had photo-montages resulted in such a completely mad jumble as those of the Dadaists and Surrealists, particularly Max Ernst, Johannes Baader, Raoul Hausman, Hannah Höch and Kurt Schwitters, who also tried his hand at photograms. In the attempt to destroy all visual illusion, and to shock the conventional, disjointed pieces of photographs were combined with torn-off bits of newspaper, or stuck on canvas without any apparent relation to the painting.

In 1921 Man Ray, the American abstract painter and Dadaist, settled in Paris, and hearing from Tristan Tzara of Christian Schad's 'Schadographs' with flat objects, started experimenting by placing

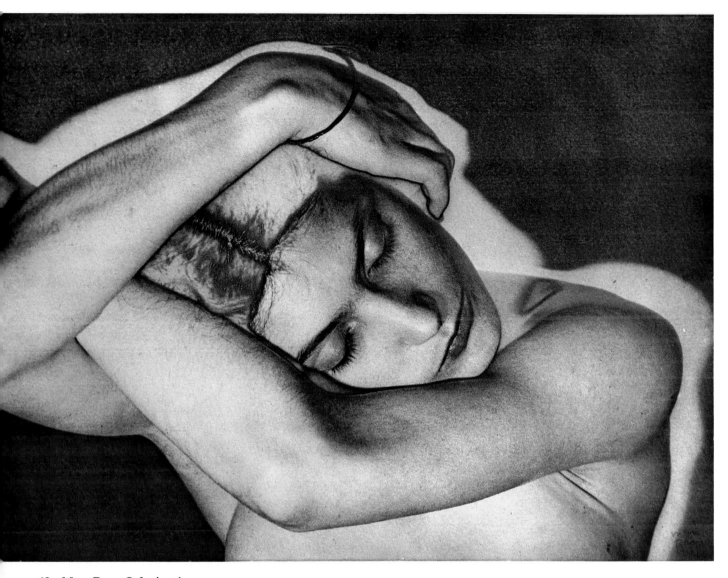

168. *Man Ray. Solarization,* 1931

Five or six years later Man Ray, who was then making his living chiefly by photography—reproducing paintings by leading modern artists and taking their portraits—accidentally stumbled upon solarization. The partial reversal of the negative into a positive image by a short exposure to light during development is a physical phenomenon due to extreme over-exposure, and known since 1862 as the Sabattier effect. Attracted by the graphic design he obtained, Man Ray in lengthy experimentation sought to bring the fault under control so that he could deliberately use it for the sake of artistic effect. In this way he produced some fascinating designs (*No.* 168).

In 1923 the architect Walter Gropius invited Moholy-Nagy to join the teaching staff of the Bauhaus, the experimental art school which he had founded in Weimar in 1918. Gropius aimed at restoring the unity of all the arts in the service of architecture, reverting to the idea of the medieval cathedral on which architects, stained-glass artists, sculptors, painters, woodcarvers, metal-workers and other craftsmen had worked collectively. In the same spirit Gropius and his staff of distinguished *avant-garde* artists— Paul Klee, Wassily Kandinsky, Lyonel Feininger, Herbert Bayer, Oskar Schlemmer and others—worked as a team in close collaboration with one another and their students. Many features of modern architecture and industrial design had their origin at the Bauhaus.

169. *L. Moholy-Nagy. View from radio tower, Berlin, 1928*

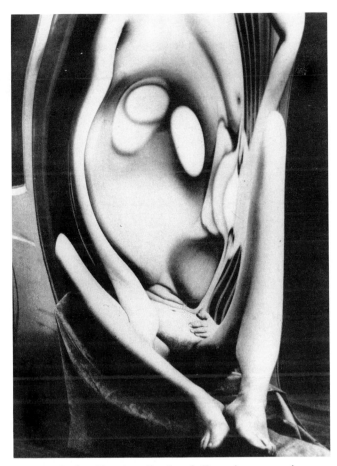

170. *André Kertész. Study of distortion*, 1934 (*reproduction*)

171. *Helmut Gernsheim. One seed of a dandelion* (35 × *mag.*), 1936

Moholy-Nagy, whose activities ranged from metal-work and designs for plastics to typography, became very interested in photography through his wife Lucia, who was a trained photographer. His primary intention was to investigate its potentialities as applied to other branches of art. No photography class was offered at the Bauhaus until 1928, after Moholy-Nagy had left. His special interest lay in the relationship of painting, photography and film, to which he added the 'typophoto'—the combination of the printed word with a photograph in layout and advertising. He expounded his theories on the future of photography in his Bauhaus book *Malerei, Photographie, Film* (1925) and in an essay published in *Das Deutsche Lichtbild*,[1] a photographic yearbook of the less conventional type. In 1929 the German Werkbund arranged an important Film and Photo Exhibition in Stuttgart, organized by Gustaf Stotz and shown from May 18 to June 7. It was the first international exhibition demonstrating the new vision, with nearly a thousand tradition-shattering

photographs, many of them contributed by Moholy-Nagy, Renger-Patzsch, John Heartfield, A. M. Rodchenko, Edward Weston, Berenice Abbott, Edward Steichen and others of the American School. A selection of seventy-six was published the same year in a book called *Photo Auge* (Photo Eye), with text by Franz Roh.

These various publications demonstrated the great variety of possibilities which Moholy-Nagy envisaged 'for creating a more complex language of photography': angle shots (*No.* 169), deliberate distortions (*No.* 170), exaggeration of texture, superposition of photographs or multiple exposures on one negative, aerial photographs giving a pattern effect, solarization, negative prints, non-medical X-ray photographs, astronomical photographs, photomicrographs (photographs of minute objects taken through the microscope), photomacrographs (over-life-size photographs of small objects taken with an ordinary camera), reticulation (breaking up the emulsion by the application of heat), abstract photographs without the use of a camera (photograms, Schadographs and Rayographs), photo-montages and 'typophotos'. Undeniably these revolutionary

[1] L. Moholy-Nagy, 'Die Beispiellose Fotografie': *Das Deutsche Lichtbild*, Vol. I, Berlin, 1927.

experiments extended the boundaries of photography and uprooted outworn conventions. Most of them were achieved by purely chemical or optical techniques and so could not be objected to on photographic grounds. Yet many were artifices leading to a *cul-de-sac*, as inevitably happens when painters interest themselves in photography for their own ends, forgetting that photography and painting have to follow different paths.

Pioneers always want to pull down what has preceded them. It is part of their mentality, but it is particularly ironical that Moholy-Nagy should have dismissed one of Stieglitz's New York street views with the words: 'The victory of Impressionism, or photography misunderstood. The photographer has become a painter instead of using his camera correctly, i.e. photographically'; for if 'abstract art' is substituted for 'Impressionism', this verdict applies to most of Moholy-Nagy's own photographs far more than to Stieglitz's. The American photographer at least pursued the proper aims of photography, whereas the Hungarian painter was concerned with image-making for his own aesthetic ends. Much of Moholy-Nagy's darkroom experiments were misapplied from the point of view of furthering photography itself: they had as little to do with real photography as the composite productions of the fine art photographers or the photo-paintings of the impressionists. Abstract photography is just as much an aberration as these. None of the photograms and photo-montages by Moholy-Nagy, Max Ernst, John Heartfield and other Constructivist or Surrealist artists has any significance for true photography.

The most useful Bauhaus contribution to photography seems to me to be the 'typophoto', the possibilities of which were brilliantly exploited by Jan Tschichold, El Lissitzky, Herbert Bayer, Herbert Matter, Elfer, and many other designers and poster artists, chiefly in Germany, Switzerland and the United States. A photograph puts across the advertiser's message far more forcibly than any other kind of picture (*No.* 3), and I have often wondered why it is so little used for posters and newspaper advertisements in England. Here it has been far too long the practice to commission paintings when a photograph would do the job much better and more cheaply. In this sphere Man Ray, the Bauhaus and the Dadaists have contributed more than is realized to modern advertising techniques.

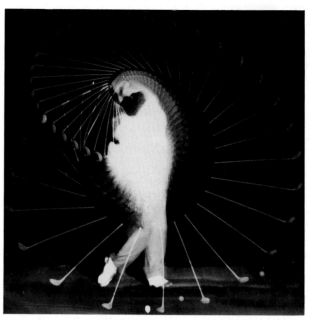

172. Harold E. Edgerton. Multiple flash photograph of the golfer Dennis Shute. 100 flashes per second, c. 1935

In periods of financial necessity both Man Ray and Moholy-Nagy also practised photography for its own sake: the former in advertising and portraiture, the latter for books and magazines. 'I photograph what I cannot paint, and paint what I cannot photograph: the goal is the same whether it is done with the camera or the brush', Man Ray said to me during a visit to London in 1961. Often, of course, he does both. The famous mouth, for instance, was first a photograph, then a painting. Moholy-Nagy had produced some fine photo-reportages for the *Münchner Illustrierte Presse* in 1928 and for three books during his London sojourn in the early thirties.[1]

More fascinating than any man-made abstract designs are some of the patterns of Nature. As Coburn pointed out, exploration with the microscope will reveal beautiful patterns that sometimes have an extraordinary analogy to the designs of the modern artist (*No.* 171). In scientific photography striking designs invisible to the human eye are often recorded in the course of investigations (*No.* 173). High-speed electric spark photography with exposures ranging from one hundred thousandth to one

[1] *The Street Markets of London*, by Mary Benedetta, with 64 photographs by L. Moholy-Nagy, London, 1936. *Eton Portrait*, by Bernard Fergusson, with 58 photographs by Moholy-Nagy, London, 1937. *An Oxford University Chest*, by John Betjeman, with 56 photographs by Moholy-Nagy, London, 1938.

173. *Dame Kathleen Lonsdale, F.R.S. X-ray diffraction photograph of a pentaerythritol crystal having tetragonal symmetry. (The sharp spots are due to the regular arrangement of the atoms; the diffuse spots are due to the thermal vibrations),* 1960

174. *Harold E. Edgerton. Corona resulting from a drop of milk falling seven inches into a plate of milk. A second drop is seen falling. Exposure One millionth sec. at F.64, 1936*

millionth of a second, pioneered in the 1890s by English scientists, was perfected by Harold E. Edgerton and Kenneth J. Germeshausen of the Massachusetts Institute of Technology in 1933. Firing flashes at rapid and regular intervals they were able to record on one plate a complete analysis of the movement of a golfer hitting the ball (*No. 172*), a man tossing a baton, etc., resulting in fascinating patterns. A drop of milk falling into a dish of milk produces a cavity on the surface surrounded by a coronet of splashes (*No. 174*); aesthetically this is a most satisfying picture.

175. *Albert Renger-Patzsch. Driving shaft of a locomotive,* 1923

XVIII

THE NEW OBJECTIVITY

In the 1920s a number of German photographers, usually referred to under the collective title 'Neue Sachlichkeit' (new objectivity, new realism), had an infinitely greater influence on the aesthetic development of photography than the dark-room experiments of the Bauhaus. The term 'Neue Sachlichkeit' was originally applied in 1925 by Gustav Hartlaub, Director of the Mannheim Art Gallery, to the work of a number of painters who in reaction against Expressionism had adopted a new realist style. Later it was also used to denote a new objective approach to subject matter in photography and in the cinema. The first important exhibition of this new realist painting under the term 'Neue Sachlichkeit' took place in the Kunsthalle, Mannheim, in the summer of 1925. The first exposition of the movement was given by the art critic Franz Roh in his book *Nachexpressionismus*, Leipzig, 1925. Surrealism was an analogous and perhaps more fertile art movement in France. Some artists were active in both. Typical representatives of 'Neue Sachlichkeit' in painting in 1925 were Otto Dix, Tsugouharu Foujita, Auguste Herbin, George Grosz, Alex Kanoldt, Moïse Kisling, Franz Radziwill, Christian Schad, Oskar Schlemmer, Georg Schrimpf and Georg Scholz. Best known among American realist painters are Edward Hopper, Charles Sheeler, Andrew Wyeth and the Mexican Diego Rivera.

The originator of this style in photography was Albert Renger-Patzsch. Fascinated by beauty in nature and in man-made objects, he started in 1922 on a series of close-ups, and by isolating the object from its surroundings discovered remarkable forms and motifs which are normally overlooked. His photographs enabled others to see the world with fresh eyes. The photographer remained the objective observer, careful not to let his personality intrude on the subject. He only strove to intensify appreciation of it by representing it as realistically as possible: hence the term 'new objectivity' or 'new realism'.

By chance both Moholy-Nagy and Renger-Patzsch published their very different aims in photography in the same annual, *Das Deutsche Lichtbild*, in 1927. Unlike the Bauhaus teacher, Renger-Patzsch did not feel any need to extend the boundaries of photography. On the contrary, he believed that within its limitations there was ample scope for the creative spirit, if only photography were used as it should be, instead of trying to obtain painterly effects which inevitably lead the photographer to abandon the unique qualities of his medium. 'The secret of a good photograph, one that possesses aesthetic quality, lies in its realism.' In this dictum Renger-Patzsch reiterated the ideas of Paul Strand, whose work was however unknown to him. Renger-Patzsch stressed that far too little value was attached to the possibility of showing the beauty of materials. The texture of wood, stone, metal, cloth, etc. can be reproduced by photography with their characteristic qualities in a way unrivalled by any other medium. In the extraordinarily fine tone-gradation from the brightest highlight to the deepest shadow, in the analysis and representation of fast movement, and in the reproduction of form, photography is superior to all other arts. 'Let us, therefore, leave art to artists', concluded Renger-Patzsch, 'and let us try by means of photography to create photographs that can stand alone on account of their photographic quality—without borrowing from art.'[1]

Renger-Patzsch's book *Die Welt ist Schön* (1928)[2] ('The World is Beautiful') with one hundred of his

[1] *Das Deutsche Lichtbild*, 1927.
[2] The title was suggested by the publisher, replacing Renger-Patzsch's typically objective but rather colorless *Dinge* (things, objects).

176. *Albert Renger-Patzsch. Leaf of a Collocasia,* 1923

177. *Albert Renger-Patzsch. Potter's hands,* 1925

178. *Albert Renger-Patzsch. Breakwater at St Malo, Brittany,* 1942

179. *Close-up from D. W. Griffith's 'Intolerance',* 1916

180. *Albert Renger-Patzsch. Fisherwoman, 1927*

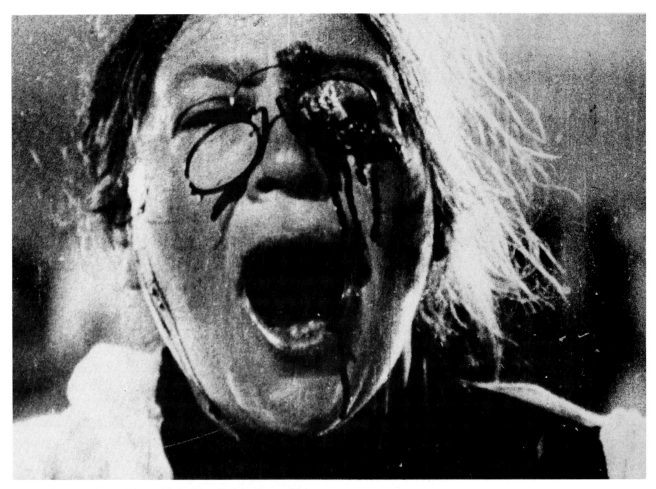

181. *Close-up from Eisenstein's 'Battleship Potemkin', 1925*

photographs and an essay by Carl Georg Heise is an eloquent exposition of good straightforward photography (*Nos.* 175–178, 180). The simplicity of these uncontrived photographs of everyday subjects—close-ups of plants, animal studies, concentration on details of landscape, the rhythm of pattern and texture of man-made objects, architecture, industrial constructions, etc.—all represented with clinical objectivity, came as a revelation at a period when photographers and artists everywhere were turning away from reality. In Renger-Patzsch's photographs ordinary things took on a new significance. They sharpened the perception of the onlooker for the beauty in everyday subjects, and enabled him, like William Blake,

> To see a world in a grain of sand,
> And a heaven in a wild flower,
> Hold infinity in the palm of your hand
> And eternity in an hour . . .

The impact of the book on literary and art circles was immediate. Thomas Mann found great aesthetic pleasure in it, and in reviewing the book[1] declared

[1]*Berliner Illustrirte Zeitung*, 23 December 1928.

that he did not share the common prejudiced view that wanted to deny to photography the ability to make a contribution in the artistic field. The art historian Dr Heinrich Schwarz went even further in stating: 'If today, the photographs of Renger-Patzsch create more pure pleasure than many paintings, it is not an accident, but evidence that the time has found in the photographer a more sensitive instrument for the expression of its artistic needs than in the painter.'[2]

In conventional photographic circles, however, *Die Welt ist Schön* met with a hostile reception. The official organ of the Royal Photographic Society complained: 'In its stark realism and entire devotion to finding patterns and designs in unexpected directions, in other words "stunts", it failed to recommend itself to British taste as reaching the highest ideals of the photographic art.' The reviewer, a pictorialist of the old school, chosen by the editor as being 'most fitted to give a sound and acceptable judgment from the British viewpoint' (as though national viewpoints existed in European art!), with

[2] *Die Photographische Korrespondenz*, May 1929.

utter lack of perception dismissed Renger-Patzsch's work as 'photographic exercises' and 'a waste of effort and of good photographic material', adding 'We would recommend the volume to those wishing to study the elementary principles on which Nature has evolved order out of chaos, but we cannot imagine that the results shown would have any other appeal.'[1]

'Neue Sachlichkeit' was a reaction against everything the Royal Photographic Society stood for: sentimentality, romanticism, artificiality, pretentiousness, characterless portraiture, and falsification of the photographic medium. For the followers of the new objectivity 'pictorialism' belonged to the photographic salons, prettiness and beauty in the conventional sense to the picture postcard, and abstract designs for their own sake to graphic art. The photographer at last recognized and returned to the unique characteristic qualities of his medium with its almost unlimited possibilities of genuine expression.

In shaping the new vision the influence of the cinema should not be overlooked. D. W. Griffith in 'Intolerance' (1916) brought for the first time the emotional close-up to the screen (*No.* 179). G. W. Pabst's realism in 'The Joyless Street' (1925), contrasting profiteers and the destitute middle class in Vienna at the time of the inflation, shocked his contemporaries so deeply that it was forbidden in England altogether, and only cut versions were released in other countries. Eisenstein's 'The Battleship Potemkin' produced the same year and released in Germany in 1926 made a sensational impact. For over six months the Berlin cinema showing it was sold out. Nothing like this film had ever been experienced in Germany, and it aroused much more discussion there than in Russia, where its artistic importance was lost in its political significance. No one who has seen 'Potemkin' can forget the horrifying realism of the shocking Odessa steps sequence (*No.* 181), which remains unique, or the close-up of maggots crawling on the sailors' meat. With 'Potemkin' the new realism was firmly established as a major style in the cinema.

Apart from films, a number of important publications were the chief disseminators of modern photography. Prof Karl Blossfeldt's *Urformen der Kunst* ('Original Art Forms') (1929) was illustrated with 120 close-ups of plants, each more surprising than

the last. The author's amazing vision in discovering natural forms and patterns—he was professor for modelling plants at the school for handicrafts in Berlin—met with such success that another selection of 120 breathtaking photographs by him appeared in 1932 under the title *Wundergarten der Natur* ('Magic Garden of Nature'). They were mostly macrophotographs, with some details enlarged 25 times. There was evident, however, a conscious striving to astonish the viewer by concentrating on unexpected forms, frequently enlarged beyond their natural size to accentuate in some cases the likeness to artefacts.

The perfect 'guidebook' to the new vision in photography is Werner Gräff's *Es Kommt der Neue Fotograf* ('The New Photographer Has Arrived') published in the same year. In it the author collected the most significant photographs featuring the Bauhaus style and typical examples of new objectivity. Following the old Chinese proverb that one picture conveys more meaning than a thousand words, he restricted himself to a running commentary, allowing the pictures to drive home his message that photography should follow the laws of

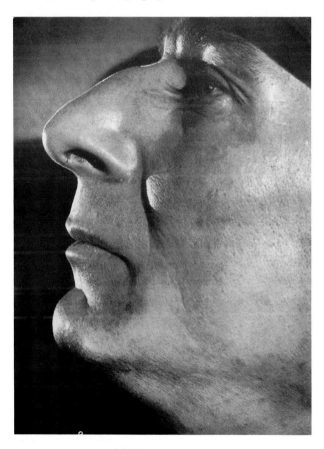

182. *Helmar Lerski. Workman*, 1931

[1] Bertram Cox, *The Photographic Journal*, September 1929.

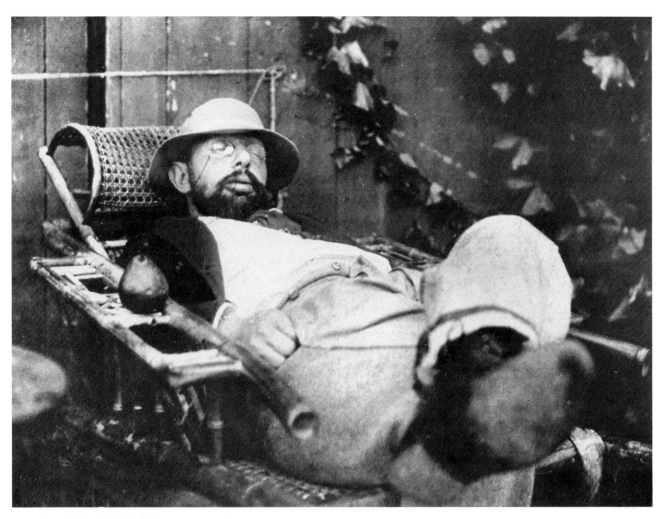

183. *Maurice Guibert. Henri de Toulouse-Lautrec at Malromé, c. 1896*

human vision and not be restricted by the old laws of composition and perspective which had been devised for painting.

In the five years following the publication of *Malerei, Photographie, Film,* Moholy-Nagy extended his narrow constructivist interest in photography to life, nature, and reportage. This is evident in a collection of his photographs published in 1930. At the same time appeared a similar book of Aenne Biermann's photographs. Each publication was prefaced with an important essay on the aims of the movement by the art historian Franz Roh.

As the movement gathered momentum, the close-up and reproduction of texture were also applied to portraiture, and since the exponents of the new objectivity were interested in everyday things, their portraits also were of ordinary people, not celebrities. Until 1927 the portrait photographer August Sander had produced pleasant, flattering images of his clients. In that year he decided, under the influence of the realist movement, 'From now on I only want the honest truth about our time and people.' In *Antlitz der Zeit* ('The Face of Our Time'), a book of 60 photographs published in 1929, he portrayed a cross-section of the social structure of Germany in such an unflattering light that the Gestapo impounded all unsold copies five years later. Erna Lendvai-Dircksen concentrated on *Das Deutsche Volksgesicht* (1930)—typical German peasants in various districts.

Helmar Lerski's *Köpfe des Alltags* ('Everyday Faces') (1931) were beggars, street sweepers, hawkers, washerwomen and servants whom he obtained through the local employment exchange (this was at

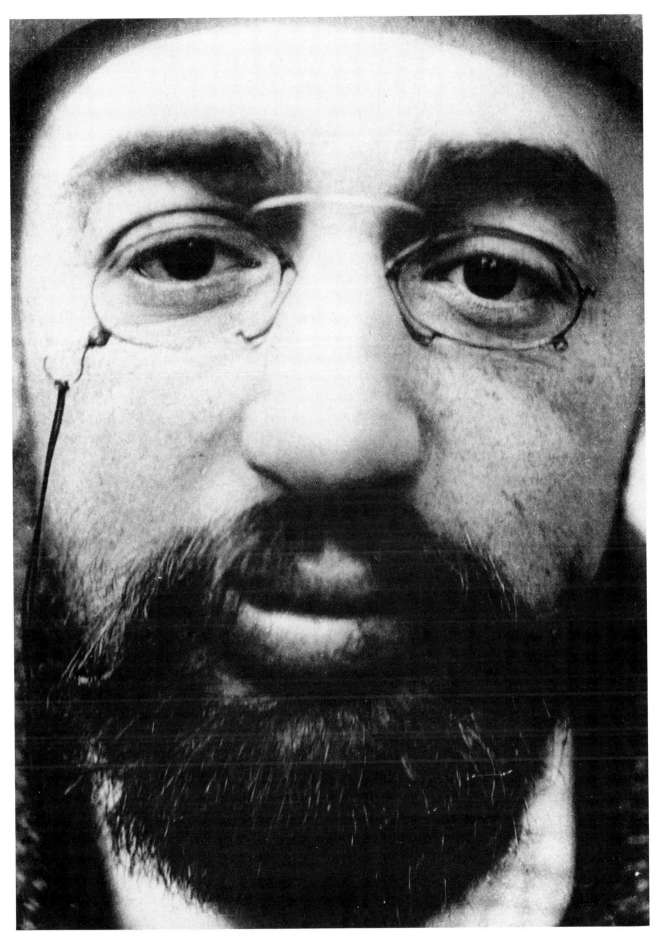

184. *Maurice Guibert. Henri de Toulouse-Lautrec (the first true close-up), c. 1896*

185. *E. O. Hoppé. 'Ship in Drydock', 1928*

the depth of the world economic depression). Lerski felt that whereas celebrities often wear a mask and strike a pose in front of the camera, these simple people gave him a chance to make objective character studies without flattery. The physical closeness of his portraits is breathtaking—but do eyes, nose and a mouth, with a great deal of over-enlarged skin texture, really give us the soul of man? (*No.* 182). Only a particularly striking face like that of Henri de Toulouse-Lautrec lends itself to such treatment. The portrait (*No.* 184), taken about 1896, by his friend Maurice Guibert, is in fact the first true close-up, and it was not a coincidence, I believe, that this and another equally striking portrait of the artist (*No.* 183), both greatly in advance of their time, should have been first published in a German magazine in 1932. Several German weekly illustrated papers and monthly magazines had for the last four or five years been making propaganda for the new paths in photographic expression by reproducing modern photographs under such titles as 'The World from Above', 'The New Vision', 'Under the Magnifying Glass',

'Beauties of Every Day', 'The Miracle of Light', 'How Our Photographer Saw It', 'The Picture Can be Found in the Street', 'Journeys of Discovery with the Camera', etc. One such photograph published in 1928 was E. O. Hoppé's forceful 'Ship in Drydock' (*No.* 185). Hoppé, for nearly forty years in the forefront of photographers, moved with the times from impressionism to new objectivity, always surprising by the freshness of his approach. His view of Manhattan from Brooklyn Bridge has been imitated countless times, but he was the first to see it that way in 1919 (*No.* 186).

While the new objectivity was beginning to take root in Germany a similar movement started independently in America among a group of photographers who had fallen under the spell of Paul Strand's practically identical outlook and work. The first to proclaim the doctrine of objectivity (see Chapter XVI), Strand developed its potentialities from 1921 onward by concentrating on the magnificent forms created by man in the machine, and close-ups of plants, time-withered trees, driftwood,

86. *E. O. Hoppé. Manhattan from Brooklyn Bridge,* 1919

87. *Paul Nash. 'Monster Field. Study No.* 1*', c.* 1943

188. *C. J. Laughlin. 'The Unending Stream'*, 1939

and rock formations. He, Edward Weston and his son Brett, Charles Sheeler, Edward Steichen (*No. 189*), Berenice Abbott and Paul Outerbridge formed the spearhead of the American realist style. Their contribution to the Film and Photo Exhibition in Stuttgart in 1929 was considered outstanding by the art critic Carl Georg Heise, who felt that the future of photography lay in 'Neue Sachlichkeit', compared with which the Bauhaus experiments were meaningless art for art's sake.

Like his mentor, Edward Weston delighted in photographing unusual natural forms, whether it were a paprika (*No. 190*), an eroded rock giving an abstract pattern, or Californian sand-dunes. That these subjects were rendered with all their surface texture and with the utmost exactitude goes without saying. Ansel Adams, pupil and close friend of Weston, took up photography about 1930 and under

Weston's influence devoted himself at first to similar subject matter (*No. 191*). Weston, Adams, and a few other photographers believing in straight technique—Imogen Cunningham, J. P. Edwards, Willard Van Dyke, Henry Swift, Sonia Noskowiak—in 1932 formed the 'F.64 Group'. This means that they used the smallest diaphragm opening of their lens in order to obtain the greatest possible depth and sharpness with the rather large (10 in. × 8 in.) plate cameras they used. And so we are back again where the first landscape photographers started three-quarters of a century earlier.

When I began my photographic studies in 1934 the State School of Photography in Munich was the leading one of its kind in the world, and I soon learned that good photography and a factual, realistic presentation were inseparable. The new outlook manifested itself in everything we were taught and

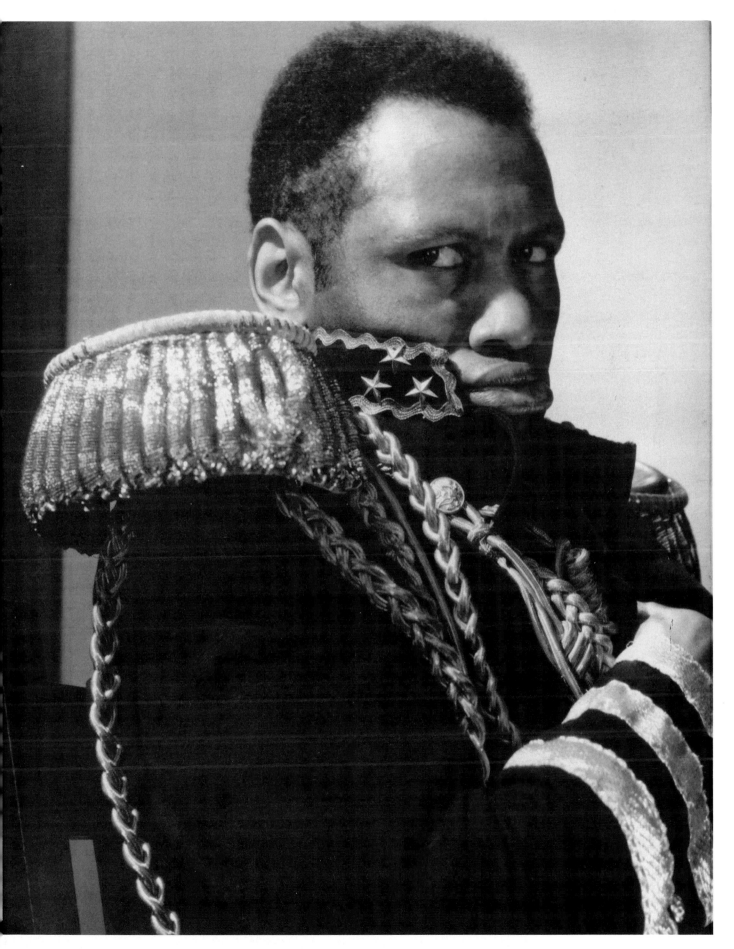

189. *Edward Steichen. Paul Robeson as 'The Emperor Jones',* 1933

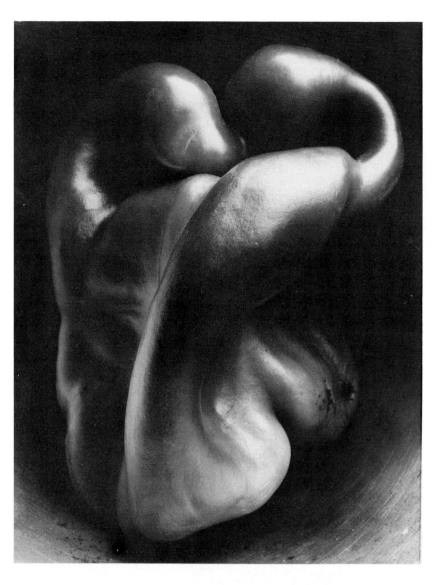

190. *Edward Weston. Paprika,* 1930

191. *Ansel Adams. Pine cone and eucalyptus leaves,* 1933

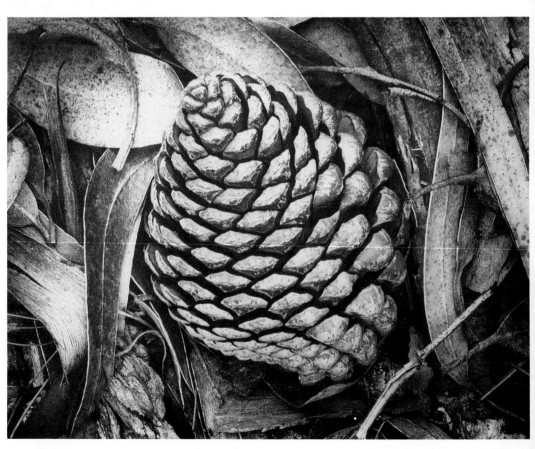

in everything we photographed (*Nos.* 192–7), but I remained unaware of the historical development of this style and the books by its chief exponents until I became interested in the history of photography. In 1934 they were already accepted as classics and were no longer debated in Germany. Switzerland was the only other country in which the new photography was wholeheartedly accepted before World War II.

Despite the fine annual *Modern Photography*—which, alas! lasted only from 1931 to 1942—the innovations were slow to penetrate the fog over these islands. The Royal Photographic Society, though putting on a one-man show of Renger-Patzsch's work—and later of my own—was nevertheless shocked at the idea that making pictures in their sense should be no part of photography's legitimate task, and dismissed the photographs of the new objectivity school as mere record work. 'This soulless use of photography has made little appeal to us in this country or in America, where sentiment still plays a part in our artistic make-up.'[1]

My book *New Photo Vision* (1942) fared no better at the hands of these pundits than Renger-Patzsch's had done. My outspokenness may shock, but I earnestly believe that by virtue of its position as the oldest photographic society in the world, the Royal has been able to retard the progress of artistic photography in England to such an extent that we are now reduced to being one of the least important countries in a field in which we were the acknowledged leaders in the nineteenth century. It is no secret amongst *cognoscenti* that the Royal Academy of Art has been similarly unprogressive, but the result is less disastrous because modern art can be seen at the Tate Gallery and in fifty private galleries in London alone. Nothing of the kind existed for photography until the foundation of The Photographers' Gallery in London in January 1971 through the private initiative of Sue Davies and a few friends. The subsequent discovery of photography as an untapped field of commerce and the unexpected *volte-face* by the Arts Council of Great Britain in supporting light-drawing as an art medium—an idea previously shunned—has changed the scene dramatically in the last twenty years. Yet is it not symptomatic of the official view of art anywhere that recognition is dependent upon commercial success?

[1] J. Dudley Johnston, 'Pictorial Photography': *The Photographic Journal*, April 1939.

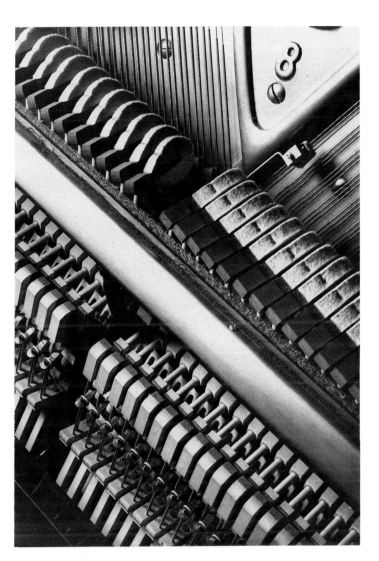

192. *Helmut Gernsheim. Piano hammers,* 1935

Was it different at the time of Van Gogh and Gauguin? The most highly priced artists on the market today died in poverty and were branded as failures.

The informed public has long viewed with derision the puerile, affected and sentimental banalities that are hung year after year in the London Salon, the exhibitions of the Royal Photographic Society, and hundreds of others up and down the country that are modelled on it. The 'best' pictures in these exhibitions are annually published in *Photograms of the Year* and *The Year's Best Photographs*. They are antiquated publications, and, like the pictorial sections in *The British Journal Photographic Almanac* and *The American Annual of Photography*, degrade the status of photography. In view of the immense number of trashy publications that appear in the

193. *Helmut Gernsheim. The new town,* 1935

194. *Helmut Gernsheim. Spiral staircase at St Paul's Cathedral: looking down,* 1943

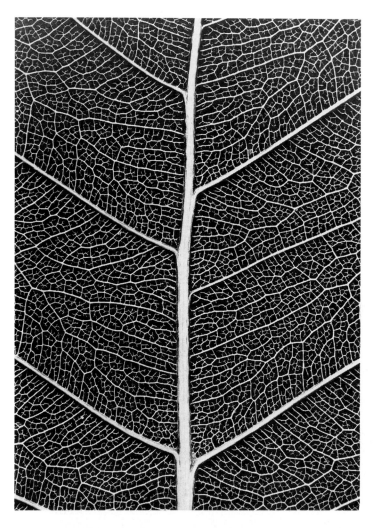

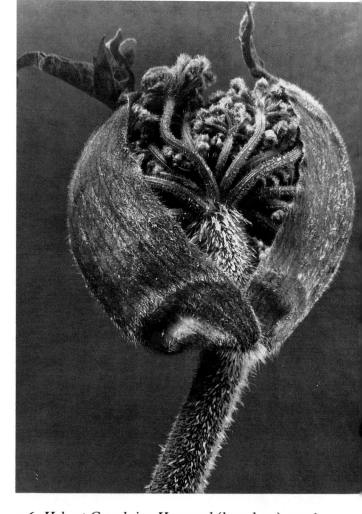

195. Helmut Gernsheim. Skeleton of a leaf (detail). (Placed between two glass plates and enlarged 2½ times directly on to bromide paper), 1936

196. Helmut Gernsheim. Hog-weed (heracleum), 1936

name of photography it is not surprising that people of cultivated taste are often its avowed enemies. If I did not know the other side of the picture, I would be, myself. Unfortunately there are not enough good publications to outweigh the bad: among the annuals I can think of only one—the *Photography Year Book*. There were several excellent magazines: *Camera* (Switzerland), *Ferrania* (Italy), *Foto-Prisma* (Germany) and *Aperture* (America). As cultural magazines of general interest with a bias towards modern photography *GEO* (Germany) and *Du* (Switzerland) are unequalled.

The traditionalists manifest a complete divorce from contemporary outlook, remaining at the level of outmoded 'picture making' before World War I, and on this point I wholeheartedly share R. H. Wilenski's devastating criticism in *The Modern Movement in Art*. Were it not for the fact that Philistinism in art also constitutes an aesthetic trend, even though a negative one, I would not feel it necessary to state so openly that the modern movement in photography has received no encouragement whatsoever from professional and amateur organizations in this country. It exists in spite of, and not because of, those whose professed aim it is to further the art of photography.

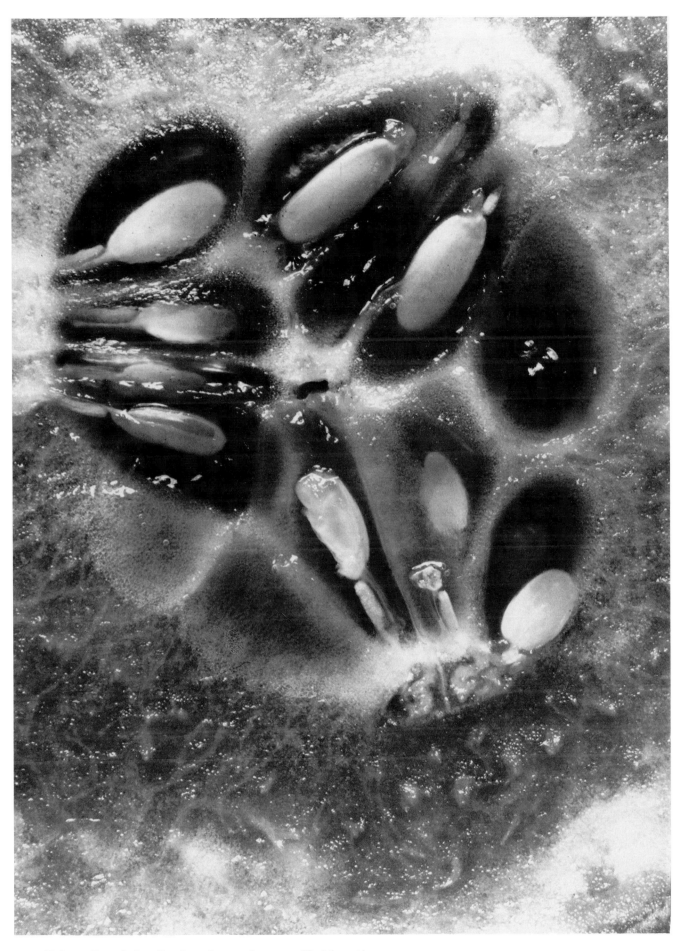

197. *Helmut Gernsheim. Section of cucumber magnified four times, 1935*

XIX

THE INFLUENCE OF SURREALISM

Consciously or subconsciously the influence of painting upon photography and *vice versa* is bound to mould the outlook of artists in both fields, for their susceptibilities will be stimulated by any novel idea. This kind of cultural cross-fertilization has nothing to do with imitation and is perfectly legi-

timate so long as it does not interfere with the autonomous means of expression of either art.

The first stirrings of the influence of surrealism on photography are apparent in Cecil Beaton's picture of Edith Sitwell taken from the top of a step-ladder. The poet lies stretched out on the floor like a figure

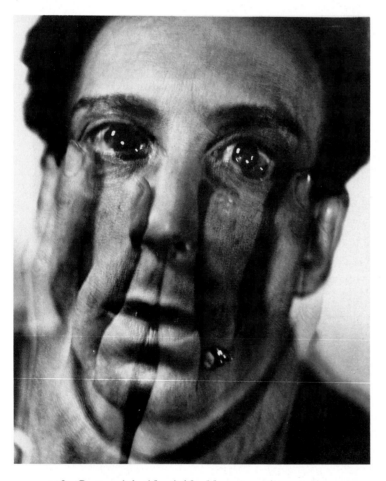

198. *Casson. 'Accident' (double exposure), c. 1935*

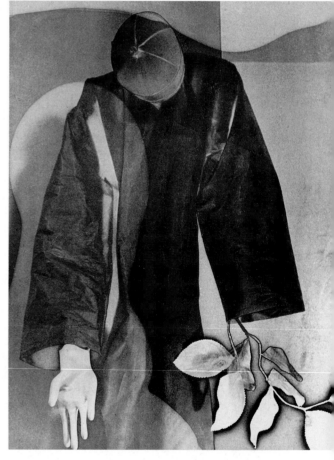

199. *Casson. Surrealist photograph, c. 1935*

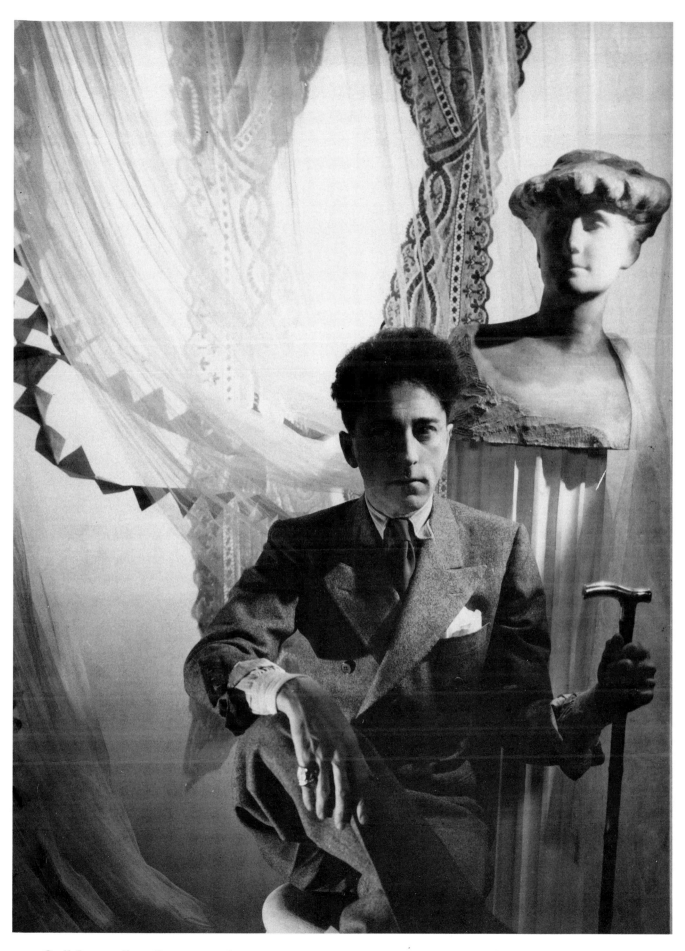

200. *Cecil Beaton. Jean Cocteau, 1936*

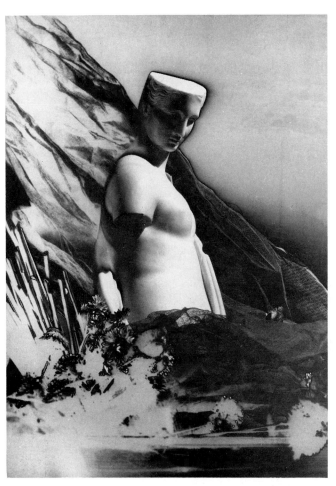

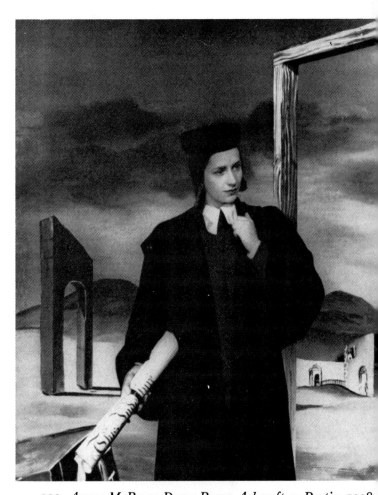

201. *Edmiston. Solarization, c.* 1934

202. *Angus McBean. Dame Peggy Ashcroft as Portia,* 1938

on a medieval monument, flanked by two cherubs. That was in 1927. Later followed portraits of society women under a glass dome, actresses peeping out from a tree-trunk, a bejewelled skull wreathed with flowers, Jean Cocteau peering through the broken windows of a closed-down Paris Metro station, and many other irrational compositions. It was a love of the incongruous that asserted itself in many of Cecil Beaton's portraits and fashion photographs as strange as the bizarre compositions of surrealist artists, only in photography the effect is all the more startling because it is real.

Even when he was not surrealist, Beaton achieved striking effects by the unusual settings he invented for his sitters (*No.* 200). Some of his first photographs of beautiful society women are typical products of the 1920s. Glittering, shallow and sham, the style may have suited the personalities of the sitters,

but like an exotic flower it wilted away. Beaton was never static in outlook, and whatever he did, at whatever period, he exercised his fertile imagination and remarkable versatility, displaying equal brilliance in many fields. Portraiture, fashion, stage photography, travel photography and reportage—all bear the unmistakable stamp of his individuality. Friendships with leading figures in the cultural life of Europe and America undoubtedly had an important influence in moulding Beaton's outlook, but his ability in breaking new ground in photography is due to his talent in other spheres: stage and film design of *décor* and costumes, book illustration, painting, and writing.

Winifred Casson, a comparatively unknown woman photographer active in London in the 1930s, was a tireless experimenter in a great many of the techniques developed in France and Germany, such

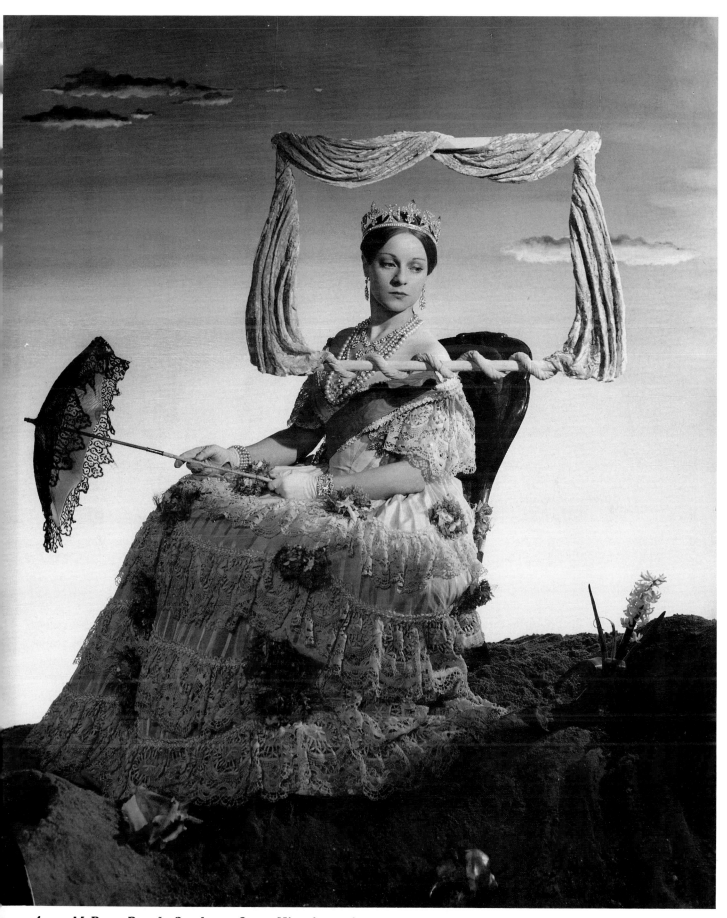

203. *Angus McBean. Pamela Stanley as Queen Victoria, 1938*

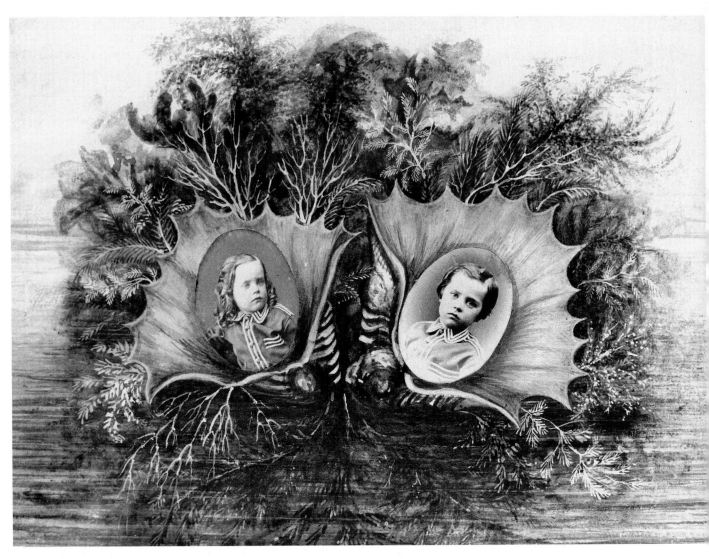

204. *Photo-montage, c.* 1868

as solarization and negative printing, in both portraiture and advertising photography. But some of Casson's best compositions have no connection with either field and seem to have been taken for the sake of finding new ways of expressing something personal in photography. 'Accident' (*No.* 198) is a masterpiece of expressionism in photography achieved by a double exposure. The technique of the surrealist photograph (*No.* 199) eludes me; I only know that it impresses me as a composition, as does the imaginative still-life (solarization) by Edmiston (*No.* 201), a London advertising photographer working about the same period. Among several other *avant-garde* photographers active in London in the 1930s and forming a kind of 'Chelsea set', the work of Francis Bruguière, Somerset Murray and

Peter Rose-Pulham will be remembered by many.

At first sight some of Angus McBean's surrealist photographs may appear to belong to the realm of the painter, but though the set-up was elaborate the photographic technique was straightforward. The leading British theatrical photographer, McBean started his series of surrealist photographs in 1938, and for about two years produced nearly every week a portrait of a stage personality in this style for *The Sketch*. The powerful picture of Peggy Ashcroft as 'Portia' (*No.* 202) evokes a dreamlike quality, for everything in the setting is artificial; even the wood of the arch was given a false grain by the surrealist artist Roy Hobdell, who is also responsible for the background which lends the picture the impression of depth and distance. One of the characteristics of

surrealist art is the juxtaposition of unusual elements; another, the interplay of textures as, for instance, rough against smooth. Pamela Stanley as 'Queen Victoria' (*No. 203*) holding a lacy sunshade in a sandy desert, her crowned head looking through a draped window-frame, is a masterpiece of incongruity.

When war broke out McBean's surrealist photographs, many of which were concerned with ruins, ended. Soon many of his fantasies came true, abruptly turning the surrealist atmosphere into stern reality.

Just as surrealism in painting had its precursors in the bizarre images of Bosch, Breughel, Callot and others, photographic surrealism also had its origin earlier—in the photo-montages of amateurs in the 1860s (*No. 204*). These were a pastime of talented amateur artists of the upper class who gave full rein to their imagination in composing and painting

a setting for cut-out photographs (mostly by professionals) of their family and friends. Their ingenious productions often equalled the fantasies of Lewis Carroll and Edward Lear. The most surrealist of these amateurs was Sir Edward Blount, financier and railway magnate, whose album contains hundreds of photo-montages which might be very revealing to a psychoanalyst: two children emerging from eggshells; a top-hatted gentleman with frog's legs serenading a mermaid sitting by a pond; a human head in a saucepan being fried over a flaming heart (*No. 205*).

On a more obvious plane were trick photographs made by professional photographers, either by double printing or by photo-montage: a man's head served to him on a dish, a figure in a bottle, a man carrying his head under his arm or pushing it in a wheelbarrow, etc.

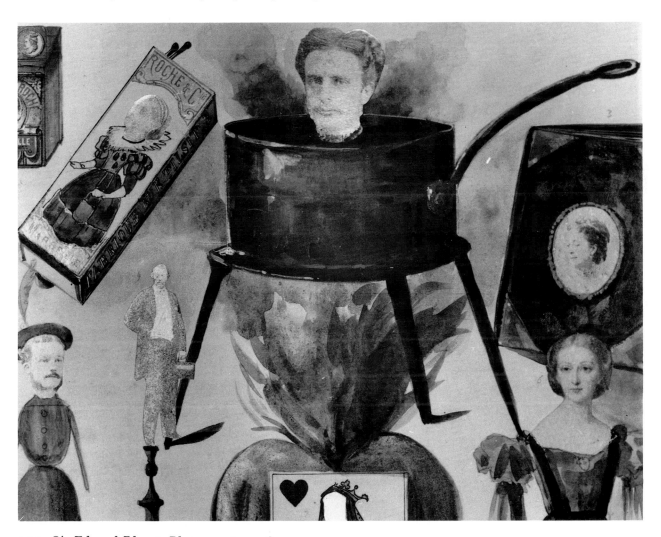

205. *Sir Edward Blount. Photo-montage*, 1873

XX

PHOTO-PATTERNS

Since most of the experimental work at the Bauhaus, which closed down when Hitler came to power,[1] was unknown to the post-war generation in Germany, there was an understandable desire to pick up the threads again, not only in photography but in the entire field of the modern manifestations in the arts which had been suppressed by the Nazis. In the great wave of abstract art which swept the post-war world it is perhaps not to be wondered at that there was a tendency to over-emphasize the graphic element in photography in this latest attempt to align it with the trends of modern art.

Largely owing to the influence of Otto Steinert, teacher of photography at the State School of Arts and Crafts at Saarbrücken, fresh impetus was given to *photo-graphic* art, which gradually spread all over Western Europe. The style introduced as 'Fotoform' and soon afterwards called 'Subjective Photography' was initiated by Steinert in 1950. Under this title he staged three exhibitions at the 'photokina' in Cologne in 1951, 1954 and 1958, of which the first two subsequently furnished the material for two superb picture albums of the same title, published in Bonn in 1952 and 1955, respectively. Through these and several group exhibitions of Steinert and pupils, Subjective Photography was widely disseminated, and outside Germany found many adherents, particularly in Sweden and Japan, then emerging for the first time in the sphere of creative photography.

What does Professor Steinert himself mean by 'subjective photography'?

'In contradistinction to "applied" utilitarian and documentary photography, Subjective Photography emphasizes succinctly and clearly the creative impulse of the individual photographer. . . . The usual picture belonging to "artistic photography" and dependent above all on the attractions of the object itself, gives place to the experimental and innovational approach. Adventures in the visual field are at first always unpopular . . . but only a kind of photography sympathetic towards experimentation can provide the means of shaping our visual experiences. A new photographic style is one of the demands of our time. Subjective Photography means therefore

[1] Gropius and Moholy-Nagy had already left the Bauhaus in 1928.

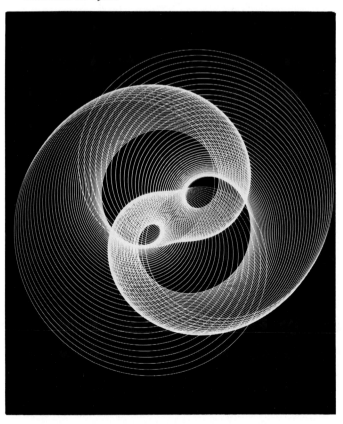

206. *Peter Keetman. Oscillation photograph*, 1950

207. *Peter Keetman. Oil drops,* 1956

208. *Peter Keetman. Ice on lake during snowfall*, 1958

to us the framework embracing all aspects of individual creation in photography—from the non-objective photogram to profound and aesthetically satisfying reportage.'[1]

The distinctive qualities all the photographs of the Steinert group have in common are, creative ability of the maker, originality, and a strong graphic design. To this latter the subject matter is completely subordinate, and in many cases the photograph gives at first sight the impression of a woodcut or linotype. Instead of the usual delineation of the world around us in all its thousandfold gradations of light and shade, there is a conscious concentration on form or pattern more akin to graphic art than to photography. Though a good deal of subjective photography is based on techniques evolved by Moholy-Nagy and Man Ray—photograms, photo-

[1] Preface to *Subjektive Fotografie I*, Munich, 1952.

montages, reticulation, solarization, negative printing, pattern photographs, exaggerated black and white effects, blurred images to suggest movement—its vocabulary was extended. The silver grain of the emulsion, formerly kept as fine as possible, was now deliberately coarsened by over-development, heat treatment or over-enlargement of small sections of the negative, re-introducing an effect similar to the coarse structure of paper in unwaxed Calotypes. Luminographs—the light pattern of traffic at night recorded with an open shutter—and oscillation photographs (*No.* 206), of which Peter Keetman, a founder member of Fotoform, was the originator in Europe, were introduced.[2] In the latter technique

[2] We always consider 'new' what we have not seen before. Meanwhile I have seen much earlier abstract light pattern spiral photograms made by C. E. Benham in 1904, published in *The Photogram* magazine, London, 1905, p. 46.

209. *Hans Hammarskiöld. Bark of a tree,* 1952

210. *Otto Steinert. 'Interchangeable Forms', 1955*

the camera revolving on a gramophone turntable in the dark-room records the movement of an electric torch swinging on a wire. *No.* 207 is a striking pattern photograph of oil drops, also by Keetman. The graphic design produced by splitting tree bark (*No.* 209) is another favourite subject in subjective photography. The cross-section through a tree by Hans Hammarskiöld (*No.* 211) is in principle the same as my cross-section through a cucumber (*No.* 197) only I wanted to reproduce the reality with all possible tone-gradation whilst Hammarskiöld's intention was to produce a graphic design by printing on extremely contrasty paper to destroy all halftone. Professor Steinert's fine graphic designs (*Nos.* 210 and 212) were achieved by the combination of a negative and a positive print in a montage. Such photographs have influenced textile design, particu-

larly in Germany and Sweden, and are finding more and more application in advertising.

These examples may suffice to elucidate subjective photography in its narrower sense. On a broader basis Professor Steinert embraces all good contemporary photography in which design, not content, plays the predominant rôle (*Nos.* 213 and 214), though in reportage the accent has obviously to be shifted to aesthetically satisfying presentation of content. Still, the name 'subjective photography' is not so apt as the original 'Fotoform', for naturally all creative photography is subjective or 'creatively guided technique'. Brilliant examples are Rolf Winquist's study of Gertrud Fridh as Medea (*No.* 216) and Peter Moeschlin's seagull in flight (*Nos.* 217 and 218).

I do not believe that the adoption of styles belong-

200

211. *Hans Hammarskiöld. Cross-section through a tree,* 1951

212. *Otto Steinert. Snow tracks. Negative montage,* 1954

213. *Caroline Hammarskiöld. Fishnet reflection,* 1950

214. *Arno Hammacher. Reflections in Amsterdam,* 1951

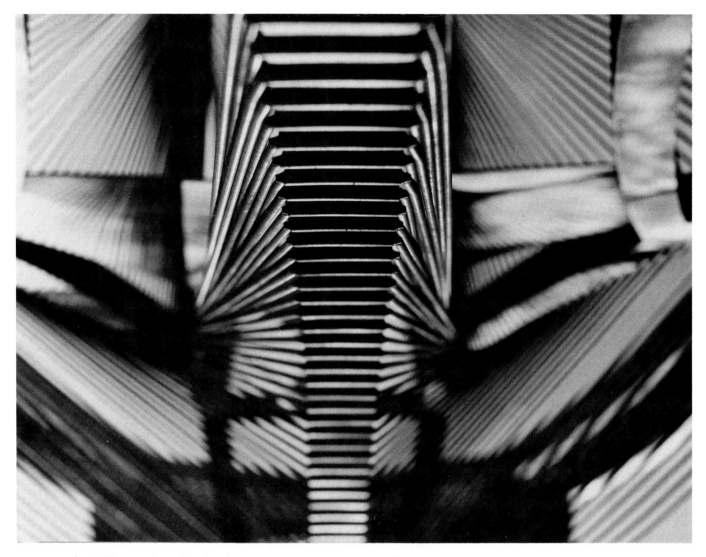

215. *Arno Hammacher. Detail of iron construction by Naum Gabo in Rotterdam,* 1957

ing to other art forms can further photography. Throughout the history of photography many of its practitioners have fallen into the error of forsaking the characteristics of their medium in order to follow whatever painterly style was then in fashion. I am all for expressing the spirit of our time in photography, but not at the expense of sacrificing one iota of its characteristics. If we abandon photographic halftone for the sake of achieving a graphic design we are left with a skeleton without substance, or fishbones without fish, as Cartier-Bresson neatly put it.

In ten years subjective photography seems to have exhausted itself, and its founder has turned to photo-historical activities. All creative movements are bound to come to a dead-end, when imagination is supplanted by effects which have been played out.

This is not to belittle the creative abilities of the initiator of the movement, who may well put aside accepted rules in his striving for new ways of presentation. The danger lies in less gifted imitators seeing in unconventional experiments the signal for a general licence to do as they please, and pass off sloppy workmanship as creative intention.

The present trend in all the arts is towards disintegration of accepted forms and standards. One-sided lighting, blurred negatives, prints with grain as big as grapeshot, gruesome distortions, flatness instead of plastic qualities, lack of halftone and texture, are all faulty technique. Previous generations of photographers would have consigned such prints to the wastepaper-basket where they belong. Today they are perversely admired and can be found in the

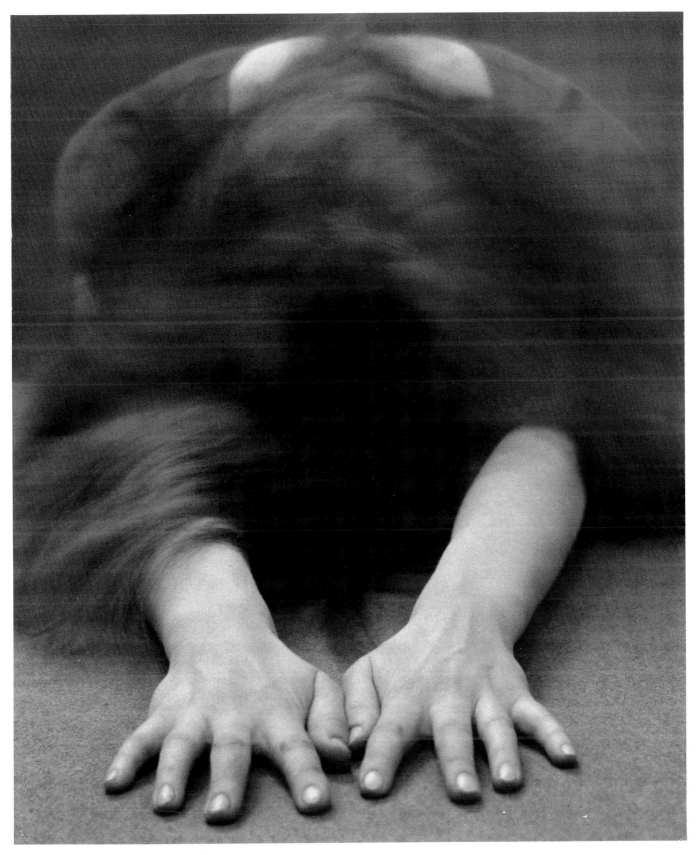

216. *Rolf Winquist. Gertrud Fridh as Medea, 1951*

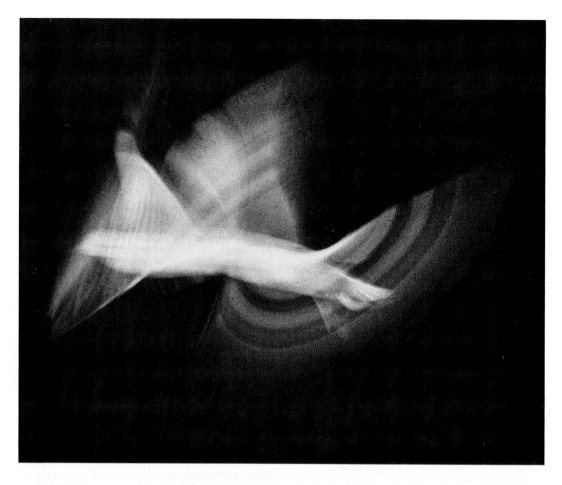

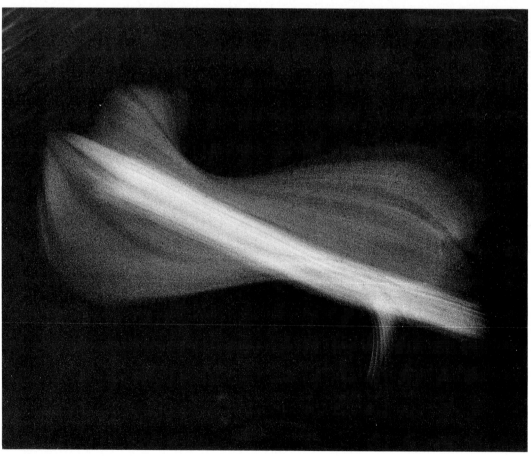

217, 218. *Peter Moeschlin. Seagull in flight, c.* 1952

books of leading magazine photographers. To satisfy the mania for sensation, the modern publicity-ridden photographer relies to an ever-greater extent on gimmicks and the public's stupidity.

In the 122 years of its existence photography has for better or for worse run through the entire gamut of artistic styles, from realism to the abstract. Most of the 'isms' in painting have been reflected in photography, only the reflection was never as good as the original. We have witnessed the absurd spectacle of photography running after painting instead of proudly occupying the fields vacated by it. With a certain time interval, painting and photography arrived at abstract design. I can conceive only one step that remains to be taken to bring photography quite up to date in art circles—photographic *tachisme*. Splashing chemical solutions on sensitive paper and exposing the 'composition' to light: so simple and yet untried!

Following a superficial facet of a style of painting does not add to the value of a photograph but rather detracts from it. Flirtation with art only pays for a limited period. Respect for the photographic image will always remain the fundamental principle of good photography.

Whilst non-objective art may be the purest form of painting, in photography it is a contradiction in terms, a negation of everything that is truly photographic: in short, photographic suicide.

Postscript for the 1991 reprint:

A couple of years after the above was written, I completely reversed my opinion and in fact became a great admirer and advocate of abstractions after seeing some superb images by Raymond Moore and Aaron Siskind. Indeed, photography is nothing but a continuous abstraction from the world around us, a reduction of the world into fragments. Moore concentrated on cracked paint, Siskind on eroded

218a. *Victor Gianella. Geometrical forms*, 1972

walls, Karl Blossfeldt on macro-close-ups of plants, Ferenc Berko on torn billboard signs, Franco Fontana on landscapes and cityscapes, Victor Gianella on painted surfaces. Pierre Cordier creates his own Chemigraphic patterns as Moholy-Nagy and Man Ray had done in the 1920s using different means.

Every image is an abstract, some more than others. When a detail in a close-up is isolated from its context, it assumes a life of its own, and some photographers have achieved great mastery in reducing the world to abstract designs. Whereas the painter can create an abstract picture with lines and colors alone, the photographer's task is more difficult, for he has to find the suitable raw material first and will, if he is lucky, achieve abstractions rather than abstract designs.

XXI

THE FACE OF OUR TIME

The only means available to the early reportage photographers to bring their work before the public had been the sale of actual photographs, or the publication of books illustrated with stuck-in photographs. It was only after the perfection of the half-tone block and its general introduction for magazine illustration during the 1890s and in newspapers in the early years of this century that photographs could be printed along with the text. Previously photo-graphs had to be copied for publication as line draw-ings, and inevitably in this translation the originals lost much of their conviction.

During the late 1920s and '30s the 'make up' of photographically-illustrated weekly magazines underwent a revolutionary change and others were started, which provided for the first time an outlet for picture-stories. The very nature of the lengthy preparations of such magazines excluded topical

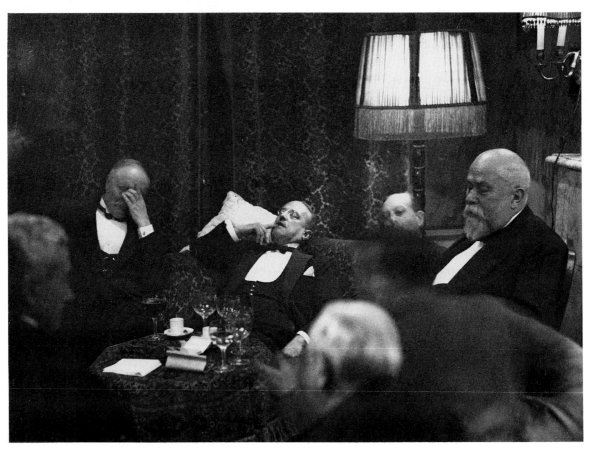

219. *Erich Salomon. At the Second Hague Conference on Reparations, January 1930. Night meeting of French and German ministers at the Restaurant Anjema. L to R, Moldenhauer, Loucheur, Tardieu, Curtius, Chéron*

events, which remained the speciality of the daily newspapers.

The picture-story was made possible by a new camera, the Ermanox, which was fitted with a large-aperture lens, the Ernostar F.1.8.[1] This was the fastest lens ever constructed until then, and in conjunction with fast negative material this $4\frac{1}{2} \times 6$ cm. plate camera opened up a new era in photography. For the first time it became possible to take photographs indoors by available light. It was hardly an exaggerated claim of the manufacturer to state in 1925 'What you can see, you can photograph'. Snapshots of stage scenes, receptions, and other indoor functions could now have been taken without disturbing magnesium flashlight. However, there was the usual time-lag until the potentialities of the new apparatus were appreciated. It was not until February 1928 when the *Berliner Illustrirte* published Dr Erich Salomon's first sensational photograph of a murder trial that other photographers began to realize the technical possibilities opened up by this camera.

Compared with the Leica, also introduced in 1925, the Ermanox gave the reportage photographer two great advantages which remained with this camera until about 1932: the Ernostar lens was several times faster than the Leica's Elmar, and glass plates gave much better enlargements than 35 mm. film, until fine-grain development was introduced.

Dr Salomon's most famous photographs were taken with the Ermanox between 1928 and 1932—indoor pictures of special occasions and events such as the *première* of an opera, the great and famous off their guard, a session of the Reichstag, and in particular international conferences. No one knew how he managed to get into secret sessions from which photographers were barred or, having gained admission, was able to take unposed pictures in lighting conditions that would have deterred any other photographer even with permission. Looking at Salomon's revealing picture of French and German politicians and financial experts at the Second

[1] The Ermanox camera with F.2 Ernostar lens was introduced in June 1924. The following year the F.1.8 lens was put on the market.

220. *Felix H. Man. Igor Stravinsky conducting at a rehearsal,* 1929

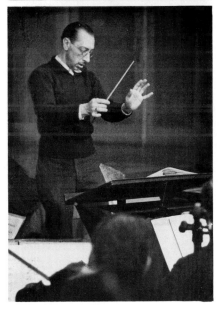

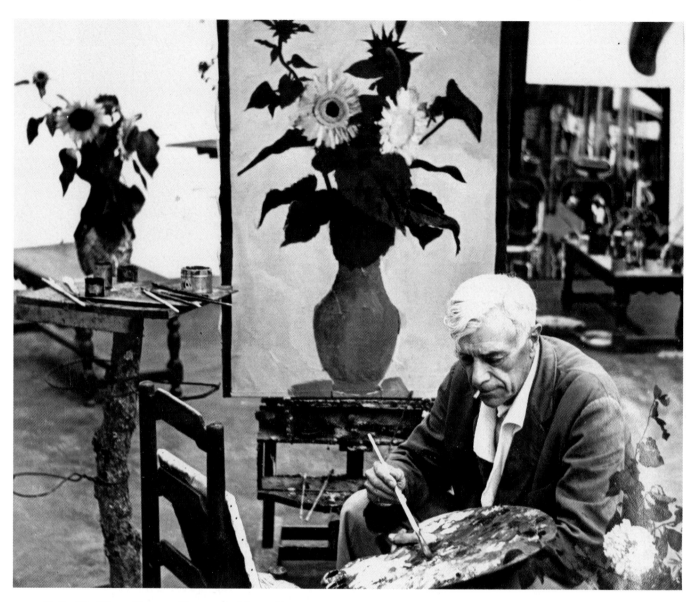

221. *Felix H. Man. Georges Braque in his studio, 1952*

Hague Conference on Reparations in 1930 (*No.* 219) one can understand why politicians preferred to carry on their discussions in private. No wonder Salomon's 'candid camera' pictures—a term coined by the art editor of the weekly *Graphic* in London[1] —caused a stir. Aristide Briand called him 'le roi des indiscrets' but jokingly admitted that a meeting without him could not be considered important.

Whilst Salomon pioneered the field of political reportage, usually in single pictures, Felix H. Man tried to tell a story or present a situation in a set of

[1] In the issue of 11 January 1930.

pictures such as a trotting race at night, an art auction in Berlin, life on the Kurfürstendamm between midnight and dawn, the expressions and movements of conductors (*No.* 220), musicians and actors during concert and theatre performances. His reportages from 1929 onward were mainly published in the *Münchner Illustrierte Presse*, which under the editorship of Stefan Lorant introduced the picture-story as a new form of photographic journalism in weekly publications. A picture-story later imitated countless times was Man's 'A Day with Mussolini', published in that paper in March 1931.

Wolfgang Weber, who long worked for an illustrated

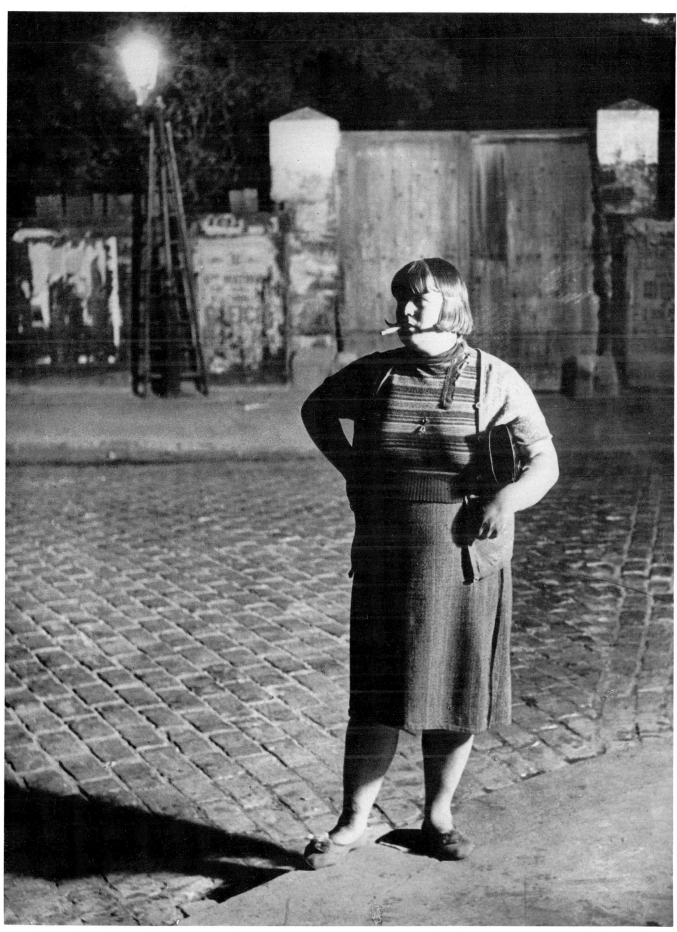

222. *Brassaï. Prostitute in Paris,* 1933

weekly in Germany, is another pioneer of photo-journalism, though probably few people today remember his name in this connection. His first picture-story—a reportage on New York—was published in the *Münchner Illustrierte* in March 1929. Kurt Hübschmann—later Hutton—and Alfred Eisenstaedt made their *début* as reportage photographers in the same weekly magazine during 1930. About this time Robert Capa, just arrived from Budapest, received his training in photo-journalism by Man at 'Dephot' in Berlin, an organization supplying photographs for magazines on a large range of subjects.

Pioneer work in theatre photography was done by the chemist Dr Hans Böhm at the Max Reinhardt stage in Vienna in 1924-25. By means of the Ermanox camera and using ultra-rapid plates, Böhm managed in 1924 to take the first stage pictures during actual performances, shooting from an auditorium box. The novelty of recording the exact expressions and gestures of the actors during a live performance instead of a special stage performance for the benefit of the photographer (as remained the routine until 1950, when still faster films became available) was immediately apparent to the experts. Hugo von Hofmannsthal declared in a letter to the photographer: 'Those modifications of gesture that are so difficult to define and which, changing from generation to generation, are the essence of the actor's style, here appear to have been recorded for the first time'.[1]

In a country that had experienced defeat, revolution, occupation and inflation, and was now afflicted anew by the economic depression, social documentation was an obvious field for the reportage photographer. A large number of illustrated articles and books depicted the plight of the worst-hit areas. The photographs in Count Stenbock-Fermor's *Deutschland von Unten* (1931), though overlooked until now by historians of photography, reveal conditions as shocking as Walker Evans' and Margaret Bourke-White's later documentations of impoverished areas of the U.S.A. Had the German Government acted as Roosevelt did with his New Deal, National Socialism might have been averted. The pictures disclose the naked truth: aesthetically they are an expression of the new realism. Modern reportage, in fact, was developed in Germany and spread from there in the early 'thirties to other countries in Western Europe and the United States by the very photographers, journalists and editors

[1] Hans Böhm, *Die Wiener Reinhardt Bühne im Lichtbild: Erstes Spieljahr 1924/25*, Vienna, 1926. The book contains 123 stage pictures taken by Böhm at the Josefstadt Theater.

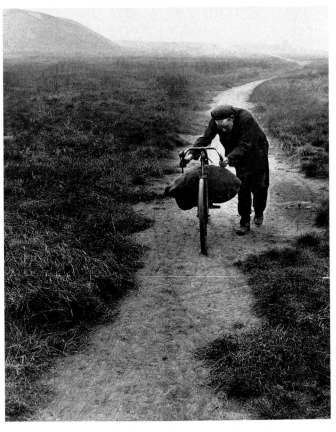

223. *Brassaï. Entrance to the Bal Tabarin, Paris, 1932*

224. *Bill Brandt. Coal searcher, 1937*

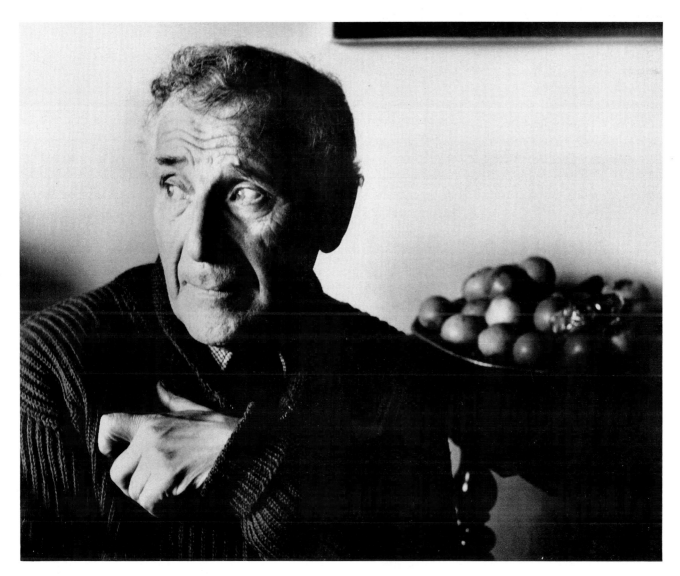

225. *Ida Kar. Marc Chagall,* 1954

who had pioneered it in Germany, for many of them became refugees from Nazism.

From about 1933 onward most reportage photographers turned to the miniature camera (Leica or Contax) with which it was possible to photograph in quick succession, and often unnoticed by the 'victim', fleeting expressions and movements. In popularizing the miniature camera Dr Paul Wolff[1] played a unique rôle—even though he was perhaps a brilliant exploiter of the technique rather than an innovator in the aesthetic field. It was due to him that the miniature camera, once ridiculed as unsuit-

able for serious work, eventually won recognition as a precision instrument always ready for action.

Brassaï's frank revelations of Parisian night life (*No.* 222) in the early 'thirties were further proof of the photographer's extended scope in portraying the face of our time. *Paris de Nuit* (1933) was the first reportage made by night. Peering behind the glamorous façade Brassaï finds lovers under the floodlit bridges; silhouetted against the cobble-stones shining under the street-lamp a prostitute appears. At cabarets and other night haunts (*No.* 223) the rich amuse themselves, while in side streets the newspaper printer, the baker, the roadmender are at work. Policemen go on patrol; bundles of misery rake through dustbins or sleep on pavements and

[1] *Meine Erfahrungen mit der Leica: ein historischer Querschnitt aus fast zehn Jahren Leica-Photographie,* Frankfurt, 1934.

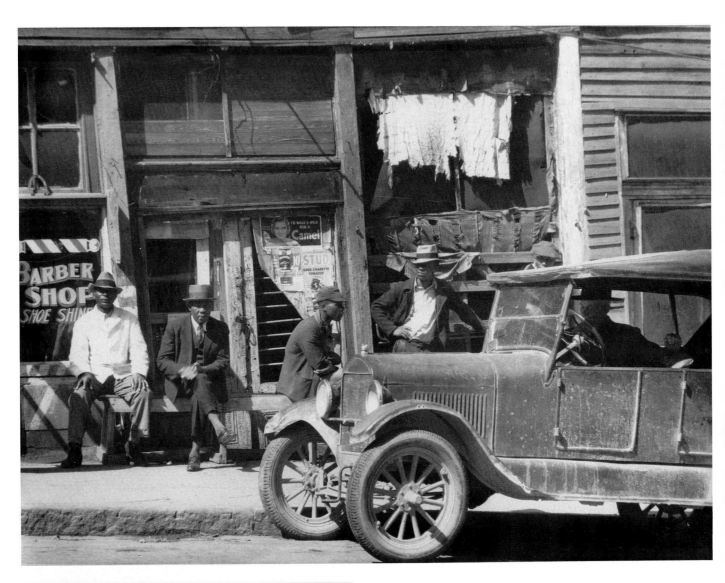

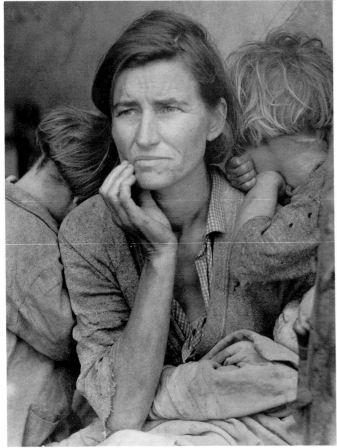

226. *Walker Evans. At Vicksburg, Miss.*, 1936

227. *Dorothea Lange. Seasonal farm labourer's family in a Southern State*, 1935–6

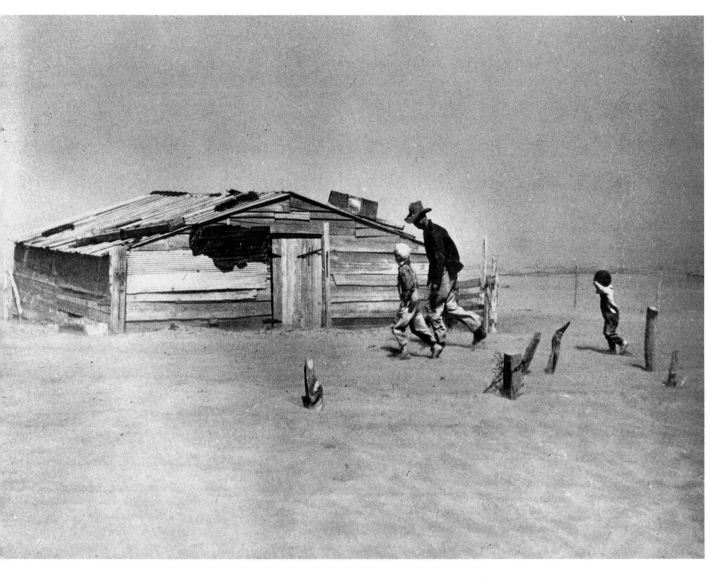

228. *Arthur Rothstein. Farmer and sons in dust storm, Cimarron County, Oklahoma, 1936*

benches, wrapped in newspapers to keep warm. The book is a brilliant exposition of night life in the capital.

Bill Brandt's classic picture of an unemployed miner (*No.* 224) epitomizes the grimness of the economic depression. It was on a path over a bare bit of moorland that Brandt met one evening an unemployed miner returning home from coal-searching. 'The man's clothes were black, and the grass by the side of the path was black, as it was near pitheads. The scene was dreary in the extreme, yet moving by its very atmosphere of drabness.' Bill Brandt's picture is a far more gripping commentary

on the social and personal injustice of unemployment than a White Paper packed with statistics could provide. Brandt has always kept a child-like sense of wonder, which is really the secret that lies behind his approach to any subject. Whereas others need to stimulate this sense by travelling to strange and faraway countries, Brandt has for nearly thirty years worked almost exclusively in England, and the interpretation of the English to the English has been his main theme. He explained to me once—

'Most of us look at a thing and believe we have seen it, yet what we see is often only what our prejudices tell us to expect to see, or what our past

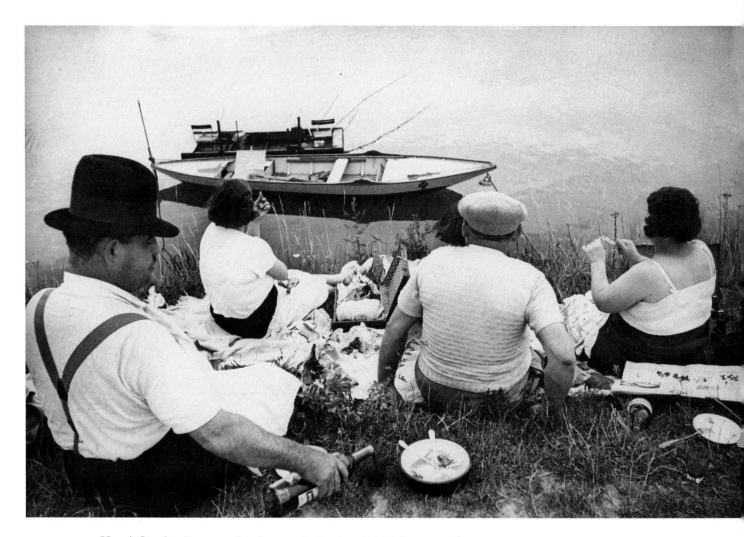

229. *Henri Cartier-Bresson. Sunday on the banks of the Marne,* 1938

experience tells us should be seen, or what our desire wants to see. Very rarely are we able to free our minds of thoughts and emotions, and just *see* for the simple pleasure of seeing. And so long as we fail to do this, so long will the essence of things be hidden from us.'

Brandt's interest in social conditions, out of sheer sympathy for the under-dog, enabled him to photograph the often inhuman conditions in which poor families had to live before the war. The industrial North, where whole sections of the community were out of work, and the fabulous life of the rich in Mayfair, provided Brandt with a wealth of contrasting subjects. In *The English at Home* (1936) he depicted the life of the Two Nations. Even without Raymond Mortimer's poignant introduction, Brandt's pictures speak volumes, for they are the commentary of a socially conscious observer on the misdeeds of our

time. They form an unforgettable documentation of the great chasm which divided rich and poor in housing, education and leisure.

Brassaï's and Brandt's pictures are haunting, as is Margaret Bourke-White's moving reportage of the Southern States of America in *You Have Seen Their Faces* (1937) and John Ford's great film based on John Steinbeck's novel *The Grapes of Wrath* (1939).

In America in the mid-'thirties a number of photographers recording living conditions following the economic crisis for the Farm Security Administration under Roosevelt's New Deal produced outstanding pictures which shocked the conscience of America by their starkness. Walker Evans's photographs 'put the physiognomy of the nation on your table', as one writer said. The ramshackle dreariness revealed in his photographs is a terrible indictment of civilization in certain parts of America fifty-

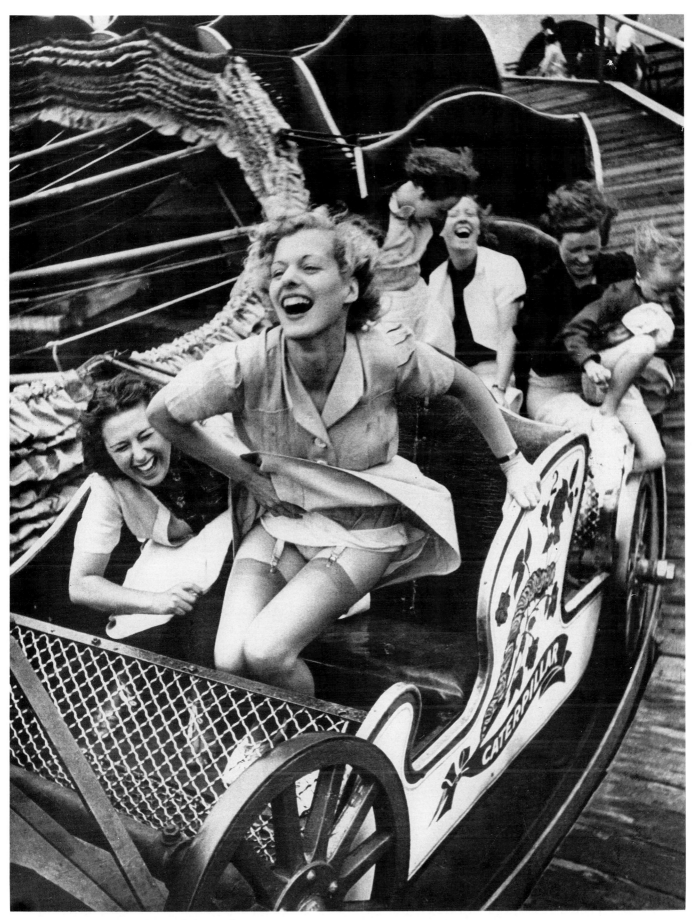

230. *Kurt Hutton. At the fair,* 1938

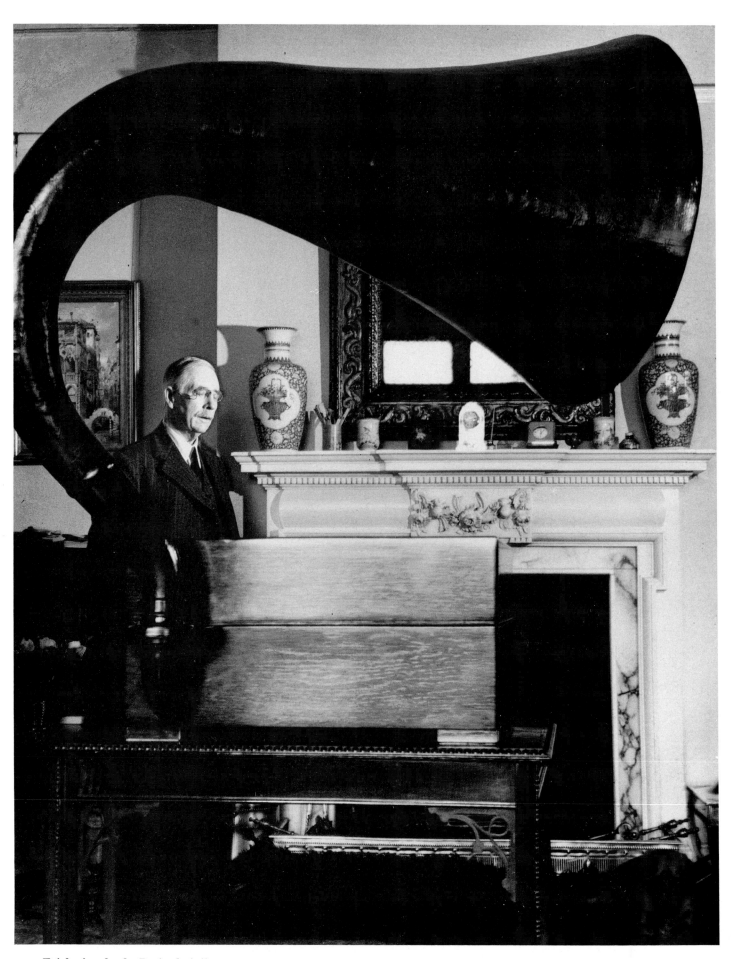

231. *Erich Auerbach. Retired civil servant, 1944*

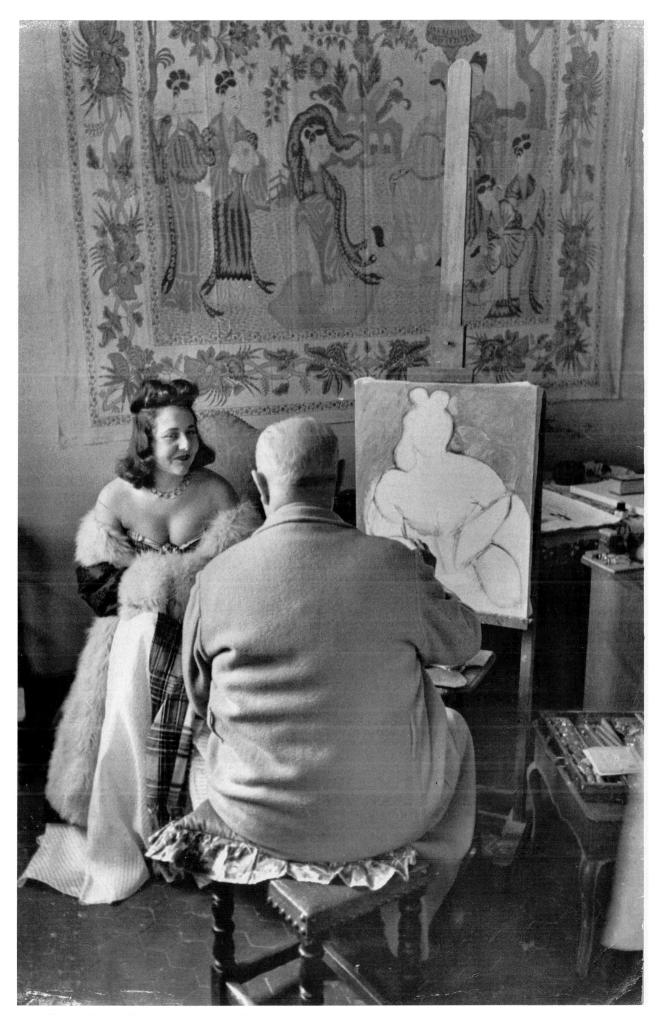

232. *Henri Cartier-Bresson. Matisse in his studio,* 1944

five years ago (*No.* 226). They are appalling documents of poverty and economic conditions unworthy of human beings with a strong underlying criticism of the life of the underdog in rich and happy America of which every Northerner is proud. What you see in Evans' photographs and those of Dorothea Lange (*No.* 227), Arthur Rothstein (*No.* 228), Russell Lee, Margaret Bourke-White and others working for the Farm Security Administration (FSA) under Roy Stryker in 1935–42 mainly in Southern areas of the United States defies description: poverty-stricken huts, ramshackle shops, farmers out of work, starving children, haggard women, unsanitary hygienic conditions and shameful practices such as chain gangs of black prisoners, the latter immortalized by Margaret Bourke-White, whose book *You Have Seen Their Faces* (1937) is full of haunting photographs.

The material on the daily life of tenant farmers in Alabama which Evans and the writer James Agee had been assigned to collect in 1936 by the editor of the fashionable *Fortune* magazine was too strong for publication. In 1941 another publisher risked a book under the harmless title *Let Us Now Praise Famous Men*, which gave no hint of the dynamite hidden inside. Yet the sales figures were shockingly low— 600 copies. Despite this the same publisher risked a paperback edition twenty years later, which the *New York Herald Tribune* hailed as 'the most famous unknown book in contemporary letters'. Today it is recognized as a classic.

Evans' photographs and the thousands of others taken for the FSA are now housed at the Library of Congress. They constitute, in my opinion, the greatest photographic documentation of all time and are the most moving comment on Roosevelt's prophetic idea: The New Deal brought no relief and no deal to the underdeveloped areas of the United States which they document. Let us face reality: conditions have changed very little in the last fifty years, as we can judge from a new set of 600 devastating photographs published by the Danish photographer Jacob Holdt not long ago.[1]

Photography is a powerful weapon in awakening

[1] Jacob Holdt, *American Pictures—Bilder aus Amerika*, Frankfurt/Main, 1984.

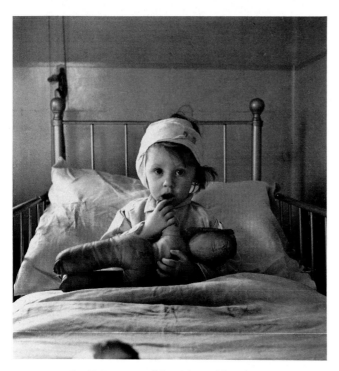

233. *Cecil Beaton. After the raid*, 1940

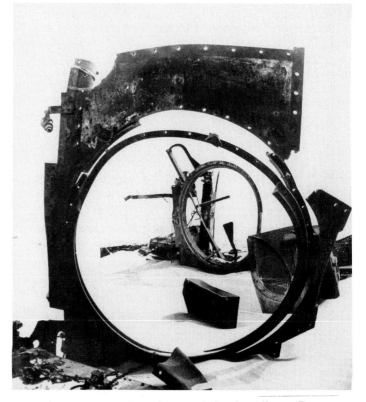

234. *Cecil Beaton. Wrecked tank in the Libyan Desert*, 1942

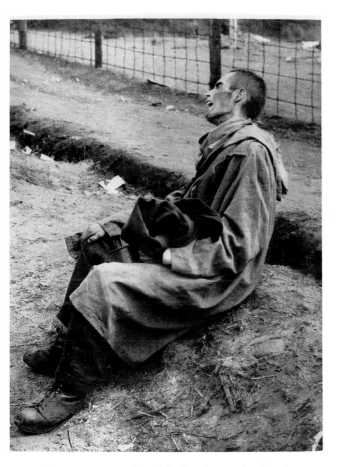

235. Anon. Demented political prisoner in Nazi concentration camp after liberation, 1945

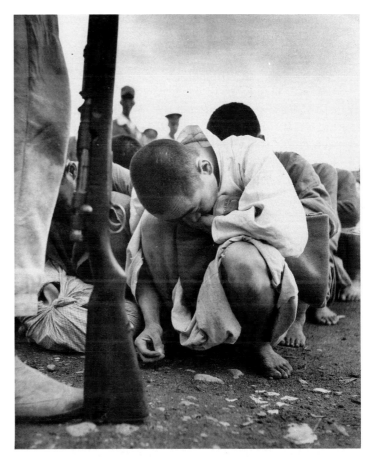

236. Bert Hardy. South Korean political prisoners at Pusan awaiting transport to a concentration camp and execution, 1950

the social conscience, as Jacob Riis first came to realize. What Gustave Doré accomplished in his dramatic pen drawings of London ninety years ago can today be achieved with even greater forcefulness by a photographer with the same penetrating powers of vision as Doré.

However, it is not only social conditions but the whole of life which photography depicts more convincingly than any other graphic art. To obtain unfamiliar shots of familiar subjects is one of the tasks of the reportage photographer working for illustrated weekly magazines. Success lies in catching the mood, atmosphere and expression. Does not Kurt Hutton's scenic railway (No. 230) evoke all the

fun of the fair? Stefan Lorant's criterion that 'the camera should be like the notebook of a trained reporter to record events as they happen, without trying to stop them to make a picture' is perfectly exemplified by Hutton's photograph. And just as he epitomizes the entire situation in this picture, so does Henri Cartier-Bresson's 'Sunday on the Banks of the Marne' (No. 229) at once convey the atmosphere of a typical petit-bourgeois family's ideal Sunday outing. Down to the smallest detail it is a French family. What traveller in France has not seen similar groups a hundred times over! Yet only Cartier-Bresson has been able to snatch such a perfect picture reminiscent of Seurat's 'Baignade' at the Tate Gallery,

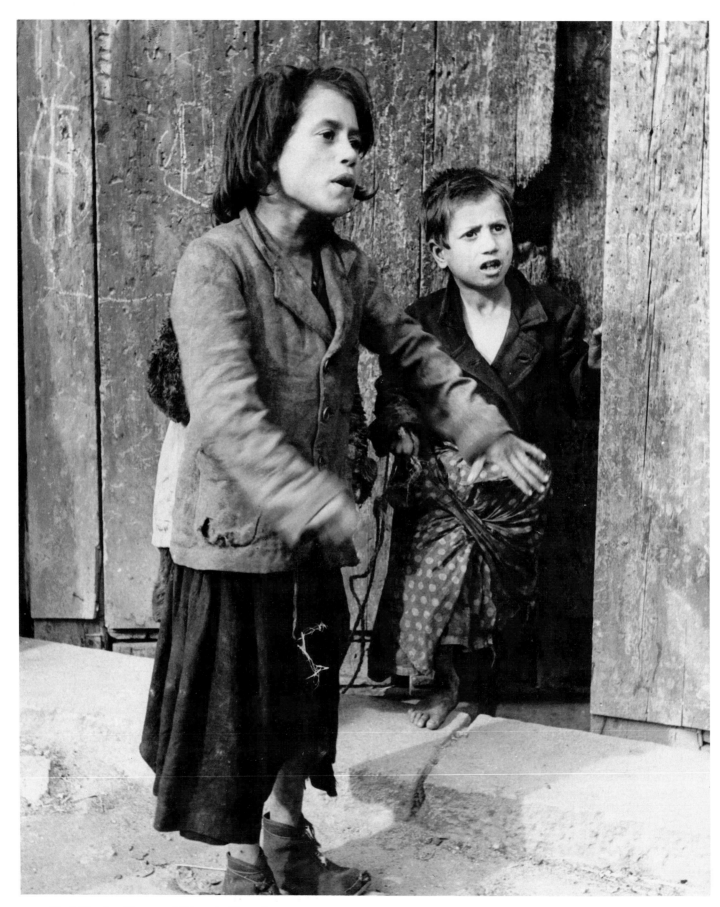

237. *Bert Hardy. Beggar children in Barcelona,* 1950

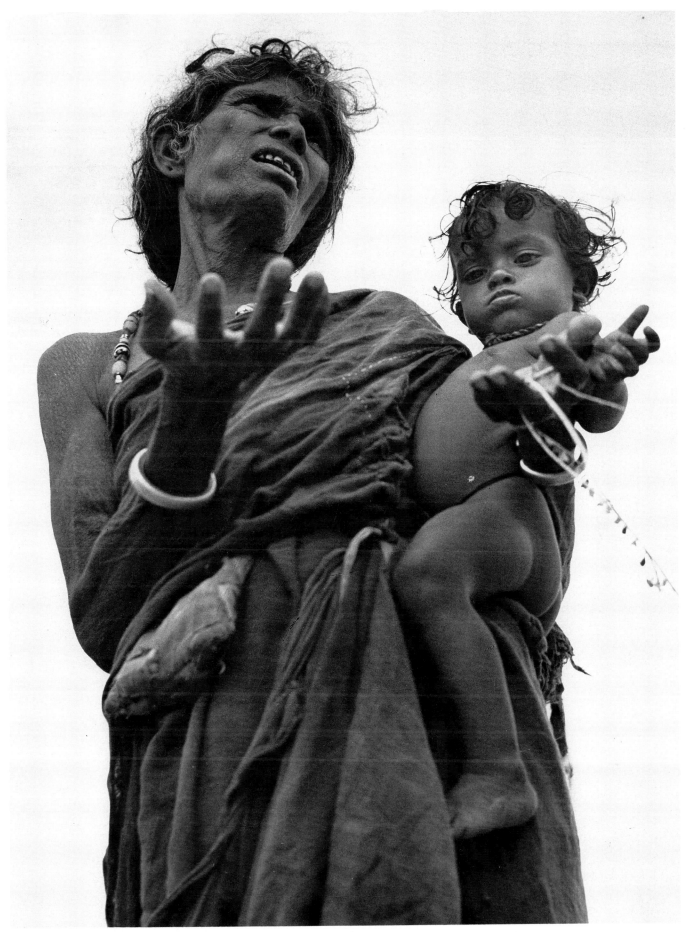

238. *Werner Bischof. Famine in Madras province, South India,* 1951

and as brilliant a composition as the painter's. Cartier-Bresson found the situation ready-made, but the reportage photographer is to a much greater extent than the graphic artist dependent on chance circumstances over which he has no control. Patiently he has to stalk his subject until all the elements in the picture are at their maximum expressiveness. Action was still lacking until the man on the left poured himself another glass of red wine. This was 'the decisive moment', as Cartier-Bresson calls it.

Cartier-Bresson once defined reportage to me as a progressive operation of the eye, the mind, and the feelings, and since photography and reportage are to him synonymous terms—implying that he considers reportage as the only legitimate field of creative photography—he added: 'Photography is for me the simultaneous recognition in a fraction of a second of the significance of an event, as well as of a precise formal organization (i.e. composition) which brings that event to life. On rare occasions a single photograph will suffice by itself to express all the essentials of a scene (*No.* 232), but usually it is necessary to have several photographs complementing each other.'

World War II and its aftermath provided photo-reportage with one of its most important tasks. At no previous period have the cruelty of war, and poverty, starvation and misery, been so vividly interpreted—with the exception of Goya's haunting 'Disasters of War'. The years of upheaval are reflected in countless memorable pictures, but out of the wealth of material available I can only select a few typical examples in which the photographer has managed to create a striking and at the same time an aesthetically satisfying picture. Cecil Beaton's photograph 'After the Raid' (1940), which was used as a poster in the American Red Cross campaign and on the cover of *Life* magazine, is said to have greatly influenced American feeling towards helping Britain, before the U.S. entered the war. A little girl in a hospital bed (*No.* 233) with bomb-terror still in her eyes, and clinging to her doll which had survived with her, stares you in the face. What expression and appeal for sympathy is contained in this directness—a directness which no one can escape, like that famous recruiting poster in the First World War of Lord Kitchener, pointing at you and saying, 'Your king and country need you'. Beaton's wrecked tank (*No.* 234) in the Libyan Desert is for me as great a war picture

as 'Totes Meer' or 'Battle of Britain' by Paul Nash, who for these and many other paintings took photographs as studies. Treating his Kodak as a kind of notebook, Nash from 1931 until his death in 1946 increasingly made use of his camera, with the result that he 'developed', as he put it, 'something like a new consideration of landscape pictorially'. In *Fertile Image* (1951) Nash's photographs stand on their own, revealing better than his paintings the hidden life of monoliths, sprawling tree-trunk monsters (*No.* 187) and other strange objects that fired his imagination.[1]

In my opinion the photograph of a demented political prisoner (*No.* 235), for whom liberation came too late, is an infinitely more expressive symbol of persecution than Reg Butler's prize-winning iron construction which is to be set up in Berlin. The photograph places on record for all time an accusation and a challenge: the sculptor's monument is an intellectual exercise. A book of concentration camp photographs given to every adolescent on leaving school would be a far more effective reminder of these horrors. As it is, some Germans still do not want to believe that they really happened.

The way Bert Hardy caught the terror-stricken South Korean political prisoners crouching abjectly before the guard's rifle in anticipation of death (*No.* 236) sums up the whole situation—man's inhumanity to man. It is obvious that a sensitive photographer cannot record such events objectively: the deeper his compassion goes, the greater will be the impact of his picture. This is exactly what I felt on first seeing Eugene Smith's wonderful reportage, 'The Spanish Village' (1950), in which he explores the eternal themes of life and death in a poor community. Eugene Smith used his camera just as Velasquez used his brush. He lived in the village for some weeks in order to win the confidence of the inhabitants, as well as to get intimately acquainted with their customs—an essential point for a stranger wishing to achieve proper contact with, and insight into, the life of a foreign country.

Werner Bischof, another artist with the camera, spent a year in Japan becoming familiar with the subtle beauty of Japanese art, and the suffering and confusion of people living in an ancient tradition with the results of the atom bomb. His intensely vivid and sensitively seen interpretation of his impressions in colour and monochrome make his book

[1] See Paul Nash, 'Art and Photography,' in *The Listener*, Vol. VI, London, 1931, p. 868.

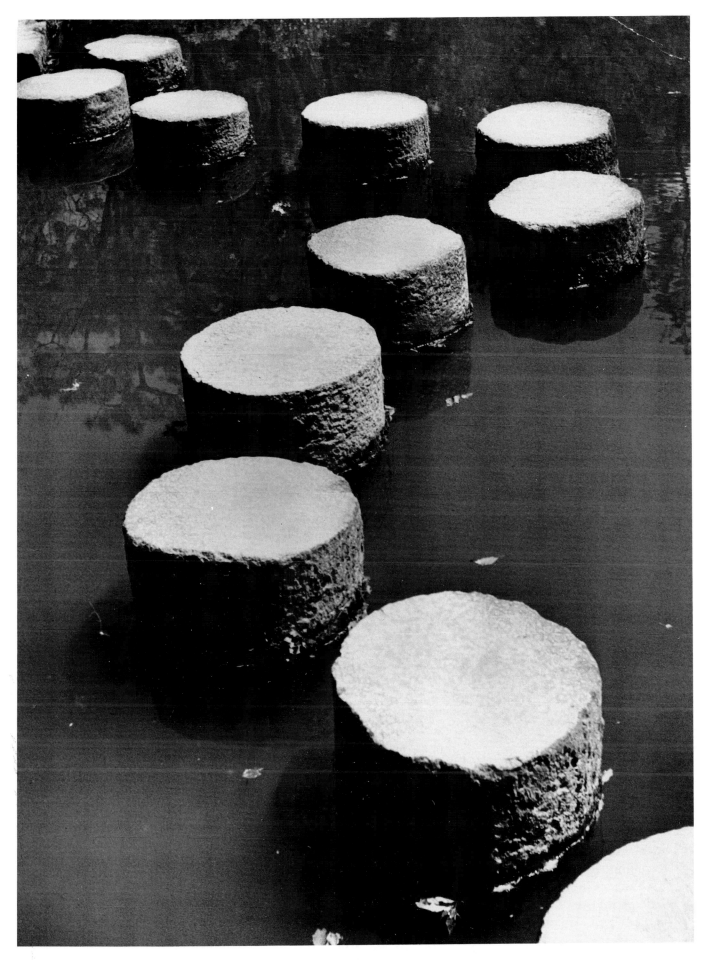

239. *Werner Bischof. Stepping-stones in the Heian Garden, Kyoto, 1952*

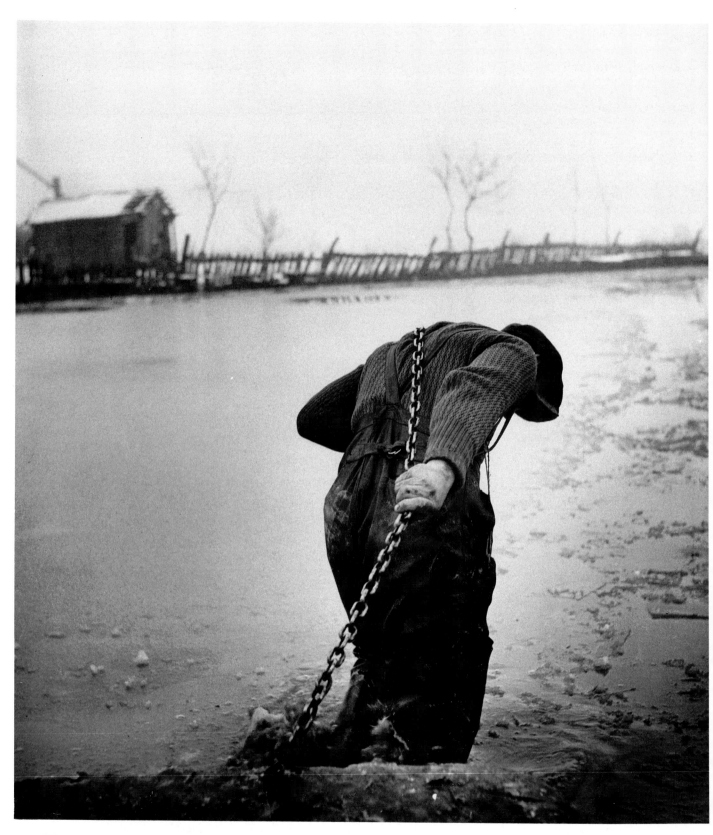

240. *Werner Bischof. Floods in East Hungary,* 1947

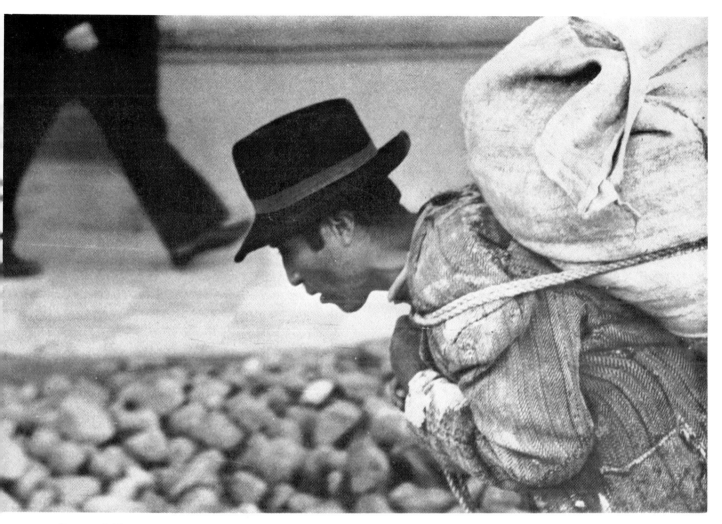

241. *George Oddner. Man with load, Peru,* 1955

Japan one of the greatest contributions in the field of reportage. The death-mask of famine on living people (*No.* 238) which he encountered in India is another typical example of his ability to transform a photograph into a timeless symbol. In his work of bringing about a greater understanding between men Bischof lost his life, like two of his colleagues in the Magnum organization, who also photographed from the depths of their heart, Robert Capa and David Seymour. To them, reportage was a mission in life.

Emil Schulthess' photographs of Africa show remarkable observation of nature with its striking variety of scenery and wild life, but one misses the feeling for human interest which make the volume *Japan* by his friend Werner Bischof so memorable.

George Oddner's hitherto unpublished Peruvian reportage comes much closer to Bischof's work. He moves one by his sympathy with the life of humble people. But both Schulthess and Oddner surprise by the intensity of vision and economy of means with which they tell their story. Oddner's Peruvian labourer (*No.* 241) walking over cobblestones, doubled up beneath the weight of a sack of flour, has great power. Counter-movement and social contrast are implied by the legs of a well-dressed man walking in the opposite direction on the smooth pavement. Intensely moving I find his picture of a blind beggar who has been collecting crumbs from the (comparatively) rich man's table (*No.* 242), a biblical scene of stark realism set in the primitiveness of Peru.

Unforgettable in its simplicity is Oddner's photo-

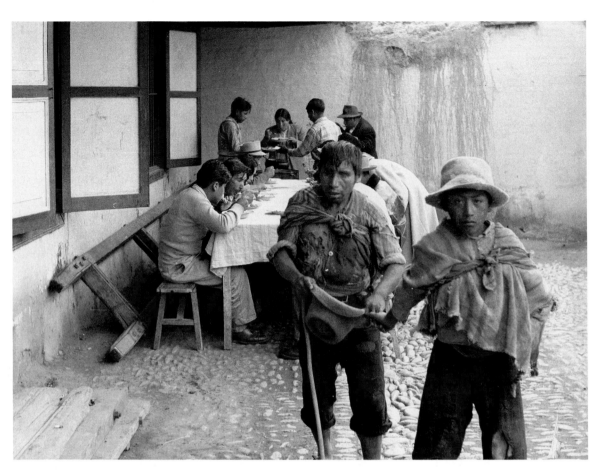

242. *George Oddner. Blind beggar in Peru,* 1955

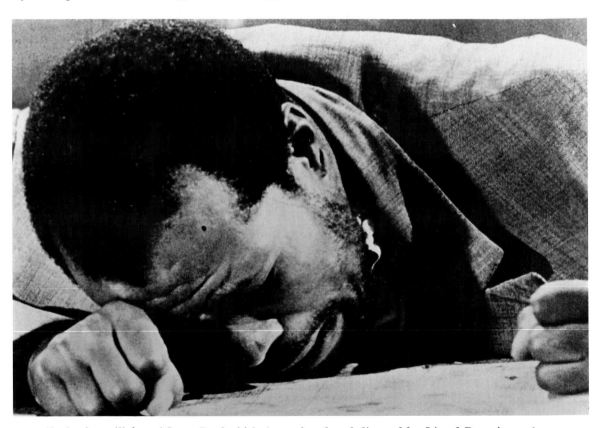

243. *Zacharia: still from 'Come Back Africa', produced and directed by Lionel Rogosin,* 1960

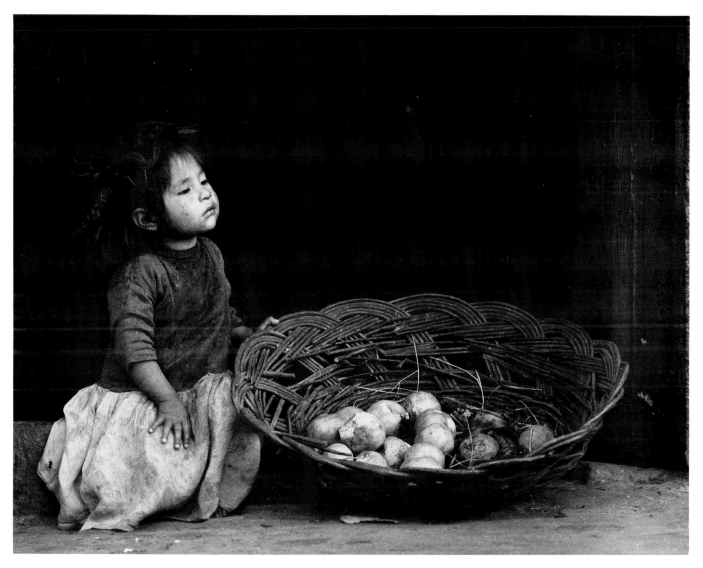

244. *George Oddner. Child selling vegetables in Peru*, 1955

graph of a Peruvian child, so hungry that she started nibbling at the vegetables she has for sale (*No.* 244). Genuine sympathy for the underdog is a necessary element for taking pictures that have an immediate impact. Zacharia's agony and grief (*No.* 243), one of the most moving shots from 'Come Back Africa', brings out in a compelling climax the tragedy of South Africa today. The film is a gripping document of our times, a powerful, moving and convincing argument against apartheid; and this close-up is more visually effective even than the news picture of the scattered bodies at Sharpeville.

The most important contribution of photography as an art form lies, I believe, in its unique ability to chronicle life. Photography is the only 'language' understood in all parts of the world, and, bridging all nations and cultures, it links the family of man. Independent of political influences—where people are free—it reflects truthfully life and events, allows us to share in the hopes and despair of others, and illuminates political and social conditions. We become the eye-witnesses of the humanity and inhumanity of mankind, and are affected according to the degree of sympathy of the photographer and his ability to communicate it. No other creative field has such a wonderful task, and offers such unique possibilities, as photography and its offspring, the film and television.

SHORT BIOGRAPHIES OF

PHOTOGRAPHERS ILLUSTRATED

Ansel Adams 1902–84
Born in San Francisco, son of a timber merchant, Adams became a professional pianist. He was an ardent amateur photographer of scenery for many years before becoming a professional in 1930. A friend of Edward Weston, Adams became in 1932 a founder member of the F.64 Group. Appointed in 1941 photo-muralist to the U.S. Department of the Interior, Adams began photographing characteristic landscapes of various regions, which made him famous. Ten years later started collaboration with Nancy Newhall on regional exhibitions and books, among them *Mission San Xavier del Bac* (1954) and *This is the American Earth* (1960). Published a number of books and portfolios of his fine landscapes, including *My Camera in the Yosemite Valley* and *My Camera in the National Parks* (both 1950).

Robert Adamson 1820-48
The son of a farmer at Burnside near St Andrews, Robert Adamson was for a year or two apprenticed to a millwright at Cupar. Too delicate for this hard work, in 1842 he learned the Calotype process from his brother Dr John Adamson, professor of chemistry at St Andrews University, and opened a professional portrait studio in Edinburgh in January or February 1843. There he was joined at the end of May by D. O. Hill. In the autumn of 1847 Adamson's health failed and he returned to his parents' house where he died the following January.

James Anderson 1813–77
Born at Blencarn, Cumberland, the watercolour painter Isaac Atkinson settled in Rome in 1838 under the name James Anderson. For a time he did a flourishing business in small bronze casts copied from antique sculpture. By 1849 he was established as a photographer working for well-known sculptors like Gibson. Anderson's photographs of antique sculpture and views of Rome, on sale at a bookseller's in the Piazza di Spagna, were in great demand by tourists. In later years he became chiefly known for reproductions of art in Italian museums. Until a few years ago the firm still flourished under the direction of Anderson's grandsons. He died in Rome.

James Craig Annan 1864–1946
Born at Hamilton, son of Thomas Annan, professional photographer in Glasgow. Trained in his father's studio, learned photogravure from its inventor Karl Klíč in Vienna and introduced it under licence into Great Britain in 1883. Like his father, Craig Annan was one of the leading creative photographers in Scotland. Through his untiring efforts in propagating the work of Hill and Adamson on the Continent and in the U.S.A. it was 're-discovered' at the turn of the century, but at the same time Annan's own work was somewhat overshadowed. Left the running of his Sauchiehall Street studio largely to assistants, photographing only prominent people. Annan's best pictures were taken on foreign holidays, and exhibited as photogravures or photo-etchings. Annan was a member of the Linked Ring and first president of the International Society of Pictorial Photographers. He died at his house at Lenzie near Glasgow.

Thomas Annan 1829–87
Born in Fifeshire, where his father owned a linen mill, Thomas Annan was trained as a copperplate engraver and came to Glasgow at the age of twenty-six. He took up photography the same year and within a few years became the leading portrait photographer in Scotland, with a studio in Sauchiehall Street, Glasgow, which still flourishes. Also a prominent landscape photographer, Annan illustrated an edition of Sir Walter Scott's *Marmion* (1866) and other literary works. Introduced the carbon permanent printing process into Scotland in 1866, chiefly for art reproductions in which the firm specialized, and opened works at Lenzie near Glasgow, where between 1879–81 a set of carbon prints of Hill's photographs was produced. Between 1868–77 Annan made a photo-documentation of Glasgow slums for the Glasgow City Improvement Trust, a selection of forty photographs being issued in a limited edition in 1878.

Edward Anthony 1818–88
While training as a civil engineer Anthony learned to daguerreotype in his spare time from Samuel Morse (1840 or '41). In 1841 he photographed the north-

eastern frontier with Canada, which was in dispute with England—doubtless the first use of photography in a Government survey. In partnership with J. M. Edwards started a portrait studio in Washington (1842) and photographed all the members of Congress (1843) forming a National Daguerrean Gallery (exhibited in New York City) which was destroyed by fire in 1852. In 1847 Anthony sold his share in the portrait business and became a dealer in daguerreotype materials. In 1852 founded with his elder brother the firm of A. & H. T. Anthony, which became the principal photographic supply house in the United States. Published stereoscopic views, including the first instantaneous street views of New York (1859).

Eugène Atget 1857–1927
Born at Bordeaux, Atget was until 1898 a comedian playing in the provinces. Retired to devote himself to a self-imposed task: the documentation of a Paris that was gradually vanishing. The playwright Victorien Sardou told him of buildings, etc., doomed to destruction, and the Archives de Documentations Photographiques bought from him cheaply all photographs relating to the history of Paris. But apart from this, he had no official support or recognition. Though Utrillo based paintings on his photographs and Braque also bought a few, Atget remained practically unknown and died in extreme poverty in Paris, leaving about 10,000 photographs. It was only in 1930 with the publication of a selection of these photographs in Paris, Leipzig and New York that Atget's work became known to a larger public.

Erich Auerbach 1911–77
Born in Falkenau near Karlsbad (Bohemia). Broke off study of music at Prague University and joined the *Prager Tagblatt* as music and film critic. To fill a temporary need for a staff photographer, Auerbach, already an amateur, began photographing for this paper in the early 1930s and in this work found his real vocation. In May 1939 Auerbach settled in London, where he worked throughout the war as photographer to the Czechoslovak Government in exile. From 1945 until its demise twelve years later he was staff photographer to *Illustrated*. Auerbach later worked as a free-lance photographer specializing in the arts, with emphasis on musicians and concert performances. In 1951 he was awarded the *Encyclopaedia Britannica* prize for feature photographs. He died in London.

Platt D. Babbitt
American professional daguerreotypist who held monopoly for photography on the American side of the Niagara Falls in the 1850s.

Edouard Baldus 1820–82
Born in Westphalia, Baldus became a naturalized Frenchman. Originally a painter of religious subjects, he changed to photography, specializing in architecture. In 1851 Baldus calotyped historic buildings in Burgundy, the Dauphiné and Fontainebleau for the Comité des Monuments Historiques. Soon afterwards he changed to the wet collodion process and made a complete documentation of the new wing of the Louvre, taking no fewer than 1,500 detail photographs. Baldus was also well known for views, especially of mountains, and invented a photo-engraving process (1854). The demand for his large mounted prints was adversely affected by the introduction of the *carte-de-visite* format.

H. Walter Barnett 1862–1934
Born in Australia, Barnett gave up his portrait studios in Melbourne and Sydney in 1897 and after working for a time in America settled in London. Established himself at Hyde Park Corner as a photographer of celebrities, royalty, and society women. Barnett's sepia-toned platinotype and carbon prints were accorded the highest praise.

Hippolyte Bayard 1801–87
Born at Breteuil-sur-Noye. Clerk in the Ministry of Finance, made photographic experiments from 1837 on; redoubled efforts in 1839 after hearing of Daguerre's success, and became independent inventor of photography on paper. Showed to Arago in May 1839 a direct positive process on paper, but on receipt of a small sum of money was persuaded to defer publication of it until further improved; in truth, in order not to prejudice Arago's negotiations with the French Government in connection with a pension for Daguerre. Bayard exhibited thirty photographs in June 1839, but Daguerre's were considered more perfect. He did not publish details of his process until February 1840. A founder member of the Société Française de Photographie in November 1854, Bayard photographed as an amateur with every process invented, including the daguerreotype. He died at Nemours.

Richard Beard 1801–85
Originally a coal merchant and patent speculator in London, Beard acquired the British rights in the American mirror camera in June 1840 and the daguerreotype patent a year later. Engaged a scientist, J. F. Goddard, to speed up the process and opened the first public photographic portrait studio in Britain (probably in Europe) on 23 March 1841 at the Royal Polytechnic Institution, Regent Street, London. Patented colouring of daguerreotypes 1842, and a year later the first photographic enlarger. Made a fortune from three London and several provincial studios, plus licence fees, but was ruined by litigation against infringers of the patent and became bankrupt in 1850. Showed portraits at Great Exhibition 1851 and took daguerreotypes for John Tallis's *History and Description of the Crystal Palace* 1851 and Henry Mayhew's social survey *London Labour and the London Poor* (1851). Continued portrait business in his City studio. Nevertheless it is doubtful whether Beard, an *entrepreneur*, ever took any photographs himself.

Cecil Beaton 1904–80
Born in London, son of a timber merchant. Educated at Harrow and Cambridge University. From 1924 worked for a few years in a City office. Amateur photography consoled him for this uncongenial work. An exhibition in Bond Street in 1928 of Beaton's bizarre portraits of well-known people led to a contract with *Vogue*. For twenty-five years Beaton took portraits of celebrities and fashion photographs for this magazine in London, Paris and New York. Also photographed the royal family on many occasions. Beaton never had a studio of his own. During World War II photographed for the Ministry of Information in the Middle and Far East. Later Beaton was chiefly active as a designer of costumes and *décor* for the stage and films, his best-known creation being 'My Fair Lady.' He also painted. Author of about eighteen books illustrated with his drawings and photographs (portrait, fashion, ballet, travel). Lived in Kensington, London, and had a country house near Salisbury. Received a knighthood eight years before his death.

Werner Bischof 1916–54
Born in Zürich, son of manager of a pharmaceutical factory. After a year's training as teacher of drawing and sport, Bischof took the general course (including photography) at the Arts and Crafts School in Zürich, 1932–6. From 1936–9 he was a free-lance photographer and designer in Zürich. Went to Paris to study painting but was recalled for military service. Released in 1941, Bischof became staff photographer on the Swiss magazine *Du* 1942–5, for which he made in 1945 his first reportages on refugees and the war-ruined districts of France, Holland and Germany. From 1946–9 free-lance reportage photography for *Life* and other illustrated papers took Bischof to practically every European country. Joined Magnum group 1949. Worked for *Life* in India, Japan and Korea 1951–2; made war reportage in Indochina. In autumn 1953 worked for *Fortune* magazine in U.S.A. Started in 1954 on a tour of Mexico, Panama and Chile. Bischof died in May when car crashed in the Andes during a tour of the Amazon region. Published *Japan* (1954), *Incas to Indians* (1957), *Unterwegs* (1957).

Louis Auguste Bisson 1814–76 and *Auguste Rosalie Bisson* 1826–1900
Bisson Frères, sons of an heraldic artist, started one of the earliest photographic firms in Paris, opening a daguerreotype studio in 1841. Besides taking portraits, the brothers were considered the best French architectural photographers, and noted for their art reproductions and Alpine views. Auguste Bisson was the first to photograph from the summit of Mont Blanc in July 1861. After a three-day ascent from Chamonix with twenty-five porters to carry the equipment for the wet collodion process, he managed to take three pictures. Like Le Gray (whose studio was in the same house) the Bissons were ruined by the cheap *carte-de-visite*, since the demand for large mounted prints declined with the fashion for collecting *cartes* of views in albums. The Bisson brothers were founder members of the Société Française de Photographie.

Dr Hans Böhm 1890–1950

Fred Boissonnas 1858–1947
Born at Geneva, son of Henri Boissonnas, a photographer. Studied photography at Budapest and Stuttgart. Fred Boissonnas took over the management of his father's studio in Geneva in 1888, and eventually opened branch establishments in Paris, Lyon, Marseille, Rheims and St Petersburg. With his brother Edmond, a chemist, manufactured orthochromatic plates and obtained the first successful photographs of Mont Blanc from Geneva. Made a series of fancy studies, e.g. 'Faust', for exhibitions. In 1902 Lord Napier commissioned Boissonnas to photograph Mount Parnassos, and during numerous journeys in Greece he took several thousand negatives. Published several books on that country, best known being *En Grèce par Mont et par Vaux* with text by D. B. Bovy. King Fuad commissioned from Boissonnas a similar work on Egypt, which he undertook at the age of 75, spending fifteen months travelling from the Delta to the Sudan. He died in Geneva.

Bill Brandt 1904–83
Born in London, brought up in Germany. Brandt learned photography from Man Ray in Paris 1929–30, opened a portrait studio there, but influenced by the work of Atget, Cartier-Bresson and Brassaï, changed to reportage. Settled in London in 1931 as freelance photographer. During the depression documented the industrial North. One-man show in Paris 1938 organized by the Arts et Métiers Graphiques. During the blitz took pictures in air raid shelters for the Home Office. After the war Brandt took 'at home' portraits of celebrities, architecture and landscapes, frequently for English and American magazines. Published *The English at Home* (1936), *A Night in London* (1938), *Camera in London* (1948), *Literary Britain* (1951), *Perspective of Nudes* (1961).

Brassaï (pseudonym for Gyula Halász) 1899–1984
Born in Brassó, Hungary, Brassaï originally wanted to be a painter and studied art in Budapest and Berlin, but settled in Paris as a journalist in 1924. Under the influence of his friend, the photographer André Kertész, Brassaï changed to photography for economic reasons six years later and became known for his photographs of Paris by night and 'candid' pictures of Parisians in unguarded moments. During the German occupation was protected by Picasso, in whose studio he lived. Had many intelligent conversations with him on art and photography, which he published in 1964. Other books are: *Paris de Nuit* (1933); *Les Sculptures de Picasso* (1948); *Camera in Paris* (1949); *Graffiti de*

Brassaï, with text by Picasso (1949); *Fiesta in Seville* (1956); *Le Paris Secret des Années 30* (1976); *The Artists of My Life* (1982). A collection of his photographs was published under the title 'Brassaï' (1952). Encouraged by Picasso, took up drawing again during the German occupation; published a selection in 1946. Made photographic *décors* for the ballet 'Les Rendezvous' and for the play 'En Passant'.

Maurice Bucquet (?)–1921
French amateur photographer between 1888 and 1914. As founder-member and president of the Photo-Club de Paris (1890) Bucquet played an important part in the development of artistic photography in France. He was an advocate of straightforward photography.

Henry Herschel Hay Cameron
Youngest son of Julia Margaret Cameron and the only one to make photography his profession, after having been a teaplanter in Ceylon. Opened a portrait studio in Mortimer Street, London, about 1885. Cameron's portraits of celebrities betray unmistakably the influence of his mother's style. Illustrated Lady Ritchie's book *Alfred, Lord Tennyson and His Friends* (1893). Gave up photography *c.* 1900 to become an actor in London and the provinces.

Julia Margaret Cameron 1815–79
Born in Calcutta of an English father and a French mother, Julia Pattle married in 1838 Charles Hay Cameron, a distinguished jurist and member of the Supreme Council of India. When Cameron retired in 1848 and settled in England, first at Tunbridge Wells, later at Putney Heath, their house became a centre of intellectual society. In 1860 they bought a house at Freshwater, Isle of Wight, and here in 1863 Mrs Cameron taught herself photography. Her first success dates from January 1864. At 'Dimbola' (now a hotel) she photographed most of the famous Victorians visiting Tennyson, her friend and neighbour. A great eccentric, Mrs Cameron had little use for convention, and this comes out in her very original photographs. At Tennyson's request she made twenty-four illustrations to *The Idylls of the King*, which were published in two volumes in 1874 and 1875. Sold her portraits and composition photographs at P. & D. Colnaghi, the London printsellers. Took part in numerous exhibitions and had three single exhibitions in London in 1865, 1867 and 1868. The photographs of this famous amateur did not find favour in photographic circles but won highest praise from artists, including G. F. Watts. In 1875 the Camerons went to live on one of their coffee estates in Ceylon. Here Mrs Cameron took only rather ordinary straightforward portraits of natives. She died at Kalatura, Ceylon. Her autobiographical manuscript *Annals of My Glass House*, written in 1874, was posthumously published as part of an exhibition catalogue of her photographs in 1889.

Etienne Carjat 1828–1906
Born at Fareins. Caricaturist, writer, and editor of *Le Boulevard* 1862–3, Carjat also photographed celebrities during the years 1855–c. 1875. His first studio was in the Rue Lafitte. Undeservedly overshadowed by Nadar's great name. Died in Paris.

Lewis Carroll (pseudonym) 1832–98
Born at Daresbury Parsonage, Cheshire, the Rev Charles Lutwidge Dodgson, lecturer on mathematics at Christ Church, Oxford, is better known under his pseudonym as author of the immortal *Alice* books. Photography was his chief hobby, and favourite subjects were his child friends, usually pretty little girls. He was also an inveterate lion-hunter and pursued many a celebrity with his camera. Lewis Carroll's copious diary-entries referring to photography show that his activities in this field ranged over the period 1856–80, and my rediscovery in 1947 of his extremely fine photographic work proves him to have been the best photographer of children in the nineteenth century. Wrote *Photography Extraordinary* (1855), *Hiawatha's Photographing* (1857), *A Photographer's Day Out* (1860). Died at Guildford.

Henri Cartier-Bresson b. 1908
Born at Chanteloup, son of a businessman. At the age of twenty decided against entering family business and studied painting for two years under André Lhôte. Influenced by Man Ray and Atget's work, decided to become a reportage photographer, and his outstanding gifts were immediately evident in his unusual photographs of Spain 1933, Mexico 1934, New York 1935. Returned to France and worked as assistant to film director Jean Renoir 1936–9 ('Partie de Campagne' 1937, 'La Règle du Jeu' 1939). Also made a documentary on Spanish hospitals during Civil War. Served in film and photo unit and captured by Germans June 1940. After three years as prisoner of war escaped and organized underground photographic units to document German occupation of France and retreat. After the war worked on a film 'Le Retour' showing the return to France of prisoners of war and deportees. One-man show at Museum of Modern Art, New York, 1946 ; founder member of Magnum photo group 1947. Photographed in Far East 1948–50: Civil War in China, Gandhi's funeral in India; Burma, Indonesia, Iran, Egypt. To Moscow 1954. Exhibition of Cartier-Bresson's photographs opened at the Louvre 1957, afterwards shown in many West European countries, Japan and U.S. Published *Images à la Sauvette* (1952), *China in Transition* (1956), *Danses à Bali* (1954), *The Europeans* (1955), *People of Moscow* (1955), and several others.

Winifred Casson b. c. 1900
English woman professional portrait and advertising photographer. Self-taught, she had a studio in King's Road, Chelsea, London, in the 1930s. Plate 199 was published in *Photographie*, Paris, with the title 'Les Mains d'un poète'.

233

Antoine Jean François Claudet, F.R.S. 1797–1867
Born at Lyons, settled in London in 1827 as importer of sheet glass and glass domes. Learned Daguerre's process from the inventor in 1839, privately purchasing licence to use it in England. Sole importer of French daguerreotype pictures and Daguerre's apparatus until 1841. Communicated to Royal Society method of accelerating the daguerreotype process, and opened second studio in Britain, at the Royal Adelaide Gallery, London, June 1841. The innumerable improvements in photographic apparatus and processes introduced by Claudet make him the most eminent photographic scientist of his day. He was also the leading daguerreotypist in Britain, the first to use and the last to abandon the process, in 1858. A great protagonist of stereoscopic photography, Claudet largely contributed to the popularity of Sir David Brewster's instrument in the 1850s. Appointed photographer to Queen Victoria and elected F.R.S. 1853; Chevalier of the Legion of Honour 1865. Exhibitor at, and Juror of, several international exhibitions. Died in London.

Charles Clifford 1820–63
An Englishman living in Madrid, Clifford took up photography in the early 1850s, working with the Calotype and collodion processes. He is chiefly known for large exhibition prints depicting the beauty of Spanish architecture and scenery, and the Treasure of the Dauphin now at the Prado Museum. Published several albums of photographs including *Vistas del Capricho* (1856)—fifty views of the Palace of the Dukes del Infantado at Guadalajara—and *Voyage en Espagne* (1858). In 1861 Queen Isabella II sent Clifford, her court photographer, to Windsor to take a regal portrait of Queen Victoria, which was subsequently copied as an oil painting. Clifford died in Madrid while preparing another publication, *Scrambles Through Spain*.

Alvin Langdon Coburn 1882–1966
Born in Boston, Mass. Studied art. Was introduced to photography by his cousin F. Holland Day with whom he came to Europe in 1900. First exhibited that year at the London Salon. Founder member of Photo-Secession 1902. Coburn established his reputation in England with one-man shows in London 1906 and 1913. Arranged an exhibition of the Old Masters of photography at the Albright Art Gallery, Buffalo, in 1915. Illustrated Henry James's *Novels and Tales* (1909), books on New York (1910), London (1914) and others. Published series of hand-photogravure portraits of English and French celebrities under the title *Men of Mark* (1913) and *More Men of Mark* (1922). Took the first abstract photographs ('Vortographs') January 1917. In 1918 Coburn moved to North Wales.

Louis Jacques Mandé Daguerre 1787–1851
Born at Cormeilles-en-Parisis, son of a crier at the local magistrate's court. Artist and stage designer. Inventor with Charles-Marie Bouton of the Diorama and manager of the Paris establishment in which these enormous semi-transparent landscape and architectural views were exhibited by changing light and sometimes accompanied by sound effects to heighten the illusion of reality. Exhibited six paintings at the Paris Salon between 1814 and 1840. Experimented without success with photography prior to entering into partnership with Nicéphore Niépce in December 1829. Based on Niépce's Heliography, Daguerre worked out by 1837 a process so different that he felt justified in calling it daguerreotype. By developing the latent image he cut down Niépce's exposure time of eight hours to twenty minutes. Diorama burned down 3 March 1839. Through the influence of the scientist and Deputy François Arago, the French Government acquired the epoch-making invention in exchange for life pensions to Daguerre and Niépce's son, and gave it 'free to the world' on 19 August 1839. Five days earlier it had been patented in England! Daguerre was awarded many honours, including the Legion of Honour and the Prussian Pour le Mérite. His manual on the daguerreotype process published in eight languages went into no fewer than thirty-two editions in 1839 and 1840. Daguerre bought a small estate at Bry-sur-Marne 1840, where he lived in retirement until his death.

George Davison 1856–1930
English civil servant and amateur photographer. Follower of Emerson's naturalistic photography; then founded in 1890 the impressionistic 'school' of photography. Founder member of the Linked Ring 1892. Davison became in 1898 managing director of Kodak Ltd., from which position he was asked to resign in 1912 owing to his anarchist activities. His house at Harlech was henceforth headquarters of the movement. Died at Antibes, where he used to winter.

Philip Henry Delamotte 1820–89
A designer and artist living in London, Delamotte took up the Calotype process in the late 1840s. Started in 1853 the second printing service from amateurs' negatives in Britain. Appointed professor of drawing at King's College, London, 1856. The following year organized the photographic department of the Manchester Art Treasures Exhibition—the first exhibition at which photography was shown together with paintings, drawings and sculpture. Delamotte illustrated a large number of books with his drawings or photographs, published two photographic manuals (1853 and 1856) and edited *The Sunbeam: a Photographic Magazine* 1857–9. His *magnum opus* is the documentation of the re-erection of the Crystal Palace at Sydenham in 160 views, published 1855.

Robert Demachy 1859–1936
Banker, amateur painter and prominent amateur photographer living in Paris. Popularized the gum print 1896, and exhibited 1894–1924 portraits and landscapes with figures in the impressionist style.

Founder member of the Photo-Club de Paris and leader of the aesthetic movement in photography in France. Member of the Linked Ring. Published with Alfred Maskell *Photo-Aquatint or the Gum-Bichromate Process*, London, 1897, and with C. Puyo *Les Procédés d'Art en Photographie*, Paris, 1906.

André Adolphe Eugène Disdéri 1819–89
Of humble birth and little education, Disdéri worked as assistant in his father's draper's shop in the provinces. About 1851 he became a photographer at Brest, later Nîmes. Borrowed money in 1852 to start a big portrait studio in the Boulevard des Italiens, Paris. Applied for patent in November 1854 for a method of taking what were later called *carte-de-visite* photographs, which were made fashionable in 1859 by Napoleon III, who appointed Disdéri court photographer. By 1861 Disdéri was the richest photographer in Europe, making £48,000 a year from his Paris studio alone. Also had branches in London, Toulon and Madrid, and was appointed photographer to Queen Victoria, the Queen of Spain and the Czar. Published *L'Art de la Photographie* 1862. A typical *parvenu*, Disdéri dissipated his fortune with building speculations and racing stables, and ended as a beach photographer at Nice. Died in a poor-house in Paris.

Edward Draper
English amateur photographer in the 1860s.

Rudolph Dührkoop 1848–1918

Harold E. Edgerton 1903–90
American scientist at the Massachusetts Institute of Technology. Inventor in 1931 of an electronic flashlamp with which it is possible to analyse the fastest movements in a series of stroboscopic photographs, or to record the whole movement on one film.

Edmiston
Advertising photographer in the Strand, London, in the 1930s.

Peter Henry Emerson 1856–1936
Born in Cuba of an American father and an English mother. After the death of his father, a doctor, the family settled in Southwold, Suffolk, in 1869. Emerson was educated at Cambridge, studied medicine and took M.B. degree 1885. Abandoned his career the following year in order to devote himself to writing and photography, having been an amateur since 1882. Published between 1886–95 seven photographically-illustrated books on the life and landscape of East Anglia and founded a 'school' of naturalistic photography in reaction against old-fashioned pictorialism. Emerson's book *Naturalistic Photography* (1889) and still more his recantation *The Death of Naturalistic Photography* (1891) created a sensation not warranted by his photographs. As rocket-like as he had risen, Emerson vanished from the photographic scene after a retrospective exhibition of his photographs in 1900. Published a family history *The English Emersons* (1898–1925). Died at Falmouth.

William England (?)–1896
Started as a daguerreotypist in London in the mid 'forties. Gave up portraiture and in 1854 joined the newly-formed London Stereoscopic Co. for which he took thousands of stereoscopic views in Ireland, America, France, Switzerland and at the International Exhibition in London 1862. These were published under the firm's name. After making himself independent in 1863 England began his famous series of views in Switzerland, the Tyrol, and Italy, adding new pictures every summer for thirty years. They were sold on the Continent as well as in Britain, and brought England renown as one of the leading landscape photographers. Published *c.* 1864 an album containing seventy-seven photographs entitled *Panoramic Views of Switzerland, Savoy and Italy*. Invented focal plane shutter with variable slit (1861). Died in London.

Hugo Erfurth 1874–1948
Born at Halle (Saale). After studying at the commercial school in Dresden Erfurth learned photography at a local portrait studio. Studied art for a few terms, and from 1896 onward was a professional portrait photographer in Dresden, and supporter of the aesthetic movement in Germany. Erfurth made only gum prints and later oil-pigment prints. In the 1920s he became the most celebrated portrait photographer of the German intelligentsia. In 1934 Erfurth moved his studio to Cologne, where he was bombed out in 1943; luckily his photographic archive and graphic art collection, being in a bank safe, survived. With redoubled vigour he tried to build up a new existence at Gaienhofen on the Lake of Constance, where he died.

Frederick Henry Evans 1852–1943
Bookseller in the City of London until 1898, when he became a professional photographer, having been an amateur since *c.* 1882. From about 1895 took portraits of a number of literary and artistic friends including Aubrey Beardsley, whom he set on his career as an illustrator; William Morris for whom he photographed Kelmscott Manor (1898) and G. B. Shaw who staged for him a special 'camera' performance of *Mrs Warren's Profession* in 1902. Justly famous for his numerous photographs of English cathedrals begun in 1896 with Lincoln, later continued for *Country Life*, for which magazine Evans also photographed many of the famous French châteaux and cathedrals before 1914. Member of the Linked Ring 1901. Believed in pure technique and gave up photography when platinum paper became unobtainable after World War I. Evans died two days before his ninety-first birthday at his house in Acton, London.

Walker Evans 1903–75
Born at St Louis, Missouri. In 1930 Evans began photographing Victorian and indigenous architecture, especially in New England. Illustrated Hart Crane's *The Bridge* (1930) and Carleton Beal's *The Crime of Cuba* (1933). Made 500 photographs of African negro art for distribution to colleges and libraries (1935). Evans' most outstanding work was his photo-documentation in 1935–6 of the poverty-stricken Southern States for the Government's social programme known later as Farm Security Administration. One-man show at Museum of Modern Art, New York (1938) which the same year published eighty-seven of the most striking photographs under the title *American Photographs*. Had three Guggenheim Fellowships in 1940, 1941, 1959. Illustrated James Agee's *Let Us Now Praise Famous Men* (1941). Evans was associate editor of *Fortune* magazine, New York, from 1945 to 1965, when he retired from professional photography and became Professor of Graphic Arts at Yale University, from which he retired in 1975.

Roger Fenton 1819–69
Born at Crimble Hall, Lancashire, son of the first M.P. for Rochdale, Fenton took an M.A. degree at University College, London. He came into contact with photography in the early 1840s when studying art under Paul Delaroche in Paris. Later studied law and was called to the bar in London, but found renewed interest in painting, exhibiting three anecdotal pictures at the Royal Academy between 1849–51. At this period Fenton became so engrossed by photography that he changed his profession. A member of the Calotype Club founded in 1847, one of Fenton's earliest commissions was to record in 1851 the work in progress on the suspension bridge over the Dnieper at Kiev being constructed by Charles Vignoles, a fellow member of the Club. Succeeded in forming the Photographic Society of London (now the Royal Photographic Society of Great Britain) January 1853, and was its first secretary. Five years later appointed Vice President. Fenton won an international reputation by his landscapes and views of English cathedrals, still-lifes, etc.; also photographed drawings and classical sculpture at the British Museum, and took intimate portraits of the royal family. Fenton's fame rests, however, on his 360 photographs of the Crimean War—the first war photo-reportage—undertaken for the Manchester publisher Thomas Agnew. Illustrated several books with his photographs. In 1862 at the height of his fame Fenton gave up photography, probably because he disliked its increasing commercialization. He resumed his legal career, becoming solicitor to the Stock Exchange. Died at his house near Regents Park, London.

Francis Frith 1822–98
Born at Chesterfield, Derbyshire, in his youth Frith was in the wholesale grocery trade at Liverpool. In 1850 he bought a partnership in a printing firm there—Frith & Hayward—which nine years later was moved to Reigate, and a photographic printing department added. One of seven founder members of the Liverpool Photographic Society in March 1853, Frith's interest was from 1855 onward entirely absorbed by photography. Within a few years he became a leading landscape photographer as well as the largest publisher of English and foreign views. A catalogue of 'Frith's Photo-Pictures' issued between 1888–92 runs to 682 pages listing a few hundred thousand views. Frith's finest work is contained in a number of publications arising from three extensive tours of Egypt, Nubia, Palestine and Syria between 1856 and 1860. Frith was his own publisher of several photographically-illustrated books, issued portfolios of his photographs of Germany, the Tyrol, Switzerland, Italy, Gibraltar, Spain and Portugal, illustrated *The Queen's Bible*, an edition of Longfellow's *Hyperion* (1865) and several other works. The photographic printing for all these publications was carried out by his firm Francis Frith & Co. at Reigate, which was in existence until 1970. Frith died at Reigate.

Dr Arnold Genthe 1868–1942
Born in Berlin, son of a professor of classical languages. After obtaining the D.Ph. degree at Jena University Genthe settled in San Francisco in 1895. Became interested in photography as a hobby, and two years later opened a professional portrait studio. Moved in 1911 to New York where he was prominent as a photographer of stage and film actors and other celebrities. Genthe made excellent reportages of the Chinese quarter of San Francisco and of the earthquake and fire in 1906, and on his many travels in foreign lands. Published *Pictures of Old Chinatown* (1913) and autobiography *As I Remember* (1937), among other books.

Helmut Gernsheim b. 1913
Born in Munich, son of a historian of literature. Studied history of art at Munich University 1933 but conditions in Germany decided him to change to photography. After two-year course at State School of Photography 1934–6 learned Uvachrome colour process and settled in London 1937 as free-lance colour photographer. Interned in 1940 and sent to Australia, returned seventeen months later. 1942–5 undertook photographic surveys of historic buildings and monuments in the London area for the Warburg Institute, London University. At the suggestion of Beaumont Newhall, Gernsheim started in 1945 photo-historical collection. Gave up active photography 1947 to devote time to research and writing. Rediscovered the work of many British photographers, the photographic opus of the writer Lewis Carroll (1947) and the world's first photograph by Nicéphore Niépce (1952). Arranged exhibition 'Masterpieces of Victorian Photography from the Gernsheim Collection' at the Victoria and Albert Museum (1951), and 'A Century of Photography', the first photographic exhibition to be shown in art museums in many West European countries. Recipient of German *Kulturpreis der Photographie*

1959. Published 25 books on photo and general historical subjects, several in collaboration with his wife. They include *New Photo Vision* (1942), *The History of Photography* (1955, 1969, 1983), monographs on four great nineteenth-century photographers: Julia Margaret Cameron (1948), Lewis Carroll (1949), L. J. M. Daguerre (1956) and Roger Fenton (1954). Last book: *Incunabula of British Photographic Literature 1839–75* (1984). Since 1964 the Gernsheim Collection of Historic Photographs has been housed at the University of Texas at Austin. The following year Gernsheim moved to Castagnola-Lugano, Switzerland.

Victor Gianella b. 1918

Joseph-Philibert Girault de Prangey 1804–92
Born at Langres, Burgundy. Landowner and expert on Arabian history and architecture. Author of *Monuments arabes et moresques de Cordoue, Séville et Grenade* (1836), *Essai sur l'architecture des Arabes et des Mores en Espagne, en Sicile et en Barbarie* (1841), *Monuments arabes d'Egypte, de Syrie et d'Asie Mineure* (1846), the last-named containing illustrations copied from his daguerreotypes. Learned the daguerreotype process in 1841, travelled in Italy, Egypt, Syria, Palestine, Asia Minor and Greece, 1842–4, returning with over 1,000 daguerreotypes to his estate near Langres, where he lived as a recluse. Girault's daguerreotypes are unusually large for the earliest years of the process and the architectural and landscape subjects are rare, for Europe. Initiator of the Archeological Society and Museum of Antiquities of Langres 1834 and 1838 respectively. Died at his villa Courcelles near Langres.

William Morris Grundy 1806–59
Born in Birmingham, son of a patent-leather manufacturer. Joined family business. Lived from 1850 onward at Sutton Coldfield, where he died. Took up photography as a hobby about 1855 and became known for his series of stereoscopic *genre* pictures entitled 'Rural England'. An anthology of poetry posthumously published under the title *Sunshine in the Country* in 1861 is illustrated with twenty of Grundy's photographs.

Arno Hammacher b. 1927
Born at The Hague, son of an art museum director. Studied publicity at the Hague Academy 1950–3 and worked for four years as graphic designer at a typefoundry. Amateur photographer, published *Van Gogh, the land where he was born and raised: a photographic study* (1954). In 1957 Hammacher moved to Milan and began career as an industrial photographer. Also made reportage of the construction of the Milan underground. Active as a designer and reportage photographer.

Hans Hammarskiöld b. 1925
Caroline Hammarskiöld b. 1930
Born in Stockholm, son of a businessman, Hans Hammarskiöld for a short time learned cinematography

before becoming from 1947–8 a pupil of Rolf Winquist in his Stockholm portrait studio. Afterwards assistant in Bellander's studio for another year before branching out on his own. In 1952 Hammarskiöld's nature photographs won the coveted 'Svenska Dagbladet' prize, awarded to his wife Caroline, an amateur photographer, the following year. Staff photographer on *Vogue* in London 1954–6. Since then, fashion and advertising photographer in Stockholm; member of the Swedish group of ten free-lance photographers 'Tio'. Published two topographical books on Swedish scenery (1951 and 1953), *Objektivt sett* (1955) and two little photographic story books for children 1959 and 1960.

Bert Hardy b. 1913
Born in London, worked from age of thirteen for a small developing and printing firm, at first as messenger boy, later as darkroom assistant. Taught himself photography and supplemented his meagre wages by selling odd photographs and doing D. and P. work at night at home. A successful picture of George VI's coronation drive gave Hardy the idea of becoming a free-lance press photographer for a Fleet Street Agency in 1937. Three years later he joined *Picture Post* on free-lance basis. 1942–6 served with the Army Photographic Unit in the Far East. Returned to *Picture Post* September 1946, eventually becoming their chief photographer until the magazine ceased publication in June 1957. In 1950 Hardy produced eight features on the Korean War, for one of which he received *Encyclopaedia Britannica* prize. Later had his own firm in Fleet Street, working chiefly for big industry.

John Havindon 1908–87
Designer and advertising photographer.

Viscountess Hawarden 1822–65
Born at Cumberweald House near Glasgow, Clementina Hawarden was a distinguished amateur photographer, especially of children, and exhibitor 1860–4. Died in London.

John Heartfield (pseudonym for Helmut Herzfeld) 1891–1968

Hugo Henneberg 1863–1918
Painter and photographer in Vienna.

David Octavius Hill 1802–70
Son of a stationer and bookseller in Perth, Hill learned the new technique of lithography and his *Sketches of Scenery in Perthshire drawn from nature and on stone* (1821) is one of the earliest British publications in this medium. A pupil of Andrew Wilson, Hill exhibited 291 paintings and sketches at the Institution for the Encouragement of the Fine Arts in Scotland and at the Royal Scottish Academy—of which he was a founder member and secretary for forty years—and four paintings at the Royal Academy in London. Engravings copied

from Hill's paintings illustrated the works of James Hogg ('The Ettrick Shepherd') and *The Land of Burns* (1840). In May 1843 Hill turned to photography to make portrait studies for a painting to commemorate the resignation of 474 ministers from the Church of Scotland, entering into partnership with Robert Adamson, who had shortly before opened a Calotype studio in Edinburgh. At Rock House, Calton Hill, they photographed many distinguished people in addition to the ministers. After the death of Adamson, Hill took up painting again. He died at his house at Newington near Edinburgh. Hill's and Adamson's Calotypes were 'rediscovered' at the turn of the century by J. Craig Annan.

Lewis Wickes Hine 1874–1940
Born in Oshkosh, Wisconsin, Hine worked as a boy long hours in a factory. After university training as a sociologist, taught from 1901–7 at the Ethical Culture School in New York. In 1905 Hine took up photography in order to illustrate his sociological research work. Documented the miserable life of poor European immigrants 1905–6; made sociological-photographic study of iron and steel workers' lives at Pittsburgh, published as *The Pittsburgh Survey c.* 1908. Appointed staff photographer to the National Child Labour Committee, Hine exposed shocking conditions, which resulted in the passing of the child labour law. During World War I Hine photographed with the American Red Cross, remained with the Red Cross relief in the Balkans, returning to New York in 1920. Took hundreds of photographs of *Men at Work* (1932), including documentation of the erection of the Empire State Building.

Theodor Hofmeister 1868–1943
Oskar Hofmeister 1871–1937
Both born and active in Hamburg, Theodor as a wholesale merchant of bronze and brass household articles and Oskar as secretary of the county court. The brothers became amateur photographers in 1895, first exhibiting the following year (landscapes). In 1896 they turned to the gum print, about which Theodor published in 1898 two booklets, *Der Gummidruck und seine Verwendung als Ausdrucksmittel der Kunstphotographie* and *Das Figurenbild in der Kunstphotographie*. The brothers devoted themselves to their hobby, picturing local landscapes, the life of fisherfolk, etc. Up to 1914 they were prominent exhibitors in Germany, also giving private lessons in the complicated controlled processes. By a clever division of work Oskar took the pictures, on 13×18cm. negatives, while his brother made the gum prints, which measured up to 100×70cm. They practised the multilayer colour gum print, according to Heinrich Kühn, not the single-layer one practised in France.

Frederick H. Hollyer 1837–1933
Well-known portrait photographer in London and pictorialist of the realist school.

Emil Otto Hoppé 1878–1972
Born in Munich. Destined by his father for a banking career and worked for twelve years in banks in Munich, Berlin and London. Here in 1907 Hoppé at last fulfilled his ambition to become a professional portrait photographer, and advocated natural and truthful portraiture at a period when retouching and studio accessories were the hallmark of the fashionable photographer. Hoppé was at the same time a prominent exhibitor and an influential writer on the art of photography in English and foreign journals. After eighteen years of photographing celebrities Hoppé for the next twenty years travelled all over the world for the 'Orbis Terrarum' series of topographical books. Published a large number of books illustrated with his photographs both in England and Germany where he was equally well known before World War II. His first publication was a portfolio of fifteen *Studies from the Russian Ballet* (*c.* 1912). In the 'Orbis Terrarum' series appeared his volumes on Great Britain, America and Australia. Published autobiography *100,000 Exposures* (1945). Lived at Crowborough, Sussex.

Robert Howlett 1831–58
Professional portrait photographer and partner of Joseph Cundall at the Photographic Institution in Bond Street, London, 1855. Made a set of photographs of Crimean War heroes for Queen Victoria, photographed the launching of the *Great Eastern* (1858), and in 1856 went with W. P. Frith to Epsom and took a number of photographs from the top of a cab, which Frith used for his well-known painting 'Derby Day'. Died in London.

Alice Hughes
Daughter of a fashionable society portrait painter, Edward Hughes, learned photography in order to make studies for her father's paintings and to record them. Started *c.* 1886 a photographic portrait studio next to her father's in Gower Street in London, and was until 1910 the leading photographer of English and Continental royalty and fashionable society women. Seldom photographed men. Her fine platinotype prints are the epitome of an elegant age. Sold business in 1910 and started a portrait studio in Berlin three years later. After the outbreak of war Miss Hughes was repatriated, and bought back her right to open a new studio in Ebury Street, London. She was active until about 1925. Published autobiography *My Father and I* (1923).

Kurt Hutton 1893–1960
Born in Strasbourg. Hübschmann's law studies were interrupted by World War I. Learned photography from a professional and in 1923 opened a portrait and advertising studio in Berlin. Six years later took up photoreportage, working for various German illustrated papers 1930–4, when he emigrated to England and took the name of Hutton. Staff photographer of *Weekly Illustrated* and later *Picture Post* from its foundation in 1938 until 1955. Died at his home at Aldeburgh, Suffolk.

Ida Kar 1908–74
Born at Tombov near Moscow, daughter of an Armenian professor of physics and mathematics. Educated at the Lycée Français in Alexandria, studied singing in Paris 1930–34. Opened a professional portrait studio under the name 'Idabel' in Cairo in 1940 in partnership with her first husband. Came to London in 1945 and from then on worked as a free-lance portrait photographer. Her portraits of famous artists, writers and musicians, begun in 1953, were taken for her own pleasure. One-man exhibition at the Whitechapel Art Gallery March/April 1960; Moscow April 1962. Monograph by Val Williams, London, 1989.

Peter Keetman b. 1916
Born in Wuppertal-Elberfeld, Germany, the son of a bank manager, Keetman studied at the State School of Photography in Munich 1935–7, and was until his call-up in 1940 in turn assistant to a portrait photographer in Duisburg and an industrial photographer in Aachen. Served in the army in France, Poland, Hungary, and Russia, where he lost a leg. Returned to the State School of Photography for another year 1947–8, then assistant for five months in Adolf Lazi's studio in Stuttgart. In 1949 Keetman became a founder member of *Fotoform* (now *Subjective Photography*) and the following year started his career as a freelance photographer. Fields of activity are principally topography, industry and advertising. Published three topographical books: *Munich* (1955), *The Bavarian Lake District* (1957) and *Berchtesgaden, Reichenhall, Salzburg* (1959). Keetman lives at Breitbrunn on the Chiemsee in Upper Bavaria.

Alexander Keighley 1861–1947
Born at Keighley, son of a well-to-do Yorkshire woollen manufacturer. Worked in the family business for forty-six years. Keighley took up photography *c.* 1883, joined the Linked Ring 1892. From 1899 until his death used the carbon process for printing his large idealized romantic landscapes, the composition being frequently 'improved' by hand-work. Had a liking for sunlit objects surrounded by contrasting gloom. Prominent at international exhibitions and regarded, after the death of Horsley Hinton in 1908, as the leading British pictorialist. Died at Keighley.

Dr Thomas Keith 1827–95
Edinburgh gynaecologist and surgeon. Prominent amateur photographer in the mid-'fifties using the waxed paper process. Dr Keith concentrated almost exclusively on architecture in Edinburgh, and the surrounding scenery. He ascribed his success to limiting his hobby to a few weeks in the middle of the summer before or after his professional work, when the light was best. Owing to pressure of work, gave up photography altogether in 1857.

André Kertész 1894–1985
Born in Budapest, Kertész was briefly an accounts clerk at the Stock Exchange before being drafted into the Austro-Hungarian army during World War I. Self-taught in photography, he emigrated to Paris in 1925 and free-lanced for various magazines. In 1936 he emigrated to America under contract with Keystone, New York, which was not a happy collaboration. In 1942 Kertész became staff photographer to *House and Garden*, where he remained until his retirement twenty years later. Though already a well-known photographer in Europe, Kertész received hardly any appreciation in the United States—which greatly embittered him—until the Museum of Modern Art gave him a one-man show in 1964. Though recognition was late in coming, Kertész's most fertile period was the eleven years he spent in Paris. Nearly all his later publications are concerned with this period: *Paris par André Kertész* (1934), *André Kertész' Photographs* (1964), *On Reading* (1971), *Sixty Years of Photography* (1972), *J'aime Paris* (1974), *Washington Square* (1975), *Of New York* (1976), *Distortions* (1976), *André Kertész—A Lifetime of Perception* (1982). In his photographs Kertész expressed a sympathetic feeling for human relationships and a fine sense of ordinary life situations.

Heinrich Kühn 1866–1944
Born in Dresden, studied science and medicine. Moved to Innsbruck 1888 and devoted himself to photography in which he had become interested as an amateur in 1879. Introduced in 1897 the multiple gum print for colour prints. Prominent exhibitor of portraits and landscapes, and with Watzek and Henneberg led the aesthetic movement in photography in Austria. Member of the Linked Ring. Honorary doctor of Innsbruck University 1937 for work in developing artistic photographic printing methods.

Lacroix
French amateur photographer in the impressionist style between 1895–1914. Member of the Photo-Club de Paris.

Dorothea Lange 1895–1965
Born in Hoboken, New Jersey. Studied photography under Clarence H. White at Columbia University and opened portrait studio in San Francisco 1915. In 1932 became a member of the F.64 Group. During the depths of the economic depression in the early 'thirties, Dorothea Lange felt impelled to photograph the workless in the streets. An exhibition of these photographs was seen by a professor of economics, Paul Taylor (later her second husband) and the two reported to the State of California in 1935 on the plight of migrant labour. The Federal Government in setting up an organization later called the Farm Security Administration included a photographic division for which Dorothea Lange, Walker Evans and other photographers worked in the mid-'thirties. John Steinbeck credits Lange's photographs for inspiring his classic novel *The Grapes of*

Wrath. She continued her work on social-documentation, several examples of which were published in *Life*. Her books include *An American Exodus* (1939) and *The New California* (1957).

Clarence J. Laughlin 1905–85

Born in New Orleans, took up photography at the age of thirty, and was from 1936–41 staff photographer at the U.S. Engineer's Office in New Orleans, photographing old buildings, statues, and wrought-iron work in that city. A selection of his pictures was published in *New Orleans and Its Living Past* (1941). 1941–2 Laughlin worked for *Vogue* in New York City and the National Archives in Washington. He did four years' war service as photographer at the Office of Strategic Services, specializing in colour photography,. Following his discharge in 1946 Laughlin returned to New Orleans to take more photographs of the decaying architectural beauty of his home town and the abandoned Louisiana plantations which have remained his favourite subjects. His second book *Ghosts Along the Mississippi* was published in 1948. Laughlin resided in New Orleans as a free-lance architectural photographer. Monograph: *Clarence J. Laughlin: The Personal Eye*, with text by Jonathan Williams, New York, 1973.

Gustave Le Gray 1820–82

Born at Villiers le Bel near Paris, Le Gray studied art under Paul Delaroche and exhibited paintings at the Salons of 1848 and 1853. About 1848 he took up the Calotype process and became a professional portrait photographer in Paris. Le Gray is the author of several photographic manuals, and inventor of the waxed paper process (1851) with which he took a large series of photographs of historic buildings in Touraine and Aquitaine for the Comité des Monuments Historiques. A founder member of the Société Française de Photographie in November 1854, and a frequent exhibitor, Le Gray achieved international fame with his instantaneous seascapes with clouds (1856). Unwilling to follow the fashion for cheap *cartes-de-visite*, Le Gray retired from photography at the end of 1860 or beginning of 1861 and settled as a Professor of drawing in Cairo, where he died following a riding accident.

John Leighton 1823–1912

Designer and painter of architecture in London. Exhibited and published under the pseudonym 'Luke Limner'. Leighton was an amateur photographer from 1853 onward with the Calotype and later collodion process, contributing photographs to *The Sunbeam* and other collective publications under the pseudonym 'Phoebus'. Published *Suggestions in Design, including original compositions in all styles, for the use of artists and art-workmen, etc.* (1853), and other books.

Helmar Lerski 1871–1956

Born in Strasbourg, Lerski was brought up in Zürich where his parents settled and became Swiss. He went to the U.S. in 1893 and acted at the German Theatre in New York City, Chicago and Milwaukee. In 1911, learned photography from his first wife, a professional portrait photographer in Milwaukee, Wis., and became one himself. In 1915 Lerski went to Germany and had an exhibition of his portraits in Berlin, which led to his employment as cameraman by the leading film companies. After the introduction of the sound film, Lerski returned to portrait photography, studying the creative effects of light in characterization, taking close-ups of simple people. Published *Köpfe des Alltags* (1931). The same year Lerski went to Palestine where until 1948 he made physicgnomical studies of Jewish peasants and Arab labourers under varied lighting conditions, pursuing his idea of 'metamorphosis through light'. In 1948 Lerski returned to his home town, Zürich, where he died eight years later. A retrospective review of his portrait work both in Germany and Palestine is contained in the recent book *Der Mensch, Mein Bruder*, Dresden 1958.

Alois Löcherer 1815–62

Pharmaceutist and professional photographer in Munich from 1847 onward. Noted for photo-reportage of the transport of the gigantic statue 'Bavaria' from the foundry to its position in front of the Hall of Fame in Munich (1850) and for Calotype portraits of celebrities published in *Photographisches Album der Zeitgenossen* (1854). Löcherer also made *genre* and nude studies for artists, and published reproductions of engravings in the Bavarian royal collection (1855). Published a photographic manual (1854).

Nahum Ellan Luboshez 1869–1925

Born in Russia, brought as a child to America by his parents. Learned photographic retouching. Returned to Europe *c.* 1892 to study art, earning his living as a portrait photographer and retoucher in Hamburg and other German cities. Came to England in 1894 and joined Kodak Ltd. as a roving Continental representative, demonstrator and lecturer in many European countries; started Kodak branch in St Petersburg *c.* 1910. During World War I and after, Luboshez worked at the Kodak Research Laboratory, Harrow, and introduced many improvements in radiological apparatus and film emulsions. Continued as an amateur taking portraits of well-known people; one of George Eastman was used as a U.S. stamp. He was also a prominent exhibitor. Died at Harrow.

Robert MacPherson 1811–72

Originally a surgeon in Edinburgh, MacPherson settled in Rome in the early 1840s and became a painter and art dealer. He discovered one of the Michelangelo paintings now at the National Gallery, London. Learning photography from a visiting friend in 1851, MacPherson took it up professionally and within a few years was the leading photographer of architecture, views, and Roman

antiquities. His splendid large pictures of the principal classical sites and over 300 photographs of sculpture in the Vatican are unequalled by later photographers. They were mainly bought by English tourists. An exhibition of MacPherson's work from the Gernsheim Collection at the British Council in Rome in 1954 made a deep impression, for few of his photographs are preserved in Roman collections. MacPherson is also known for a process of photolithography introduced in 1855 and for a *Guidebook to the Sculpture in the Vatican* (1863).

Felix H. Man (pseudonym for Hans Baumann) 1893–1985
Born in Freiburg, the son of a banker, Man's art studies were interrupted by war service, after which he began his career as an illustrator of sports events for the *B.Z. am Mittag*, Berlin. Photographed at first to assist him in his work, and in October 1928 became a professional, pioneering with an Ermanox camera, the new field of photo-reportage, for the *Münchner Illustrierte Presse* and the *Berliner Illustrirte*. Made reportages of social and general interest events by available light, and had photo-interviews with practically everybody of importance in Europe. Pioneered a new kind of picture story with *A Day with Mussolini* (1931). After the Nazis seized power Man settled in London (1934), worked for *Weekly Illustrated*, and was chief photographer to *Picture Post* from its foundation in 1938 until 1945. Freelanced for this paper 1947–51. Took for *Life* the first reportage in colour by night—the Festival of Britain 1951. Retired in 1953 to devote himself to the study of modern art and to collecting lithographs. Published 150 *Years of Artists' Lithographs* (1953) and *Eight European Artists* (1954), the latter illustrated with his colour and black and white photographs. Published autobiography *Man with Camera*, London, 1984.

Paul Martin 1864–1944
Martin began photography as an amateur in 1884 during his apprenticeship to a firm of wood-engravers working for newspapers. In the early 'nineties he gave up pictorial photography for exhibitions, and with a concealed hand-camera began to take candid snapshots in London streets and at the seaside. Caused still greater sensation with his photographs of London by twilight in 1896. Four years later gave up wood-engraving and worked as free-lance press photographer until about 1908; thereafter process-engraver in London. Autobiography *Victorian Snapshots* (1939).

Maull & Polyblank
Well-known firm of portrait photographers in the City and in Piccadilly. From the mid-'fifties onward they made an extensive series of fine portraits of the distinguished members of learned societies and other celebrities.

Angus McBean 1905–90
Born in South Wales, son of a surveyor. After several unhappy years as a bank clerk in Wales and shop assistant in London, McBean, who was already an amateur photographer, worked in 1934–5 in the London studio of a well-known society photographer, Hugh Cecil. In 1935 he opened his own studio, venturing also into stage photography, and within a few years became London's leading theatrical photographer. Under the influence of surrealism McBean combined the fantastic with the realistic in a new type of portrait of actors and actresses in elaborate *décors* designed by him. In 1963 sold his negatives to the Photography Collection at Harvard University. Had a studio near Covent Garden, London, until he retired from professional work about 1970 and moved to Sussex to restore houses.

Mélandri
Professional portrait photographer in Paris in the 1860s and '70s.

Léonard Misonne 1870–1943
Leading Belgian amateur photographer specializing in landscape, and prominent exhibitor between 1898–1939, working with the bromoil printing process. Lived and died at Gilly.

Peter Moeschlin b. 1924
Born and active in Basle, where he trained as a photographer 1940–3. After working in different studios in Switzerland Moeschlin spent eight months in England in 1947 as free-lance reportage photographer. The following year spent several months in French North Africa. In 1950 started studio in Basle for commercial photography, continuing reportage. Made a documentary film 1956–8, and published a picture book on Pablo Casals 1956.

László Moholy-Nagy 1895–1946
Born in Bácsborsod, Hungary, Moholy-Nagy was wounded and taken prisoner by the Russians in World War I; came in contact with Russian *avant-garde* art and took up painting in Odessa. Painted portraits and landscapes; 1921–3 abstract painter in Berlin. First photograms 1922. Founder and director of the department of photography at the Bauhaus 1923–8. Published two Bauhaus books, *Malerei, Photographie, Film* (1925) and *Von Malerei zu Architektur* (1929). Made seven films between 1926–35. In 1934 Moholy-Nagy emigrated to Amsterdam, the following year to London. During a short stay in England made photo-reportages of Eton College and Oxford. From 1937 until his death in Chicago Moholy-Nagy was director of the School of Design there, founded by him, teaching photography among other subjects.

James Mudd
Professional portrait photographer in Manchester in the late 1850s and '60s. Made a reputation with brilliant landscape photographs which he took for exhibition purposes.

Nadar (pseudonym for Gaspard Félix Tournachon) 1820–1910
Born in Paris, son of a publisher and bookseller at Lyon. After studying medicine for a time, Tournachon went to Paris in 1842 and made a precarious living with articles and caricatures in comic magazines such as *Le Charivari*; founded *La Revue Comique* 1849. Played an active part in the revolution of 1848. Became a professional photographer 1853, for a while in partnership with his brother Adrien at 113 Rue St Lazare, continuing at the same time his work on *Le Panthéon Nadar* (1854). This consisted of lithographed caricatures of famous Frenchmen, many of whom he also photographed. In 1860 Nadar opened an elegant studio at 35 Boulevard des Capucines. Photographed the sewers and catacombs by electric light (1860). Equally famous as an aeronaut, Nadar took the first balloon photograph (1858), and constructed the world's largest balloon 'Le Géant' (1863). During the Siege of Paris he commanded an observation balloon corps, and provided a balloon postal service to the seat of the Delegate Government at Tours (later Bordeaux). After the Commune he had a studio in the Rue d'Anjou. In 1886 Nadar retired from active photography, but pioneered a new field—the photo-interview. In old age he continued writing books on various subjects including a biography of Baudelaire and *Quand j'étais Photographe* (1899). Died in Paris.

Charles Nègre 1820–79
Born at Grasse. Studied art in the studios of Delaroche and Ingres. Began to Calotype *c.* 1850, opened a portrait studio in Paris, but is chiefly known for his excellent architectural photographs. One of the earliest French photographers to compose *genre* pictures, Nègre exhibited at the Salon of 1855 a painting copied from his photograph of an organ-grinder. Founder member of the Société Française de Photographie and a constant exhibitor at International photographic exhibitions. Nègre invented in 1854 an excellent photo-engraving process on steel plates but kept the details secret. Returned to live at Grasse and became professor of drawing at the Lycée Impériale in Nice in 1864. He died at Grasse.

Lusha Nelson
Professional photographer in New York and Paris. The nude black woman (ill. 87) was published in *Photographie*, Paris, 1937.

Joseph Nicéphore Niépce 1765–1833
Born at Châlon-sur-Saône, the son of a King's Councillor. Landowner and amateur scientist; inventor of photography and of photo-etching, both of which he called Heliography. Experimented with photography from 1816 onward on paper sensitized with chloride of silver. Unable to fix his pictures Niépce turned to other substances, and in July 1822 succeeded in making a contact copy of an engraving of Pope Pius VII on glass coated with bitumen of Judea. Later made similar heliographic copies on zinc and pewter plates. The best of these, a heliograph of an engraving of Cardinal d'Amboise made in 1826, was etched by the Parisian engraver A. F. Lemaître and four prints pulled in February 1827. During 1826 Niépce succeeded in taking the first permanent photograph from nature in the camera. He brought this and other heliographs (which were, however, only copies of engravings) to London in September 1827 and endeavoured to interest King George IV and the Royal Society in his invention. Failing in this, he entered into partnership with L. J. M. Daguerre in December 1829. Niépce was the first to use—possibly to invent—the bellows camera and iris diaphragm. He died at his estate, Gras, at St Loup de Varennes near Châlon four years before his partner perfected the invention that bears his name—daguerreotype.

Esther Nothmann
German amateur photographer in the impressionist style, living in Berlin and active at the turn of the century.

William Notman 1826–91
Born in Paisley, learned to daguerreotype in Glasgow. Established himself in 1856 as a portrait and landscape photographer in Montreal and became Canada's first internationally known photographer. Notman was a virtuoso in *trompe-l'oeil* effects and is today mainly remembered for his elaborate and realistic folk-like compositions depicting trappers, buffalo-hunters, camp-life, skating and other winter sports. Though these scenes were built up in the studio, their great documentary value in depicting bygone customs is undeniable. Notman died in Montreal.

Georg Oddner b. 1923
Born in Stockholm. Originally a jazz musician, Oddner was trained after the war in typography and layout by Svenska Telegrambyrå, in Malmö, the largest advertising agency in Scandinavia. Study tour of U.S. advertising methods 1949. Persuaded by the agency to take up photography, Oddner in 1950 opened in Malmö a photographic studio in close collaboration with them. In addition to industrial and commercial photography Oddner does fashion and reportage work for leading Swedish magazines. Undertook several journeys for the Scandinavian airline SAS: California 1954, South America 1955, the Soviet Union, Middle and Far East 1956. Exhibition at the Malmö art museum 1956—the

first one-man photographic show held in any Swedish art museum. Member of the Swedish group of ten freelance photographers 'Tio'. Monograph published Malmö, 1984.

Timothy H. O'Sullivan c. 1840–82

Born in New York City. Learned photography at Brady's New York portrait studio, later transferred to Brady's Washington studio under management of Alexander Gardner. During the Civil War O'Sullivan worked for Gardner with the Federal Army on map work, taking also photographs on the battle fronts, forty-five of which were published in Gardner's *Photographic Sketchbook of the War* (1866). After the war O'Sullivan had an adventurous career photographing for Government exploratory expeditions in Nevada and the High Rockies, the Colorado River, Arizona, the Isthmus of Darien to make a survey for a ship canal (now the Panama Canal), etc. A year before his death at Staten Island, O'Sullivan was appointed chief photographer to the Treasury Department, Washington.

Richard Polak 1870–1956

Born in Rotterdam. Dutch amateur photographer from 1900 on. Limited to one subject: 'Figure studies in old Dutch costumes'. Lived in Lausanne, Switzerland.

Carlo Ponti

Leading Venetian architectural photographer specializing in views of **Venice**, Padua and Verona. Published in the 1860s a number of albums under the title 'Ricordo di Venezia', each containing twenty large views, some by other Venetian photographers such as Perini. Ponti also made a valuable documentation of Venetian street types in the early 1860s. After Venice was given up by Austria following her defeat in the Seven Weeks' War in 1866, Ponti, now an Italian subject, was appointed optician to the King of Italy.

William Lake Price c. 1810–96

Watercolour painter in London, exhibited chiefly architectural subjects at the Royal Academy and the Water Colour Society 1828–52. Published *Interiors and Exteriors in Venice* (1843)—twenty-five coloured lithographs copied by Joseph Nash from Price's original drawings. Changed to photography in 1854 and was the first in Britain to compose historical and literary subjects and to make combination pictures from several negatives. Price's portraits of the royal family were published as engravings (1856). Photographed views in Rome in 1857 for the London Art Union. Received commissions from Price Albert and from Colnaghi and other art publishers to reproduce Old Master paintings and frescoes in Rome, for which he commanded extremely high fees. Issued in 1858 twelve 'Portraits of Eminent British Artists'. Gave up photographic career in May 1862 for 'health reasons' but dislike of the commercialization of photography may well have driven him to this step, as it did Fenton, Le

Gray and others. Price's *Manual of Photographic Manipulation* (1858) was the first handbook stressing the aesthetic aspect of photography.

Man Ray (pseudonym for Emmanuel Rudnitzky) 1890–1976

Born in Philadelphia, moved at the age of seven to New York. In 1907 began studying architecture and constructional engineering but after some months took a job as draughtsman and typographer. Started at the same time to study painting, and first exhibited in 1912. Three years later first one-man show in New York. Ray was one of the first American abstract painters 1915–16 and became a co-founder with Duchamp and Picabia of the New York Dada group 1917. Took up photography in 1920 in order to reproduce his own paintings. Settled in Paris 1921 and studied at the Académie des Beaux-Arts; worked in close association with the Dadaists and Surrealists. In 1922 made abstract photographs called 'Rayographs' and published twelve of them under the title *Champs Délicieux* with a preface by Tristan Tzara. For many years Ray made a living by reproducing paintings for artists, taking portraits, and advertising photographs. Among his photographic pupils were Bill Brandt, Lee Miller and Berenice Abbott. In 1926 Ray made his first surrealist film *Emak Bakia*. A collection of his photographs was published in book form in 1934 entitled *Man Ray*. After the fall of France (1940) Man Ray moved to Hollywood. Returned to Paris in 1951 for painting and photographing. Published autobiography, New York, 1963.

Oscar Gustave Rejlander 1813–75

Son of a Swedish officer, Rejlander was a portrait painter in London from c. 1840–51. The following year he went to Rome to study art, supporting himself by copying Old Masters. Married an Englishwoman and settled in Lincoln later that year. In 1853 learned photography as an aid in painting. Two years later Rejlander changed his career to photography, opening a portrait studio in Wolverhampton and taking in printing from amateurs and professionals. In 1860 he moved to London and continued there as a professional photographer until his death. After Robinson, Rejlander was the most prominent 'fine art' photographer. He made studies for artists and anecdotal pictures and was the first in Britain to photograph nudes (1857). Rejlander's allegorical composition 'The Two Ways of Life' shown at the Manchester Art Treasures Exhibition 1857 was bought by Queen Victoria. He was commissioned by Darwin to make illustrations for *The Expression of the Emotions in Man and Animals* (1872). Between 1848 and 1873 Rejlander exhibited four paintings at the Royal Academy. He died in poverty in London.

Albert Renger-Patzsch 1897–1966

Born in Würzburg, the son of a musician who was also a keen amateur photographer. Renger-Patzsch after war

service studied chemistry and in 1922 was appointed head of the photographic department of the Folkwang art publishing house in Hagen. At the same time he began taking close-ups of flowers and man-made objects, and after various jobs during the inflation, opened in 1925 a photographic studio in Bad Harzburg, and exhibited in Hanover and Lübeck. Pioneer of 'Neue Sachlichkeit' as exemplified in his classic book *Die Welt ist Schön* (1928), which was preceded by *Die Halligen, Porträt einer Landschaft* the previous year. Since then, Renger-Patzsch's activity was mainly directed to portraying German landscapes and towns in several picture books. Moved in 1929 to Essen and was for a time teacher of photography at the Folkwang-Schule there, and photographer to the Folkwang Museum. After being bombed out in Essen in 1944, Renger-Patzsch moved to Wamel on the Möhnesee and produced several more books, of which *Bäume* (1962), *Im Wald* (1965) and *Gestein* (1966) are particularly fine documentations.

Jacob A. Riis 1849–1914

Born at Ribe, Denmark, Riis, a carpenter, emigrated to America in 1870. Seven years later he became a police-court reporter for the *New York Tribune*. In 1887 Riis began his series of flashlight photographs of the slums of New York, documenting the social conditions responsible for crime. Riis is America's first photo-reporter. His reportages influenced Theodore Roosevelt, then Governor of New York State, to undertake a number of social reforms, including the wiping out of the notorious tenements at Mulberry Bend, where today the Jacob A. Riis Neighbourhood Settlement commemorates the photographer's great work. Riis wrote and illustrated, among other books, *How the Other Half Lives* (1890) and *Children of the Poor* (1892). He died at his country house at Barre, Mass.

James Robertson

Designer of medals which he exhibited at the Royal Academy, London, in the 1830s. About 1850 Robertson was appointed chief engraver to the Imperial Mint at Constantinople. An enthusiastic landscape photographer noted particularly for long panoramas made up from several prints, Robertson published in the 'fifties views of Constantinople, Malta and Athens. Arriving in the Crimea immediately after the fall of Sebastopol in September 1855 he took some fine photographs of the Russian batteries, the English and French camps and entrenchments, and Sebastopol harbour. These photographs form a sequel to Fenton's famous war reportage. In association with A. Beato, Robertson photographed in Palestine and Syria in 1857 and then went to India and made a valuable documentation of the scenes of the recent mutiny. Made a 7-ft. long panorama of Lucknow 1858. Last exhibited in 1860.

Henry Peach Robinson 1830–1901

Born in Ludlow, Robinson was a bookshop assistant in Leamington. A keen amateur painter, he had a picture hung at the Royal Academy in 1852. Two years later he became interested in photography and in January 1857 opened a portrait studio in Leamington; from 1868 onward in Tunbridge Wells in partnership with N. K. Cherrill. His composition photograph 'Fading Away' (1858) made Robinson famous overnight. He continued to make elaborate compositions for every annual exhibition at the Photographic Society of London. Throughout the second half of the nineteenth century Robinson was the most influential pictorial photographer in the world. Published several books including *Pictorial Effect in Photography* (1869) and *Picture Making by Photography* (1884). On retiring from business in 1888 he devoted more time to writing and to the organization of exhibitions at the Photographic Society (of which he had become Vice-President in 1887), and later at the London Salon. Founder member of the Linked Ring 1892. Died at Tunbridge Wells.

Arthur Rothstein 1915–85

American reportage photographer since 1934, Rothstein made in the two following years a series of impressive documentary photographs of impoverished land-workers in the Southern States for the Farm Security Administration. Later he photographed for the American Army, for the United Nations, and for the magazine *Look*, of which he was director of photography until 1971.

Royal Engineers Military School, Chatham

Officers and sergeants of the Royal Engineers were taught photography at the Military School at Chatham from 1856 onward. Two years later a similar course for officers of the Royal Artillery was arranged at Woolwich.

Harry C. Rubincam

American amateur photographer in Denver, Colorado, before World War I. Member of the Photo-Secession.

Dr Erich Salomon 1886–1944

Born in Berlin. Doctor of law at Munich University. During the post-war inflation Dr Salomon found employment in the publicity department of the Ullstein publishing firm in Berlin. Taking up photography as an amateur in 1927 he became in February 1928 a free-lance photo-reporter after the sensational success of his photograph of a murder trial. Using the Ermanox camera, Salomon pioneered modern photo-journalism, selling his pictures to the *Berliner Illustrirte* and other papers. He photographed social events, but is chiefly famous for his candid photographs of politicians, especially at international conferences, taken in available light conditions. Aristide Briand called him 'le roi des indiscrets'. Published *Berühmte Zeitgenossen in unbewachten Augenblicken* (1931). Being Jewish, Dr Salomon and his family emigrated to Holland in 1934. Ten years later he was murdered with his wife and second son in the Auschwitz extermination camp.

Lyddell Sawyer 1856–(?)
Son of a portrait painter and photographer at Newcastle, from 1871 onward worked in his father's studio. Sawyer made himself independent in 1885, and opened a second studio in Sunderland 1893. Leaving these to the management of his brothers, Sawyer moved to London and opened a studio in Regent Street in 1895. In his spare time he took landscape photographs in the naturalistic style. Founder member of the Linked Ring 1892.

Christian Schad 1894–1982
Born in Miesbach, Bavaria. Studied art at the Munich Academy 1913. Until 1917 Schad was chiefly known for woodcut illustrations in leading German and Swiss literary magazines. From 1915–20 he lived in Zürich and Geneva, belonging to the circle of artists and writers who formed the Dada group in Zürich. Painted abstract pictures and exhibited in collective shows in Switzerland. In 1918 made abstract photographs called by Tzara 'Schadographs'. For the next seven years Schad lived in Italy, changed to 'Neue Sachlichkeit' style, painted portrait of Pope Pius XI in 1921. After a year in Vienna he moved to Berlin in 1928. Took part in numerous collective exhibitions. From 1942 on, Schad lived and worked in Aschaffenburg. Monograph by Max Osborn: *The Painter Christian Schad*, Berlin 1927. At the request of Helmut Gernsheim, Schad took up photography again in 1960, producing a new series of (larger) Schadographs of which ill. 164 is the first. Schad had a fine retrospective exhibition of his paintings at the Kunsthalle, Berlin, two years before his death.

Camille Silvy
French aristocrat and diplomat. Prominent amateur landscape photographer from c. 1856–9. The sudden fashion for *carte-de-visite* portraiture decided Silvy to give up his diplomatic career and become a portrait photographer. He opened an elegant studio in Porchester Terrace, London, in autumn 1859. The most fashionable photographer of society and royalty, Silvy deserves the designation of 'The Winterhalter of Photography'. Published a series of *cartes* entitled 'The Beauties of England'. By 1869 the fashion for *carte* portraits was on the wane and Silvy sold his business, retiring to his ancestral château. After the Franco-Prussian War, in which he was wounded, Silvy opened another portrait studio in a suburb of Paris.

John Shaw Smith 1811–1873
Landowner in County Cork, and amateur photographer. Travelled through Europe and the Near and Middle East 1850–52 and made about 300 Calotype and waxed paper photographs. One of the first Europeans to venture to Petra and certainly the first to photograph the mysterious cave-city. Died in Dublin.

Edward Steichen 1879–1973
Born in Luxembourg. Steichen's parents came to the United States in 1881, and he was educated in Milwaukee, Wis. Studied art and worked for a lithographic firm; took first photographs in 1896. In Europe 1901–02, showed paintings at the Paris Salon 1901 and a one-man show of paintings and photographs, Paris 1902. Founder member of the Photo-Secession 1902, and prominent exhibitor of gum prints. Founded with Stieglitz the Photo-Secession Gallery, New York, 1905. The following year Steichen settled in Voulangis near Paris, where he bred plants and painted. Sent to Stieglitz for exhibition works by modern artists. During World War I was chief of aerial photography in the American Expeditionary Forces. After the war returned to Voulangis, burned his paintings and arty gum print photographs and started straight photography. Chief photographer for *Vogue* and *Vanity Fair* 1923–37, taking fashion photographs and portraits of leading personalities. In World War II was in command of all Navy combat photography. In 1947 Steichen was appointed director of the photographic department at the Museum of Modern Art, New York. Organized in three years' work, with assistance of Wayne Miller, 'The Family of Man' exhibition, opened at the Museum in 1955 and circulated throughout the world. In 1961, just before his retirement, the Museum put on a retrospective exhibition of his photographs.

Otto Steinert 1915–78
Born at Saarbrücken. Doctor of Medicine, Berlin 1939. Steinert's interest in the graphic arts and particularly photography led to his giving up medicine in 1948 in order to teach photography at the State School of Applied Art at Saarbrücken, of which he was appointed director in 1952. In 1959 Professor Steinert became head of the department of photography at the Folkwang-Schule in Essen. Founder of 'Subjective Photography' in 1950, and organized large exhibitions in 1951, 1954 and 1958, shown in many countries. Published *Subjektive Fotografie* 1 (1952) and *Subjektive Fotografie* 2 (1955).

Carl Ferdinand Stelzner c. 1806–1894
Born at Flensburg, Stelzner learned miniature painting from Isabey and other well-known artists in Paris. Together with his first wife Caroline, also a miniature painter, he painted many distinguished people in Germany, England, Austria, Russia, before settling in Hamburg. In 1842 Stelzner changed over to the daguerreotype and opened a portrait studio in Hamburg in collaboration with Hermann Biow. Together they took the earliest news photographs: the ruins after the Hamburg fire, May 1842. The following year Stelzner opened his own studio. About the mid-'fifties his sight failed and henceforth the studio was run by an employee. Stelzner died in Hamburg.

Alfred Stieglitz 1864–1946
Born at Hoboken, New Jersey, son of a German immigrant businessman. Educated in New York, studied mechanical engineering and photography at the Berlin

Polytechnic 1882–90. After returning to New York Stieglitz worked for five years in a photo-engraving firm. In 1892 he began taking street-life photographs of New York with a hand-camera. Three years later he retired from business and devoted himself to furthering creative photography and—later—the recognition of modern art. Advocate of straight photography and prominent exhibitor. Organized the Photo-Secession 1902, founded and edited the magazine *Camera Work* 1903–17, directed the Photo-Secession Gallery at 291 Fifth Avenue 1905–17, where he introduced the work of modern photographers and of many European *avant-garde* artists to America. Director of 'Intimate Gallery' 1925, and 'An American Place' 1929–46. Died in New York.

Sir Benjamin Stone 1838–1914
A well-to-do businessman and Member of Parliament for Birmingham, Stone learned photography in order to record British ceremonies, festivals and customs that were dying out. Founded in 1895 the National Photographic Record Association. Stone made the first documentation of the ceremonies connected with the Houses of Parliament and was the first to photograph a Coronation (George V's) inside Westminster Abbey. Published a selection of his photographs in a two-volume book *Sir Benjamin Stone's Pictures* (1905). About 6,000 photographs were given to the British Museum; Stone's personal collection of 22,000 photographs was presented to the Birmingham Reference Library in 1922.

Faul Strand (pseudonym for Paul Stransky) 1890–1976
Born in New York City, of Bohemian descent. In 1907 Strand learned photography from Lewis Hine and five years later set up as a commercial photographer. Street-life photographs of New York 1915; first to advocate new realism in photography 1917. War service as X-ray technician led Strand to make medical films 1921. Free-lance news-reel cinematographer 1922–32. Began 1926 close-up still photographs of natural forms. 1933–4 chief photographer and cinematographer to Mexican Ministry of Education for whom he made a film about fishermen, 'The Wave'. Returned to U.S. 1935 and worked on documentary films. During World War II Strand made some films for Government agencies, and returned to still photography. One-man show at Museum of Modern Art, New York 1945. Published portfolio of twenty Mexican photographs (1940), *Time in New England* with text by Nancy Newhall (1950). In 1948 Strand settled in France, taking photographs for *La France de Profile* with text by Claude Roy (1952), followed by a 'portrait' of an Italian village—*Un Paese* with text by Cesare Zavattini (1955); *Outer Hebrides* (1962); and *Ghana* (1976), the last two with text by Basil Davidson. A very fine retrospective monograph in two volumes was published by Aperture, New York, 1971–72.

Frank M. Sutcliffe 1859–1940
Son of a watercolour artist. Opened a photographic portrait studio in Whitby 1875, but preferred landscape and *genre* subjects and was prominent in the naturalistic school of photography. Founder member of the Linked Ring 1892. In 1923 Sutcliffe was appointed curator of the Whitby Museum.

William Henry Fox Talbot, F.R.S. 1800–1877
Born at Melbury House, Dorsetshire. Talbot distinguished himself in many fields apart from inventing photography on paper. Experimenting with the *camera obscura* and silver chloride paper he discovered in June 1835 the fixing property of common salt and this enabled him to produce the first permanent photograph on paper. Multifarious activities in other fields made him overlook the importance of his discovery, which was in any case only in the embryo state, but on hearing of Daguerre's invention in January 1839 Talbot published his Photogenic Drawing process to establish priority. He patented his greatly improved process called Calotype, the right to sell prints, and their use in book illustration, in February 1841. Relaxed his patent in favour of amateurs in July 1852 at the request of the Presidents of the Royal Academy and the Royal Society. Published the first photographically-illustrated book *The Pencil of Nature* (1844–6) and *Sun Pictures in Scotland* (1845). Pioneered flash photography of fast-moving objects (1851) and introduced in 1852 Photoglyphic Engraving which was perfected six years later. Talbot's claim that Frederick Scott Archer's collodion process (1851) was covered by his Calotype patent led to a law-suit in December 1854, which he lost. His various patents greatly retarded the progress of photography in Britain until 1855. Died at Lacock Abbey, Wiltshire, the Talbot family seat.

William Telfer
An early professional daguerreotypist and later *carte-de-visite* photographer in Regent Street, London, Telfer abandoned photography when the daguerreotype was superseded by the collodion process.

John Thomson 1837–1921
Scottish explorer and photographer. Following ten years' travels in the Far East, Thomson published *The Antiquities of Cambodia* (1867), *Illustrations of China and Its People* (1873–4) and *The Straits of Malacca, Indo China and China* (1877). The two former were illustrated with his photographs, the latter with woodcuts from his photographs and sketches. Settled in London *c.* 1870 and became instructor in photography to the Royal Geographical Society. Translated Gaston Tissandier's *Les Merveilles de la Photographie* into English (1876). In this year Thomson made the first social photo-documentation, *Street Life in London*, published 1877. In 1880 he pioneered another field, 'at home' portraiture

of celebrities. He also had a portrait studio in Grosvenor Street, London.

Hans Watzek (pseudonym for Johann Josef) 1848–1903
Viennese amateur photographer from 1890 onward. Joined the Viennese Camera Club 1891 and was soon with Henneberg and Kühn one of the three leading figures in artistic photography in Austria. Favoured the gum print process and introduced the simple 'monocle' lens to obtain greater diffusion in his impressionistic photographs—portraits, landscapes, still-life. Prominent at international exhibitions.

Weegee (pseudonym for Arthur Fellig) 1899–1968
Born in Poland. Came to New York at the age of twelve, the son of a poor Jewish immigrant. Fellig was in turn dishwasher, darkroom assistant (for twenty years) and street photographer before becoming a press photographer about 1930. Built up a big reputation with his candid news coverage of poverty, crime, and calamities in New York during fifteen years' close collaboration with the New York police as a free-lance photographer. In the last few years won notoriety with brilliant satirical photo-caricatures of famous contemporaries, and other distortion pictures in both cine and still photography. Published *Naked City* (New York) 1945, *Weegee's People* 1946 and *Naked Hollywood* 1953.

Edward Weston 1886–1958
Born at Highland Park, Illinois. Began career in California as an itinerant photographer. Had portrait studio in Tropico, now Glendale, California, 1911–22, and also made traditional 'Salon' style pictures for exhibitions. Came under the influence of Tina Modotti, who was a far more progressive photographer than himself, and had jointly with her a portrait studio in Mexico City 1923–26. During this period his outlook changed completely. On his return to California in 1927 he started making sharp objective photographs and close-ups of unusual natural forms. Opened portrait studio with his son Brett, first in San Francisco, later in Carmel. Founder member of the F.64 Group, 1932. Five years later Guggenheim Fellowship enabled Weston to devote himself exclusively to landscapes and close-ups of nature, selections of which were published in his books *California and the West* (1940) and *My Camera on Point Lobos* (1950). Unable to photograph in the last decade of his life owing to Parkinson's disease, Weston died at his house in Carmel, California. His diaries, ably edited and published in two volumes by Nancy Newhall, were acquired with his archive by the Center for Creative Photography at Tucson.

Clarence Hudson White 1871–1925
For sixteen years head bookkeeper in a wholesale grocery firm at Newark, Ohio, and amateur photographer from 1894 onward. Founder member of the Photo-Secession 1902, advocate of straight photography and prominent exhibitor. Lecturer on photography at Columbia University, New York, from 1907 until his death. In 1910 White established his own summer school of photography with Max Weber, the painter and Paul L. Anderson. Until 1915 this was located at Sequinland, Maine, and from 1916–25 at Canaan, Conn. White was also instructor at the Brooklyn Institute of Arts and Sciences from 1908–21.

Henry White 1819–1903
Partner in a firm of London solicitors, and prominent amateur photographer from 1854–*c*. 1864. One of the earliest artistic landscape photographers and considered by many contemporaries the best, White showed his pictures frequently at international photographic exhibitions. His landscape idylls were compared with the poetic images of James Thomson's *The Seasons*.

Benjamin Gay Wilkinson 1857–1927
Born in London. A solicitor 1881–1926, photography was for Wilkinson only a holiday pursuit. First exhibited in 1877, and became a prominent follower of the naturalistic school of photography. Founder member of the Linked Ring 1892. Died at his house at Limpsfield, Surrey.

Rolf Winquist 1910–69
Born in Gothenburg, Winquist studied photography there *c*. 1930. Until 1933 commercial photographer and 1933–7 photographer on Swedish-American Line cruises. Settling in Stockholm, Winquist became fashion and portrait photographer at the studio of Åke Lange and, from 1939 to 1968, at the Studio Uggla. After 1950 Winquist took mainly portraits. Member of the Swedish group of photographers 'Tio'.

PROCESSES

Albumen process

The first practical process on glass, devised by Abel Niépce de Saint-Victor (a cousin of Nicéphore Niépce) and communicated to the Académie des Sciences, Paris, on 12 June 1848. A glass plate was coated with a thin layer of white of egg containing a solution of potassium iodide, and when dry, sensitized with an acid solution of nitrate of silver. After exposure, the latent image was developed with gallic acid. On account of its slowness (5-15 minutes' exposure according to circumstances) its application to portraiture was precluded, but the process was excellent for landscapes, architecture and art reproductions, giving very fine detail owing to the perfect transparency of the medium. The advantages of the much faster collodion process on glass introduced in 1851 soon made the albumen process obsolete except for lantern slides. The positive prints were either Calotype positives or, more usually, from 1851 onward albumen prints.

Albumen prints

The albumen printing paper introduced by L. D. Blanquart-Evrard in a communication to the Académie des Sciences, Paris, on 27 May 1850 remained in general use until c.1895. After the first ten years or so this glossy printing-out paper could be bought partly prepared, i.e. coated with a thin film of white of egg. It was sensitized with silver nitrate solution by the photographer. To avoid an unattractive yellow colour, and to achieve greater permanence, the albumen print was generally toned with chloride of gold, which produced various shades of sepia. It was exceedingly slow, needing an exposure of some hours, so could not be used for enlarging.

Ambrotype, or collodion positive on glass

A modification of the collodion process devised in 1851 by Frederick Scott Archer and Peter W. Fry. The under-exposed negative was bleached with nitric acid or bichloride of mercury, and when framed with a backing of black velvet, black paper or opaque varnish, it exhibited a positive effect. Ambrotypes were made in small sizes like daguerreotypes, and fitted into similar cases. For these reasons they are frequently confused; yet the bright mirror-like surface of the daguerreotype is distinctly different from the dull grey appearance of the Ambrotype.

Ambrotypes were used almost exclusively for portraiture, and since the materials were cheaper than the daguerreotype and the manipulation simpler, they soon replaced the daguerreotype altogether. Ambrotypes were very popular in Europe with the lower-class photographers from 1852–1862, when the carte-de-visite superseded them. In America during the same period the ferrotype (a variation of the Ambrotype on lacquered sheet metal) was in common use at the cheaper photographic establishments.

Bromoil process

This process introduced by E. J. Wall and C. Welborne Piper in 1907 largely replaced the oil-pigment process because it could be used for enlargements as well as contact prints. The print was made on fast gelatine-bromide paper, and then bleached to get rid of the black silver image. After fixing and washing, the resulting gelatine relief print would take up oil-pigment of any colour, applied with a brush. The wet relief print was put on a glass plate and inked with the chosen oil-pigment. The gelatine absorbed the pigment gradually, according to the degree in which it had been affected by light, but variations in brush action and the use of pigment of different consistency allowed the photographer a certain amount of control. Action with a dry brush removed surplus pigment and lightened the tone in the highlights.

Calotype

Endeavouring to improve Photogenic Drawing, Talbot on 20–21 September 1840 made the important discovery of developing the latent image, which reduced the exposure time to a few minutes.

A sheet of writing-paper was sensitized with solutions of nitrate of silver and iodide of potassium, forming silver iodide. After exposure, the latent image was developed with gallo-nitrate of silver, fixed with sodium hyposulphite, washed and dried. Sometimes the negative was made more transparent by waxing it, to facilitate the process of making prints and to minimize the appearance of the fibres of the paper. Owing to the texture of the paper, the Calotype is characterized by broad effects of light and shade. The positive prints are reddish or purplish brown in colour. The average exposure time was a few minutes, varying considerably according to size of picture and light conditions. Pictures as large as 12 in. × 16 in. are not uncommon.

The Talbotype or Calotype (from the Greek *kalos* = beautiful) was patented in England, Wales and the Colonies in February 1841, in France in August 1841 and in the United States in June 1847.

At the request of the Presidents of the Royal Academy and Royal Society, Talbot—who was very litigious as regards his rights—relaxed the Calotype patent in 1852 in favour of amateurs. The chief period of its use in England and Wales was 1852–7. It was largely superseded by the collodion process, which until December 1854 Talbot claimed to be covered by his patent.

Up to *c.*1857 prints from glass negatives were also occasionally made on silver chloride (Calotype) paper.

Carbon print

Based on Alphonse Poitevin's carbon process of 1855, perfected by Sir Joseph Wilson Swan in 1864. In principle it was similar to the gum print, except that gelatine not gum arabic was used, and the pigment was powdered carbon (which could be tinted by the addition of other colouring matter). It was usual to buy manufactured 'carbon tissue' (a thin sheet of coloured gelatine), which the photographer sensitized with bichromate of potash. It was then exposed in contact with a negative. Any manipulation or retouching had to be done on the negative. Gelatine, which becomes insoluble by the action of light, is much harder than gum, and the amount that dissolves is completely controlled by the exposure, and cannot be altered by brushing, etc., as in the gum print. After the gelatine was washed out, the print was immersed in an alum clearing bath, rinsed and dried. The resulting print looks like an ordinary photograph.

Collodion process

Frederick Scott Archer's wet collodion process on glass plates was published by him in *The Chemist*, March 1851. It was the fastest process so far devised and the first in England to be free from patent restrictions. Hence its immediate popularity, superseding all other processes.

Collodion containing potassium iodide was poured on to the glass plate, which was tilted until the collodion formed an even coating. Sensitizing followed immediately by dipping the plate in a bath of nitrate of silver solution. It then had to be exposed while still moist, because the sensitivity deteriorated greatly as the collodion dried. Development had also to be carried out directly after exposure, with either pyrogallic acid or ferrous sulphate, and fixed with sodium hyposulphite or potassium cyanide. For the travelling photographer this necessitated transporting a dark-tent and an entire darkroom outfit to the scene of operation.

Exposures varied from 10 seconds to $1\frac{1}{2}$ minutes for landscape and architectural pictures of moderate size. Ambrotype portraits could be taken in 5 to 20 seconds.

Though a number of so-called dry collodion processes were introduced in the 1850s and '60s, their slowness was a serious drawback compared with wet collodion, which remained in general use until *c.*1880 when the still faster and more convenient gelatine dry plate and cut film were introduced.

The positive copies made from collodion negatives are usually albumen prints, to which a warm sepia colour and greater permanence was imparted by a gold-toning bath.

Controlled printing processes

The manipulated prints favoured by the majority of pictorial photographers of the aesthetic period 1895–1914 were made by various techniques, of which the most popular were the gum print, oil-pigment process, and bromoil process. They all allowed the photographer latitude in altering the image.

Daguerreotype

Invented by Louis Jacques Mandé Daguerre in 1837 and named after him, the process was given 'free to the world' by the French Government on 19 August 1839—but had been patented by the inventor in England, Wales and the Colonies five days earlier.

Silvered copper plates (bought ready-made) were exposed to the fumes of iodine, and after exposure in the camera the latent image was developed with mercury vapour, fixed with sodium hyposulphite, and rinsed. The result was a positive picture, which could not be multiplied, and had to be protected by a cover-glass from oxidation and from abrasion.

In an attempt to reduce the 15–20 min. exposure to make the daguerreotype applicable to portraiture, considerable chemical and optical modifications were introduced during 1840–1. Chemical acceleration methods were discovered by J. F. Goddard (1840), Franz Kratochwila (1841) and Antoine Claudet (1841). Optically, the speeding up was effected by Alexander Wolcott's convex-mirror camera without a lens (1840) and the large-aperture Petzval lens introduced by Voigtländer (1841). A further improvement was toning with chloride of gold, introduced by Hippolyte Fizeau in 1840.

The world's first public portrait studio was opened in New York by Alexander Wolcott at the beginning of March 1840, and on 23 March 1841 followed Richard Beard's in London.

The daguerreotype gave remarkably fine detail, but suffered from several disadvantages. (*a*) The picture was laterally reversed, unless taken through a reversing prism (introduced by Antoine Claudet in 1841) which, however, trebled the exposure time. (*b*) Being on solid metal, the daguerreotype could not be used as a negative for the production of copies; each picture was unique. (*c*) Owing to the mirror-like surface of the plate, the picture has to be viewed at a certain angle.

In Great Britain the daguerreotype did not long survive the introduction of the wet collodion process in 1851, though a few daguerreotypists continued to make pictures until about 1858. In America the process remained popular until the mid-'sixties.

Gelatine emulsion

The invention of gelatino-bromide emulsion for coating glass plates, and from 1889 onward celluloid roll-film, is usually attributed to Dr Richard Leach Maddox, who published a fragmentary report of his experiments in the *British Journal of Photography*, 8 September 1871. The emulsion underwent considerable improvement by John Burgess, Richard Kennett and Charles Bennett, and by April 1878 four firms in Great Britain were producing rapid gelatine dry plates on a large scale. The exposures were ten to twenty times faster than with wet collodion, which by 1881 was more or less superseded.

Though the gelatine emulsion is basically the negative material still in use, present-day emulsions differ widely through the addition of a variety of chemicals with the object of (*a*) increasing its speed a hundred to a thousandfold compared with 1880, and (*b*) making the originally colour-blind emulsion sensitive to the correct transcription of some (orthochromatic) or all (panchromatic) of the spectrum colours.

Positive contact copies from gelatine plates or films were usually made until *c*.1895 on toned albumen paper. This was gradually replaced by gelatine silver chloride printing-out paper introduced in 1882, and the considerably faster chloro-bromide or gaslight paper introduced the following year. Enlargements, which became general practice with the widespread use of small plate or miniature cameras in the late 1920s, are made on bromide paper, the fastest of all the gelatine papers, and manufactured since 1880.

Gum bichromate process, or gum print

The gum process introduced by A. Rouillé-Ladêvèze in 1894 and popularized by Robert Demachy the following year was an adaptation of Alphonse Poitevin's gum bichromate process of 1855, the principle being that those parts affected by light became to some extent hardened.

Sized paper was coated with a mixture of gum arabic, potassium bichromate solution (the sensitizer) and watercolour pigment of the desired colour. When dry, the prepared paper was exposed in contact with a negative. After exposure, the print was put face downward in a dish of cold water, and the pigmented gum in the parts that had not been hardened by light were washed out. The amount washed out could be influenced by the warmth of the water, by spraying, sponging, or brushing, according to the photographer's intentions. The process could be repeated several times using pigments of different colours. Finally the print was soaked in a solution of potash alum to get clear highlights, and then rinsed in water. By modifications in coating and washing out, the photographer exercised a great deal of control over the final result. By choosing different types of paper and pigment colours he could create variations of the same picture.

Heliography

The process by which Nicéphore Niépce took the world's first camera photograph in 1826 consisted in coating a polished pewter plate with bitumen of Judea dissolved in white petroleum. This asphalt hardens under the influence of light. After an exposure of at least eight hours in the camera, the latent image on the plate was made visible by dissolving away the parts of the bitumen which had not been hardened by light, with a solvent of oil of lavender and white petroleum. The result was a permanent positive picture in which the lights were represented by bitumen and the shades by bare metal. Niépce's ambition was to etch the plate with acid, ink it, and pull paper prints from it, but this he never achieved because his camera pictures were too weak. However, he succeeded in copying engravings by superposition in about three hours in sunshine, and some of these plates (which he also called heliographs) he had etched and printed from by the Parisian engraver, A. F. Lemaître. The earliest heliograph of an engraving was made by Niépce on glass in 1822, the best is on pewter and dates from 1826. Other materials used were zinc and silvered copper plates.

Oil-pigment process

In this process, introduced by G. E. H. Rawlins in 1904, paper coated with gelatine was sensitized with a solution of potassium bichromate. Exposure under a negative, followed by thorough soaking, produced a gelatine relief with the highlights considerably raised, i.e. the unaffected areas of the gelatine absorbed water and swelled in inverse proportion to their exposure to light. The picture was produced by the application of oil-pigment or fatty ink dabbed on gently on the moist print with a brush. The gelatine accepted or rejected the pigment according to the degree to which the light action had taken place on the bichromated gelatine: the swollen areas repelled the greasy ink and the hardened areas accepted it. The photographer could only exercise a certain degree of control in lightening or strengthening parts locally. The pigment image could be transferred to another sheet of paper in a press, and then re-inked. This double procedure increased the contrast.

Photogenic Drawing

A method of making light pictures on writing paper sensitized with silver chloride and fixed in a solution of common salt, invented by W. H. Fox Talbot in 1835 but not made known until January 1839. On hearing of Daguerre's invention, Talbot, wishing to establish priority, exhibited a number of Photogenic Drawings at the Royal Institution, London, on 25 January, and at the Royal Society six days later.

Owing to the length of exposure in the camera ($\frac{1}{2}$–1 hour), Photogenic Drawings were in the main negative contact copies of botanical specimens, lace, etc., but Talbot also took some views of his house, Lacock Abbey, in the *camera obscura* and exhibited some positive copies printed from his paper negatives. Although Photogenic Drawings were technically much inferior to the daguer-

reotype, the negative/positive principle was of the greatest significance for the future of photography.

Platinotype
The introduction of platinum instead of silver salts for positive printing is due to William Willis, whose platinotype paper was put on the market in 1879. Its great advantage over other positive papers was the permanence of platinum prints. The image was partially printed out in one-third of the printing time necessary with albumen paper, and then developed to its full strength. The matt platinotype was, after the Calotype, the most beautiful positive printing surface, giving very delicate halftones and rich blacks. Its soft silver-grey colour was particularly favoured by artistic photographers. (It could also be toned sepia.) Owing to the constantly rising price of this rare metal, from 25*s*. an ounce in 1879 to £3 in 1891 and still higher in the early years of this century, platino-

type paper was replaced by palladium paper during World War I.

Waxed paper process
An improvement on the Calotype process, published on 8 December 1851 by Gustave Le Gray. The negative was taken on thin paper saturated with white wax. This imparted to the paper greater transparency than the Calotype, giving as fine detail as a glass negative. The waxed paper process was more convenient than the Calotype for the travelling photographer because the paper could be prepared ten to fourteen days beforehand (instead of the day before as with the Calotype), and did not need to be developed until several days after the picture had been taken (whereas the Calotype had to be developed the same day). Exposures were about the same as with the Calotype, but development took from one to three hours.

BIBLIOGRAPHY

AND STUDY LIST

The following works are recommended for a more detailed study of aesthetic trends in photography. Some of them are also listed in the biographical entries:

GENERAL WORKS
Freund, Gisèle. *La Photographie en France au dix-neuvième siècle: Essai de Sociologie et d'Esthétique.* Paris 1936. 154 pp.
Gernsheim, Helmut. *Masterpieces of Victorian Photography.* London 1951. 107 pp. including 72 plates.
Gernsheim, Helmut and Alison. *The History of Photography from the earliest use of the* camera obscura *in the eleventh century up to 1914.* London and New York 1955. 395 pp. and 359 illustrations.
Lécuyer, Raymond. *Histoire de la Photographie.* Paris 1945. 452 pp. including approximately 500 illustrations.
Newhall, Beaumont. *The History of Photography from 1839 to the present day.* New York 1949. 256 pp. including 163 illustrations.
Newhall, Beaumont and Nancy. *Masters of Photography.* New York 1958. 192 pp. including 150 illustrations.

Pollack, Peter. *The Picture History of Photography from the earliest beginnings to the present day.* New York 1958. 624 pp. including 600 illustrations.
Whiting, John R. *Photography is a Language.* New York 1946. 142 pp. including many illustrations.

MONOGRAPHS ABOUT, AND AUTOBIOGRAPHIES BY, IMPORTANT PHOTOGRAPHERS WHO ARE ILLUSTRATED IN THIS BOOK
Atget, Eugène. *Atget.* Introduction by Camille Recht. Paris, Leipzig and New York 1930. 34 pp. and 96 plates. The French and American editions are introduced by Pierre Mac-Orlan.
Bayard, Hippolyte. *Bayard,* by Lo Duca. Paris 1943. 30 pp. and 48 plates.
Bayard, Hippolyte. *Bayard, ein Erfinder der Photographie.* Introduction by Dr Otto Steinert and Pierre G. Harmant. Essen 1959. 18 pp. text and 28 plates.
Beaton, Cecil. *Photobiography.* London 1951. 254 pp. including 60 plates.
Boord, W. Arthur (editor). *Sun Artists.* London 1891. 62 pp. and 32 plates. Contains monographs on J. M.

Cameron, Col Gale, H. P. Robinson, Lyddell Sawyer, J. B. B. Wellington, B. Gay Wilkinson.

Brandt, Bill. *Camera in London*. London 1948. 88 pp. including 58 plates.

Brassaï. *Brassaï* by Henry Miller and Brassaï. Paris 1952. 76 pp. including 60 plates.

Cameron, J. M. *Julia Margaret Cameron: Her Life and Photographic Work*, by Helmut Gernsheim. London 1948. 85 pp. and 55 plates.

Carroll, Lewis. *Lewis Carroll—Photographer*, by Helmut Gernsheim. London and New York 1949. 138 pp. and 64 plates.

Cartier-Bresson, H. *The Photographs of Henri Cartier-Bresson*, by Lincoln Kirstein and Beaumont Newhall. New York 1947. 56 pp. including 41 plates.

Daguerre, L. J. M. *L. J. M. Daguerre: the History of the Diorama and the Daguerreotype*, by Helmut and Alison Gernsheim. London and New York 1956. 220 pp. and 64 plates.

Erfurth, Hugo. *Sechsunddreissig Künstlerbildnisse*, with introduction by J. A. Schmoll gen. Eisenwerth. Essen 1960.

Fenton, Roger. *Roger Fenton, Photographer of the Crimean War*, by Helmut and Alison Gernsheim. London and New York 1954. 116 pp. and 64 plates.

Genthe, Arnold. *As I Remember*. New York 1937. 290 pp. and 112 illustrations.

Gernsheim, Helmut. *The Man Behind the Camera*. London 1948. 144 pp. including 54 illustrations. Contains chapters on Cecil Beaton, Helmut Gernsheim, E. O. Hoppé, Angus McBean, Felix H. Man, Wolfgang Suschitzky, etc.

Hill, D. O. *David Octavius Hill: der Meister der Photographie*, by Heinrich Schwarz. Leipzig 1931. 61 pp. and 80 plates. Also English and American editions published in 1932.

Hoppé, E. O. *Hundred Thousand Exposures*. London 1945. 229 pp. including 64 plates.

Hutton, Kurt. *Speaking Likeness*. London 1947. 88 pp. including 58 plates.

Lerski, Helmar. *Der Mensch, Mein Bruder*, a symposium ed. by Annaliese Lerski. Dresden 1958. 31 pp. and 79 plates.

Martin, Paul. *Victorian Snapshots*. London 1939. 72 pp. and 79 plates.

Moholy-Nagy, L. *L. Moholy-Nagy: 60 Fotos*, edited and introduced by Franz Roh. Berlin 1930.

L. Moholy-Nagy, edited by Fr Kalivoda. Brno 1936. 134 pp. including many illustrations. Text in Czech, English, French and German.

Nadar (Gaspard Félix Tournachon). *Quand j'étais Photographe*. Paris 1899. 312 pp.

Ray, Man. *Man Ray: Photographs 1920–1934*. Hertford, U.S.A. 1934. 10 pp. and 104 plates.

Steichen, Edward. *Edward Steichen*, by Carl Sandberg. New York 1929.

Stieglitz, Alfred. *America and Alfred Stieglitz: a Collective Portrait* (a symposium). New York 1934. 339 pp. and 32 plates.

Strand, Paul. *Paul Strand, Photographs 1915–45*, by Nancy Newhall. New York 1945. 32 pp. including 23 plates.

Weston, Edward. *Edward Weston*, by Nancy Newhall. New York 1946. 36 pp. including 23 plates.

BOOKS SIGNIFICANT FOR CREATIVE PHOTOGRAPHY AT VARIOUS PERIODS

I. PICTORIAL PHOTOGRAPHY

Caffin, Charles H. *Photography as a Fine Art*. New York 1901.

Guest, Antony. *Art and the Camera*. London 1907. 159 pp. Illustrated.

Hinton, A. Horsley. *Artistic Landscape Photography*. London 1896.

Hinton, A. Horsley. *Practical Pictorial Photography*. London 1910. Part I 108 pp., Part II 69 pp. Illustrated.

Johnston, J. Dudley. *Some Masterpieces of Photography from the Collection of the Royal Photographic Society*. London 1936. 56 plates.

Petit, Pierre A., fils. *La Photographie Artistique*. Paris 1883. 46 pp.

Robinson, Henry Peach. *Pictorial Effect in Photography*. London 1869. 199 pp. Illustrated.

Robinson, Henry Peach. *Picture Making by Photography*. London 1884. 146 pp. Illustrated.

Robinson, Henry Peach. *The Elements of a Pictorial Photograph*. London 1896. 167 pp. Illustrated.

Robinson, Henry Peach. *Letters on Landscape Photography*. London 1888. 66 pp.

Schintling, Karl von. *Kunst und Photographie*. Berlin 1927. 68 pp. Illustrated.

Spörl, H. *Portrait-Kunst in der Photographie*. Part I Ästhetik. Leipzig 1909. 125 pp. Illustrated.

Tilney, F. C. *The Principles of Photographic Pictorialism*. Boston 1930. 218 pp. and 80 plates.

Wall, A. H. *Artistic Landscape Photography*. London 1896. 171 pp. Illustrated.

II. NATURALISTIC PHOTOGRAPHY

Emerson, P. H. *Naturalistic Photography for Students of the Art*. London 1889. 307 pp.

III. IMPRESSIONISTIC PHOTOGRAPHY

Bourgeois, Paul (editor). *Esthétique de la Photographie*. Paris 1900. 96 pp. Copiously illustrated.

Demachy, Robert, and Puyo, C. *Les Procédés d'Art en Photographie*. Paris 1906. 146 pp. and 42 plates.

Doty, Robert. *Photo-Secession. Photography as a Fine Art*. Rochester, N.Y. 1960. 104 pp. including 32 plates.

Holme, Charles. *Art in Photography*. London 1905. 60 pp. and 112 plates.

Holme, Charles. *Colour Photography and other recent developments of the art of the Camera*. London 1908. 18 photographs in colour and 98 in monochrome.

Juhl, Ernst. *Das Lichtbild als Kunstwerk*. Halle 1897.

Juhl, Ernst. *Internationale Kunstphotographie*. Halle 1900 and 1901.

Juhl, Ernst (editor). *Camera-Kunst* (a symposium). Berlin 1903. 107 pp. including numerous illustrations.

Lichtwark, Alfred. *Die Bedeutung der Amateur Photographie*. Halle 1894.

Loescher, Fritz. *Die Bildnisphotographie*. Berlin 1903. 200 pp. including 94 photographs.

Matthies-Masuren, F. *Künstlerische Photographie: Entwicklung und Einfluss in Deutschland*. Berlin 1907. 117 pp. Illustrated.

Puyo, C. *Notes sur la Photographie Artistique*. Paris 1896. 51 pp. Illustrated.

Sauvel, Edouard. *De la Propriété Artistique en Photographie*. Paris 1897. 126 pp.

Sizeranne, R. de la. *La Photographie, est-elle un Art?* Paris 1899. 51 pp. Illustrated.

Gummidrucke von Hugo Henneberg, Heinrich Kühn, Hans Watzek. Halle 1902–3. Portfolio of reproductions of gum prints.

The following illustrated periodicals give an excellent picture of international art photography, chiefly of the impressionist period:

Photograms of the Year. London 1895 to date. An excellent source to study the most banal photographs shown at the chief London pictorial exhibitions.

The Photographic Art Journal, edited by Harry Quilter and Fred. C. Shardlow. Leicester, March 1901–February 1904. A monthly magazine with mainly English illustrations.

Die Kunst der Photographie, edited by Franz Goerke. Berlin 1897–1908, Halle 1908–ca. 1914. First a bimonthly, later a quarterly magazine, each issue containing 25–36 photogravures, later mixed with autotypes of artistic photographs.

Die Photographische Kunst, edited by F. Matthies-Masuren. Halle 1902–c.1912. Superbly illustrated annual.

Die Bildmässige Photographie, edited by F. Matthies-Masuren. Halle 1904–5. Four issues: No. 1 *Die Landschaft*, No. 2 *Das Bildnis*, No. 3 *Figur und Staffage*, No. 4 *Interieur und Architektur*. Each issue contains 51 pp. and 16 plates.

Photographisches Centralblatt, edited by F. Matthies-Masuren and others. Karlsruhe, later Munich 1895–c.1910. Beautifully illustrated monthly magazine.

Camera Work, edited by Alfred Stieglitz. New York 1903–17. A quarterly magazine illustrating the work of leading American and European art photographers in photogravure plates on Japan paper. 50 issues published.

La Revue de Photographie. Paris 1903–8. Monthly magazine published by the Photo-Club de Paris.

IV. BAUHAUS AND NEW OBJECTIVITY

Blossfeldt, Karl. *Urformen der Kunst. Photographische Pflanzenbilder*. Introduction by Karl Nierendorf. Berlin 1929. 18 pp. and 120 plates.

Ehrhardt, Alfred. *Das Watt*. With introduction by Kurt Dingelstedt. Hamburg 1937. 96 plates.

Ehrhardt, Alfred. *Die kurische Nehrung*. With introduction by the author. Hamburg 1938. 44 plates.

Ehrhardt, Alfred. *Kristalle*. With introduction by Waldemar Schornstein. Hamburg 1939. 64 plates.

Ehrhardt, Alfred. *Muscheln und Schnecken*. With introduction by Eduard Degner. Hamburg 1941. 112 plates.

Feininger, Andreas. *New Paths in Photography*. London 1939. 15 pp. and 47 plates.

Gernsheim, Helmut. *New Photo Vision*. London 1942. 32 pp. and 32 plates.

Gräff, Werner. *Es Kommt der Neue Fotograf*. Berlin 1929, 126 pp. Illustrated.

Lerski, Helmar. *Köpfe des Alltags*. Introduction by Curt Glaser. Berlin 1931. 10 pp. and 80 illustrations.

Lendvai-Dirckson, Erna. *Das Deutsche Volksgesicht*. Berlin 1930. 240 pp. including 140 photographs.

Moholy-Nagy, Laszlo. *Malerei, Photographie, Film*. Munich 1925. 132 pp. and approximately 80 illustrations.

Moholy-Nagy, Laszlo. *The New Vision*. New York 1931.

Nash, Paul. *Fertile Image*. Edited by Margaret Nash. London 1951. 32 pp. and 64 plates.

Renger-Patzsch, Albert. *Die Halligen*. With foreword by Johann Johannsen. Berlin 1927. 10pp. and 144 plates.

Renger-Patzsch, Albert. *Die Welt ist Schön*. Edited and introduced by Carl Georg Heise. Munich 1928. 22 pp. and 100 plates.

Renger-Patzsch, Albert. *Eisen und Stahl*. With a foreword by Albert Vögler. Berlin 1931. 8 pp. and 97 plates.

Roh, Franz, *Foto-Auge: 76 Fotos der Zeit*. Edited by Franz Roh and Jan Tschichold and with an introduction by Franz Roh on 'Mechanism and Expression'. Stuttgart 1929. 18 pp. and 76 plates.

Roh, Franz. *Aenne Biermann—60 Photographien*. Edited and introduced by Franz Roh. Berlin 1930. 11 pp. and 60 plates.

Sander, August. *Antlitz der Zeit*, with an introduction

by Alfred Döblin. Munich 1929. 17 pp. and 60 plates.

Tietgens, Rolf. *Der Hafen*. Hamburg 1939. 95 plates.

V. SOCIAL AND POLITICAL REPORTAGE

H. Th. B. *Wehrlos Hinter der Front. Leiden der Völker im Krieg*. 144 agency photographs. Frankfurt 1931.

Bourke-White, Margaret and Caldwell, Erskine. *You Have Seen Their Faces*. New York 1937. 54 pp. including 72 photographs by Margaret Bourke-White.

Brandt, Bill. *The English at Home*. London 1936. Introduction by Raymond Mortimer. 8 pp. and 63 plates.

Brassaï. *Paris de Nuit*. Paris 1933. 62 plates.

Evans, Walker. *American Photographs*, with an essay by Lincoln Kirstein. New York 1938. 198 pp. including 87 plates by Walker Evans.

Ostwald, Hans. *Sittengeschichte der Inflation. Ein Kulturdokument aus den Jahren des Marktsturzes*. Berlin 1931. 280 pp., including numerous agency photographs.

Riis, Jacob A. *How the Other Half Lives*. New York 1890. 304 pp. including 43 woodcuts from photographs by Riis.

Salomon, Dr Erich. *Berühmte Zeitgenossen in unbewachten Augenblicken*. Stuttgart 1931. 48 pp. and 112 photographs.

Stenbock-Fermor, Graf Alexander. *Deutschland von Unten: Reise durch die proletarische Provinz*. Stuttgart 1931. 160 pp. and 62 agency photographs.

Schultz, Edmund. *Das Gesicht der Demokratie*. Introduction by Friedrich Georg Jünger. Leipzig 1931. 152 pp. including numerous agency photographs.

Thomson, J. and Smith, A. *Street Life in London*. London 1877–8. 36 photographs by Thomson with text by Thomson and Smith. Published in monthly instalments.

VI. POST-WAR PERIOD

The following is a small selection from the many excellent modern picture books:

Avedon, Richard. *Observations*. Lucerne, London and New York 1959. 151 pp. including numerous photographs. Text by Truman Capote.

Bischof, Werner. *Japan*. Zürich, London and New York 1954. Introduction by Robert Guillain. 26 pp. and 109 plates.

Bischof, Werner. *Unterwegs*. Zürich 1957. Introduction by Manuel Gasser. 76 plates.

Cartier-Bresson, Henri. *Images à la Sauvette*. Paris 1952. 126 plates.

Cartier-Bresson, Henri. *China in Transition*. London 1956. 144 plates.

Feininger, Andreas. *The Anatomy of Nature*. New York 1956. 168 pp. including numerous plates.

Franke, Herbert W. *Kunst und Konstruktion*. Munich 1957. 74 pp. and 67 plates.

Franke, Herbert W. *Wohin kein Auge reicht*. Wiesbaden 1959. 40 pp. and 95 plates.

Izis (pseudonym for Israel Bidermanas). *Grand Bal du Printemps* with text by Jacques Prévert. Lausanne 1951. 144 pp. profusely illustrated.

Klein, William. *New York*. Geneva, London and New York 1956. 188 pp. (no text).

Pawek, Karl. *Totale Photographie*. Olten, Switzerland 1960. 150 pp. and 80 plates.

Penn, Irving. *Moments Preserved*. Lucerne, London and New York 1960. 151 pp. including numerous photographs.

Schulthess, Emil. *Africa*. Zürich 1958; London and New York 1960. 260 plates.

Steichen, Edward. *The Family of Man* (book of the exhibition). New York 1955. 207 pp. of pictures.

Steinert, Dr Otto. *Subjektive Fotografie* 1. Bonn 1952. 40 pp. and 112 plates.

Steinert, Dr Otto. *Subjektive Fotografie* 2. Munich 1955. 39 pp. and 112 plates.

Weegee (pseudonym for Arthur Fellig). *Naked City*. New York 1945. 244 pp. including numerous plates.

ANNUALS

American Society of Magazine Photographers' Picture Annual. New York 1957. 192 pp.

Das Deutsche Lichtbild, edited by H. Windisch and others. Berlin 1927–38; revived Stuttgart 1955–79.

Modern Photography, edited by C. G. Holme. London 1931–42.

Photographie. Paris 1930–9, 1947 (special numbers of *Arts et Métiers Graphiques*).

Photography Year Book (various editors). London 1950 to date.

U.S. Camera Annual, edited by Tom Maloney. New York 1935–68.

INDEX